More Praise for *A World Without "Whom"*

"A small revolution ... Unlike the language scolds of yore, Favilla embraces the new ways, punctuating her writing with emoji, inserting screen-grabs of instant messages, using texting shortcuts such as 'amirite?' Hers is a rule book with fewer rules than orders to ignore them." —**Tom Rachman, *The Times Literary Supplement***

"The internet has brought a range of changes to society, not least of all to our communication. Emmy J. Favilla explores this particular evolution in *A World Without "Whom": The Essential Guide to Language in the BuzzFeed Age.* In true internet style, she incorporates fun emojis, quizzes, and more into her book." —***Bustle*, The 13 Best New Nonfiction Books of the Month**

"Witty and informative ... This is the rare style manual that is as entertaining as it is instructive." —***Publishers Weekly***

"A lighthearted take on communicating in the digital age." —***Kirkus Reviews***

"A smart and amusing work that will appeal to those who enjoy the fun point of contact between language's inherent ambiguity and its cultural and technological biases." —***Library Journal***

"[*A World Without "Whom"*] lifts up what matters in language, namely clarity and respect for others, and grants permission to dismiss those hobgoblins disguised as 'rules.'" —***Booklist***

"Snappy and irreverent—but it's also thoughtful, well-informed and relentlessly commonsense ... While it may induce cringing among red-pen wielders, Favilla's book will also provoke (literal) LOLs and

may inspire a kinder, gentler, more free-flowing approach to language for grammar nerds both traditional and modern." —*Shelf Awareness*

"Equal parts LOL, OMG, and WTF, *A World Without "Whom"* is an entertaining and thought-provoking look at language in the internet age." —**Erin McKean, founder, Wordnik.com**

"Favilla's anti-prescriptive manifesto is an *Anarchist Cookbook* for writers and editors (which covers almost everyone). Sample advice: 'No one uses proper capitalization on Twitter'; 'LOL is "played out"'; and the all-important 'When you publish stuff on the web, you're writing for a global audience, whether it's your intention or not.' I only threw it across the room once!" —**Stephin Merritt, author of *101 Two-Letter Words***

"I admire Emmy J. Favilla's passionate thoughtfulness about language as much when I agree with her—'Serial comma for president!' indeed—as when I don't—she can messenger over to my office all those poor sad discarded *whoms*, and I'll give them a good home. Tackling problems so of-the-minute I didn't even know they existed, she displays throughout this witty guide that bracing combination of open-mindedness and sheer willfulness one relishes in a word person." —**Benjamin Dreyer, author of *Dreyer's English: An Utterly Correct Guide to Clarity and Style***

**The Essential Guide to Language
in the BuzzFeed Age**

a world without "whom"

Emmy J. Favilla
BuzzFeed Copy Chief

BLOOMSBURY PUBLISHING
NEW YORK · LONDON · OXFORD · NEW DELHI · SYDNEY

BLOOMSBURY PUBLISHING
Bloomsbury Publishing Inc.
1385 Broadway, New York, NY 10018, USA

BLOOMSBURY, BLOOMSBURY PUBLISHING, and the Diana logo
are trademarks of Bloomsbury Publishing Plc

First published in the United States 2017
This paperback edition published 2019

ISBN: HB: 978-1-63286-757-5; eBook: 978-1-63286-759-9; PB: 978-1-63286-758-2

Library of Congress Cataloging-in-Publication Data

Names: Favilla, Emmy, author.
Title: A world without "whom" : the essential guide to language in
the Buzzfeed age / Emmy Favilla.
Description: New York : Bloomsbury USA, 2017.
Identifiers: LCCN 2017018955| ISBN 9781632867575 (hardcover : acid-free paper) |
ISBN 9781632867599 (epub)
Subjects: LCSH: Authorship—Style manuals. | English language—Style—
Handbooks, manuals, etc.
Classification: LCC PN147 .F38 2017 | DDC 808.02—dc23
LC record available at https://lccn.loc.gov/2017018955

2 4 6 8 10 9 7 5 3 1

Designed and typeset by Sara Stemen
Printed and bound in the U.S.A. by Berryville Graphics Inc., Berryville, Virginia

To find out more about our authors and books visit
www.bloomsbury.com and sign up for our newsletters.

Bloomsbury books may be purchased for business or promotional use.
For information on bulk purchases please contact Macmillan Corporate and
Premium Sales Department at specialmarkets@macmillan.com.

To everyone at BuzzFeed who helped make this book come to life and all of the brilliant and hilarious humans I've been fortunate to work with since 2012.

To my parents, Emily and Joe, who encouraged me to start reading books mere moments after popping out of the womb and didn't care that I was reading things like Stephen King's *Misery* at age ten. As long as I was reading. That was cool.

To my friend Belma, who's been asking me to write a book since I was in college. Ta-da!

Contents

Introduction **1**

1 The Birth of the BuzzFeed Style Guide **5**

2 Language Is Alive **13**

3 Getting Things Right:
The Stuff That Matters **36**

4 How to Not Be a Jerk:
Writing About Sensitive Topics **59**

5 Getting Things As Right As You Can:
The Stuff That Kinda-Sorta Matters **80**

6 How Social Media Has
Changed the Game **153**

7 "Real" Words and Language Trends
to Embrace **193**

8 How the Internet Has Changed
Punctuation Forever **239**

9 From Sea to Shining Sea:
Regional Stylistic Differences **271**

10 At the Intersection of E-Laughing
and E-Crying **289**

11 Email, More Like Evilmail, Amirite? **300**

12 We're All Going to Be Okay **309**

Acknowledgments **312**

APPENDIX I The BuzzFeed Style Guide (US & UK) Word Lists **314**

APPENDIX II Terms You Should Know **347**

APPENDIX III Headlines on the Internet **349**

APPENDIX IV Editing for an International Audience **356**

Additional Quizzes **364**

Notes **371**

Index **383**

Introduction

World peace is a noble ideal, but I'd like to step that goal up a notch: A world with peace *and* without *whom* is the place I'd like to spend my golden years, basking in the sun, nary a subjunctive mood in sight, figurative *literally*s and comma splices frolicking about.

This is a book about feelings, mostly—not about rules, because how can anyone in good conscience create blanket rules for something as fluid, as personal, and as alive as language? Something that is used to communicate *literally* (literally) every thought, every emotion humans are capable of experiencing, via every medium in existence, from speech to print to Twitter to Snapchat? We can't. Nearly everything about the way words are strung together is open to interpretation, and so boldly declaring a sentence structure "right" or "wrong" is a move that's often subjective, and we'd be remiss not to acknowledge that most of the guidelines that govern our language are too. Communication is an art, not a science or a machine, and artistic license is especially constructive when the internet is the medium.

And let's clear the air here, just so you're aware of the level at which you should realistically set the bar for what you are about to read: I am not an academic. I am not a lexicographer. I am not a grammar historian (a job description I just made up but am pretty confident is a title that actually exists). I did not study linguistics in my collegiate years. I wasn't even an English major. I am constantly looking up words for fear of using them incorrectly and everyone in my office and my life discovering that

I am a fraud. I was a journalism student (and a FASHION journalism graduate student, lol—cut me some slack, I wanted to live in London) with minors in creative writing and Italian studies. I spent my undergraduate years writing reviews of tourist-trap Little Italy bakeries and local Queens venues frequented by high school goths, and my graduate experience consisted almost exclusively of trying to convince snotty PR people to agree to give me a ticket to the standing row of bottom-tier fashion shows. I landed my job at BuzzFeed after admitting during my first-round interview that the only television shows I watched regularly were *Teen Mom* and all prison reality shows currently on air. This has not changed.

What I am is a person with what I think/hope is a decent grasp of English syntax, an interest in how words are used and how language changes, a fascination with how usage and punctuation (or lack thereof) affects tone, and an unwavering appreciation for an artfully placed em dash. I am a person who happened to stumble into a career in copyediting by way of my journalism degree. It is my accidental livelihood, and I do my best to not fall apart at the seams whenever someone asks me whether to spell the abbreviated version of *until* as *'til* or *til* or *till* (spoiler: I don't care) or apologizes for a typo or punctuation error in an email to me (what kind of a monster do you think I am???). I have a casual relationship with language, and I know my way pretty well around grammar basics—but I'd never considered myself much of a "language expert" until Kathie Lee and Hoda Kotb invited me on their show in 2014 to do a trivia segment about the origins of everyday phrases and described me as such in that little banner at the bottom of the screen that they put in front of guests. So, I guess it must be true. Let's drink a giant Wednesday morning glass of wine to that, amirite?

No, I'm not right. I google (that's right, lowercased as a verb—back me up here, *Merriam-Webster*) the names of tense categories on a regular basis to trick writers into thinking I know my shit when I present my edits, but I couldn't identify a future passive progressive verb tense

in the wild (i.e., without help from the internet) if my life depended on it. I have to consult the dictionary to figure out whether it's *lain* or *laid*. Every. Damn. Time. I skipped the session on diagramming sentences at the last copy editors conference I attended because I had neither the fortitude nor the brain capacity to last a full hour engaging in said activity.

Screenshot of an exchange with the world's worst copy chief.

I would consider myself more of a feelings-about-language expert than a straight-up language expert, mostly because I don't consider myself a language expert at all. When English isn't your father's first language and your mom sounds like she's spent her entire life auditioning for Fran Drescher's character in *The Nanny: The Musical*, that distinction takes a considerable amount of effort to attain—an amount of effort that I'm not sure I'm willing to put in. I'd rather focus my energy

on the important stuff, like rescuing street cats or Instagramming the progression of my cactus's new arms. (It's grown five of them in less than a year, okay?)

I landed my first real job as a copy editor after a string of editorial internships where my hodgepodge of duties included everything from setting up fashion shoots for indie bands to reviewing books on customer relationship management to visiting showrooms full of lacy decorative pillows. I enrolled in the lone copyediting class that NYU offered during my senior year as an undergraduate journalism student. It was on Friday mornings at 8:30, and Thursday night karaoke at the local bar usually went strong until at least 2 A.M., so I was asleep/hungover/drunk for most of the lesson and had to let my ~feelings~ (more on the elusory tildes on page 239) guide me through making plenty of editing decisions I didn't know the hard-and-fast rules for. And either I have really good intuition or my colleagues have been too polite to tell me that my edits have been nothing short of reprehensible over the past decade, but that process has seemed to work pretty well ever since. So well, in fact, that one fateful day in 2012 a slew of senior-level managers at BuzzFeed were duped into thinking I'd be the perfect person to craft what would become the BuzzFeed Style Guide.

The Birth of the BuzzFeed Style Guide

My first day at BuzzFeed was October 29, 2012. It was also the day that Hurricane Sandy, the largest Atlantic hurricane on record to date, hit New York City. And so while all my new coworkers were adhering to contingency plans and working from their own or someone else's home, I spent my first week at this weird little startup (at the time, comprising roughly 150 employees) hanging out on my couch, meeting all my new colleagues over email and Twitter—and frantically combing through my Twitter history for anything inappropriate, which I would soon learn was wholly unnecessary, if not detrimental to making new

friends—and trying to figure out a logical, sustainable system for copy-editing a site that had never before employed a copy editor. All this as the entire editorial team swarmed the story of the storm from every angle possible, from the somber and heartfelt ("60 Extremely Powerful Photos of Sandy's Destruction Everyone Needs to See") to the silly, absurd, and uplifting ("Hurricane Sandy Texts from Your Mom"). It became immediately clear to me just how dedicated, intelligent, creative, diligent, fearless, and ridiculous the entire group of humans I would go on to call my BuzzFeed family was. From day one (literally) I've been filled with a profound sense of pride and awe that has only intensified in the years since, as I've watched the company balloon into a household name and witnessed the birth of BuzzFeed News, BuzzFeed Motion Pictures, the BuzzFeed Entertainment Group, distributed content, and a global, cross-platform network of reporters, editors, video producers, illustrators, and more.

BuzzFeed had hired an editor-in-chief, Ben Smith, at the start of 2012, and that fall the longform (aka features) vertical would launch under features editor Steve Kandell; it was due time, the powers that be had decided, for a copy editor. Luckily for me, I'd projected just the right combination of strangeness and competency during my interview and was selected to fill the role, despite the copyediting test consisting primarily of a story about Mitt Romney—the problem being that I didn't know anything about politics, and still don't. (Sorry, Ben, please don't fire me.) My interest in politics peaks during presidential elections, but even then, it's marginal at best, so I was worried I'd missed something huge, like affiliating someone with the wrong party or not realizing some fancy political term was entirely made up. ("Just because I don't use *assemblybustering* regularly doesn't mean other people don't, right?"—me, asking myself this question during the copy test.) Such was not the case, miraculously, and I was put to work several weeks later as a copy editor at BuzzFeed, when my coworkers were foolish enough to trust I wouldn't butcher their finely tuned prose or

routinely ask them ignorant questions about the words sitting in front of me. I like to think I've come through roughly 75 percent of the time.

With no one IRL to show me the ropes during my first week, and little training in place for new hires (even less so when I was being trained via screen, in the middle of a hurricane, a needy cat meowing furiously by my side), I improvised. I started poring through the home-page, making edits on stories I thought were interesting enough to click into. I made the choices I thought were best, with little to no pushback (mostly due to little to no oversight); everyone else was just trying to figure out this BuzzFeed thing too. Said process would go on to be the foundation for shaping my attitude toward copyediting the site in the years to follow: Using your best judgment and your experience to guide you, do what you think is right and then ask other people if they agree. If they say yes, cool. If they say no, work something out together that seems most appropriate.

The first style call I was asked to make was one of utmost impor-tance to our nascent food section: how to spell the abbreviated form of *macaroni and cheese*. I settled on *mac 'n' cheese*, because the *'n'* is cuter than an ampersand, and it signifies that letters have been elided on either side of the *n*. I did not consider *and* an option; when spoken, the abbreviation of this delightful dish typically loses any inkling of a *d* sound. The conversation with our food editor at the time went like this:

EMILY: hi
how do you want me to write down mac and cheese
like should I say macaroni and cheese every time
ME: hey! maybe mac 'n' cheese?
EMILY: ok
ME: is that cool?
EMILY: yeah whatever you want!
ME: k!

Even in instances as petty as The Great Mac 'n' Cheese Call of 2012, I felt a supreme responsibility to put into place the most logical and appropriate language guidelines, given BuzzFeed's readership ("everyone on Facebook," as Ben Smith made sure to inform me during my interview). The site needed standards that accurately reflected the tone of its lighthearted and sometimes utterly ridiculous posts and engaged readers with its signature relatable, conversational tone, as well as rules that maintained the integrity of news stories—ones that wouldn't distract readers, pull them out of immersion, or cause them to question our authority.

All of a sudden I found myself tasked with the even more supreme responsibility of creating a style guide for BuzzFeed. The existing "style guide" consisted of roughly four lines on a bare-bones intranet page: It was composed exclusively of notes on formatting numbers and a rule that the first line of a dek—i.e., the typically one- or two-sentence subheading that expands on or supplements a headline—is always in boldface. (That rule has since been overturned, as the site's content evolved and deks generally got shorter.) With a two-and-a-half-week trip to Thailand looming in January 2013, I had a non-negotiable deadline; I had to pull it all together by the end of December. I consulted style guides from prior gigs (I had previously been the copy chief at *Teen Vogue* and had copyedited in both full-time and freelance roles for a host of national magazines), asked former coworkers to send me additional style guides for reference, and pooled all my resources within the company: some style help from the music editors, recipe-formatting thoughts from the food gang, language suggestions from the LGBT section's team. I used

MUPHRY'S LAW

The adage that if you criticize someone's editing skills—for grammar, punctuation, or otherwise—there will be an error in your written criticism.

The Associated Press Stylebook (*APS*) and *The Chicago Manual of Style* (*CMOS*) as our overarching style manuals and Merriam-Webster.com (which I'll refer to in all instances going forward as *MW*) as our dictionary, noting exceptions and making decisions on the issues on which these reference materials had conflicting (or no) advice.

Within two months of my start date, BuzzFeed's one-woman copy department had sent along a five-thousand-word first draft (it has since quadrupled in volume) of the style guide to the site's editor-in-chief, executive editor, and editorial director. There were few revisions: The big ones were an executive decision to lowercase *internet*, because, well, capitalizing it looked weird (a guiding principle I would go on to use regularly, and with much success, when making style decisions across the board), at a time when the prevailing style guides called for a capital *I*, and my editor-in-chief's insistence to pluralize *M.D.* as *M.D.s* instead of *M.D.'s*, despite how much the sight of that made me want to jump from a multistory building (I made sure to always avoid a situation in which this was the only option, until we revised our rule to go sans periods in *MD* and similar constructions). *APS* finally came around on the lowercase *internet* (and *web*) front in 2016, but nothing looks as good as smug feels, so never forget that BuzzFeed did it first, way back in 2012. The staff's collective gut instincts on which words have entered common usage and can be justifiably lowercased have been pretty on point in the time since.

Over the next year, as the company expanded and outgrew yet another office, we continued to add and revise and delete and revise until we were secure that this fully blossomed flower was a version of a guide that accurately represented our ethos and our standards and our tone—and one that covered all the content we published, which was challenging, because that translated to, well…virtually everything. We added sections about race and ethnicity, mental health, and our very transparent corrections policy, among other things, taking suggestions from a majority of the editorial staff and adding entries based on FAQs.

Some of my favorites include *come* (verb); *cum* (noun—omg, yes, this is really here); *Juggalo/Juggalette*; and, just to settle a long-standing internal battle, our only entry specifying pronunciation, *GIF/GIF'd* (as a verb), *GIFs*, and *GIFable* (pronounced "gif" with a hard *G*, NOT like the peanut butter, Jif). And let's not forget the style guide's one true Easter egg: *updog*. ("Nothing, what's up with you?") Thank you, internet oddball Katie Notopoulos, for asking for spelling clarification on this one.

 cates 11:30 AM
how is rickroll not in our style guide

Ask and you shall receive, dear coworkers.

In February 2014, after copying and pasting this internal document into the CMS (that's content management system for any of you 'net n00bs), with some polishing help from my now deputy copy chief, Megan Paolone, and at the instruction of Ben Smith, I hit "publish" and sent it off into the abyss. I'd been very vocally hesitant to make it a public document—coming from a magazine background, I thought the idea of publishing a publication's internal style sheet seemed bizarre and entirely unnecessary—but my reluctance would soon be proven shortsighted. For some reason NPR and a host of other media outlets wanted to interview me about it, which was cool but unexpected. *Never see a style guide before, weirdos?* I remember thinking. *It just has a few offbeat entries. What's the big deal?* Nevertheless, it resonated with journalists and non-journalists alike, and while, of course, sacrificing anything word-related to the internet gods puts one at risk of being mercilessly scrutinized by trolls, language nerds, and miserable humans alike, the feedback was overwhelmingly positive.

The abundance of publicity around "the internet's first style guide" was rooted in the plain fact that nothing like it had really been created on that scale before. Plenty of unconventional news sites, like *The Onion*, for instance, have similar guides typically circulated among

editors internally, but to publish such a style sheet conveyed a sense of authority that BuzzFeed felt poised to make, in a "We're not always super serious about ourselves and sometimes you need to be flexible and break the rules and maybe you should take a cue from us" sort of way. There's certainly value in pragmatic style advice you wouldn't find in *APS* or a standard dictionary, about the kind of language people actually use in real life and on the internet—language that often consciously breaks the rules for a specific intent. That value came into perfect focus when someone sent a BuzzFeed editor a picture of their journalism course syllabus from the University of Illinois in which the BuzzFeed Style Guide had been included as recommended reading.

On a personal level, by way of creating the style guide, I've learned a lot more about myself and the values I hold and hope to instill in others. I've always followed the rules, but from a safe distance, so as not to be completely stripped of my ability to see them critically and to

reshape them into what best fits the situation if need be—in the name of both practicality and fun. This has been a running theme in my life. At age thirteen, I was salutatorian of my junior high school class but dated a boy behind my parents' backs (he smoked pot!); I went to the top-ranking specialized public high school in New York City but got my first tattoo at seventeen with a fake ID; I graduated from NYU magna cum laude but was an avid underage drinker and recreational drug user. Learning was important, but—cornball alert—enjoying and finding meaning in life, even when it meant breaking the rules, was important to me too. And that same ideology, in a sense, is what helped me to shape the BuzzFeed Style Guide and approach the art of copyediting in a way I had never quite done before. It's fine to flout "the rules" when you have a solid understanding of what the rules are and a calculated reason for doing so—for tone, for humor, for readability. Blindly following the rules every day does no one any favors and often leads to resentment and frustration when writers point out that a certain phrasing looks odd and you agree but shrug your shoulders and point, with exhaustion and defeat in your bloodshot eyes, to the yellowed *AP Stylebook* tethered to your desk.

This, by far, has been my greatest compliment to date:

buzzfeed:

> 13th-december-1998:
>
> > Petition for buzzfeed to stop saying 'yas'
>
> According to our official style guide, the correct spelling is "yaaass."

Your style guide reads like it was written by a guy who had way too much cocaine one weekend and an unlimited data plan...

Language Is Alive

There is no such thing as correct style. And sometimes there's no such thing as correct spelling.

If these notions are not inherently horrifying to you, congratulations! You've picked up the right book. And if you think diagramming sentences is a pastime reserved for losers, we're going to get along very well on this journey. But if you prefer your grammar rules packaged neatly in a little box filled with etchings in stone rather than as wads of Silly Putty, you may be moved to tears—and possibly violence—as you attempt to get through these pages in one piece. I'll argue that this

book is for you too, and will save you from the sordid path of a misguided prescriptivist's lifestyle. (I know, I know, the prescriptivist-descriptivist binary is a false one, but more on these distinctions later, if the first part of this sentence didn't already catapult you into an intensely deep sleep.) Accepting language as malleable is deeply liberating, and I highly recommend it. As a copy chief, when faced with questions about gray-area style choices, I have been known to regularly tell editors, "Just follow your heart," because I am a commitment-phobe when it comes to language—and because tone, voice, and readership often weigh more heavily than any one page of your tattered old copy of the *Elements of Style* does.

Change is, after all, what keeps a language in business. "The moment English stops changing, it's dead, it's Latin," as Katherine Connor Martin, head of US dictionaries for Oxford University Press, said valiantly at the 2015 American Copy Editors Society conference—a delightfully nerdy gathering of descriptivists and prescriptivists and people with unflappable, aggressive feelings for or against the Oxford comma (for the record: big fan here)—and as I breathed deeply and counted from one to ten to stop myself from bum-rushing the speaker with hugs and sobs.

And the pace at which this change takes place has never before in the history of the English language escalated as fast as it has since the internet took center stage. The web is often (though not always) where this evolution begins: It's where insidery language is instantly available to a wider group of people. It's where fandoms come together to create and use both generalized slang, like *ship* and *stan*, and more specific terms, like *Neville Longbottoming*. It's where grandparents are reading the same Facebook feeds as their grandchildren, wondering what, exactly, *bae* means. It's where a limitation of characters has perhaps led to the modern tendency to omit the word *of* and the article after the word *because* (either that or people are just getting lazier or there's a more prevailing urgency to seem funnier and on trend), so phrases like *because internet* are used playfully with abandon. And this technology is the driving force behind the English language becoming even more

ubiquitous across the globe than it already is. On a visit to China, for example, copy editor Paul Chevannes observed that "English slang was commonplace: bye-bye, okay, cool. And English tech terms were everywhere: Internet, email, iPhone, iPad, selfie, selfie stick, PDF, download, upload, chip, WiFi, smartphone."

It's where, thanks to Google Ngram and other resources, we have concrete evidence of the way most of the world is spelling a word or how they're using a phrase. In a 2012 story for *The Guardian*, for instance, linguist David Crystal wrote that "the internet is allowing more people to influence spelling than ever before. In 2006 there were just a few hundred instances of 'rubarb' on Google. By 2010 there were nearly 100,000. This month there's around 750,000." Alas, the great *doughnut* vs. *donut* battle of 2015:

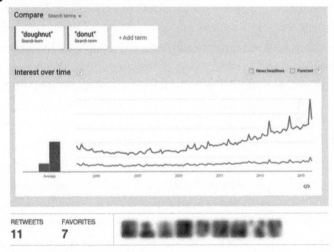

And the internet is where discussion about style choices regarding pop-culture events, the proper way to refer to a group of people, or how to create the verb form of *Vine* (RIP!)—it's *Vine-ing*, though *post a Vine* or *use Vine* is preferred, per BuzzFeed style—for example, is instantly available. (In fact, Twitter is where I learned that the word *Juggalo* derives from the title of a song, thus justifying its capitalized entry in the style guide.)

 BuzzFeed Style Guide @styleguide · Feb 4
Bold move, but we're going with capital Left
Shark as a noun/adjective, Left-Shark as a
verb/adverb, because LEFT SHARK IS A
LIVING BEING

↩ ⇄ 34 ★ 80 •••

One problem with trying to preserve the sanctity and rigidness of the written language as laid out by Strunk and White is that today everyone is a writer—a bad, unedited, unapologetic writer. From Twitter feeds to Yelp and Amazon reviews to personal blogs, we've come a long way from painstakingly edited letters to the editor as filtered versions of the way people truly string together words and use punctuation marks. There's no hiding our collective incompetence anymore. Not exempt from this is one Donald J. Trump tweeting about an "unpresidented" act just prior to taking office; the US Department of Education's Twitter account misspelling W.E.B. Du Bois as DeBois in 2017; and Secretary of Education Betsy DeVos/DuVos describing Trump's inauguration as "historical" rather than "historic." Yes, this is real life, and we are living it. #Help

And while the only logical antidote to this epidemic, in my mind, is to give copy editors of a certain caliber free access to comment sections and product reviews and unedited blogs, the internet hasn't yet jumped on board with this proposal (maybe because I haven't officially made this proposal in writing, maybe not). So my prediction is that, more and more, common mistakes are going to be accepted as standard use in our

lexicon simply because they're seen more often, and the average person isn't running off to check the nearest dictionary or usage manual every time they encounter something dubious. Terms and phrases traditionally regarded as unquestionably erroneous will enter common use, and after enough exposure to them our resistance will be futile.

As Crystal writes in *Internet Linguistics: A Student Guide* (which, though thorough, was published in 2011, aka eons ago in internet time, so some language is already a bit outdated), "It is virtually impossible now to read anything in print which has not been through a standardizing process. But in blogs, we see discourses of sometimes substantial length which have had no such editorial interference. As a consequence, we find syntactic patterns that are never seen in traditional written varieties, other than the occasional literary approximation...It is a syntax that reflects the way writers think and speak." Bingo! And here, my friends, we have the nut graph of reading and writing on the internet: It's often more personal and more plain-languagey, and so it resonates immediately and more widely. As a copy editor, it's my duty to strike a balance that preserves that tone but also upholds certain standards.

Syntax is not the only element of prose affected by the internet's omnipresent influence; spelling choices are also shifting. Take, for example, the word *minuscule*, whose entry in *MW* includes the variant *miniscule* and the etymology note "The adjective *minuscule* is etymologically related to *minus*, but associations with *mini-* have produced the spelling variant *miniscule*. This variant dates to the end of the 19th century, and it now occurs commonly in published writing, but it continues to be widely regarded as an error." Oxford Dictionaries reported that the technically incorrect *miniscule* currently accounts for 52 percent of the word's usage. Yup, you read that clearly: More people were spelling the word incorrectly than correctly, so dictionary editors were like ¯_(ツ)_/¯ (which, as a side note, I have no doubt will one day secure its own entry in the dictionary, and which, I'll argue, was more deserving of OED's Word of the Year distinction than Mx. Tears

of Joy Face—more on an emoji as *Word* of the Year, *Mx.*, and "shruggie" later) and let anarchy take its course. While this misspelling has been rampant for quite some time pre-internet, it's only one example of organic change dictating usage despite what has, for as long as we've written in modern English, been accepted as technically correct. See also: *restauranteur*, an accepted variant of *restaurateur*—which, yes, could be mistaken as a misspelling because of its lack of an *n* before the *t*, since we eat at restaurants, not restaurats, but is indeed the preferred spelling, since the word that describes a person who owns or manages a restaurant is of French origin. Search further back, and you'll find that *restaurateur* has roots in the Late Latin *restaurator*. Language, man.

I do understand the frustration in this and can see someone asking: Well, what's next? We start spelling the word *cat* as *caat* (add the extra *a* for awesome!) and suddenly it's raining caats and dogs from New York to Melbourne? But I also understand that being resistant to change is impractical—not to mention that it can make you seem stodgy and miserable and irrelevant. And that's exactly why descriptivists have all the fun. Descriptivists believe that language should be defined by those who use it; they observe and record, and so "correctness" is an ever-changing notion based on how people are writing and speaking at any given time. To denounce a new word that has come into prominence as not being "real" takes a whole lotta gall (and, yes, I will argue that *lotta* is a word as real as they come).

Prescriptivists, on the other hand—their heart rates elevated ever since the shift from *e-mail* to *email* and *Web site* to *website* (and whose facial expressions, frozen in sheer shock, have not yet returned to their normal resting state ever since AP's ruling to finally lowercase *internet* was announced in April 2016)—believe that there are rules you simply must follow; they were created for a reason, and when any of these rules are broken, it's an inarguable mistake. You may recognize some of these rules from your grammar-school textbooks from the 1950s, such as "Don't use the passive voice" or "Don't end a sentence with a

preposition." And, sure, while such rules may sometimes improve the quality of a sentence, these "improvements" are often quite subjective. Try telling someone in the twenty-first century that *type* is not a synonym for *kind of*—and that it is, in fact, a "vulgarism," as the *Elements of Style* unabashedly declares, to write something like *a small, home-type hotel* rather than a *small, home-like hotel*—and you're likely to be met with this:

Same for *worth while* as being "overworked as a term of vague approval and (with *not*) of disapproval. Strictly applicable only to actions: 'Is it worth while to telegraph?'" (not "His books are not worth while"). Lol wut? What's a telegraph? And if you believe anyone, before uttering the phrase *worth while*, is thinking, *Hold on a second: Is what I'm just about to say a verb or a noun? Let me rephrase my thought so it includes an action*—well, it's clear no one is ever thinking that and you can use *worth while* any way you damn well please and the world will continue to turn as usual.

Never forget maverick George Orwell's six rules from his 1946 essay "Politics and the English Language," which still ring true today:

1 Never use a metaphor, simile, or other figure of speech which you are used to seeing in print.

2 Never use a long word where a short one will do.

3 If it is possible to cut a word out, always cut it out.

4 Never use the passive where you can use the active.
5 Never use a foreign phrase, a scientific word, or a jargon word if you can think of an everyday English equivalent.
6 **Break any of these rules sooner than say anything outright barbarous.**

If you don't accept this as reality, you're doing yourself a grave disservice as a writer or editor—especially on the web—seeking that acute connection with readers that drives them to engage with and share your content. The desire to connect with others is intrinsic, and it's irrefutably easier to do so with the people who speak your language. In her TED Talk "What Makes a Word 'Real'?" rock-star linguist and professor Anne Curzan says, "It's really a question of attitude: Are you bothered by language fads and change, or do you find it fun, interesting, something worthy of study as part of a living language?" Although "Because it's fun!" as the rationale dictating a style choice would have Strunk and White rolling over in their graves, in the most reductive sense in our virality-chasing culture, fun also equates to shareable and successful. And it's fun to read and to share things written in the sort of plain, casual language we speak with. And, yes, I just ended a sentence with a preposition and started one with an *and* and I bet you didn't even flinch, so, no, I will not apologize.

It is important to acknowledge, however, that humans, never ones to enjoy being squeezed into tiny little boxes (unless that's your thing, in which case I totally respect your unconventional hobby, because hey, I don't own you, man), generally should not be expected to fit neatly into one or the other category of this prescriptivist-descriptivist dichotomy. As Kory Stamper, lexicographer for Merriam-Webster, wrote in a post in her colorful blog *Harmless Drudgery: Defining the Words That Define Us* titled "A Compromise: How to Be a Reasonable Prescriptivist":

"Descriptivist" is not a slur, and neither is "prescriptivist" a title of honor (or vice versa). They are merely terms that describe two

approaches to analyzing language use. They are not linguistic matter and anti-matter, and when brought together, they will not destroy the universe in a cataclysm of bombast and "ain't"s. Good descriptivism involves a measure of prescriptivism, and good prescriptivism involves a measure of descriptivism.

So, sure, the ratio of prescriptivism-leaning to descriptivism-leaning molecules just hanging out in our DNA, waiting to pounce like a lion stalking its prey on the writer who asks if *languagey* is a "real" word, fluctuates across the human population as much as our propensity for doing household chores does. But a reasonable person is likely—and, in my humble opinion, would be smart—to employ a mix of the two approaches in their everyday standoffs with words. As Stamper suggests, educate yourself by reading usage dictionaries and realize that opinions and facts about usage are two different things; by doing this, I'm certain you'll grow measurably more agreeable and sprightly, not just in your day-to-day editing, but also in your existence as a living being. (Note that if you don't suffer from severe character flaws, erring heavily on the side of descriptivism will probably, most likely, come as second nature.)

Precisely because it *is* human nature to connect, to want to understand and be understood, make no mistake that correct punctuation and proper grammar do play an incredibly important role in expressing both the elemental components and the complexities of human thought, of course. If they didn't, I'd be out of a job, and hundreds of kindhearted nerds would be out of a reason to get drunk for three consecutive nights, inevitably culminating in some poor soul karaokeing Vampire Weekend's "Oxford Comma" at the annual copy editors conference. (By "some poor soul," I mean me.) There is nothing quite as frustrating as being yanked out of immersion in a compelling story because of ambiguous phrasing or a poorly written sentence—swinging you violently out of a narrative and into the putrid armpit of a fellow

commuter on the subway ride home or the bloodcurdling screams of the neighbor's newborn you'd been triumphantly tuning out as you were doing some bedtime reading. So, in addition to the obvious avoidance of typos, there are more than a handful of things I think writers should be conscious of when reviewing their prose—like fixing danglers or adding hyphens for clarity, and using commas when they are undoubtedly necessary, like in this example:

> BuzzFeed Style Guide retweeted
>
> **Joe Bernstein** @Bernstein · Jun 8
> "i'm hard at work" is a phrase that can be changed a lot by punctuation
>
> ↩ ↻ 4 ★ 9 •••

Besides purely grammatical matters, it's often crucial to be mindful of respectful and inclusive terminology—for example, using precise, neutral language when reporting on sensitive topics, like disease, immigration, or suicide; not lumping together groups of people in phrasings like *the disabled* or *the mentally ill*; and using the correct pronouns when referring to people who don't adhere to the gender binary. (More on all of this in chapter 4.) With so many resources to turn to on the internet, it's never been easier in the history of communication to hone our awareness of appropriate language about concepts or communities we may not be immediately familiar with; there's no longer an excuse to say, "Oh, I didn't know that wasn't the right way to talk about that."

And then there are things I think people shouldn't really care about (unless, of course, it provides them with great joy to ruminate on such matters; who am I to tell anyone what they should or shouldn't spend a lot of time with in their own heads?)—like whether to spell *roller coaster* as one word or two (or, hey, even *roller-coaster*). This is one of those situations where the "Follow your heart" mantra applies, because really: Who cares, as long as you're not spelling it *rollie coter* or *rolleerecoasaer*

and making comprehension difficult to near impossible for the reader? (And who cares that what preceded that colon just now was not, in fact, a complete sentence? Not me. Not I? Whatever.)

I was once a guest on a self-described "drunk word nerds" podcast, *Drink Drank Drunk*, where I was asked to respond to a listener's question. The person worked in finance, and there was dissent across his office as to whether "thousands" should be denoted with a lowercase or a capital "K" (e.g., *$10k* vs. *$10K*). My answer: Who cares? Just pick one! In my personal life, I have no strong feelings either way, but I'd use a capital "K," since it's what *MW* advises—and dictionary entries are based on common use, so why not go with prevailing style? It'll be understood either way; just keep things neat and consistently stick with one or the other.

Here's another common "Who cares?" example:

to Copy ⊡

I can't believe I'm sending this email, but... is it butthole, butt-hole, or butt hole?

I looked at the style guide and could only find buttface and butthead.

As always thank you <3

Like having to choose between cuddling with a kitten or a puppy, there are certain situations where you just can't lose. While *butthole* does indeed appear in *MW* and is BuzzFeed's preferred spelling, styling the word as *butt hole* or *butt-hole* isn't going to have the embarrassing consequences of say, erroneously using *marshal* to mean *martial*, or *tenant* when you'd meant *tenet*.

And let's get this one out of the way (are you ready for it?): *Impact* just as sturdily functions as a verb meaning "to have a direct effect on" as it does a noun describing said effect. Though a room full of five hundred copy editors may disagree (seriously, people who attend the annual ACES conference have *feelings* about it), and 85 percent of the *American Heritage Dictionary*'s Usage Panel detests its use as a verb, DESPITE evidence that it functioned as a verb (in the early 1600s) long before its shift to a noun (late 1700s), at least our beloved *MW* can get behind me on this one. Wisdom teeth can be impacted, and so can a business's revenue. And if you're thinking, *Man,* affect *would really be the better choice here,* go ahead and use it! This is a free country, and synonyms are fun. However, if you're one of those people who have trouble distinguishing *effect* from *affect*, maybe just stick with *impact*. Unless you're my colleague Kate:

Language Is Alive

Kate: "impact" as a verb in the splash — STABS SELF, LIVES, BUT BLEEDS.
Sent at 5:24 PM on Wednesday
me: happy to see you are still alive

verb | im·pact | \im-ˈpakt\

Simple Definition of IMPACT Popularity: Top 1% of lookups

: to have a strong and often bad effect on (something or someone)

: to hit (something) with great force

Full Definition of IMPACT

transitive verb

1 **a :** to fix firmly by or as if by packing or wedging
 b : to press together

2 **a :** to have a direct effect or impact on : impinge on
 b : to strike forcefully; *also :* to cause to strike forcefully

intransitive verb

1 : to have an impact —often used with *on*

2 : to impinge or make contact especially forcefully

—**im·pact·ful** \im-ˈpakt-fəl, ˈim-ˌpakt-fəl\ *adjective*

—**im·pac·tive** \im-ˈpak-tiv\ *adjective*

—**im·pac·tor** also **im·pact·er** \-tər\ *noun*

The People v. Merriam-Webster.

Countless words in the English language function as both a noun and verb, or as a noun and an adjective, or as an adjective and adverb, and so forth. Anyone wanna give *decay* a piece of their mind? Get into a bar brawl with *grimace*? Wage an all-out war against *support*? The source of animosity toward *impact* as a verb in particular is mysterious and unfounded, so how about we all agree to stop bullying the little fella and focus our energies elsewhere. (That being said, I will sheepishly poke my head out through the curtains that separate me from the roomful of *impact* haters to admit that, yes, the word *impactful* is ugly and clunky, and unless I'm running on little sleep or have more important things to worry about that day, I will hunt it down and replace it with a more audibly pleasing alternative if I see it monkeying around in the wild. It does not mean I am "right," nor that its use is "wrong" and that you should change it—if you think the word is out there living its life and doing the right thing, stet away. *Stet* is copy editor lingo for "let it stand," or keep as is.)

Don't even get me started on *hopefully* and *healthy*. (I am going to anyway.) Throughout my copyediting career, I've seen *hopefully* used to mean "it is hoped" or "I hope" exponentially more than I've seen it used in the sense of "in a hopeful manner." To be honest, I can't even confirm I've ever copyedited a piece in which it was used in that second sense, though it's a possibility. To be clear, we're talking "Hopefully we'll go to the beach this weekend" vs. "He gazed into the distance hopefully." To the pedants shaking their fists at those of us who are thinking, *Hopefully, one day this won't even be a discussion-worthy topic anymore,* I present to you the usage note in *MW*'s entry for *hopefully*:

In the 1960s the second sense of *hopefully* ("it is hoped"), which dates to the early 18th century and had been in fairly widespread use since at least the 1930s, underwent a surge in popularity. A surge of criticism followed in reaction, but the criticism took no account of the grammar of adverbs. *Hopefully* when used to mean "it is hoped" is a member of a class of adverbs known as disjuncts.

Disjuncts serve as a means by which the author or speaker can comment directly to the reader or hearer usually on the content of the sentence to which they are attached. Many other adverbs (such as *interestingly, frankly, clearly, luckily, unfortunately*) are similarly used; most are so ordinary as to excite no comment or interest whatsoever. The second sense of *hopefully* is entirely standard.

Secondly, I present to you a portion of the entry for *hopefully* from Bryan A. Garner's *Garner's Modern English Usage*, also known to many in the editing world as the bible (emphasis mine):

Four points about this word. First, it was widely condemned from the 1960s to the 1980s. Briefly, the objections are that (1) *hopefully* properly means "in a hopeful manner" and shouldn't be used in the radically different sense "I hope" or "it is to be hoped"; (2) if the extended sense is accepted, the original sense will be forever lost; and (3) in constructions such as "Hopefully, it won't rain this afternoon," the writer illogically ascribes an emotion (*hopefulness*) to a nonperson. *Hopefully* isn't analogous to *curiously* (= it is a curious fact that), *fortunately* (= it is a fortunate thing that), or *sadly* (= it is a sad fact that). How so? Unlike all those other sentence adverbs, *hopefully* can't be resolved into any longer expression involving a corresponding adjective (*hopeful*)—but only the verb *hope* (e.g., *it is to be hoped that* or *I hope that*)...

Second, whatever the merits of those arguments, the battle is now over. The *AP Stylebook*, considered the bible of U.S. newspaper copy desks, controversially accepted the "it is hoped" or "let's hope" sense in its 2012 edition. ***Hopefully* is now part of AmE, and it has all but lost its traditional meaning...**

Third, some stalwarts continue to condemn the word, so that anyone using it in the new sense is likely to have a credibility problem with some readers...

Fourth, though the controversy swirling around this word has subsided, it is now a skunked term. Avoid it in all senses if you're concerned with your credibility: *if you use it in the traditional way, many readers will think it odd*; if you use it in the newish way, a few readers will tacitly tut-tut you.

Case. Closed. (Side note: *Tut-tut* is a great word.)

On to sticklers' problem child number two, *healthy*. I can eat a healthful diet or a healthy diet, but only one of those statements is not going to sound awfully pretentious and awkward to the ears of English speakers living in the twenty-first century. Same goes for *eating healthily* vs. *eating healthy*. As of May 2017, the phrase *eat healthy* yielded 13.2 million Google search results; *eat healthily* raked in a measly 407,000. We all know how that story ends. (Spoiler! Popular usage wins.) Save for the definition of *healthy* to mean "considerable," living things are no longer the only nouns that can be described as *healthy*; they haven't been since the 1500s. Not only does *American Heritage Dictionary* recognize *healthy* as an adverb, with the example *If you eat healthy, you'll probably live longer*, its usage note for the adjectival form of *healthy* reads as follows:

> Some people insist on maintaining a distinction between the words *healthy* and *healthful*. In this view, *healthful* means "conducive to good health" and is applied to things that promote health, while *healthy* means "possessing good health," and is applied solely to people and other organisms. Accordingly, healthy people have healthful habits. However, *healthy* has been used to mean "healthful" since the 1500s, as in this example from John Locke's *Some Thoughts Concerning Education*: "Gardening...and working in wood, are fit and healthy recreations for a man of study or business." In fact, the word *healthy* is far more common than *healthful* when modifying words like *diet*, *exercise*, and *foods*, and

healthy may strike many readers as more natural in many contexts. Certainly, both *healthy* and *healthful* must be considered standard in describing that which promotes health.

Appallingly, no other major standard dictionary has seemed to come around on the adverb-recognition front, but one dictionary—and the fact that most people use it as an adverb, and we don't need a dang dictionary to tell us what's real and what's not—is enough validation for me. *twirls out of the room and into a party full of double-duty words wearing a skirt made of shredded dictionary pages*

I'm sure by now you'd be unfazed to learn my feelings on *importantly* are similar. In traditional usage, *importantly* should be used to function only as an adverb that means "in an important way" or "in an arrogant or pompous manner." We're talking weird sentences like *He walked around importantly* and *She contributed importantly to the meeting this afternoon* but not *More importantly, there will be a cat at the party*. That last sentence is an example of its use as what's called a "sentence modifier," and it's also an example of the way we're accustomed to seeing *importantly* used most often—though purists believe it's a downright travesty. *Meh*. If you're on Twitter and are short the two characters you need to sufficiently express your thought, sure, stick with *more important*. Otherwise? Don't sweat it.

There have been plenty of heated debates (if you missed them, don't worry, you are probably cool and have many hobbies) about the use of *over* to mean *more than*. Here's what I think about that (surprise!): Either is fine in relation to quantitative matters. The BuzzFeed copydesk has made a point to include an entry in our style guide about this, mostly to appease the pedants and not seem completely anarchistic, though I'll be honest—it's not my favorite entry. It reads as follows:

more than vs. over: OK to use interchangeably, but typically, use *more* with quantities and *over* with spatial relationships. (e.g.,

A World Without "Whom"

There were more than twenty people packed into the apartment.
The plane flew over the Atlantic Ocean.)

We use *over* to mean *more than* in everyday spoken language, and we have for a very, very long time. It's five fewer characters than *more than*, so that's an added perk. They mean the same thing; synonyms exist for a reason, so do yourself a favor and take advantage of them.

And then there's the war-inducing *titled* vs. *entitled*. Sigh. Only *entitled* can be used to mean "has a right to" (as in, say, "those pesky entitled millennials"), but both can indeed be used to mean "has the title of." It's fine to say, "My cat was prominently featured in a book entitled *Tiny Hats on Cats: Because Every Cat Deserves to Feel Fancy*" (true story)—and perhaps *entitled* lends a false sense of seriousness and air of a sophistication (as tiny hats on cats is both a very serious and very sophisticated matter), but for brevity's sake, why not just go with *titled*? Your tweet will be happy you did.

For a significant stretch of the BuzzFeed Style Guide's existence, it advised *OK* (rather than *O.K.* or *okay*) as preferred spelling, which I finally admitted to myself, three and a half years after the guide's inception, I was not entirely convinced was...OK. Blindly following *APS* on this entry, which had been a part of the guide since its very first iteration, I will agree that *O.K.* is ridiculous, since it looks kinda old-timey and is not a shortened version of anything spelled with an "O" or a "K." Well...fine, it sort of is. According to Allan Metcalf, the author of *OK: The Improbable Story of America's Greatest Word* (actual book title), the word *OK* was "born as a lame joke perpetrated by a newspaper editor in 1839." In short, it's an abbreviation for "all correct," and a cool trend at the time—because what else was there to do for fun in 1839?—was to base abbreviations on misspellings or alternate spellings; in this instance we're talking about "oll korrect." (Fast-forward to great-great-grandchildren *kewl* and *phun*, who came of age in the '90s.)

OK's chiller, friendlier cousin *okay* is devoid of the shoutiness and terror that two stark capital letters barging into the middle of a sentence may tote; perhaps *APS* has decided this deviation from the word's origins is too radical to tolerate. Still, it's one of those behavioral problems that copy editors find difficult to self-diagnose and treat properly, where a "rule" is so deeply ingrained in one's DNA—stemming, perhaps, from the conception of a house style, and passed down from years at previous publications where it was also prevailing style—that it feels traitorous, preposterous, and viscerally painful to suggest a change. It's why it took me so long to yank this tiny but powerful entry from the style guide in mid-2016, yet still find it impossible to allow a straggling *ok* to thrive on my watch. Let's not even get into the Stockholm syndrome–induced tic that violently thrusts my fingertip at the "delete" key, as if possessed by a space-saving demon, whenever the words *towards* or *afterwards* appear, *s* in tow. It's sick and it's twisted, but at least I can take solace in knowing I'm not alone. Love you, fellow copy editors.

Nixing the periods in U.S., U.K., U.N., L.A.? 📨 Inbox x 📑 🖨 📋

Emmy Favilla		12:53 PM (4 hours ago) ☆
What are your thoughts on this? My copy editors here & in London are on a mis...		

Ben Smith		12:55 PM (4 hours ago) ☆
Ooh. I'm into it.		

Tom Namako		12:59 PM (3 hours ago) ☆
Nix them! most swayed by the idea of cross-site unity ·		

Lisa Tozzi		1:05 PM (3 hours ago) ☆
NIX NIX NIX i got so used to not using them when editing UK copy		

Anna Kopsky		3:41 PM (1 hour ago) ☆
OMG!!!!!!!!!KA;SDFJ;LAEIS;HFALSKDFDASLFLADSFJSF;LDAS YAASSSSSS OKAY!!!!!!!!!...		

Tom Namako		3:40 PM (1 hour ago) ☆
Amen ·		

Conz Preti		3:42 PM (1 hour ago) ☆
👥		

A World Without "Whom"

Anup Kaphle 3:41 PM (1 hour ago)
W.O.W.

David Mack 3:43 PM (1 hour ago)
Next up, adding 'u' to color and spelling more things with S instead of Z

Adam Davis 3:42 PM (1 hour ago)
is this going to be on the next copy quiz y/n

Julia Reinstein 3:42 PM (1 hour ago)
THIS IS TRULY THRILLING NEWS LONG LIVE "OKAY"

Kari Koeppel 4:15 PM (41 minutes ago)
to Megan, Jeff, Leena, Matt, Rachel, Julia, Lisa, me, EditorialUS, Canada, Copy, world,

 whitney 4:06 PM
omg yay hahah

can't wait wait for us to be in this together

also OMG everyone is so excited about the OK/ok/okay change over there

i gasped when i read it

 meganpaolone 5:33 PM
it makes me happy when I see someone making their own
choice about okay/OK/ok/Ok

 sarahwillson 5:34 PM
yeah, i like that one a lot

drumoorhouse 5:34 PM
oh yes. positively gleeful

**BuzzFeed editors were reeeeally excited about the lift on the *ok*
and *okay* ban, which I snuck into an email that also noted we'd
be forgoing the use of periods in abbreviations like *U.S.* and *L.A.*,
something they were mostly fine with, but less excited about.**

Let's venture briefly into the turbid space known as the all right–alright vortex. (Bonus points if you just spotted that sweet, sweet use of the en dash.) Sticklers would have you believe that *alright* is an abomination of sorts and, at least in formal writing, that *all right* is always the way to go. *Oxford Dictionaries* notes, "There is no logical reason for insisting that 'all right' should be written as two words rather than as 'alright,' when other single-word forms such as 'altogether' have long been accepted. Nevertheless, 'alright' is still regarded as being unacceptable in formal writing." *MW*'s entry for both variants includes the note that "although the spelling *alright* is nearly as old as *all right*, some critics have insisted *alright* is all wrong." *Alright*'s first known use, at least in literature, according *MW*, was 1865—aka more than 150 years ago—by Mark freakin' Twain, so you should take a long, hard look in the mirror and confront your inner demons if you think there's anything wrong with using *alright* in formal writing. *All right* more often than not looks awkward and out of place, like someone dressed in a black-tie ensemble for a sweet 16 party being held at the local veterans hall. I'd also like to make the argument that the sentences *These hands are all right* and *These hands are alright* can mean two very different things—an image of a dozen right hands vs. a pair of mediocre mitts that didn't quite make the cut for the hand-model gig—so maybe it's *all right* that should instead be seeing itself out.

Inaccurate information, insensitive language, and sentences that have egregious structural issues all put wear and tear on credibility. A typo sucks, but that's the least of a copy editor's worries, really. I mean, sure, you'll probably be fired if you allow a really awful typo in a headline to make it into print, but clarity matters too: You never want a reader to be jolted from their engrossment in a story because they've been distracted by an awkwardly structured, unclear, or offensively worded sentence. You also don't want to come across as a dated publication run by a bunch of squares who just don't "get it."

The *Washington Post*, for instance, finally came around on its use of *mic* instead of *mike*, *website* over *Web site*, and *email* rather than *e-mail*. As

its former copy editor, the late Bill Walsh (who I've described exclusively as my personal hero since first picking up a copy of his essential text *The Elephants of Style: A Trunkload of Tips on the Big Issues and Gray Areas of Contemporary American English*), said, "Our goal as editors is to remove distractions—the things that Merrill Perlman would call 'speed bumps'... Readers now expect to see 'email' and 'mic,' and it's 'e-mail' and 'mike' that have become speed bumps. There's a similar dilemma with some of the less-common trademarks: capitalizing Jetway or Bubble Wrap or Onesies is going to stop readers, because 99 percent of them don't know that those terms are trademarks, but as editors it's also our duty to use words correctly." I know... Onesies as a trademark? *jumps out of skin*

 drumoorhouse 5:08 PM
Ugh, must we cap Bubble Wrap? http://www.apstylebook.com/online/?do=entry&id=3914&src=AE http://www.merriam-webster.com/dictionary/bubble%20wrap

> **Definition of BUBBLE WRAP**
> See the full definition...

 emmyfavilla 5:09 PM
i know.

i mean: Bubble Wrap (Source: AP Stylebook)
A registered trademark. Unless the trademark name is important to the story, use cushioning or packaging material .

why don't we say bubble packaging

 drumoorhouse 5:10 PM
well, this instance is a quote, so i guess i should cap

 emmyfavilla 5:10 PM
yeah

 drumoorhouse 5:10 PM
blech

Legality matters; if you're writing a story about how to make boozy ice pops, be mindful not to call them boozy Popsicles unless you've signed a contract cementing your new partnership with the Popsicle brand. Being relevant and trusted matters. What doesn't matter is if

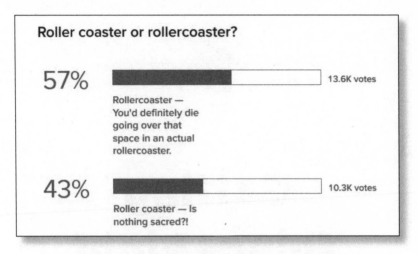

Roller coaster or rollercoaster?

57% Rollercoaster — You'd definitely die going over that space in an actual rollercoaster. 13.6K votes

43% Roller coaster — Is nothing sacred?! 10.3K votes

Results via 2015 BuzzFeed poll "How Should You Style These Contentious Nightmare Words?"

you wrote 50% in that article you published on Monday but then spelled out *50 percent* in the one you published on Thursday, unless you're vying for a spot on the Consistency Wall of Fame. (Sorry, my beautiful, talented, wonderful copy team, who spot these inconsistencies on a regular basis. You'll always find yourselves on the Consistency Wall of Fame in my heart.)

Yes, standards are important, and, yes, *Just be consistent* is a line you may recognize from the tombstones of copy editors across the world, though I'll argue that there's a time and place for consistency. And at a time like the present and a place like the internet, which houses everything from essays on sexual assault to world news stories to quizzes that test your ability to identify an animal based on an image of its butt, there isn't always a one-size-fits-all approach to language. And that's really been the basis of the BuzzFeed Style Guide since day one: a fluid, evolving set of standards that shouldn't be thought of as the iron-fisted rulers of prose—there's often no need to catastrophize the things that don't neatly adhere to these guidelines—but as a thing that exists to just sorta help everyone out.

Getting Things Right

The Stuff That Matters

dan.toy 5:14 PM
typo of the week!!!

> Instructions: Pour everyone in a shaker with ice and shake
> vigorously, strain it in a cocktail glass and drink as is.

sarah.schweppe 5:14 PM
^mood

Let's talk about the important stuff, or what I'll call "getting things right" in this section, for the sake of distinguishing these topics from the more flexible grammar and spelling and style rules we'll get to a little later. (Surprise: This is a short chapter. But the following chapter is also included under this thematic umbrella. I'm not a total anarchist.) Traditional values still apply to the language we use in nontraditional media; just because words don't live on paper doesn't mean they're exempt from being held to standards for clarity, accuracy, and inclusivity. For professionals who work in the digital space, integrity

is especially important; competition is stiff, and there are countless other sources out there clamoring for our attention, their clammy virtual hands outstretched toward our exhausted virtual faces. In addition to simply getting your facts straight (this is important; you're welcome), you should, like, know how to spell and be able to string sentences together coherently—or at the very least in a way that doesn't make the reader cringe. Here's some advice on the biggies to look out for:

Getting things right when it comes to spelling

I'm not talking about your *OK*s and *okay*s and your accidental typos here. Though, yeah, try to watch it with the typos too. I'm talking using the incorrect homophone or wrong word in an idiomatic phrase… which turns it into an idiot-matic phrase? (Sorry. Low-hanging fruit.) You should know that something can *whet* your appetite, not *wet* it; that you make *do*, not make *due* (unless you're literally setting the due date for something); that a *capital* is a city and a *capitol* is a building. Get these things right to avoid coming off as uneducated or ignorant or too lazy to double-check before you subject your words to hundreds, thousands, or millions of human eyeballs—and consequently cement a reputation for being less than trustworthy.

You should know your *imminent*s from your *eminent*s from your *immanent*s, because, really, how am I to have faith that the guy who can't be bothered to get his *stationery* and *stationary* straight got the reported facts correct in a story about a missile strike? If someone couldn't take the extra thirty seconds to consult a dictionary, it's tough to have complete confidence that they've made the effort to ensure the accuracy of factual information too. And the cumulative effect of this is one that can really put a dent in both an individual writer's and a publication's credibility.

Quick, wake up, it's trivia time!

1 **Do you know [whose/who's] birthday cake this is?**
Answer: whose.
Whose means "relating to or belonging to whom"; *who's* means "who is."

2 **Here's how birth control actually [affects/effects] your mood.**
Answer: affects.
Affects means "has an effect on"; *effects* is usually a noun, but it can also be a verb that means "makes (something) happen."

3 **A massive downpour of rain accompanied the awe-inspiring flashes of [lightening/lightning].**
Answer: lightning.
Lightening is a verb that means "making lighter"; *lightning* is the flashes of light during a storm.

4 **Their constant chatter was more than I could [bare/bear].**
Answer: bear.
Bare means "remove covering from"; *bear* means "endure."

5 **Julie Andrews lost her full singing voice after an operation on her vocal [chords/cords].**
Answer: cords.
Chords are musical note combos; *cords* are tissue folds in the larynx or long, thin wires.

6 **My last job was as a teacher's [aid/aide] for a private company.**
Answer: aide.
Aid means "help"; *aide* means "helper."

7 **[Forego/forgo] the body spray altogether and rely on your deodorant instead.**

Answer: forgo.

Forego is to go before (though it's also a less common spelling of *forgo*, per *MW*); *forgo* is to go without.

8 **Drake's sole reason for being is to [elicit/illicit] thirst.**
Answer: elicit.
Elicit is a verb meaning "bring out"; *illicit* is an adjective meaning "not allowed."

9 **When you're being followed by a [hoard/horde] of photographers, every shot counts.**
Answer: horde.
A *hoard* is a large collection of something; a *horde* is a large group of people.

10 **To give a shirt some designer [flair/flare], try some geometric cutouts.**
Answer: flair.
Flair refers to style or ability; a *flare* is a bright light.

11 **The couple had their wedding photos taken on a [shear/sheer] cliff face.**
Answer: sheer.
Shear means "to cut"; *sheer* means "very steep."

12 **If you have long hair, it's easy to have a [discreet/discrete] undercut.**
Answer: discreet.
Discreet means "unobtrusive"; *discrete* means "distinct."

13 **To test her [medal/meddle/metal/mettle], she conducted an interview by emoji.**

Answer: mettle.

A *medal* is what you get for an achievement; to *meddle* means "to interfere"; *metal* is the shiny substance; *mettle* is strength of spirit.

14 We [pored/poured] over the pages of the magazine.
Answer: pored.

To *pore* is to read intently; to *pour* is to flow or cause to flow.

15 In due time, they shall take the [reigns/reins] of their queendom.
Answer: reins.

To *reign* is to rule over; *reins* are the straps used to control a horse (or a figurative restraining influence).

Getting things right when it comes to clarity

The same that can be said about ensuring you spell words correctly goes for a few sacrosanct grammar and punctuation rules: Make sure blatantly singular subjects agree with singular verbs and plural subjects with plural verbs. Capitalize proper nouns. Put end punctuation outside the closing parenthesis unless a full sentence is enclosed in parenthesis. Never use an apostrophe to indicate plurality—UNLESS you're pluralizing a single letter, like in *cross your T's,* or readability is truly at stake, like *ha*'s to indicate just how many *ha*'s are in a phrase like *hahaha* (as seen in this very book on page 295). Don't use double spaces between sentences unless you live in 1965. This is the stuff you don't want to screw up.

Agreement

A good piece of writing is engaging, interesting, and thorough. Duh, right? These factors aren't reliant on creativity and voice alone; a good writer, from a technical standpoint, is adept at presenting their thoughts succinctly and clearly. An educated reader shouldn't have to read a sentence several times over because clunky phrasing has obscured its

meaning. Not to toot the horn of my craft here (JK, totally tooting the horn of my craft), but this is often where a good copy editor comes in to lend a hand, because sometimes the grammar and punctuation rules aren't so cut-and-dried.

Consider this question, in reference to the title of a video:

Leo Chiquillo Feb 19 (3 days ago)
to Copy

Hello --

Is the apostrophe used correctly in this case?

Girlfriends Play Their Boyfriends' Video Games

Thanks!

The correct phrasing is, indeed, *boyfriends'*, but it's a question even the most seasoned copy editor may struggle with. Although the choice of *boyfriend's* may seem to employ logic, given that each girlfriend has one boyfriend, it should be considered that the title is not "Each Girlfriend Plays Her Boyfriend's Video Games"; this headline uses the plural *girlfriends*. Picture a bunch of girlfriends and a bunch of boyfriends all sitting in the same room. The answer is *boyfriends'*, unless I got it all wrong—you are free to love whoever and however many people you want to in this grand ol' land of opportunity—and the video for which this headline was being questioned captures a polyamorous situation. ("But couldn't *boyfriends' also* imply that each girlfriend has multiple boyfriends?!" you scream, unable to wrap your head around this explanation. Uh. I guess it could, but you'll figure out what's going on once you watch the video.)

Why anyone would ever willingly choose to pursue the dispiriting career path of the copy editor escapes me daily too.

Whether to use singular or plural construction with collective nouns is another thorn in the side of copy editors across the globe. (Or is it *sides*? I give up.) A collective noun, to be clear, is a noun that refers to something comprising a number of people or things—like the words

family, *group*, *duo*, and *team*. Typically the verb that follows can be either singular or plural in form, depending on whether the individuals who make up the collective noun are acting together or separately. (It should be noted that in the UK, where people would rather discuss the merits of tea than analyze such triviality, collective nouns are pretty much exclusively treated as plural.) There may be a gray area when determining whether the action being described is on behalf of the crew as a whole or each of its respective members, but here are two pretty straightforward examples: *The duo is recording an album* (they're recording it as a unit), but *The duo are going their separate ways* (both members, as individual people, are planning to embark on different journeys; the plural *ways* is a good hint that this phrasing calls for a plural verb).

And chances are, if both the singular and plural verb form sound okay, either one is fine, as I argued to my uncle, a sociology professor and author himself, about the word *menagerie*. He mentioned to me that he'd noticed a typo in an essay I wrote—one that I had pored over ad nauseam with my copy editor's hat on (it's red, shaped like an apostrophe, and made of felt, in case you were wondering), and that another copy editor on my team had read as well. I was aghast; he had to be mistaken. What he'd pointed to as the "error" was the use of plural verb *were* with singular noun *menagerie*. The sentence read: "I continued to get tattoos; he continued to think the menagerie of designs on my skin were stupid." In an Anglophilic turn of events, I quibbled that the singular *menagerie* in this case was a noun worthy of plural construction. The individual designs on my skin were the things thought to be stupid, not the general concept of the collection itself…though, yes, that too. (But see? Either works!)

And until *datum* makes its long-awaited return, galloping back into our lives with loyal friends *lorem* and *ipsum* by its side, *data* should typically be used as a singular noun (e.g., *the data shows* rather than *the data show*) but can act as a plural one as well. Pick what doesn't sound weird and what makes the most sense in context. Usually it's the singular form, but be comforted that you can't lose either way.

Hey! So I already made sure Henry corrects "anyways" to "anyway", but should "minds" be "mind", or is it ok as is?

BUT JOHN HAS TRAVELED HERE FROM DC ANYWAYS, HOPING THE CAMPAIGN WILL CHANGE THEIR MINDS

Thanks!

Dru Moorhouse 3:15 PM (28 minutes ago)
to Mariana, Copy

Yes, please do change to "hoping the campaign will change **its mind**"! Collective nouns can be tricky but in this case the campaign is acting as a singular thing (not a person, thus the change to its).

Thanks as always for checking in! :)

Then there are phrases relating to money, distance, and space, which may contain a plural number but are typically singular in concept, like these:

- **Fifty dollars is enough to cover your share of the bill.**
 (Could you imagine saying "Fifty dollars are enough"? No, that's weird.)

- **Ten miles is all we have left before we're there.**
 (This one could go either way, but I think singular construction sounds more natural; another way to think about it is "Ten miles is the distance we have left before we're there.")

- **At least seven hundred square feet is what I'm looking for.**
 ("At least seven hundred square feet are what I'm looking for" if the creep in question is seeking hundreds of square-shaped feet. If you are not a foot-collecting creep and are simply in the market for a new apartment, what is being described here is the amount of space, not individual units of square feet.)

The word *any*, as a pronoun, can also be used alongside either singular or plural construction, depending on whether it refers to a singular or plural concept:

Is any of the money left?
(*Is* refers to *money* as a single unit.)

Are any of your friends coming?
(*Are* refers to the plural *friends*.)

Something I find myself fixing on a near-daily basis is the *here's* vs. *here are* mess. Most often I'll see something like "Here's the nominees" or "Here's the facts," when these should, of course, both read "Here are" given that a plural noun follows. Be mindful of using these lil' buggers correctly:

- **Here's** = "Here is" = what follows should be singular (hint: *is*), like "Here's a picture of a baby goat."

- **Here are** = what follows should be plural (hint: *are*), like "Here are three cool dogs wearing sunglasses."

 Isaac Fitzgerald
to me ▾

> me: :ahem:
> so
> 16 Heartbreaking Confessions From Men With A Micropenis
> should be plural, right?
> and, thus, what's the plural of micropenis
> Megan: no, that's correct
> because the man doesn't have more than one penis
> or rather, more than one micropenis

**A solid grammar tip. Sometimes you have to rely on readers'
common sense: that men do have only one penis each.**

Hyphenation

To hyphenate or to not hyphenate: a question with the extraordinary ability to morph an otherwise convivial, warmhearted group of copy editors into bristling bitter enemies determined to fight to the death, but an ever-important one to consider in the name of clarity. Notably, to avoid this colorful salutation:

 lylebrennan 5:56 AM
Cap the "A" in "A-hole", yes?

To stop it reading like "aboard"

Welcome ahole!

Also, a fun thing writers like to do these days is use long-winded modifying statements when a pedestrian ol' adjective just won't do. A question that often comes up is "Should I use hyphens or put this phrase in quotes?" I'm talking *"I might ruin your life" kind of revenge* vs. *I-might-ruin-your-life kind of revenge.* The answer is simple: Pick what looks best and is easiest to read. Perhaps the use of ten hyphens does not fulfill those parameters, so use quotation marks. Perhaps both look just fine. In that case, good news: You can follow your heart! (FWIW, I'd go with hyphens in the aforementioned example, but you don't have to.)

Tense

Keeping tense consistent is helpful not only for ease of reading in even a short story or list but also because in a narrative it's important to differentiate between the thing that happened seven years ago and the person being interviewed just a few months ago about the thing that happened seven years ago. Keeping the story that the piece is about in the past tense and the quoted information from sources about this story in the present tense can help the reader stay on track. There are conflicting feelings about this, though—the prevailing argument being that even a recent

interview, of course, still happened in the past, and therefore should be referenced using past tense. To supporters of this approach, I say: Have you no respect for your readers? Duh, of course anything you're writing about already happened. Are you assuming your reader is potentially so delusional that they might, for a moment, believe that a *he says* corresponds to an interview going on at the very moment they are reading your story? Barring a situation where you are typing out the responses to a real-time Reddit AMA or Facebook Live interview or writing for a group of people all presently under the influence of psilocybin mushrooms (which, cool), this idea is a moot point. I'm a fan of the interview-in-the-present-tense style for aforementioned clarity purposes.

In the traditional print magazine world, pieces that are known as front-of-book stories—aka ones that appear on the first few pages of the magazine and generally include news briefs and short, servicey blurbs—are often written using the present tense. Content in the "well," or the middle section of the magazine, reserved for the cover story and meatier features, typically comprises narratives that employ a mix of both past and present tense, as noted above. This is a sweeping generalization, and not all magazines adhere to an identical style, but it's a good guideline when determining what moves to make in digital equivalents—the idea being that service-geared pieces, with quotes from sources offering tips based on their expertise, might be best in the present tense, with *says* sort of analogous to *advises*. For instance, this line from a BuzzFeed health post addressing how different fruits affect the ~aroma~ of a certain body part: "'The best way to have a healthy vagina is to eat healthy,' says [doctor who is quoted as an expert in this story]." It's something that extends beyond just the literal act of saying words; presumably the source will continue to provide said advice on the matter after the interview is over.

And sometimes a mix of both is the more natural solution, like in this passage from an essay published on BuzzFeed:

> Although Alcoholics Anonymous has been the go-to prescription of doctors, therapists, clergy, and judges for decades, its abstinence-only model has a success rate of just 5 to 8%, says Gabrielle Glaser, the author of *Her Best-Kept Secret: Why Women Drink—And How They Can Regain Control*. "There's no science behind AA at all," Glaser told me. Nonetheless, observing a few AA meetings is all the exposure most doctors have to addiction medicine, Glaser said. "But that's not how people get better."

Notice the use of past tense with direct quotes but present tense for paraphrased thoughts, which works fine too.

Trademarked names

Unless you're referencing a specific brand, be conscious of avoiding trademarked names when you can use the generic version: e.g., *Band-Aid* vs. *bandage*; *Popsicle* vs. *ice pop*; *Xerox* vs. *photocopy*—and the trickier *Ziploc* vs. *ziplock*; *Jell-O* vs. *jello*; *Plexiglas* vs. *plexiglass*; and *Hula Hoop* vs. *hula hoop*. In 2013, *APS* finally came around on lowercasing *dumpster*, which appears to have lost its protection as a trademark and now functions as the generic form of the word. It joins defeated cohorts *aspirin*, *escalator*, *linoleum*, *pacemaker*, *thermos*, and *zipper* in the egoless Now We're Lowercase Club. We'll be patiently waiting for Velcro and Frisbee to drop their delusions of grandeur as we continue to mill about securing our shoes with fabric fastener and meeting our friends for a horror-inducing game of flying disc.

Getting things right when it comes to the possessive form

Over the past few years, I've flip-flopped a lot on the guidelines that I think BuzzFeed (and, by extension, everyone) should adhere to regarding the possessive form, and I'm not proud of it. In my defense, sometimes a universal rule just doesn't make sense—because words

wind up looking very odd—and sometimes having different rules for different-sounding words gets confusing. Here's what we've settled on, with some extended notes next to each explaining the rationale, in brackets:

- Use "s" for all singular possessive nouns, e.g., Chris's, Katniss's. [This is a standard rule in English. *APS* advises a slew of apostrophe-only possessive forms that I'll go over in just a bit, and some that also look absolutely crazy to me.] Exceptions to this:

- Corporation or brand names that are pluralized, e.g., *General Motors'*. [Makes sense, right? A plural noun would typically take an apostrophe only, so the same should apply to a proper noun that's plural in construction.]

- Proper nouns ending in *s* that make a *z* sound, e.g., *BuzzFeed News'* [a word that is plural but singular in construction, per *MW*], *Britney Spears'*, and *Serena Williams'*. [Here's where copydesk team conversations took a grisly turn. "But no one will remember this rule, it's too complicated!" "You have to actually say it aloud to gauge whether it's an *s* or a *z* sound!" "But what if it's an *s* sound to someone and a *z* sound to someone else?" I will have none of it. First off, if you are fluent in the English language, it's clear what ends with what sound. If you were to replace that *s* with a *z* and it would still sound the same, then, well, there you have it: a *z* sound!

 When you say the possessive form of a name like *Williams* or *Spears* out loud, I am going to bet that the majority of speakers will pronounce it exactly the same, and not as "Williamses" or "Spearses." You very well might pronounce it as the latter, and that's okay too. Such a choice requires a tiny bit more effort, and it sounds clunkier. Basically what I'm saying is that the option

is there, and it's the smoother-sounding one. I personally would pronounce *Britney Spears' new album* as "Britney Spears new album," not "Britney Spearses." You might do the opposite; I will respect your choice. You don't have this option, however, with a possessive phrase like *Chris's hair* (which is why it makes more sense written thusly than as *Chris' hair*). Pronouncing this as "Chris hair" implies a regression into toddlerdom, the speaker in the throes of struggling to learn proper syntax. "Alright, fair enough, Emmy. So you're saying *Torres'* but not *Torrez's*?" Yes. Yes, I am. Because a lone apostrophe after any letter but *s* just looks terrible. That's my story and I'm sticking to it. You can create your own.]

- When a proper noun is already plural, the usual rule for possessives applies: *The Smiths'*, *Rolling Stones'*, the *United States' policies*. [Again, plural nouns take an apostrophe only; following suit, this is a logical rule.]

- Do not use an apostrophe when a word is primarily descriptive rather than possessive: e.g., *homeowners association*, *kids department*, *teachers college*, *writers room*. [The word is acting more like an adjective than a possessive noun.]

- Personal pronouns never take apostrophes. [Because this is how English works. Something that belongs to a person who identifies with *she/her* pronouns is *hers*, not *her's*, which was so painful to type that I need to take a quick walk to center myself again. BRB. Okay, back! And if you, like many a member of my Brooklyn-bred Italian-American family, care to address a group of people as *yous*, that's cute, but remember that this also would never take an apostrophe, since it's a plural, not possessive, form of *you*.]

- Words that end in *-es* and are spelled the same as both the singular and plural form take only an apostrophe for the possessive of both forms (*series'*, *species'*). [Because it's just easier, okay?]

meganpaolone 4:16 PM
can it be the same singular and plural?

series' for both?

emmyfavilla 4:16 PM
that's a good rule

meganpaolone 4:16 PM
it might be anarchist but I don't see a problem with that

emmyfavilla 4:16 PM
if a word is the same as sing & plural

same here

APS seems to go off the rails with some of its possessive guidelines, but they're not so totally outlandish as to render their intention unclear. So do what you will with their rules. Here are some examples from the stylebook, with my notes in brackets:

SINGULAR COMMON NOUNS ENDING IN *S*: Add *'s* unless the next word begins with *s*: *the hostess's invitation, the hostess' seat; the witness's answer, the witness' story*. [I'm not quite sure I understand what you're trying to do here, AP. In the first two examples, any fully cognizant English speaker would pronounce the possessive noun the same way—"hostesses invitation" and "hostesses seat," right? Unless I'm in the minority and AP is trying to save me from sounding like a snakelady, in which case, thanks, I guess. But I'll still never naturally pronounce the second and fourth examples, respectively, as "hostess seat" and "witness story," so I'll keep my *'s* (*'ses? 's's?* apostrophe-esses?) close and my enemies at AP closer. You do you, though.]

SINGULAR PROPER NAMES ENDING IN *S*: Use only an apostrophe: *Achilles' heel, Agnes' book, Ceres' rites, Descartes' theories, Dickens' novels, Euripides' dramas, Hercules' labors, Jesus' life, Jules' seat, Kansas' schools, Moses' law, Socrates' life, Tennessee Williams' plays, Xerxes' armies.* [This I can kind of get behind. As noted above, BuzzFeed's rule for the possessive form is to use apostrophe + s unless the possessive noun ends in a z sound, under the logic that, for instance, Euripedes' dramas would in fact be pronounced "Euripides" and not "Euripideses"—if you disagree, just throw in the s, it's easy. Same deal for *Dickens' novels, Socrates' life,* etc. However, I cannot fully respect a blanket rule that justifies use of the apostrophe based simply on the fact that the proper noun ends in an s, with no thought given to the more important factor: pronunciation. *Jesus' life* and *Kansas' schools* are an assault on my eyes, and ears.]

SPECIAL EXPRESSIONS: The following exceptions to the general rule for words not ending in s apply to words that end in an s sound and are followed by a word that begins with s: *for appearance' sake, for conscience' sake, for goodness' sake.* Use *'s* otherwise: *the appearance's cost, my conscience's voice.* [This entry really takes things too far and is where I start to question: Is this all a big joke? *For appearance' sake?* What the hell? Why would anyone ever write that? I can see where we're going with *goodness' sake,* fine. That one is pronounced as "goodness," even though it's a possessive form. But I'm too perplexed—and, if I'm honest, hurt—by *conscience' sake,* which looks like a typo, to take this conversation any further without getting overly emotional. I'll just end this by noting that BuzzFeed does not adhere to this guideline.]

Will I change my mind on *Williams'* vs. *Williams's* again within a year? Maybe. Which is to say, it's not *actually* that important. We

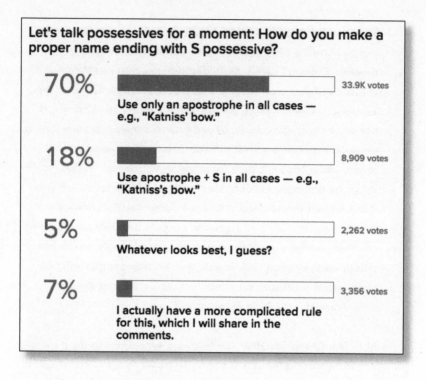

Let's talk possessives for a moment: How do you make a proper name ending with S possessive?

70% — 33.9K votes
Use only an apostrophe in all cases —
e.g., "Katniss' bow."

18% — 8,909 votes
Use apostrophe + S in all cases — e.g.,
"Katniss's bow."

5% — 2,262 votes
Whatever looks best, I guess?

7% — 3,356 votes
I actually have a more complicated rule
for this, which I will share in the
comments.

can all recognize either construction as the possessive form and, sure, it would be nice to maintain a certain consistency within a story and across a publication or website. Now, given that whether you choose to go with *Chris's* or eyesore *Chris'* is not make-or-break, knowing when to choose *Chris's* or *Chrises* or *Chrises'*, of course, is. A more likely scenario, considering I haven't encountered very many rooms full of Chrises in which I had to describe something all aforementioned Chrises were in possession of: *the family's* vs. *the families'*. Getting your singular possessive forms and plural possessive forms straight is essential not only to avoid coming across as a professional who doesn't know how to form the possessive but, more importantly, to ensure accuracy. Are we discussing something that affects one family or multiple families?

Getting things right when it comes to punctuation

Sometimes commas can truly wreak havoc on a sentence. We'll get to unnecessary comma panic in chapter 5, but first, consider this sentence I came across in an unedited post: *Again, stop with the boxes companies.* The writer here appears to be on a one-woman quest to obliterate those intolerable companies that manufacture boxes. Given the context of the sentence, though—which described a pair of socks with minimal packaging—it was clear that a comma was necessary to form an imperative sentence (one addressed not to companies that create boxes but rather to companies that package products in them): *Again, stop with the boxes, companies.*

I won't bore you with countless scenarios where commas matter, mostly because I shouldn't have to: The ones where this punctuation mark is essential will scream it out at you, loud and proud. And if you're on the fence, there are plenty of usage manuals for you to consult. Use your judgment. For good measure, though, here are some situations where a hard-and-fasty (sorry) applies:

- As in the above example, before a thing or a person being directly addressed ("I love partying, guys!"—without the comma, it means something entirely different, though potentially still true).

- Between a city and a state (or country) name, and after a city + state or city + country in running copy ("I lived in Knoxville, Tennessee, for three years; she lived in Lima, Peru, for four years").

- With full dates ("March 16, 2016, was the due date").

- To set off degrees or titles ("I spoke with Janelle Jones, PhD, about this topic").

- Between adjectives whose order can be swapped ("He was a kind, generous man").

- To separate independent clauses, especially when a pause helps with clarity ("I have two cats and a dog, and my sister has two dogs and a guinea pig").

- To set off nonessential clauses ("Simon, who's in the red jacket, is my coworker").

And now, the bane of every copy editor's existence: the hyphen conundrum. As Lynne Truss forewarned us in punctuation bible *Eats, Shoots & Leaves: The Zero Tolerance Approach to Punctuation* way back in 2003, "Hyphen use is just a big bloody mess and is likely to get messier." She wasn't lying! Where do we draw the line with hyphenated modifying phrases? In addition to words that the dictionary hyphenates, it's generally a safe bet to hyphenate the following:

- Compound modifiers consisting of two or more adjectives that precede a noun and act as a single idea, like *silly-looking monster* (to differentiate from a jovial monster whose primary responsibility is to look).

- The combination of an adverb that doesn't end in *-ly* plus an adjective preceding a noun, like *long-awaited reunion*—to clarify that the reunion wasn't what was long, but rather the anticipation for it. (Note that adverbs, by definition, modify the word or phrase they precede, so using a hyphen after one otherwise is typically unnecessary, e.g., *a critically acclaimed film*.)

- With spelled-out fractions, like *three-fourths of the company*.

There's no need to hyphenate *ice cream cone*, for instance (there's no room for misinterpretation there sans hyphen, because a cream cone that's ice doesn't make sense to anyone but eighteen-year-old me on LSD), but I would hyphenate *fast-food truck* (to distinguish it from a food truck traveling at 100 mph). Hyphenation, clearly, is a very subjective matter (Woodrow Wilson called the hyphen "the most un-American thing in the world," but I think that's taking things a little too far—didn't he need a hyphen to make that sentence?), though in the most extreme situations it can save you from an embarrassing misinterpretation:

 BuzzFeed Style Guide retweeted

 Sarah Grey @GreyEditing · Apr 27
Today's hyphenation lesson: there's a big difference between "young-adult film projects" & "young adult-film projects." #amediting

↰　↻ 16　★ 23　•••

Less extreme but still potentially troubling (we've acknowledged the ridiculousness of the average person reading this as the latter, but whatever, I still maintain it's a possibility):

 dan.toy 5:35 PM
"Are you a sour cream person?"

 meganpaolone 5:48 PM
yes please hyphen

bc otherwise you could be a cream person who's sour

whatever that is

 dan.toy 5:53 PM ★
haha yeah

emmyfavilla 5:56 PM
a person who's into cream but with a generally sour disposition

dan.toy 6:03 PM
i'm a sour cream person

but not a sour-cream peson

person*

emmyfavilla 6:05 PM
ditto

sarahwillson 2:05 PM
you guys. why is it ok to hyphenate sour-cream but you have to be a monster to hyphenate ice-cream?

So, yeah, hyphenation can be a pretty contentious issue. You've been warned.

There are also times when hyphenation prevents an awkwardly spelled or misinterpreted word, as in *pearl-like* rather than the not horrible but still strange-looking *pearllike*; *de-ice* rather than eyesore *deice*; *sea-like* rather than *sealike*, which has the potential of being misread as describing something similar to a seal; and *re-cover* rather than *recover* (a re-covered couch, of course, is different from a recovered couch, though a couch *could* ostensibly be both). Dictionaries sometimes include separate entries in cases like this, such as with the *recreate* (to take recreation) vs. *re-create* (to create something again) distinction.

Hyphens are also often found in surnames to denote a combined last name, whether someone who has just gotten married has decided to join their last name with their partner's, a child has a surname that is the product of their parents' combined last names, or any similar situation. It is important to remember, however, that simply because two last names exist within a given family, it isn't always accurate to refer to them using a hyphenated form. Consider, for instance, the Kardashian and Jenner family. (I promise there are only two more Kardashian references in this book.) No one in the Celebrity First Family has the hyphenated last name Kardashian-Jenner, so it's not quite correct to

sarahwillson 3:14 PM
hyph, right? — > Are You Hipster-Intolerant?

dan.toy 3:28 PM
id say nah

like lactose intolerant

sarahwillson 3:28 PM
hmm

i might use a hyphen there too

meganpaolone 3:28 PM
I would probably

meganpaolone 3:29 PM
otherwise it's maybe a little confusing?

like, we hyph most adjectives like that

"Are you well-read?"

drumoorhouse 3:29 PM
AP makes a specific exception for well- tho

meganpaolone 3:30 PM
does it?!

I did not know!

drumoorhouse 3:30 PM
yes. when used with "to be" verbs

meganpaolone 3:30 PM
ah good to know

meganpaolone 3:30 PM
I would say, "I'm lactose intolerant"

but "she is a lactose-intolerant person"

 1

meganpaolone 3:31 PM
"hipster intolerant" feels different simply because
hipster is an annoying word, but it shouldn't be

F u, hyphens.

call them the Kardashian-Jenners, as there are both Kardashians and Jenners involved, but none with a surname that includes both.

The BuzzFeed copydesk has collectively decided that a slash is more appropriate than a hyphen (i.e., *the Kardashian/Jenners*), as it suggests shorthand for both *and* and *or*, which does the job the often helpful hyphen just doesn't here. Of course, where space constraints aren't an issue, you could always go with *the Kardashian and Jenner family* or *the Kardashians and Jenners* too.

How to Not Be a Jerk

Writing About Sensitive Topics

Ready to take a sharp turn into Serious Territory? Changes to the way we use language are not always directly related to the rising influence of the internet but rather because, as a (global) society, we've become more aware of the essentiality of inclusive language—and this has of course trickled into the dialogues we have online. The internet is the means by which these conversations and these stories are communicated daily. That said, writers and editors have a responsibility to their readers to write and report not only with clarity and accuracy but also with an awareness of sensitivity and the weight that certain words

or phrases can carry. Sometimes the language we use—for instance, when referring to marginalized groups that we are not a part of, or the experiences that affect them—can be unintentionally low-key (or not-so-low-key) offensive, or have connotations we may have otherwise been incognizant of. Language has the impressive ability to craft social construct, and if the result is negative, then we learn and we listen and we phrase things better the next time.

This matter certainly isn't specific to the internet, but being especially attuned to it *is* specific to the new millennium (mostly because the previous generations screwed this one up so hard—thanks, blatantly sexist and racist ads from the beginning of time up until like two minutes ago), though we've still got a long way to go. As inclusivity and wider representation of all the very many human beings who inhabit our world become increasing priorities across all forms of media, language, of course, has followed suit. In the same manner that we want to read things that speak the way that we do, we all want to see ourselves in the things we read—which means language that doesn't make anyone feel alienated, or Othered (a reference to the use of language that ultimately serves to call someone, or a group, out as intrinsically different), or in any way excluded.

It's especially important to keep in mind that some words and phrases may mean slightly—or totally—different things in other English-speaking countries. What follows are guidelines on potentially sensitive topics, adapted from the BuzzFeed Style Guide, so you can save yourself from looking like a jerk. (And there are plenty of other thorough resources that offer guidance on using inclusive and respectful language available online—the GLAAD Media Reference Guide, Conscious Style Guide, the Diversity Style Guide, and the National Center on Disability and Journalism's Disability Language Style Guide among them.)

Abortion

Pro-choice and *pro-life* are loaded terms; use the neutral *pro–abortion rights/abortion rights advocate* or *anti-abortion* instead.

Adoption

Avoid any form of the phrase *give up for adoption* when referring to a child who has been placed for adoption; preferred phrasing is *place for adoption*, a neutral term that is absent of the implication of abandonment by a birth parent or the idea that the adoptive parents robbed the child of their real parents (e.g., *she placed the baby for adoption* rather than *she gave up the baby for adoption*). Also, the word *adoptive* should be used to describe the family that has adopted a child: an *adopted* baby has *adoptive* parents.

Be mindful of using the appropriate terminology when describing non-adoptive parents. The terms *birth parent* and *biological parent* may not always be interchangeable. For example, a surrogate can birth a child without being a biological parent, and a sperm donor can be a biological but not birth parent. Use context—and, where applicable, a subject's preference—as your guide.

Immigration

Contrary to *APS*, BuzzFeed style advises that *undocumented immigrant* is acceptable terminology, but avoid *illegal immigrant* unless referencing quoted material. (Also, young undocumented immigrants brought to the US are referred to as DREAMers, retaining capitalization of the DREAM Act.) Avoid the use of *import* in any form when referring to international people.

Migrants and refugees

In running copy, describe people fleeing their countries as *people* (and variations thereof: *people fleeing war, people escaping Eritrea, people fleeing for Europe, people escaping the war in Syria*, etc.). This allows us

to humanize the crisis. When shorthand is necessary (i.e., for head-lines/deks), be precise: Per *APS*, use *refugee* when referring to "a person who is forced to leave his home or country to escape war, persecution or natural disaster." Use *migrant* when referring to someone seeking economic opportunity.

Slavery

The term *enslaved person* is preferred over *slave* when used in modern contexts; use people-first language when writing about slavery, unless it appears in a direct quote. But in a historical context, it's okay to use *slave*—we don't want to whitewash the severity of slavery in US history.

Suicide

When reporting on suicide, use language such as *killed oneself* and, when possible, give specificity, e.g., *shot oneself*. However, do use good judgment in terms of the extent to which specifics are reported. *Died of an apparent suicide* is also acceptable phrasing if information has not yet been confirmed. Avoid *committed suicide*, *died by suicide*, and *took one's life* unless in a direct quote; to some, *committed* may carry a criminal or negative moral connotation that we wish to avoid in reported stories, and the latter phrasings suggest passivity and veer into euphemism, respectively. Do not refer to an *unsuccessful suicide attempt*; use *attempted suicide* instead.

LGBT issues and topics

BuzzFeed published a story in 2016 that was slated to run with the headline "CDC Reports First Sexual Transmission of Zika in Gay Men"—*gay men* referring to male partners who had been together for a decade. This was tricky, because not all men in a relationship with another man identify as gay; while it may be very likely they do, it's also conceivable that they do not. They might self-identify as bisexual, for instance, or a host of other identities, but our reporters could

not interview the men in question to confirm how they preferred to be identified because of the HIPAA (Health Insurance Portability and Accountability Act of 1996) Privacy Rule. We entertained the idea of a headline that substituted *men who have sex with men* for *gay men*, but not only was that awfully long, it also seemed to imply that Zika had affected a larger sampling than just the two people this story was about. We ultimately settled on *same-sex male partners*, accurate phrasing to describe the men without assuming their sexual orientation.

Basically: Be conscious of not making assumptions. Some other, generalized guidelines that BuzzFeed advises when writing about topics that affect or are about LGBT people include the following:

- When referring to the broader community, *queer* (as in *queer people*) or *LGBT* (as in *LGBT people*) is appropriate; *gay* is not. *LGBT* is only appropriate when referring to the broader community or groups of people, not when referring to individuals.

 He identifies as being part of the queer community.

 He is an LGBT.

Discrimination
- Use *anti-gay* rather than *homophobic*; *anti-trans* rather than *transphobic*, etc. The suffix *-phobic* implies a fear, and although this fear may or may not be figurative, it also implies something inherent that cannot be helped, and its use can perpetuate stereotypes. *Anti-* is a more accurate, neutral prefix in these constructions.

 She was heard making anti-gay comments.

 She has made some homophobic comments.

Identification

- Unless you already know based on research, it should be standard to ask how people identify themselves: gay, bi, genderqueer, queer, trans, etc.

- A person can be trans without also being gay or lesbian. Don't assume.

- *Gender-diverse, gender-expansive,* and *gender-fluid* are preferred to *gender-nonconforming,* the latter of which may have certain connotations—namely, that there is a gender experience to be conformed to. Though it's commonly used as an umbrella term, and a person may identify as *gender-nonconforming,* it could also be seen as defining someone's gender as what it isn't (i.e., by suggesting it's not the norm) rather than what it is, so be mindful of that and confirm a person's preferred terminology when possible. Also recognize that someone can identify as any of the aforementioned gender identities without being transgender. As noted in the GLAAD Media Reference Guide, "Many people have gender expressions that are not entirely conventional—that fact alone does not make them transgender. Many transgender men and women have gender expressions that are conventionally masculine or feminine."

- *Cisgender* (or the abbreviated form *cis*) is used to describe people who are not transgender. As the GLAAD Media Reference Guide explains, "'Cis-' is a Latin prefix meaning 'on the same side as,' and is therefore an antonym of 'trans-.' A more widely understood way to describe people who are not transgender is simply to say *non-transgender people.*"

- Use the correct term or terms to describe gender identity. For example, a person who transitions to become female is a

transgender woman, whereas a person who transitions to become male is a transgender man.

- Opt for *assigned sex* rather than *biological sex* (as *biological* could imply gender essentialism).

Marriage
- Use *marriage equality* and *same-sex marriage* rather than *gay marriage*. Generally, in running copy, when reporting on legal issues surrounding this issue, it is more accurate to refer to *same-sex couples' marriage rights* or something similar rather than *same-sex marriage*, though this is still acceptable shorthand for space or clarity purposes (i.e., in headlines).

 👍 *He has always been a big proponent of marriage equality.*

 👎 *He has always been a big proponent of gay marriage.*

Out vs. openly
- *Openly* is preferred over *out* as a modifying phrase, the rationale here being that *out* implies *out of the closet*, a turn of phrase that is outdated and may carry with it a negative connotation.

 👍 *He is the state's first openly transgender senator.*

 👎 *He is the state's first out gay senator.*

Pronouns
- *Always* defer to the pronouns a person chooses to use for themselves. (It's not rude to ask. In fact it's encouraged to ask, "What pronouns do you prefer to use?")

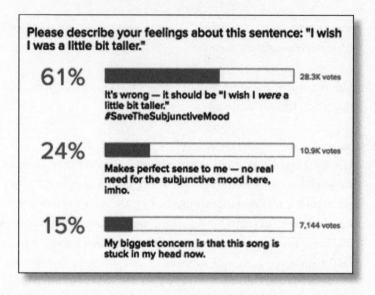

Please describe your feelings about this sentence: "I wish I was a little bit taller."

61% 28.3K votes
It's wrong — it should be "I wish I *were* a little bit taller."
#SaveTheSubjunctiveMood

24% 10.9K votes
Makes perfect sense to me — no real need for the subjunctive mood here, imho.

15% 7,144 votes
My biggest concern is that this song is stuck in my head now.

- *Mx.*, a recent Oxford Dictionaries entry, is a title used by those who wish to avoid specifying their gender or who prefer not to identify themselves as male or female. If it is not possible to ask a transgender person which pronoun they prefer, avoid use of any gendered pronouns and opt for the singular, gender-neutral *they* when necessary.

- Likewise, some may prefer to identify using gender-neutral pronouns such as *ze* (subjective), *zir* or *hir* (objective), and *zirs* or *hirs* (possessive), and *xe* (subjective), *xem* (objective), and *xyrs* (possessive).

Transitioning
- Avoid the antiquated *sex change operation*. Use *sex reassignment surgery* or *gender affirmation surgery*.

- *Deadnaming* refers to using a trans person's assigned name at birth, and you should never deadname a person unless it's a confirmed preference of the subject.

Race and ethnicity

Use good judgment when determining if it's appropriate to mention a person's race or ethnicity. Per *APS*, appropriate instances include "biographical and announcement stories that involve significant, groundbreaking, or historic events" (e.g., Barack Obama being elected the first black US president) and when reporting on "a demonstration or disturbance involving race or such issues as civil rights or slavery." Some other examples of appropriate use include the following BuzzFeed headlines:

Chinese-American Co-Founder Of Twitch Wakes Up To Hate Crime At Home

But Justin Kan sees the silver lining: "Last time I checked I'm still balling."

posted on Aug. 17, 2015, at 3:40 p.m.

Stephanie M. Lee
BuzzFeed News Reporter

Three Other Black Men Have Died In Altercations With University Of Cincinnati Police

Federal civil court records show that, in addition to Samuel Dubose, three other people have died in altercations with University of Cincinnati police since 1997 — all of them black men.

posted on Jul. 30, 2015, at 1:09 a.m.

Salvador Hernandez
BuzzFeed News Reporter

- Use *black* rather than *African-American*, unless it is relevant in the context of a story (e.g., a conflict between African immigrants and African-Americans) or if someone prefers to be identified as African-American.

- When describing the ethnicity of people with origins in Caribbean countries, use *Haitian, Haitian-American, Jamaican-American*, etc., rather than *African-American*. In stories where race is a factor, when possible, ask people how they choose to self-identify.

- Avoid clumsy euphemisms like *urban-targeted* or *race-themed* to describe films or television programs with majority black casts.

- *Latino* refers to those having Latin-American origin; *Hispanic* commonly refers to people from countries in the Americas colonized by Spain. Use more specific identification when possible (e.g., *Cuban, Puerto Rican, Mexican-American*), but generally use *Latino* rather than *Hispanic* when a broader term is necessary. There is mostly overlap between those who identify as Latino and Hispanic, but not all: One example of Latinos who are not Hispanic are Brazilians. And this should go without saying, but use *Spanish* to describe only people who are from Spain.

- Use *Argentine* to describe the people and culture of Argentina. (It's preferred to *Argentinian* or *Argentinean*, which can sometimes carry a condescending connotation to Spanish speakers.)

- This is an important one to remember, as Hawaii is home to indigenous groups of people in the way most other states aren't—so while someone who moves from Ohio to New York may consider themselves a New Yorker in their new home, a person who is not of Native Hawaiian ancestry who moves from Ohio to Hawaii

should never be referred to as a Hawaiian, regardless of how long they've lived in the state. Use *Hawaiian* or *Native Hawaiian* to refer to people indigenous to the Hawaiian Islands, and *Hawaii resident* for a person who lives there but is not native to the state.

- Aleuts, Eskimos, and Indians are groups indigenous to Alaska and are collectively referred to as *Alaska Natives*.

- More on the correct language to use when referring to native peoples in other parts of the world on page 287.

International naming conventions
Not all populations across the globe adhere to the given name + family name format for personal names—so it's not always correct to refer to someone after their initial reference by the last part of their full name, as we typically do in English-speaking countries. Note that this is not by any means a comprehensive list but these are only several examples of naming conventions that people from various areas or of certain ethnicities use:

- Conventions differ across Arabic countries, but Arabic names are often formatted as personal name + father's first name + paternal grandfather's first name, each sometimes offset with *bin* or *ibn* (meaning "son of") or *bint* ("daughter of"). Fahad ibn Hussein ibn Abdul Aziz, for instance, would mean "Fahad, son of Hussein, son of Abdul Aziz." One's ancestral tribe is sometimes added to their name as well.

- Bantu names (East/Southern Africa) typically place the family name first and given name second. As my colleague Jina Moore, a foreign correspondent based in Nairobi who spent a decade in East Africa, notes, one example would be Gakindi Jean Jacques, "but there's not a Western news organization I've ever seen that preserves that as it

is preserved with Asian names. Also, Jean Jacques's friends will call him Gakindi." While it's starting to change in places, generally, in Bantu-language countries—which do not make up all of Africa—naming conventions are similar to Asia's.

- Chinese names are often formatted as family name first, then given name. So it's important to remember to refer to a person with a Chinese name by the first part of their name rather than the latter on subsequent references. (*APS* uses the example of Deng Xiaoping, who on second reference would be Deng.) Some Chinese people have Westernized names, however, or use both a Chinese and English name. When it's uncertain—regardless of a person's ethnicity or nationality—whenever possible, ask what the individual's preference is.

- In Icelandic names, siblings have different surnames—typically patronymic, with a person's name rooted in the given name of their father. Therefore, if Jon Ragnarsson had a daughter, she'd be Olga Jonssdottir (literally, "daughter of Jon"). His son would be Kris Jonsson ("son of Jon"). So, based on his surname, Jon Ragnarsson's father was named Ragnar. (And, yes, the rumors are true: People are indeed listed by their first names in the Icelandic telephone book.)

- Most Indonesians don't use family names in the way Westerners do; their names may be based on factors including geography, social standing, and religious influences. It's difficult to speak broadly about Indonesian naming conventions: Some people use only one name (the Javanese, especially older generations, tend to adhere to this naming style, like Javanese leader Sukarno), while others use three. When in doubt, ask your subject what their full name is; if that's not an option, do some googling.

- Latino surnames often comprise both the maternal and paternal family name (e.g., Vicente Fox Quesada is the son of José Luis Fox Pont and Mercedes Quesada Etxaide), and on second reference a person is referred to either by their patronymic last name, which always precedes the matronymic, or by both last names—as in Gabriel García Márquez, who on subsequent references would be called García Márquez.

 And some married women also take on their husband's name, adding it to their existing name, as in Argentina's former president Cristina Fernández de Kirchner (whose husband was Néstor Kirchner). Subsequent references to her vary based on publication and geography—in Spanish-speaking countries, Fernández is a common name not necessarily associated with the former president, and so she's often referred to as either Kirchner or CFK. In non-Spanish-speaking countries, she's likely to be referred to on second and further references as either Fernández or Fernández de Kirchner.

- North Korean names are usually written as three separate words, family name first (e.g., Kim Jong Un). South Korean names are typically two names: family name first, and given name hyphenated, with a lowercase letter after the hyphen (e.g., Park Geun-hye). Second reference for both would be Kim and Park, respectively. Note that some outlets may style both North and South Korean names using standard conventions for South Korean names, simply for internal consistency (which is contra AP style as well as BuzzFeed style).

- Russian names see a bit of variation in their transliterated versions. *APS*, for instance, uses *-ei* at the ends of common male first names (e.g., Alexei and Sergei rather than Alexey and Sergey, with one exception being the foreign minister, who prefers being

called Sergey Lavrov). Opinions also vary on, for instance, Elena vs. Yelena or Ekaterina vs. Yekaterina, the latter of each pair more similar to how the name is pronounced in Russian. It's standard for women to add an "a" to the end of their last name if they aren't married or if they are commonly known as such (e.g., Anna Kournikova or Vladimir Putin's ex-wife, Lyudmila Putina), but not always—e.g., if one's last name ends in "o." Style also differs across publications as to whether or not to use a patronymic middle initial (e.g., Vladimir V. Putin, the "V" standing for Vladimirovich).

Disabilities, diseases, and disorders

Disability
BuzzFeed adheres to *APS*'s guidelines on disability, which advise: "In general, do not describe an individual as disabled or handicapped unless it is clearly pertinent to a story. If a description must be used, try to be specific. *An ad featuring actor Michael J. Fox swaying noticeably from the effects of Parkinson's disease drew nationwide attention.*

Avoid descriptions that connote pity, such as *afflicted with* or *suffers from multiple sclerosis.* Rather, *has multiple sclerosis.*"

- Use people-first language (i.e., a person's name or the word *person* or *people* before a condition) to avoid phrasing that could be seen as defining someone by their disability:

 The facilities accommodate people with disabilities.

 The facilities accommodate disabled people.

 Along the same lines, it's advisable to avoid lumping groups of people together in phrasings like *the mentally ill* or *the disabled.* The inclination to do so to avoid circumlocution may sometimes

be one's first instinct, but it's an important one to resist. In fact, a study published in the *Journal of Counseling & Development* found that people were less tolerant toward individuals described as being "mentally ill" than they were toward those described as "people with mental illness." Surprisingly, this extended even to counselors' attitudes being affected by the language choice. "Person-first language is a way to honor the personhood of an individual by separating their identity from any disability or diagnosis he or she might have," said one of the study's authors, Todd Gibbs. "When you say 'people with a mental illness,' you are emphasizing that they aren't defined solely by their disability. But when you talk about 'the mentally ill' the disability is the entire definition of the person."

(It should be noted, however, that in both the UK and Australia the opposite guidance applies, and standard phrasing is *disabled people* rather than *people with disabilities.* This is in line with the social model of disability, which argues that people have impairments, not disabilities, and are disabled as a result of barriers put in place by society. However, using the term *the disabled* is discouraged across the pond as well.)

Some examples of headlines with person-first language:

21 Texts Everyone Who Is Anxious Has Definitely Sent

Please tell me everything is going to be OK.

TOP POST
651,077 VIEWS

A School Choir Surprised A Teacher With Cancer With "I'm Gonna Love You Through It"

"Cancer don't discriminate."

(As opposed to, for instance, "21 Texts Every Anxious Person Has Definitely Sent" and "A School Choir Surprised A Teacher Battling Cancer With 'I'm Gonna Love You Through It.'")

- Avoid use of *mentally retarded*. *Mentally disabled*, *developmentally disabled*, and *intellectually disabled* are preferred.

- Use *wheelchair user* or *uses a wheelchair* rather than *confined to a wheelchair* or *wheelchair-bound*. Why? In addition to sounding flowery and Victorian, words like *confined* or *bound* perpetuate stereotypes that the wheelchair user is restricted, and may connote a sense of pity. If known, when possible, say why a wheelchair is used.

 After a car accident, she now uses a wheelchair.

 A car accident left her wheelchair-bound.

- The lowercase *deaf* refers to someone with no hearing. The capitalized *Deaf* is used by members of the Deaf community in relation to identity and culture. Avoid using *hearing-impaired*; use phrasing such as *hard of hearing* or *partially deaf*.

- Do not use the term *deaf-mute*; preferred phrasing is that an individual cannot hear or speak. (A mute person may or may not be deaf.)

- The term *sign language* is lowercase, but capitalize *American Sign Language* (*ASL* on second reference). Someone who communicates in sign language is a *signer* (e.g., an *ASL signer*).

- Avoid the use of *bipolar*, *OCD*, or any other medical condition in a nonclinical sense (i.e., in jokes); don't casually say someone's

been "acting OCD" or that "the weather has been so bipolar lately."

• Use plain language when reporting on death, and avoid euphemisms, at least in news stories; use *died* rather than *passed away*.

Little People/Dwarfism

Use the term *little person* when referring to someone of short stature. Use *dwarfism* only if referring to the medical condition; per person-first guidelines, use *person with dwarfism* rather than *dwarf*. Never use the word *midget*. Per the National Center on Disability and Journalism, some people prefer *short stature* instead of *little person*. When possible, ask the person which term is suitable.

STD vs. STI

Is it an STD or an STI? The CDC would advise you to go with *STD* (sexually transmitted disease), much to the chagrin of editors everywhere who prefer to use *STI* (sexually transmitted infection). *STI* is arguably the more accurate term, and the one many medical professionals also prefer using, given that a person may have an infection without presenting symptoms, and so *disease* could feel a bit heavy in describing such a condition; it's also arguably the less stigmatizing term (though of course one could counter that diseases shouldn't be stigmatizing, period) and the one most media outlets have been increasingly opting for over the past few years.

But because most information and statistics from the CDC use *STD*, using the terms interchangeably in a story has the potential to get confusing. So until everyone's on the same page, one solution is to use *STD*—a term that is more immediately recognizable to the majority of English-speaking Americans than *STI*—in a headline and then opt for *STI* in the body of a story, spelling it out on first reference. (If you're writing for the internet, of course, you also likely have the option to

test your headlines to see which one invites more clicks.) And if there are multiple quoted references that use *STD* and the use of both abbreviations seems unwieldy, use your best judgment in determining if it would instead be better to use *STD* throughout.

Rape and sexual assault

The following points are the guidelines published under this category in the BuzzFeed Style Guide. If you take away only one thing from this section, I hope it's that the word *alleged* should be used with careful consideration. Much like *claims*, *alleged* can imply doubt, though its use is often legally necessary to avoid a libelous statement; try not to overuse it. Additionally, question graphic details when editing a piece about sexual violence in order to determine if these details are furthering the story or if they're simply being employed for more sensational value. (H/T to BuzzFeed reporter Katie J.M. Baker, who helped craft these tips.)

- Avoid using the word *accuser* (except in a direct quote), since it implies a blame placed on the victim; *alleged victim* (though not perfect) is a better choice, but, when possible, use more precise language. Note: Using *alleged* once toward the beginning of a story is legally advisable, but aim to avoid repeated uses.

- Instead of prefacing everything with *alleged*, try to rely on more precise verbs:

 Original: *The woman looked shaken as she described how the man allegedly pushed her.*

 Edited: *The woman looked shaken as she testified that the man pushed her down.*

- Instead of frequently using the word *victim* or the word *accuser*, try to write about the subject as you would one of any other story.

 Original: *The alleged victim said she was worried about reporting the man.*

 Edited: *The girl said she was worried about reporting the man.*

- Instead of relying on verbs like *claims* or *alleges* to indicate legal uncertainty, look for descriptions that don't have judgmental connotations; *said* almost always works.

Bodies and body image

We're all born with one body—one we form an intimate relationship with, because it follows us everywhere we go, every day of our lives. We did not choose to live in the body that holds us all together in human form, and we may love it, or hate it, or have found a moderate acceptance of it—or we may be generally indifferent to it—and these feelings may change daily, so let's please all try to respect one another's bodies, friends.

Puzzlingly, some women's interest outlets have enjoyed describing women's bodies as fruit-shaped, rather than body-shaped, for quite some time. (Interesting that not once have I read an article likening the male form to a celery stalk, a carrot, or a coconut when dishing out style advice. 😕) If you are still doing this, please stop. I don't think I need to elaborate. Same goes for comparisons to various geometric shapes. I am not a pear; I am not a hexagon. I am a beige-colored sack of bones, fat, water, and muscle.

Some other general guidelines for writing and reporting about various body types—and notably women's bodies—include the following (shout-out to BuzzFeed editors Nora Whelan and Julie Gerstein for these):

- Avoid the phrases *real women, regular women,* and *normal women.* Real as opposed to…the female-identifying cyborgs who've covertly integrated themselves into our general population? Use *non-models* if you're looking for a way to describe people who are not professional models.

- Be mindful of the terminology people use for themselves; some are very publicly averse to the *plus-* label, for instance. (The use of *plus-size* in headlines may, however, sometimes be necessary for guiding the right people to the right post.) Some people prefer *fat* for its directness or as a way of reclaiming the word; others prefer *curvy*; others prefer both or neither. If it's unclear what a subject's preferred terminology is, or if there is no specific subject, offer multiple options.

TL;DR? I'll leave you with this: I'm a big supporter of animal rescue organizations. Let's say a dog up for adoption has been listed as a "red nosed pit bull mix." Despite its mild to moderate annoyance factor, the lack of a hyphen in *red-nosed* isn't really worth getting worked up about; the term is clear without it. Though it's *possible*, it's not very likely that someone is going to read that as a red pit bull mix who, wouldn't you know it, also happens to have a nose, rather than what it's actually describing: a pit bull mix with a red nose. No biggie. If the description of said canine companion read, "Not aggressive, like other pit bulls can be," then we have a problem. The use of phrasing that perpetuates stereotypes about the breed is undoubtedly a more crucial matter to address than the lack of hyphenation in the dog's description.

Regardless of the medium in which you're editing, proper spelling, punctuation, and grammar are all important and reflect a certain level of thoughtfulness, credibility, and professionalism—but making poor language choices can often have more dire consequences than simply forgoing a hyphen or using a singular instead of plural verb form.

There's a reason, as *Time* noted in a 2014 piece about the BuzzFeed Style Guide, why the guide "dedicates three times more space to 'LGBT' terminology than it does to dates, going beyond rules about how to refer to same-sex marriage (never *gay marriage* at BuzzFeed) and into less-worn territory." #Priorities

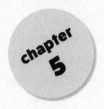

Getting Things As Right As You Can

The Stuff That Kinda-Sorta Matters

And now to what I'll call "getting things as right as you can," aka back to our regularly scheduled programming. Most of the stuff that you shouldn't lose sleep over are matters of style: how to spell a word that has acceptable variations, whether to style abbreviations with or without periods, use of the serial comma, whether to capitalize or lowercase words of a certain length in titles, etc. That said, it's important to strive for consistency (across a publication, yes, but at the very least within a story), and there are certain things, like technical errors and typos, that may not necessarily diminish your credibility as one-off instances but,

cumulatively considered, could make your work and the publication you represent look sloppy and careless. All of these things can lead to a lack of respect for stories you produce in the long run—or at least less than you have the potential to garner—because if you don't care enough about the small things, how are you to be trusted with the bigger ones?

In fact, a recent study showed that copyedited stories, compared with their unedited counterparts, were rated as significantly more professional, more organized, and better written, and participants of the study "reported a greater willingness to pay for edited journalism." (Please send this study to the next editor-in-chief who thinks company layoffs should start at the copy and research desks.)

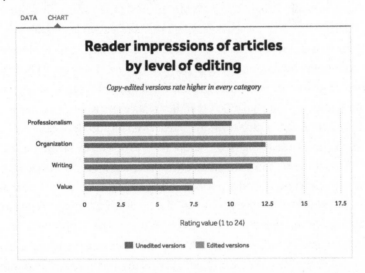

DATA CHART

Reader impressions of articles by level of editing

Copy-edited versions rate higher in every category

Rating value (1 to 24)

Unedited versions Edited versions

Some of the things that it will help to have a good handle on but won't necessarily make or break your story include the following:

The correct forms of words

Here's the thing: You can't always listen to the dictionary. As Kory Stamper, associate editor at Merriam-Webster and the person who I'd like to be when I grow up, put it, "Dictionaries are not guardians

of language; they simply record it"—which is why you may notice that *hour-long* is hyphenated in *MW*, but *daylong, weeklong, monthlong,* and *yearlong* are not. "But this makes no sense!" you shout in frustration, to which I shout in response, "You're right!" and throw not only my fist in the air but also confetti made from the pages of said dictionary in celebration of DOING YOUR OWN THING. I present to you an entry from the BuzzFeed Style Guide:

> notspot, Wi-Fi connection
> hourlong
> hoverboard

In Curzan's "What Makes a Word 'Real'?" TED Talk, the linguistics expert says, "I think most people, when they say a word isn't 'real,' what they mean is it doesn't appear in a standard dictionary." She challenges the commonly held notion that all dictionaries are the same: "They are human, and they are not timeless. I am struck as a teacher that we tell students to critically question every text they read, every website they visit—except dictionaries, which we tend to treat as unauthored, as if they came from nowhere to give us answers about what words really mean."

It is for the reason Curzan mentions that when I did a Skype interview with University of Missouri journalism students in 2016, I warned them of being overly trustworthy of "the dictionary," citing entries for *Chap Stick* in multiple dictionaries as evidence. I have no problem with the capital letters—it's a trademark, after all—but rather the space. It's one word, ChapStick, on the product's packaging, on the brand's website, and in its trademark entry, so it will be one word in my prose, thank you.

In terms of picking up a dictionary (lol, by which I mean, obviously, checking the internet) to confirm you haven't made an egregious misspelling, by all means, yes, this is an excellent idea. But because the dictionary reflects popular usage over time, stylistic variations abound (like *minuscule* and *miniscule*)—and at the 2015 ACES conference, I learned from Stamper that up until the last *Merriam-Webster Unabridged*

Email or e-mail?

71% 15.9K votes

Email — Language
and words evolve;
toss the hyphen.

29% 6,566 votes

E-mail — Brings me
back to the golden
days of the '90s
and early aughts.

update, the first entry in *MW* was sometimes not the preferred spelling, as one might assume, but simply the first spelling that was chronologically entered. (It has since started listing the most common variant as the first entry online as well, *Hanukkah* being one example.)

Additionally, there have been several instances in which our beloved dictionary has appeared to be under the influence of some mind-altering chemical. A few examples in particular include the entries for *bloodred*, *redbrick* (*red* really has a stronghold in the weird combined-words game), and *unself-conscious*, and UK standard *Collins Dictionary*'s entry for *orang-outang* (albeit an antiquated spelling). And so my test for determining the "right" capitalization, punctuation, or spelling of something I'm editing is this: I ask myself, *How would I write this in an email to a friend, or in a Facebook status?* If the answer is that I would not, under any circumstance, capitalize the word *laundromat*— even though many dictionaries (and apparently Microsoft Word) suggest I do—or spell *goosebumps* as *goose bumps*, then, well, that settles it.

And to really drive the point home (and I'm sorry, Merriam-Webster, I really do love you, but sometimes love manifests in the form of constructive criticism), recently I was alerted by one of my fastidious

copy editors to the fact that *Bombay* is the primary entry for the city now known as Mumbai; the entry for *Mumbai*, at the time, read "see *Bombay*." (As of May 2017, however, there was no stand-alone entry for *Mumbai* on *Merriam-Webster.com*.)

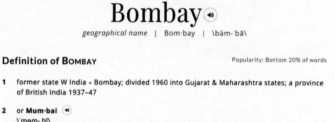

Bombay ◄

geographical name | Bom·bay | \bäm-ˈbā\

Definition of BOMBAY

Popularity: Bottom 20% of words

1 former state W India • Bombay; divided 1960 into Gujarat & Maharashtra states; a province of British India 1937–47

2 or **Mum·bai** ◄
 \ˈməm-ˌbī\
 city & port W India on **Bombay Island** (in Arabian Sea *area* 24 *sq miles or* 62 *square kilometers*) • of Maharashtra & of former Bombay state *metropolitan area pop* 11,914,398

Since we live in an era where we can literally TALK TO THE DICTIONARY, we decided to go straight to the source and ask what the hell was up. Here's what happened:

And a few months later, there was this exchange:

Emmy Jo Favilla ✓
@em_dash3

Hey @MerriamWebster: heterosexual men aren't the only ones who've got pickup lines — consider revising this? 🙁

Definition of PICKUP LINE
a comment made by a man to start a conversation with a woman he is attracted to See the full definition...
merriam-webster.com

RETWEETS 6 LIKES 35

10:57 AM - 7 Mar 2017

↩ 1 ♺ 6 ♥ 35

Tweet your reply

+ **Merriam-Webster** ✓ @MerriamWebster · Mar 7
Replying to @em_dash3
Asking one of our editors to take a look at this—thanks for the heads up.

↩ 1 ♺ 4 ♥ 27

The lesson learned here? Always question the dictionary, and don't blindly follow the rules found in usage manuals and other published sources if you don't think they're a fit for you or your organization. And as an added bonus, sometimes there may not be any "official" rules in place to consider, and you'll have to work with what you've got to make the best decision. Check out this rollicking meditation my undergraduate copyediting course could have never prepared me for:

 meganpaolone 2:05 PM
one word?

> ...as if to remind me that, somewhere out there, there truly was an audience for my shitposts.

 sarah.schweppe 2:06 PM
....i think so

emmyfavilla 2:08 PM
um

meaning shitty posts?

meganpaolone 2:08 PM
yeah

emmyfavilla 2:08 PM
i feel like shit posts works

meganpaolone 2:08 PM
like garbage content

sarah.schweppe 2:08 PM
shitpost is an internet term though!

meganpaolone 2:08 PM
but then isn't that a post about shit?

oh is it?

emmyfavilla 2:08 PM
really?

sarah.schweppe 2:08 PM
yeah

sarahwillson 2:09 PM
yeah one word

emmyfavilla 2:09 PM
i mean in the UK shit is used as an adjective

sarah.schweppe 2:09 PM
it's like....garbage meme stuff not just "bad posts"

meganpaolone 2:09 PM
right yes

ah I love that

emmyfavilla 2:09 PM
wow never knew that

meganpaolone 2:09 PM
shitpost

doin' it

emmyfavilla 2:09 PM

I was recently faced with the quandary of how to spell the word that describes the condition of something covering or filling one's face, as in *a face full of water*. In a split decision I soon conceded was a bit too avant-garde, even by BuzzFeed standards, I suggested *faceful*. Much like *armful* or *bucketful*, its meaning is clear and it is, I would argue, a word more aesthetically pleasing than alternatives *face full*, *facefull*, or *face-full*. Language evolution, right? Sadly, my valiant attempt at forming a new word just because I liked it, damnit, was not met with the enthusiasm I had anticipated, and so I acquiesced to my team's wishes to not bombard the English language with the birth of another word when we could easily use *face full*. Also, *faceful* doesn't *quiiiite* carry the same connotation as words like *armful*, *bucketful*, and *handful*, which indicate an amount that can be held or carried by the word preceding the suffix *-ful*. Here's how it went down:

emmyfavilla 12:01 PM
not that this is to be particularly trusted but:
https://en.wiktionary.org/wiki/faceful

kinda same concept as handful, bucketful, etc., so i almost don't mind a made-up spelling of the word?

emmyfavilla 12:02 PM
but if anyone thinks i'm being too radical pls come forward

i'm actually gonna tweet that as a poll

meganpaolone 12:22 PM
oh whoa

I would totally do face full

maybe faceful

that seems a little crazy

meganpaolone 12:22 PM
a face full of water

emmyfavilla 12:24 PM
i guess the question is, is it comparable to armful/bucketful/handful (maybe not, bc those indicate amounts that can be carried?)

yeah maybe just face full is the more reasonable option

> **+ BuzzFeed Style Guide** @styleguide · Jan 20
> How would you spell the word that describes something that covers or fills one's face? A:
>
> | 40% | faceful |
> | 12% | facefull |
> | 12% | face-full |
> | 36% | rewrite the sentence |
>
> 103 votes • Final results

Sarah Willson
@swillson Following

@styleguide face full

11:33 AM - 20 Jan 2016

Abbreviations: acronyms and initialisms

How do you decide when to spell something out on its initial reference and when it's perfectly acceptable to refer to it on first mention by its abbreviated form? Audience is a determining factor, as are the things that are simply more recognizable by society at large as an acronym or initialism, or familiar enough in their shortened form to warrant it. Would you ever tell someone that having an eagle eye for typos is

simply in your deoxyribonucleic acid? You might, if you're a pretentious asshole who's trying to make a good impression on a first date with a biologist, but, no, the answer is you wouldn't. You'd say it was in your DNA, because that's the more familiar (and far more auditorily pleasing) form for everyone's favorite double helix. Similarly, do you know what GIF even stands for? I have to look it up every time, and I get paid to spend at least eight hours a day staring at them. (It's graphics interchange format.)

While you'd never find yourself telling someone to "check out this post of cute kitten graphic interchange format files," some judgment calls for abbreviations are not as obvious, and you'll just have to use your instincts. *APS*, for example, allows for FBI on first reference to the Federal Bureau of Investigation but advises spelling out the Department of Motor Vehicles before calling it the DMV. I'm not sure I agree with the latter ruling: Whether you tell someone you've got an appointment at the DMV or the Department of Motor Vehicles, they're sure to understand either way. (You'll know from the sympathetic hand placed on your shoulder and the hushed "I'm so sorry.")

Simply put, it would serve the reader best to refer to things as they are commonly recognized, and for larger organizations, companies, and brands—as well as familiar abbreviations regularly used in everyday conversation—this often means their abbreviated form. Sometimes the recognition is on a global level (BBC, IQ, MTV, PMS), sometimes it's on a national level (ASPCA, NBA, SATs), and sometimes it's on a more regionally specific level (like New York's MTA for the Metropolitan Transit Authority, and London's TfL for the Transport for London, which, yes, is commonly abbreviated using the lowercase "f"). Take your readership and the subject matter of your publication into account, and you'll find your way. At worst, someone will either have to look up a shortened form they're unfamiliar with (yay, learning!) or your sentence will run a few characters longer. And, of course, sometimes the joke is in the abbreviation itself—that is, in the shortened form being

an ordinary phrase that wouldn't normally be abbreviated and then quickly evolving into ~a thing~ of its own, an ironic sense of importance being placed on something that isn't really significant enough to warrant being referred to as a recognizable abbreviation yet. Examples include YOLO ("You only live once," and an acronym made famous by Drake's song "The Motto") or AF (for anyone who hasn't used the internet in the past five years, that's "as fuck"—which, just by the simple act of abbreviation, imparts a more fun, softened tone than the full phrase, much like how *F you* is so much cuter than a hearty *Fuck you*).

Reason vs. reason why: Redundancy can be okay

If you haven't noticed, we love making lists of reasons at BuzzFeed—reasons why kids are actually the worst, reasons why cats are better than dogs, reasons why you should never visit Texas (it's sarcastic, relax), reasons why boy bands were better in the '90s (as if you even need a list for this one). Roughly once every few months a wary, self-conscious editor will pop up on Gchat to ask whether *reasons* or *reasons why* is correct and if they've been doing it wrong this whole time. Much to their delight, my answer is always "Either is fine!" with, yes, the exclamation mark for emphasis to properly convey how joyful it is to live in a world where we needn't be kept up all night worrying about such things.

"But *reasons why* is *redundant!*" yells the president of the Strunk & White fan club from across the room, proceeding to light everything around him on fire. I mean, yeah, it is. But it's also a common idiomatic phrase, and the expression just sorta rolls off the tongue. Repeat after me: If we speak that way, it's okay to write that way. Even Oxford Dictionaries acquiesces to the use of *reasons why*—and, in a shocking twist, *the reason is…because.* A usage note states that both usages "are well established and, although they may be inelegant, they are generally accepted in standard English."

This is not to say that I advocate redundant phrasing such as "It was 11 A.M. in the morning" (this just sounds silly) or "I won $10,000

dollars" (this just looks silly). A *safe haven* is indeed redundant as well (a haven is, by definition, a place where one is protected from danger), but if it's good enough for the title of a Nicholas Sparks movie, it's good enough for me. Use your judgment, friends.

-Size vs. -sized

This one isn't going to cause otherwise bulletproof prose to crumble, but the distinction between *-size* and *-sized* can sometimes be a helpful one in the way of precision. Generally, *-sized* is used to comparatively describe the size of something (e.g., a *nickel-sized spider* would describe a spider roughly the size of a nickel) and *-size* to indicate something's function or utility (e.g., *child-size furniture* describes furniture meant for the use of children, not a piece of furniture whose dimensions are necessarily identical to those of a human child). Don't sweat it too much, though: Bite-size or bite-sized, it's clear said food item is a smaller size than the standard, and nickel-size spider or nickel-sized spider, you should fear more for your life than whether or not to use a *d*.

Italics vs. quotation marks: a survival guide

The *AP Stylebook* is a great reference for very many things in the world of news journalism, but guidelines for when to use italic type vs. quotation marks is not one of them. The stylebook was created with the newswire in mind and thus does not even *recognize* italic type as being a thing that exists (same goes for accent marks). *Chicago Manual of Style* is your best bet for pragmatic approaches to determine when to italicize and when to set something in quotation marks.

Q. How does the AP Stylebook recommend use of the word "resume" (i.e., the written document): with or without the accents? from Reston, Va. on May 06, 2015

A. AP doesn't use accents in news stories because the marks won't transmit through all computers. If your system allows accents, it's fine to use them.

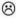

(If you are an owner of one of said computers, consider donating it to a museum and put the money from your charitable tax deduction

toward one that recognizes accent marks and is capable of high-speed internet access.)

Pretty much all titles of things that can be considered creative works are going to find themselves in either the italicized or enclosed-in-quotation-marks category. Some exceptions to this rule are the titles of board games, initiatives and projects, and some websites (we'll go into detail on websites in a bit). A good way to remember when to use what: The bigger-picture creation (the "mother," if you will) takes italics, while the components within it (the "baby" creations) take quotation marks. You'd put book titles in italics but chapter names in quotes; the names of newspapers and magazines are in italic type, but the names of articles are in quotation marks; TV series, podcast titles, and web series are in italics, but episode names are in quotes; album titles take italics, but song titles are set in quotes. You get the picture.

The picture gets a little hazy, however, when trying to categorize all the various things in existence on the web. Way back when the only stuff being published on the internet was via personal blogs and the online counterparts of print publications, the rules were pretty simple: Italicize the titles of blogs as you would a publication name, and set off individual blog entries (analogous to article titles) in quotation marks. Soon enough, though, publications were thriving on the web as stand-alone entities, independent of any print magazine or newspaper—and then Tumblr pages came along, and there were giant media conglomerates that shared the same name as their online publications, and blogs within a bigger publication, and aggregation sites, and the digital world became a hot mess for copy editors.

BuzzFeed's rules are these: Use italics for news websites and blogs (essentially anything that produces regular, dated content and is in other words analogous to a newspaper or magazine), and quotation marks for articles; blogs that exist within a publication are also italicized (e.g., *The Atlantic*'s *CityLab*), in all their double italicization glory, because this is life now. Also be sure to distinguish between media companies

and their publications with identical monikers—e.g., Vice the media company in roman type and *Vice* the website in italics; Gawker Media but *Gawker* (RIP) to refer to the site specifically. We make an exception for BuzzFeed, not just because we can, but also because italicizing BuzzFeed doesn't feel quite right for a company that comprises BuzzFeed Entertainment Group, BuzzFeed News, and distributed content, and sometimes the lines are so blurry that even we ourselves aren't always certain if we're referencing the company as a whole or the title of the website or maybe a little of both. (Important note: Several months before this book went to print, BuzzFeed revised its guidelines on italicizing publications, making the bold decision to instead style all print and digital publication titles—magazines, newspapers, websites, etc.—in roman type, in an effort to make everyone's lives easier. Will we revisit this rule again in a year after we've gotten sick of adding "magazine" to sentences like "*People* reported…" for clarity? Maybe.)

The BuzzFeed Style Guide advises that individual Tumblr blog names should be capitalized and set in roman type, since, on what is often described as a "microblogging" site, the components that make up any given Tumblr page cannot always be defined as distinct elements in the same way that written blog posts are. Some Tumblr blogs are made up exclusively of screengrabs of text messages, for instance, or Facebook exchanges or GIFs of Ryan Gosling eating a superimposed spoonful of cereal. Sometimes they exist as discrete projects, and sometimes they are the pages associated with a retail brand or are the counterpart of a web series. It's pure pandemonium out there; there are instances where it doesn't seem quite right to put a Tumblr blog name in italics, and there are situations where quotation marks don't seem quite right either, and so, as a big fan of nonconfrontation, I made the executive decision that roman type avoids the awkwardness altogether.

And then what to do with a project like Humans of New York (HONY), which isn't solely a photo "collection" and not an exhibition title but a larger initiative (and one where the photos don't have titles

themselves)? Roman type seems the most logical to me, but again, it's all subjective. No one's going to run away screaming if they stumble across an italicized *HONY* either. Pick a style and stick with it.

Things get a little tricky with series and franchises. *CMOS*'s rule is that titles of book series should be capitalized but not italicized: "Roman type ensures that the titles of these series will not be mistaken for the title of a book itself." That is to say, "To write '*Harry Potter* series' would falsely suggest that the work itself is known as *Harry Potter*." While I understand and can certainly agree with this logic—and it is a style ruling I have adhered to for basically all my years in media prior to BuzzFeed—I also concede to the fear of not wanting to appear like I've made a copyediting error, and I think it's fair to assume that the majority of readers who aren't editors may not necessarily be aware of *CMOS*'s ruling on this. Moreover, to mention both *Harry Potter and the Sorcerer's Stone* and the Harry Potter book series in the same paragraph could appear, to the everyday person's eye, an oversight in terms of consistency; it may seem like a lazy editor failed to italicize the second *Harry Potter*.

Enter BuzzFeed's position on the matter: Italicize titles of films, but use roman type for franchises in the general sense or when they act as a descriptor: "He has tons of Star Wars memorabilia" or "I got a Fast & Furious tattoo," but "I can't wait to see *Star Wars: The Force Awakens*." Italicize franchise names, however, when referring to a media series: e.g., "the *Saw* movies," "the *Song of Ice and Fire* books," "What's your favorite *Fast & Furious* movie?" Distinguishing between the franchise name when used as a descriptor for a fandom and as a reference to a book series, for instance, in my opinion, helps to avoid the distraction (and potentially presumed error) of the use of both italic and roman type in instances referring to the title of an individual work and the title of a media series, respectively. You may or may not agree, of course, so you have every right to create a style rule you feel most comfortable with.

When punctuation kinda-sorta matters

Punctuation can be a real drag. Half of my day is spent arguing for or against a hyphen in a compound-modifier situation, or whether to opt for two hyphens rather than one en dash, and, honestly, that's no way to live a life. If you haven't noticed, lots of people on the internet have avoided the problem of using punctuation incorrectly by forgoing its use altogether. That's cool. There's a time and a place for stylistic abandonment of punctuation, which we'll get to later. For now, here are some soft guidelines and a few short love letters to varying standard punctuation marks.

The en dash conundrum

If anyone is unfamiliar with the shy sibling of the hyphen conundrum, you're not alone. Spotting a properly used en dash in the wild (unless you live in the UK, where en dashes typically replace em dashes altogether, let's not talk about it) is like locking eyes with a purple-maned unicorn. En dashes are roughly the size of a hyphen and a half (or the width of an N, hence the name) and are an elusive, dying dash, both feared and revered by copy editors and their brethren. Its use is generally limited to these situations:

- As a stand-in for the word *to*, to signify a time range, as in *March 2010–April 2017*, or direction, as in *the Chicago–Miami flight*.

- To combine hyphenated compounds, like the *editor-in-chief–editor-at-large liaison* (lol, like you'll *ever* have to write this, but just in case, the en dash will be there to the rescue).

- To combine open compounds, like the *United States–Mexico border, non–high school friend* (to differentiate from your *non-high school friend*, a pal who just turned down a fat one), or a *New York–born woman*.

Though I concur with the argument that substituting a hyphen for any of the examples above will do the job just as well (and take up marginally less space), that last usage of the en dash is the only one I can truly get behind as legitimate. Behold, the following example that I came across while editing—one which caused my screen-fatigued eyeballs to light up like the 4th of July sky at the opportunity to use an en dash to do the job NO OTHER DASH could properly fulfill:

18. Wild Honey Rubber Waterproof Rain Sneaker, $70, available at Thom Brown.

Thom Brown / Chuck Taylor / Via thombrown.com

A cool tennis shoe–rain boot hybrid.

As any dash aficionado would agree with, there is simply NO room for a hyphen here: *A cool tennis shoe-rain boot hybrid* (rather than *shoe–rain*, using the technically correct en dash) would turn this piece of functional footwear into a shoe-rain boot for tennis, an accessory that, based on the several years I spent in the fashion-magazine industry, I am pretty sure doesn't exist.

Other award-winning examples of this magical, misunderstood dash include the following (cue Yeah Yeah Yeahs' "Maps" as a montage of en dash memories is projected on a larger-than-life screen):

The first to walk the red carpet was Raya, a 4-year-old black Labrador retriever–Norwegian elkhound cross.

Getting Things As Right As You Can

Come back later to a peanut butter–free garment!

Put it in a paper towel–lined plate.

Check out these Pinterest fail–proof ideas.

Sometimes, however, copy editors will truly push the limits of the en dash's utility—because what else is there for us dweebs to do for fun?—until we find ourselves looking into a mirror only to see a mere shell of the person we once were staring back at us, questioning every last one of our career and life choices:

 meganpaolone 4:07 PM
would you stet the hyphen in "West Elm"?

gorgeous, straight-out-of-West-Elm house

 drumoorhouse 4:07 PM
shudder

 sarahwillson 4:07 PM
¯_(ツ)_/¯

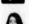 **meganpaolone** 4:07 PM
I'm leaning toward yes

I realized I don't care enough

lol

it looks weirder without

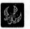 **sarahwillson** 4:08 PM
haha, that would probably be my thought process too

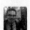 **dan.toy** 4:09 PM
straight-out-of–West Elm house?

haha

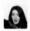 **meganpaolone** 4:10 PM
kicking you out, Dan

(To be fair…the en dash *is* technically correct here.)

The width of the en dash can vary from font to font, which is yet another factor contributing to its imminent extinction. Sometimes an em dash–esque (see what I did there?) en dash can look awkwardly long in a modifying phrase, leading en dash noobs to wonder what the hell that hyphen just ate for breakfast:

doree 4:18 PM
can i ask a really picayune question @here
in this sentence: On the other side are the anti–pit bull, pro-BSL advocates.
why are the hyphens two different sizes?

emmyfavilla 4:19 PM
great question

And admittedly, the combination of hyphens *and* an en dash in a modifying phrase often results in something less than aesthetically pleasing:

emmyfavilla 2:56 PM
en dash alert
The implicated veteran, who had been practicing her magic-trick–tap-dancing talent,

dan.toy 2:58 PM
dear lord

meganpaolone 2:58 PM
whoaaaaa

dan.toy 2:58 PM
that is worse than sun-dried tomato–flavored cheese

sarahwillson 2:59 PM
😵

dan.toy 3:00 PM
magic-trick tap-dancing talent doesn't work?

But still, the capacity for a well-placed en dash to effect pure, childlike joy in the hearts of copy editors across the globe will forever validate the humdrum career we've chosen for ourselves. Here's a screenshot of something I titled "great en dash." When I discovered it hidden among a jumble of desktop icons, it did not fail to deliver.

 roryl 10:22 AM
en dash–tastic hed:

17 Pictures Of Donald Trump's Not At All Below Average–Sized Hands

 emmyfavilla 10:29 AM

 meganpaolone 10:34 AM
whoa that's a good one

En dashes: They just want everyone to have a good time. But it's okay if you don't want to use them, because sometimes they look like awkwardly long hyphens and it defeats the purpose.

The em dash: The pinnacle of elegance

Warning: Here's where I might start to get a little emotional. Because what's more beautiful than a strategically placed em dash? Answer: interspecies friendships, random acts of kindness, Oscar Isaac, an empty subway car during rush hour that isn't the result of a putrid mystery substance permeating the air. But the em dash is not too far behind! Precisely because of its beauty, however, everyone always seems to be vying for a piece of it. Why use a plain-Jane comma, curmudgeonly Mr. Colon, or Try-Hard Harry the semicolon when an em dash could fill in just as well, and add a dash (lol, accidental pun) of drama to boot? Well, first, because you don't want your story to look more like Morse code than English. Second, overuse of the em dash weakens the effect of a well-executed one; though it pains me to admit this as the truth (note that I am someone who has the proofreader's symbol for the em dash tattooed behind my ear, and will happily challenge you to an em dash enthusiasm-off any day), the em dash is just...*not* always the best punctuation mark. If you're introducing a list, go with the colon. Connecting two closely associated sentences? Sling a semicolon with pride. Use ellipses if an air of suspense is what you're seeking. The em dash will shine bright, however, if you're indicating a break in thought, aiming for an emphatic pause, or setting off an aside that's a step above being relegated to parentheses. Here are some

winners:

> *I ask you—nay, demand you!—to take a look at this video of a*
> *hedgehog grooming a hamster.*

> *Go ahead, treat yourself to a drink—or three!*

> *Here's a product perfect for the mom on the go—or all moms, really.*

Even if you aren't a professional writer or editor, you'll inevitably find yourself faced with the parentheses vs. em dash dilemma at some point during your lifetime. There *is* a smidgen of a science behind the decision to set off an aside with either parentheses or with em dashes— but sometimes there's not, and they can be used interchangeably. As a general rule, before you toss a few words in between parentheses, ask yourself, "Are these words integral to the meaning of a sentence?" The answer should always be no; they should further explain or qualify, as a service to the reader. It is futile to deny, however, that there's something about the em dash pair that makes both the introduction and conclusion to the aside smoother than its more intrusive counterpart, the parentheses pair. Sure, it can be hard to resist the sleek, all-purpose em dash sliding its way into your sentences so gracefully you barely noticed it was there at all, but before you find yourself on a dash spree, remember: less Morse code, more English. Here's a sentence where either, truly, would do, but em dashes seemed the less jarring choice:

> *Even Douglas, whom Biles is relentlessly compared to—both are*
> *black American women who rank No. 1 and No. 2 in the world—*
> *scarcely stands a chance.*

Should you consider how important the potentially parenthetical statement is in relation to the rest of the sentence before making a decision? Maybe. But sometimes it simply doesn't involve that much

thought and a dash just seems more natural. Either way, there are a few situations where parentheses are the clear go-to, like in the following sentences, for cut-and-dried contextual information:

Pisces (February 21–March 20) are especially prone to addictive behavior.

The champagne was expensive ($85), but the wine was cheap ($7).

And sometimes parentheses work for humor, when used in a sort of ironic way, to downplay a statement with more gravity than one you would expect to be reduced to a paltry parenthetical phrase:

We Need To Talk About How The Voice Message Feature On iMessage Is Evil And Must Be Stopped

A true technological life-ruiner.

posted on Jun. 24, 2016, at 9:01 a.m.

Lauren Yapalater
BuzzFeed Staff

Hello. It's me, Lauren. On behalf of millions who suffer like myself, I'm writing this open letter to the world (but really to Apple) to say one thing: PLEASE LET US HAVE THE ABILITY TO DISABLE THE VOICE MESSAGE FEATURE ON IMESSAGE.

And finally: Why add a space on either side of an em dash? Because we can! Coming from a print magazine background, I had never entertained the idea of wasting precious space in this manner; it defied logic

and was a tactic reserved for tabloids seeking filler characters. So when I arrived at BuzzFeed, fresh-faced and ready to tackle all the wacky text I could get my lanky phalanges on, I was prepared for anything— except spaces on either side of an em dash. It had never even crossed my mind, nor had I ever considered that anyone could have so much passion for said style choice that accepting pushback toward it was not an option. Editor-in-Chief Ben Smith wanted spaces, and so we went with spaces. It was a tough learning curve, but it made me stronger in the end. Today? I couldn't imagine it any other way. Space isn't at a premium on the internet, and spaces on either side of an em dash allow a sentence to breathe. It is a thing of beauty. They add a touch of softness, make things easier on the ol' peepers; and when you're reading on a screen, your eyes could use all the TLC they can get. "Spaces with an em dash: because your eyeballs are human too and deserve to be treated right!" reads the slogan that happened even less than *fetch*. (Note: This does *not* mean spaces on either side of a hyphen or an en dash are EVER acceptable.) (Additional note: Bloomsbury house style does not use spaces around the em dash—as is commonly the case in print media—which is why this book does not adhere to BuzzFeed style in this regard.)

Comma panic

I'm not here to tell you how and when to use commas. You can pick up *Eats, Shoots & Leaves* or Jane Straus's *Blue Book of Grammar and Punctuation* for more on that. I am here to talk about how comma use is often (but not always) subjective, yet comma panic is a widespread phenomenon wherein writers think there is a hard yes-or-no answer to whether a comma is necessary in situations where no such answer exists. Take, for instance, use of a comma (or not) after an introductory phrase: *Honestly I don't care* vs. *Honestly, I don't care.* Honestly? I don't care. Think of the comma as a tiny little yogi telling you to chill out and breathe. If you'd like the reader to pause for a second after *Honestly*, add

a comma. If you don't, then don't.

Some of you may have been taught the comma rule that if what follows an *and* could stand alone as its own complete sentence, a comma is necessary before the *and*—like in the following sentences:

They are looking, and he cannot be found.

It's a weird, wonderful, busy, spooky, friendly place, and from what I can see of their work, Season 2 is going to be face-meltingly awesome.

It has one of the best ensembles on television right now, and they work so well off of each other.

I am, however, open to the use of artistic license with commas, and the first and third examples above were (*gasp!*) actually published under my watch without a comma before the *and*:

They are looking and he cannot be found.

It has one of the best ensembles on television right now and they work so well off of each other.

In each sentence, the clause that follows the comma is so tied to what precedes it that using a comma, and thus signaling to the reader to pause briefly, seems (to me) to read as bit more stilted. Subjective? Sure. Let's say it all together now: "Follow your heart."

In one extreme version of comma panic, the writer assumes complete inability of the reader to understand repeated words for emphasis or parallel phrases placed next to each other without the assistance of a comma. I'm talking about the *It's what makes you, you*s and the *Only people who know, will know*s out there. I'd like to suggest we instead have some confidence that the reader possesses a modicum of intelligence

and can understand based on context that *you you* is not a typo but in fact integral to the meaning of the sentence. There is no need for a pause in either example, and thus no good reason for a comma. If you are truly afraid that the reader's eye will graze over the *you you* or you're looking to pack in some drama, *It's what makes you…you* or *It's what makes you, well, you* are acceptable solutions as well. Remember: What happens in Vegas stays in Vegas, and that comma before *stays* can stay in Vegas too.

Commas are often also used after the word *which*, in a newfangled slangy way, to indicate elided or implied text, like in this sentence from a story about Ryan Reynolds' lack of Valentine's Day plans: "With only a few days left before the holiday, Ryan admitted he hasn't made plans yet…which, good luck making a dinner reservation." Anyone who thinks the *which* or the comma or the use of both is wrong, please come forward so I am aware of who I should by no means ever be tricked into hiring or befriending. *Which*, in this instance, suggests an implied *which means* or *which makes us think*, though there's no good reason to add all those extra words in this sentence. "Just cut out the *which*! Or, if you must, add something else! Like *so* or *yikes*!" is what I imagine the worst person on the planet yelling in my ear as I leave this sentence be. No can do, buddy. The *which* followed by a comma implies a deliberate sort of snobby laziness: "I could continue this sentence in a properly formed manner, but it's so clear what I'm about to get at that I can't even be bothered to, so let's just get there now."

The serial comma: The cilantro of punctuation marks

Love it or hate it, the serial comma—also known as the Oxford comma—has the unique ability to provoke intense feelings exclusively; there's never a neutral stance to be taken when discussing this bad boy. But not having an opinion is boring and unhumanlike, so good for the serial comma! It encourages us to be our truest, most human selves.

Some may argue that the serial comma is curmudgeonly and wholly unnecessary. "It takes up precious space!" yells one anti–serial comma

(but pro–en dash) activist. "It reminds me of a 1940s newsroom!" shouts another. Both of these may be true, but do you know what else the 1940s gave us? Microwaves, kitty litter, penicillin for the general public, and the color TV. And I don't see anyone complaining about those being old-fashioned or taking up too much space today. Basically what I'm saying is that just because something was in use long ago doesn't mean it no longer serves an important purpose in the modern day.

Take the age-old example *We invited the strippers, JFK, and Stalin* vs. *We invited the strippers, JFK and Stalin*, for instance. *Hardy-har, JFK and Stalin were strippers!* is what the jester who crafted this example wants you to think when you read the latter, chuckling your way to serial comma advocacy in an instant. Cheesy, yes, but what happens in a sentence like this is something I've observed often: the not-actually-appositive comma posing as what could in fact be misread as the appositive comma. (The appositive comma, to clarify, is a comma that separates a noun from the noun or noun phrase preceding it that further defines it.) Alternately, that sentence could be phrased without the serial comma as *We invited JFK, Stalin and the strippers*, with no accompanying guffaws, but to that I say: Why spend time worrying about the arrangement of nouns when the serial comma, a true good Samaritan, realizes that you already have enough worries weighing you down and is here to help at any cost?

And then there's a sentence like *On the breakfast menu today, we have chocolate chip pancakes, avocado toast, and steak and eggs*, which without the serial comma would read as *On the breakfast menu today, we have chocolate chip pancakes, avocado toast and steak and eggs*. Does the steak come with the avocado toast or with the eggs? The serial comma clears up that situation real quick, doesn't it? And, sure, if you are vaguely familiar with what a typical American breakfast menu looks like, you'd probably realize, without the assistance of any commas, that steak and eggs is a thing and that those two food items are part of a single meal. And, yeah, you could also stick *steak and eggs*

at the beginning of that sentence to make it clear without use of the serial comma. But hear me out. Maybe the award-winning pancakes are this restaurant's specialty, ten times better than the snoozy ol' steak and eggs, and placing that dish's name first was intentional. I'm sure non-regular-US-breakfast-eaters and people who don't need you to tell them where the hell they should place *steak and eggs* in their sentences would be thrilled to find the serial comma chiming in to lend some help. Serial comma for president!

Commas for direct address
As mentioned in chapter 3, one important function of the comma is its use in what's called the vocative case, or when someone (or something—sometimes life gets lonely) is being addressed directly. Take, for example, the following:

> *I love your sister, Drew.*
> *I love your sister Drew.*

In the first sentence, Drew is being addressed by the speaker, who has fond feelings for Drew's sister. In the second, the person being addressed is unknown, and the speaker is expressing their love for someone's sister, and that sister is named Drew. (It could also be argued that the first sentence is indicative of an unknown addressee who has only one sister, named Drew, and in that case the appositive comma is instead what is being used; but let's pretend this is not the case and the addressee in question has several sisters, none of which are named Drew, and the second sentence is simply punctuated incorrectly. Got it?)

So we've established that the comma is great in these situations, helping to avoid ambiguity in a line like *Which one do you think is my favorite Leticia?* (a sentence where, it appears, there are many Leticias, and the speaker is asking which one you think she feels is the best) vs. *Which one do you think is my favorite, Leticia?* (Leticia is being addressed;

the speaker is asking Leticia to guess which thing in question is the speaker's favorite). It also helps save countless innocent lives when correctly punctuating sentences like *Let's eat children* as *Let's eat, children*. I think we can all agree that the comma does a top-notch, A+ job when put to work in these scenarios.

However! I've had email exchanges with many copy editors who've appeared to believe that it is their solemnly sworn professional duty to use this comma in email salutations, because everyone ought to know what correct punctuation looks like, damnit, even in an email chain discussing what flavor cake pops to get for Barbara's birthday party in the conference room this afternoon, and I'd like to request we all put an end to this abusive behavior. Not only does this make the copy editors who don't prefer to use said comma look like bona fide slackers, weighing them down with crippling guilt about their life choices as they flout the rules in this situation because, well, everyone else does it, but also: It just looks weird. If you do this, you are a weirdo, and not in the fun, quirky way. Forming an emotional bond with anyone who starts off an email to me with *Hi, Emmy,*—or, worse, *Hi, Emmy.*—is off the table. No. This is creepy. The only person allowed to write me an email that begins with *Hi, Emmy.* is the serial killer watching me from just outside my living room window. We don't need the comma here, and we all know that I am Emmy and you are writing me an email because my email address is in the "recipient" field and yours is in the "sender" field.

Commas with interjections

Commas are also typically placed after interjections, like in the following sentences:

> *Oh, not at all!*
> *Phew, that was close.*
> *Whoa, what a beautiful zebra.*
> *Uh-oh, that's gonna be awk.*

Some technically correct commas used after interjections—especially in common expressions using *oh* and a noun in a vocative case—can come off as stilted, their hypercorrectness distracting in a phrase we already know is idiomatic, like *oh god, oh dear*, or *oh no*. Perhaps it's because the emphasis is on the entire phrase rather than the thing being *oh*'ed at. Consider, for example, someone in a hushed voice saying, "Oh, deer!" at the sight of an adorable family of deer during a camping trip, and later, "Oh dear" when spotting a hungry grizzly bear just several yards from her tent. The cadence is different; it rises more in the former phrase (because deer are a thing to be excited about), while the words in *oh dear* are typically spoken at roughly the same tone. Or take, as another example, a person yelling, "Oh no!" when they realize their checking account has gone into overdraft vs. "Oh, no, I didn't," when asked if they've called their mother. *Oh no* is an expression we're all familiar with—another way of saying *drat* or *yikes*. In the latter sentence, the word *no* is not merely a sidekick to *oh*, but it functions as an adverb, integral to the meaning of the sentence; it is acting alone and not as part of the *oh no* phrase.

Commas with names

And while we're at it, what of that comma that often makes an appearance before the *Jr.* in a person's name? It's a total nuisance, tbh—and no longer used by most trade publishers, *APS*, or *CMOS*—because then we'll have to set it off with commas on either side when it appears in the middle of a sentence and it'll be a big ol' mess. While "He lives on the Northside, on Martin Luther King, Jr., Boulevard, in a house that…" might be just fine in *The New Yorker* (a publication whose diaereses and *teen-ager*s give it a distinct style we all love to prod at but secretly think is pretty cool in a rebellious, "I'm going to pretend that it's the 1920s forever and I don't give a hoot what you whippersnappers say" sort of way), a sea of unruly commas does absolutely zero in the way of making a sentence easy on the eyes. And that's all we copy editors were put here to do on this gorgeous, green earth: to serve you, dear reader.

STANDARD PUNCTUATION MARKS, RANKED WORST TO BEST

Much like the children in your family, we need to admit that not all punctuation marks are created equal.

13 Apostrophe

,

Apostrophes are just kinda basic. They don't lend much in the way of added emotion or emphasis—they serve their purpose and get on with their lives. Snorefest. Next.

12 Quotation Marks

,,

What can I say about quotation marks that hasn't already been said? Nothing, that's what. Much like Snoozehead McGee the apostrophe, quotation marks have a specific purpose—to introduce and end quoted material—and it's not one that's particularly exciting. The quotation mark gets one extra point for being cute and fun because it travels in pairs.

11 En dash

▬▬▬

Aside from copy editors and grammar historians, literally no one in the world cares about what the en dash is and how it functions. I mean…had you ever even heard of an en dash until now? Do you even know how long it is?!?! Sadly, there are too many dashes vying for space in this grim, overcrowded world, and the death of the en dash is something we simply must accept as imminent. (Sorry, lil'

guy. Say hi to the dodo for us.) This dash gets a few extra points, because in the UK (and presumably other places too) it's often used to function as an em dash, which is the coolest dash.

10 Colon

Colons are pretty OK. They build suspense, providing a teeny bit of excitement to help get you through those long days filled with otherwise ho-hum sentences. They also share a name with the thing that your poop passes through, so that's funny. Heh heh heh. *Colon.*

9 Semicolon

Sure, the semicolon is a little stodgy—and, let's face it, not nearly as chic as the em dash—but it's elegant and it's useful in very specific circumstances. It can also make your writing look totally legit and sophisticated when used properly (an art in and of itself, which is where the semicolon loses a few points). But I mean, the semicolon shouldn't be blamed for the fact that most people don't know how to use it correctly, I guess. Nonetheless, the semicolon *can* only take you so far when it comes to fun times in Punctuationville, and what's the point of life without some fun? Sorry, semicolon: You are just alright.

STANDARD PUNCTUATION MARKS, RANKED WORST TO BEST

8 Comma

,

Commas can be kind of assholes because they confuse the living crap out of everyone on earth—with the word *which*, with quotation marks (inside or outside?), with nonessential vs. essential clauses, and virtually any other situation that can and will arise in a sentence. When used properly, however, they lend plenty in the way of emphasis, emotion, and clarity.

Also, they've sparked the greatest punctuation debate of our time: to serial comma or not to serial comma? Much like the Kanye vs. Taylor feud once did, the comma has managed to evenly divide our world's population into two fierce groups at battle—just by hanging out, being a silly lil' comma. So that's pretty cool.

7 Parentheses

Parentheses are cool because they make room for things that need further explaining—and for fun little jokes. And I like learning things and laughing at jokes and tangential thoughts. Also, like the quotation mark, the parenthesis always travels in pairs, which is cute. Also, look, a butt: (l)

6 Question Mark

?

As Aristotle once said, "What is life if not but a series of endless questions?" JK, I totally just made that up. Sounds legit, though, right? Had I not fessed up, you probably would've never known otherwise—unless you had questioned it! Which is to say, we can't learn or grow or become fully functioning human beings without asking questions, and questions involve *question marks*.

On a date with a hot babe? Without some questions in tow, it'll be your last (unless you're really hot too, in which case you'll probably get one more). Trying to land that dream job? Good luck without an inquiry or two up your sleeve for the head honcho. There is no such thing as a stupid question—only a stupid punctuation mark. The question mark, alas, is not one.

5 Ellipsis

The ellipsis is a true Multipurpose Marla: great for rambling, for appearing mysterious or flirtatious, and for eliminating useless information. What other punctuation mark do you know who can do all three things in one fell swoop? None of 'em, that's who. The modest, adorable ellipsis is a true jack-of-all-trades. It loses points for not being super user-friendly, since confusion about where to put spaces (before the ellipsis marks? after? in between?) runs rampant, and people who overuse ellipses are a little spooky.

STANDARD PUNCTUATION MARKS, RANKED WORST TO BEST

4 Hyphen

The hyphen clarifies stuff like "kick-ass woman" (hell yeah!) vs. "kick ass woman" (who's ass woman and why in god's name are you kicking her?). The hyphen is multifunctional and user-friendly, and always makes a sentence better when it's correctly placed. That being said, it loses points for being a real stick-in-the-mud for deciding to be a part of words and terms (like *stick-in-the-mud*...and *face-lift* and *half-and-half*) seemingly at random. Also, our overreliance on hyphens has led many a writerly human to use them erroneously after adverbs, which is a bummer, but, hey—things could be worse in this cold, cruel world.

3 Period

I mean, duh. It's the basic building block of our language, punctuation-wise; we'd be lost in a meaningless sea of words without it. Also, periods are great for being badass. Really need to lay down the law? Facilitate a major business deal? Not gonna happen if you end your email with that silly joker the exclamation mark. Honestly, you could probably write an entire book using only periods and no other punctuation mark and it would still make complete sense. Also, it's called a full stop in the UK, which is very cool and logical. This be-all and end-all punctuation mark comes in third only because what it provides in functionality it lacks a bit in personality. I would be a little scared to hang out alone in a room with the period for too long.

STANDARD PUNCTUATION MARKS, RANKED WORST TO BEST

2 Em Dash

The em dash comes in a close second. For starters, when you're in the mood for a real good punctuation fix, it pretty much always works—(<—see what I did there?) and it's essential for those times when you're not sure what other punctuation mark to use and you don't want to consult your dusty old grammar books or your crotchety old copy editor. It's multipurpose. Aesthetically pleasing. Not as creepy as the ellipsis but not as snoozy as the colon, it's a peacemaking, graceful gazelle in a dog-eat-dog world of rogue commas out to get you and your loved ones.

1 Exclamation Mark

Not too many punctuation marks are emotive, and for that reason, the exclamation mark is the best mark—simply because to feel is to be human. "Fuck you, numbskull!!!" just doesn't carry the same conviction when finished off with a period. Coming in strong at #1, it's also the only mark you can use, aside from the question mark, to express a higher magnitude of emotion simply by using more of them. Pressed for time? Throw in a quick *!* to convey your excitement about that baby bunny GIF or your friend's new job. And they say life isn't easy.

Bonus: Overuse of exclamation marks is a fun way to look like you're out of your mind OR a really excitable great-aunt.

The colon craze

The colon is a relatively inoffensive punctuation mark, but that's no excuse to run around using it all willy-nilly. As noted on GrammarBook .com (the online counterpart of sacred grammar text *The Blue Book of Grammar and Punctuation* fame), "a colon means 'that is to say' or 'here's what I mean.'" It serves to introduce examples or provide more information about the first part of a sentence, almost as a reveal, as in *She got what she wished for: a puppy*. Don't use the colon instead of a semicolon, don't use it after the word *including*, and try not to use it following an incomplete sentence. Again, however, artistic license may prevail, allowing for some exceptions. (You'll notice I've strayed from the "Don't use a colon after an incomplete sentence" rule in this very book, and I've done so proudly.) Don't freak out and word something ridiculously if you simply cannot make an independent clause before a colon happen.

In *But Can I Start a Sentence with "But"?*, CMOS's cheeky compilation of the best advice from its Q&A section, one reader asks why the manual never explicitly states that an independent clause must precede a colon, even though all of its examples follow this guideline. *CMOS's* lively answer: "Because we're a bunch of spineless and ineffectual prevaricators? Or because there are times when a colon need not be preceded by an independent clause? A case in point: this one." Could you imagine the alternative? "A case in point is this: this one." That's bananas.

• No need for a colon after "including" when it precedes a list of items in a sentence, e.g., "They packed a whole bunch of stuff for their trip, including hard drugs, DIY fleshlights, and Mang-O-Ritas" -or- "They packed a whole bunch of stuff for their trip: hard drugs, DIY fleshlights, Mang-O-Ritas."

Punctuation advice using some solid example sentences, from an email I sent to the BuzzFeed staff.

Ellipses: The problem child

If punctuation marks were music genres, ellipses would be the emo-goth band of your dreams. The ellipsis is the most cryptic punctuation mark known to man, and so it's difficult to be fully certain of the sender's motive: Are they trailing off? Indicating omitted information? It's also virtually impossible to decipher if the ellipsis-user is being coy or has the intention to murder you in your sleep. The elusive dots are moody and can be creepy AF. Have you ever seen a note written in blood end with an exclamation mark? There are ellipses all over the damn place in horror movies. As if that weren't enough, ellipses harness the capacity to take home the award for single most annoying punctuation mark where overuse is concerned. There is a special place in hell for people who use ellipses to end every sentence, and it's one where they are forced to instead end every sentence with three exclamation marks.

What ellipses lack in clarity and joy, however, they make up for in functionality. They serve the unique purpose of indicating that words have been elided, a duty of utmost importance in published quoted material that has been condensed. Watch it with the overuse here too, though, because too many ellipses floating around in a quoted passage is not only wildly distracting, it could suggest that the writer has their own agenda and is attempting to massage someone's words into something they aren't. Throw an ellipsis in the wrong place and *I love children. I'll probably be working in the daycare industry until I'm dead* can become *I love children...dead* and suddenly you're at fault for one good-natured daycare provider's recent filing for bankruptcy and general demise.

That being said, it may be a bit unclear as to whether those three little dots mean "this thought trailed off" or "I took out a bunch of fluff." This is where some house style guidelines call for brackets around ellipses to avoid ambiguity. I think brackets are ugly and distracting and should be reserved to enclose words exclusively. A more

elegant alternative is to simply add a space on either side of the ellipsis; that's BuzzFeed's style, and I'm sticking to it. Our thoughts on this melancholy trio include the following:

- For ellipses, use three dots in a row, no spaces between each dot: ...

- If ellipses are used to indicate a mid-sentence pause, don't use a space on either side. (e.g., "We could go there...or not.")

- If ellipses are used to indicate a trailing off in thought or a long pause before a full sentence, insert a space before the next sentence. (e.g., "I don't know... Certainly, I don't think it will be good.")

- If ellipses are used after a full sentence to indicate omission of a full sentence or more (as in a quote), use a period followed by a space before inserting the ellipsis. (e.g., "We moved to New Orleans in 2010. ... By 2012, we were back in New York.")

- If ellipses are used to indicate omission of words rather than a full sentence or are inserted mid-sentence, use a space on either side of the ellipsis. (e.g., "I adopted a cat yesterday ... and he's already made himself right at home.")

Capitalization: No one cares if you capitalize French fry

There are very established rules about capitalization that we all learned in grade school: Capitalize a word that starts a sentence, capitalize proper nouns, capitalize the words in a title. For more nuanced matters, such as how to treat the capitalization of certain state departments or questions like "Is it Soviet bloc or Soviet Bloc?" (it's the former), we have resources like the *AP Stylebook* to turn to. What happens, though,

with words like *Brussels sprout*, *French fry*, and *venetian blind*, which derive from a proper noun but no longer depend on that noun for their meaning to be understood? There are some dissenting opinions: *APS* says lowercase. *MW* lowercases *venetian blind* and notes that *Brussels sprout* and *French fry* are "often" capitalized. Another follow-your-heart sitch.

If you're wondering where my heart leads (and you may not be—I'm not offended): While *Brussels sprout* with a capital "B" seems a bit more intrusive than *French fry* for a reason I can't quite articulate (the pervasiveness of French fries in American fast food? the semi-recent trauma of the "freedom fries" vs. French fries situation forcing us to confront the word's origin?), I'll take 'em either way. And I guess *Venetian blind* jumps off the page a bit too, but I wouldn't question the sanity of the copy editor who left it as is; it's innocuous enough. So if a capital "V" makes you happy, go for it as well.

what are your feelings on capital vs. lowercase brony??

Inbox x

An important question. BuzzFeed style is to lowercase the word used to describe the (typically adult male) My Little Pony fan.

In general, I'm of the opinion that you're safer capitalizing anything derived from a proper noun than you are lowercasing it. Among other categories, this goes for hairstyles derived from proper nouns (*Afro*, *French braid*, *Marley twists*); animal breeds, whose names are often rooted in regions or the person who "discovered" them (*Chihuahua*, *Cavalier King Charles spaniel*, *Maine coon*, *Flemish giant*); cooking styles (*spaghetti Bolognese*, *beef Stroganoff*); and surprise capitalized words like *Pilates* that aren't necessarily trademarks but derive from a proper noun (Joseph H. Pilates, in this case).

And go on, don't be shy about capitalizing the audience-generated names of both people and anthropomorphized characters whose impact

on pop culture has been significant. I'm talking Pizza Rat, Ridiculously Photogenic Guy (aka RPG), Left Shark, and the like. Again, capitalization lends legitimacy to said characters as entities in their own right, to humorous effect. It's fun to assign obvious names to attractive humans, ambitious tiny animals, and dancers in shark suits who've become accidental celebrities.

How about names of food items or meals? You might go to Taco Bell for a bean burrito or for a Quesalupa, but—despite the equal likelihood of your being found in the bathroom keeled over in pain T minus one hour later after demolishing either one—only one of those is capitalized. Outback Steakhouse's Bloomin' Onion, McDonald's Big Mac, and Burger King's Whopper are all trademarked items; the baby back ribs at Outback, the hot fudge sundae at McDonald's, and the garden salad at Burger King are not. And don't panic about running to the registered trademark office to check on the status of a menu item; it should generally be obvious enough if something is a generic description or a brand-specific item. Parmesan-herbed crusted chicken? Not so much. No Rules Parmesan Pasta? Might wanna cap. If it's not immediately clear, the establishment's menu probably isn't the best place to confirm. Most restaurants want you to believe that all their menu items are The Best Thing, and you'll likely find consistent capitalization across the board; instead, check for a TM or ®, or turn to Google and see how other outlets style it. I call it capitalization inspiration.

Food and drinks are a joy to consume, a nightmare to style. For the most part, as noted above, the names of edible things that are derived from a proper noun (usually a geographic location, sometimes a person's name)—especially when the item in question consists solely of the proper noun (e.g., Brie, as opposed to Brussels sprouts)—are typically capitalized. I'm talking your Asiago and Parmigiano-Reggiano cheeses, your Bordeaux and Chianti wine, and your Arnold Palmers. Sometimes they can go either way: bloody mary (*APS*) or Bloody Mary (*MW*) or

bloody Mary (why not?); Champagne (*APS*), because the bubbly drink has its roots in the French region, or champagne (*MW*), because it's moved into generic territory? Why is (capital "M" and "J") Monterey Jack also known as (lowercase) jack cheese (*APS*)? It's completely out of control. So just pick a style and try to stick with it—for your sanity more than consistency's sake.

What your grade-school teachers didn't tell you was that at some point in the near future we would all be living in a state of mass hysteria and uneasiness, our world overrun by an aggressive community of capitalization renegades. You know who(m) I'm talking about: those writers who love to point out that everything is A Thing. That *Agents of S.H.I.E.L.D.* is their Favorite Show Ever (and a nightmare for copy editors). That they've finally become a Real Adult™.

With careful application, however, it works—to signify extreme emphasis, as a sort of pseudo-title, like in Anne Helen Petersen's "Jennifer Lawrence and the History of Cool Girls" for BuzzFeed. Petersen uses the capitalized Cool Girl to refer to the nonchalant type of woman who puts on a performance of sorts in order to paint herself as someone who can "act like a dude but look like a supermodel." As Petersen explains, she might be into comics or climbing and can scarf down hamburgers and hot dogs like a pro. "She's always down to party, or do something spontaneous like drive all night to go to a secret concert. Her body, skin, face, and hair all look effortless and natural—the Cool Girl doesn't even know what an elliptical machine would look like—and wears a uniform of jeans and tank tops, because trying hard isn't Cool. The Cool Girl has a super-sexy ponytail." Here, you see, we're not just talking about any cool girl on the planet as defined by someone's opinions on what's cool and what's not. There's a specific connotation at play—one that applies exclusively to the Doritos-eating, clear-complexioned woman, licking her Doritos-dusted fingers confidently, who fits into this subgenre. The capitalization of the term serves to pseudo-brand Cool Girl as something precise outside of the generic, a thing for which no other term currently exists.

There's a difference, in this context, of course, between *She's a cool girl* and *She's a Cool Girl*. And short of putting the latter in quotation marks—which sort of undermines the effect in a "Well…allegedly she's a cool girl" kind of way and doesn't look quite as authoritative—I suppose there's no better solution here.

And sometimes playful capitalization for the effect of ironic or silly pseudo-branding works too: Humor is good for the soul, and who am I to take away all the capital letters you require to nourish it properly? Consider, for instance, a photo depicting a cake a mother made for her son when he brought a girl over for the first time to a family dinner that read "Alec, who's your 'special friend'?" The photo was captioned in a BuzzFeed list as "A mom who asks the Real Questions."

The BuzzFeed Style Guide has also given in to the Random Capitalization Trend with one entry in particular: The One (as in destined romantic interest). It's more elegant than the next best option, "the one," though let's be real: The capital-letters-as-emphasis fad is all subjective and often context-based. Just try your best not to throw capital letters all over the damn place in the middle of every sentence you write. Much like the phrase "I love you," overuse weakens the intended effect. Or at least that's what one of my ex-boyfriends told me, IDK. He has a face tattoo now.

Another BuzzFeed post, "Hey, You Should Totally Eat Non-Breakfast Food for Breakfast," is a diatribe by Alanna Okun where she calls the American rules for what kind of foods constitute a normal breakfast "totally fucking arbitrary" and encourages the reader to instead embrace choices like grilled cheese and tomato soup for the first meal of the day. Okun makes reference to "the aforementioned Rules" and ultimately decides not to make her grilled cheese more "breakfast-y" by adding an egg, and you know what? I can get down with that capital "R." The exaggerated emphasis of these as ingrained golden rules of a Ten Commandments–type caliber works, and proves that sometimes all you need to add a shred of humor is a capital letter.

Here's an example of a phrase, however, where a capital letter didn't seem completely necessary:

meganpaolone 5:14 PM
the cap R is weird here?

Think Recent Bieber, but with talent that allowed you to make more excuses for his revelry.

right?

emmyfavilla 5:14 PM
yes

meganpaolone 5:14 PM
I don't want us to get into the habit of doing these emphasis caps everywhere

emmyfavilla 5:14 PM
i get the effect she's going for but i don't really think it works here

meganpaolone 5:14 PM
it's very much Twitter language

emmyfavilla 5:14 PM
totally

In this situation, I suppose the writer was going for the effect of "Recent Bieber" as a character in and of himself outside the entity, the person who is Justin Bieber—highlighting the disparity between the Justin Bieber of yore and the persona he's projected more recently, at the time of writing. I get it, but I simply don't think it's Necessary, and I fear that setting that type of Precedent will lead us to a Place in several years where Silly-Looking Sentences abound and we all look like we've gone off the Deep End.

sarahwillson 6:14 PM

"this is why fashion jesus invented the keyhole back" (edited)
Fashion Jesus?

drumoorhouse 6:15 PM
that would be my vote

sarahwillson 6:15 PM
👍

Another thing your teachers didn't tell you is that one day, arguments over whether or not to capitalize the word *internet* would constitute half of your workday and lead to severed ties with many people you once considered close friends and family. In a 2015 *Wired* piece called "Should You Be Capitalizing the Word 'Internet'?" Susan C. Herring writes, "According to Bob Wyman, a Google tech staffer and long-time Net expert, the 'I' should be capitalized to make clear the difference in meaning between the Internet (the global network that evolved out of ARPANET, the early Pentagon network), and any generic internet, or computer network connecting a number of smaller networks."

Solid reasoning, I suppose, that I could defend—if I were living in 1994 and using my dial-up modem to sign on to Prodigy so I could spend forty-five minutes on a Saturday night downloading a low-res JPEG of Kurt Cobain to use as my screensaver. Oh, crud, Mom picked up the phone again and now I have to start this download all over. *Moooommmm!!!*

If other internets are still thriving at this stage in the game (I'm not a tech expert, so I don't actually know the answer to this, but I'm guessing there might indeed be some cute little baby internets floating around out there somewhere? IDK), the internet we all use to check our email and watch videos of dogs riding Roombas is clearly the most commonly used one on Earth by a landslide. Admittedly I didn't really do the research here, but some big clues that support my hypothesis include (1) we call it *the internet*, not *an internet*, and (2) its name literally used to be the World Wide Web. It should no longer require a unique, capitalized name to distinguish it from the other internets that may or may not exist. Like heroin, cellophane, and windbreaker before it, *internet*'s use has shifted to the generic; we've already seen this shift happen in plenty of internet-y (internetty? sure) words, like *E-mail* to *email* and *Web* to *web*. If you're still trying to make *Internet* happen, I'm afraid it's a losing battle and it counters the widespread English linguistic trend of words eventually being combined and lowercased once they've been well-established in common usage. Lol, remember *Web log*?

Directionals

When it comes to *north, south, east,* and *west,* and their adjectival counterparts, things are simple enough: If using them in the sense of "toward/ to the [north/south/east/west]," always lowercase. For example:

Head north on Amsterdam Avenue.
We walked to the eastern end of the park.
The venue is located south of the shopping center.

Specific defined regions—like the Northeast and the South (in the US), the Western Hemisphere, Southern California, West Africa, Southeast Asia, and London's East End—should be capitalized.

Sometimes the answer to the "Is this an officially defined region?" question isn't always immediately clear, and you may have to do some sleuthing (aka googling). It's also interesting to note that *APS* has flip-flopped on its guidelines regarding *Eastern Europe*; older entries have advised capitalizing *Eastern* only when referring "in a historical sense" to the political bloc and using *eastern Europe* when referring to the easternmost regions of the European Union, but newer "Ask the Editor" answers have advised that *Eastern Europe* and *Western Europe* be used to refer to the geographic regions. It's kind of the Wild West out there (two capital "W's," thanks), but examples of what you might consider "nondefined" regions that do not require the capitalization of directionals include southeast Brooklyn and western Ukraine.

For god's sake

People have different gods, and some people have no god. There's an easy way to respect this: Capitalize only if referring or alluding to a deity, and lowercase in a generic sense (as in the prior sentence) or in common expressions, like *thank god, oh god, god only knows,* etc. Because after all, someone's god could be a saltshaker:

drumoorhouse 3:49 PM
God?

"I've told my god I didn't want to live any more," she said.

sarahwillson 3:50 PM
hmmmmmm

dan.toy 3:51 PM
id say no?

drumoorhouse 3:51 PM
ty.

dan.toy 3:51 PM
her god may not be God-God

lol

sarahwillson 3:51 PM
yeah, need more information

drumoorhouse 3:52 PM
her god could be a salt shaker

just sayin'

sarah.schweppe 3:52 PM
it's like her god vs. I told God

meganpaolone 3:52 PM
yeah I would keep lower

drumoorhouse 3:52 PM
bueno!

thank god we all agree ~ drops 🎤 ~

dan.toy 3:53 PM
my god is taco bell 🌮

drumoorhouse 3:53 PM
i do worship their mild sauce

Vanity capitalization, aka sticking it to the man
Vanity capitalization refers to the ~fuNky~ styling of brands, products, works of art, and the like. Some examples of my mortal enemies over the past decade include the bands tUnE-yArDs and Panic! at the Disco—who, it is important to note, were sinister enough to drop their exclamation point for a brief, but buoyant period before stealthily tossing it back in, pushing copy editors across the world ever-closer to an early

grave—Rihanna's album *ANTI*, and brands like LEGO and IKEA. Latest miscreant on the scene: Jay-Z, who, in a P!ATD-flashback-inducing turn of events, not only rebranded his name with the hyphen in 2017 after going without it for years, but also decided he'd like to be referred to as all-capital JAY-Z, thank you. *rips up every style guide in existence upon realizing that both life and hyphens are meaningless*

At what point do you give up and give in? Not at tUnE-yArDs, that's for sure.

BuzzFeed generally adheres to the self-stylization of names of prominent figures—like e. e. cummings or bell hooks—as a show of respect for their work and their artistry, which extends to the stylistic choices they've made for their names. (The screamy JAY-Z, however, dominates a sentence with a marketing-ploy-esque motive, in a way that an inoffensive all-lowercase name doesn't; bell hooks, for instance, does the opposite.) In the same manner one's preferred pronoun should always be used, shouldn't someone's preferred styling and spelling for their own name, something so integral to their identity, be as well? I realize that not everyone agrees with this style choice; they can have it out with bell hooks on their own time. Perhaps the argument can be made that doing so could appear as a typo, which, while valid, I'd counter that all one needs to do is look up the name in question and they'll discover both more about this person—three cheers for learning!—and that the publication in question hires only quality copy editors and there is nary a typo in sight. Short of ignoring the person's self-stylization altogether, the alternative, being obvious about it by writing something like "bell hooks (who self-styles her name with all-lowercase letters)," is tacky and a bit of an insult to those with a smidgen of cultural awareness. I wouldn't advise going that route. We have Google now, and doing follow-up homework is easy—and fun. (Not to be confused with fun., the band. Ugh.)

Also, lol, remember t.A.T.u.? BuzzFeed did, in a post about early-'00s songs, and, after the ensuing conversation, the copydesk settled on making an exception for the magical pseudo-lesbian duo of yore.

also omg guys

remember the band t.A.T.u. (edited)

i have come across it in the wild and unsure how to handle

Tatu? T.a.t.u.?

 lylebrennan 12:43 PM
delete post

 emmyfavilla 12:43 PM
good idea

 lylebrennan 12:43 PM
I think this is one instance where it's kind of fun to keep the vanity styling because it kind of says a lot about what that band was

 lylebrennan 12:45 PM
Oh wow. So apparently it is an actual acronym

 emmyfavilla 12:45 PM
is it?? i am searching for this information

 lylebrennan 12:46 PM
From the gospel according to wikipedia:

After completing the duo, the producers decided on the name "Тату" (Tatu). Sounding like the English word "tattoo", it is also a shortening hint to the Russian phrase "Эта девочка любит ту девочку", (Aita devochka lyubit tu devochku, meaning "This girl loves that girl"). [5] For the release of their first English-language album, they decided to go by t.A.T.u., using uppercase letters and periods to distinguish themselves from an already existing Australian band, Tatu.

 meganpaolone 12:46 PM
huh

 emmyfavilla 12:46 PM
or T.a.t.u.

 meganpaolone 12:46 PM
I like the fun t.A.T.u.

omg no

 emmyfavilla 12:47 PM
am i being unfun? i guess i can keep as is

 meganpaolone 12:47 PM
the fun. t.A.T.u

 emmyfavilla 12:47 PM
hahahha

 meganpaolone 12:47 PM
imagine if they did a collab

vanity cap nightmare

 emmyfavilla 12:47 PM
copy editors across the world would combust in unison

You'll sometimes find yourself having to decipher between vanity capitalization and an all-caps word that isn't obnoxiously eager for attention but rather one that actually stands for something—like *Navy SEAL* for the special operations force, where *SEAL* is an acronym for *sea, air, and land* (as opposed to a *navy seal*, a marine mammal who has decided to dye their fur an unconventional color, because #yolo). There have also been instances where brand names whose letters once served as an acronym no longer do; take, for instance, Asos, an online fashion and beauty retailer whose name once stood for As Seen on Screen. These days Asos just means Asos (that's pronounced "ACE-oss," per its website), so my thought is that we can toss those capital letters aside, since the brand isn't pronounced "A-S-O-S." To make matters worse, its logo is styled in all-lowercase letters, but it's ASOS in self-referential instances on the company's site, so I'm pretty sure that means we're extra-allowed to style it however the hell we'd like.

And then there's the product that self-stylizes as beautyblender. Twenty dollars may get you a sponge with an impressive cultlike following, but it's gonna take more than that to convince me that it shouldn't be styled as Beautyblender outside of official marketing materials.

Company names often take all caps as a form of self-promotion, in an effort to stand out—or simply to mimic the stylization of a brand's logo. As Bill Walsh says in *The Elephants of Style*, "Use all caps

BEG THE QUESTION

Yes, technically *beg the question* is a term derived from formal logic, and it means to make an assumption based on a premise that lacks evidence, or a kind of circular reasoning. But—are you ready?—it's just fine as a stand-in for "raises the question." We can't take back the past several decades in which it's been used in that sense, and the fine art of logic is a dying one. Don't be a pedant.

for names that aren't initialisms and your writing will look like a cheesy news release: *The sponsors include NIKE and VISA.*" The BuzzFeed Style Guide advises capitalizing only the first letter of words in trademarked product and brand names, unless that name is made of initials (e.g., *AT&T*, but *Ikea, Lego, Nike*). There are, of course, situations where you'll find it's in clarity's best interest to make an exception, which is why we also have entries for cosmetics company MAC and the iPod Nano (but not, it's important to note, *iPod nano*). Companies and products like eBay and iPad are such a ubiquitous part of our culture that it would be beyond awkward to force an *Ipad* or *IPad* into an innocent little sentence. Sure, you might want to avoid beginning a sentence with one, but if there's no work-around, I feel confident that readers would cringe more at the sight of *IPad* than at a lowercase letter at the start of a sentence. And to beauty aficionados, super-popular cosmetics brands MAC and NARS would likely appear peculiar-looking as Mac and Nars. (Plus there's the added Mac computer vs. MAC Cosmetics brand-recognition factor at play.) There are also some initialisms that are so recognizable with one lowercase letter rather than all capital ones, like *GoT* for *Game of Thrones*, that following an established style probably makes the most sense.

If you're willing to write "iPhone," then you need to write "UGGs." You can't just make your own "Buzzfeed Style" rules and then tell others they're wrong. I've seen Apple products referenced on Buzzfeed using Apple's "vanity capitalization." You don't get to arbitrarily select which stylistic capitalization you'll honor, then use your subjective decision to make an answer wrong on a quiz.

RESPOND 27 0 SHARE ▾

Emmy Favilla
a few minutes ago

You're correct, we do style Apple products as iPhone, iPad, etc., but don't typically don't adhere to all-capitalized brands, because that's BuzzFeed's style. (How weird would Iphone or IPhone look?!) Our choices aren't "right" or "wrong" just as much as AP's style guidelines aren't "right" or "wrong" — they simply are. And the "correct" answers in this quiz, as stated, are correct in that they adhere to our style — but it doesn't mean they're incorrect in the grand scheme of our language, hence the disclaimer in the dek. We like to have fun with language and use guidelines that make the most sense for our content — and always appreciate feedback. That's the beauty of having a style guide!

RESPOND 0 0 SHARE ▾

a few minutes ago

But you're telling us our choices are wrong. When did you become the capitalization police?

RESPOND 0 0 SHARE ▾

The newest rookie on the squad.

When in doubt, I like to check what prevailing style is by scoping out other major publications. And as Walsh puts it, "You have to draw the line somewhere. Tomorrow a company could incorporate with the name iNTERNETaBcDeFgHiJkLmNoPQrStUvWxYz.com. Or worse. Are you still going to forsake journalism in favor of logo replication?"

There's a difference, moreover, between a brand logo and a brand's chosen spelling (which includes punctuation); it's why we might style Chick-fil-A as such, but wouldn't dot the *i* in Sprite with a picture of a lemon and a lime. Just because reasonable artistic license with capitalization is encouraged, don't consider it your civic duty to remove or add punctuation to company names whenever inspiration strikes. I feel personally attacked every time I pass by a Michaels craft store (acute pain that was felt even more deeply when I googled "history of Michaels," only to discover what we were all afraid was indeed the truth—that it was founded by a man whose first name is Michael, not whose last name is Michaels), but that doesn't give me a right to throw an apostrophe in there to put a swift end to my suffering any more than I have a right to add an *f* to Double Stuf Oreos.

What we do have a right to is pluralizing trademarked products whose parent companies have for some reason designated them supremely special snowflakes and therefore exceptions to standard English pluralization rules that have been in practice for centuries. I refuse to refer to multiple Lego pieces as *Lego bricks* rather than simply *Legos*. No one in the history of the world has ever willingly called them *Lego bricks*. They are Legos, and children and adults of all ages love them. Let us call them Legos. This is certainly a situation where a brand name also substitutes for the name of the product itself, and we can't backtrack and make that un-happen. It was an organic shift, likely led largely by the small humans to whom this product is marketed. The bricks are Legos, the people are Lego people. *Fin.*

Even more enraging is Apple's insistence that you can have one iPad but must have two *iPad devices*—*iPads* is out of the question, no

can do, *iPad* doesn't get along with *s*. This isn't even a situation of company name shifting to product name and an attempt to preserve the name of the company as its own distinct thing. This is literally the name of the product that was created. If you've splurged on two iPads, you deserve to tack an *s* on the end and save yourself those stolen precious moments of life when you could have been doing something more productive than spitting out the word *devices* because Apple says you have to. Pluralize trademarked names with pride, and if anyone takes issue with it, you can tell them I sent you. (JK, I don't want to go to jail for some weird loophole rule. But, you know, stand your ground if you feel strongly.) There's also the troubling concept of marketing materials referring to the product as simply *iPad* rather than preceding it with an indefinite article (*a*/*an*). My colleague Sarah put it best: "iPad is not my friend's name." It's actually pretty creepy when you think about the calculated anthropomorphization of it all. No, thank you. The iPad is not alive. (Or is it?)

On the subject of companies and organizations, are they a *they* or an *it*, a *who* or a *that* in the singular form? We may be referring to a network that is made up of sentient beings, but the place in question isn't one itself, so it's generally safe to go with the inanimate pronoun; that is, "ESPN announced *it* would air the broadcast at 10 P.M.," not "*they* would air the broadcast." Sure, the waters can get a little muddy when we have close personal ties to a brand that we so desperately in our loyal hearts would love to personify—when "I love Olive Garden because of *its* breadsticks" is as arduous to utter as the word *moist* eight times in a row—but use your judgment if something is pushing the painfully awkward-sounding boundaries. As the BuzzFeed Style Guide advises, much to the pedants' chagrin, "In lighthearted, non-News posts, it's OK to personify brands by using 'they,' especially if the alternative sounds awkward and/or stilted."

meganpaolone 2:16 PM
how do we feel about "they" here?

They literally just launched the Cinnamon Bun flavor two weeks ago. Everything OK over there, Oreo?

"it" sounds weird

sarahwillson 2:17 PM
yeah; "they" sounds way better

emmyfavilla 2:17 PM
yeah i think ok there since in a sense we're personifying the Oreo brand as experiencing something

sarahwillson 2:17 PM
sometimes i leave those in buzz posts because it's just too awkward with "it"

if there's no way around it

emmyfavilla 2:17 PM
it's playful & informal

yeah

meganpaolone 2:18 PM
ok cool

I just needed the support

maybe we should note that in the style guide

Job description vs. job title

It's a widely accepted standard that job titles (e.g., *president, governor, editor-in-chief*) should be capitalized when they directly precede a person's name and lowercased when they do not: *The pope visited New York,* but *Pope Francis gave blessings to New Yorkers.* Or *Bill de Blasio, the mayor of New York, has been in office since 2014,* but *We saw Mayor Bill de Blasio eating a sandwich.* And in a rare case of the stars aligning ever so perfectly, both *APS* and *CMOS* can agree on this, and I can too. Sometimes the world is truly a beautiful place.

It's important to consider, however, whether we're referring to someone's official job title (*Deputy Editor Jane Smith*), which would be capitalized before one's name, or their job description, which would be lowercase (*editor Jane Smith*). As *APS*'s "titles" entry reads: "A formal title generally is one that denotes a scope of authority, professional activity or academic activity: *Sen. Dianne Feinstein, Dr. Benjamin Spock,*

retired Gen. Colin Powell. Other titles serve primarily as occupational descriptions: *astronaut John Glenn, movie star John Wayne, peanut farmer Jimmy Carter.*" A+ last example, guys.

Terms like *first lady* and *first family* should also be lowercased—even preceding a person's name, as in former first lady Michelle Obama—since they do not denote official titles. Same goes for the royal family (and, alas, even royal babies).

Easy enough to distinguish, right? Not so fast! What if someone's formal title is identical to their job description—say, *copy editor* or *staff writer*? Or if you're unsure? On this issue, *APS* gives the same advice I would: Avoid the problem altogether by doing something like *Rita Smith, copy editor, named her dog En Dash.* (To be clear, here's *APS*'s stance: "A final determination on whether a title is formal or occupational depends on the practice of the governmental or private organization that confers it. If there is doubt about the status of a title and the practice of the organization cannot be determined, use a construction that sets the name or the title off with commas.")

Then there's the curious case of, say, named professorships, which, as *CMOS* points out, should be capitalized even when the title is placed after the person's name. So while *Robert J. Zimmer, president of the University of Chicago* is just fine, *Wendy Doniger, Mircea Eliade Distinguished Service Professor of the History of Religions in the Divinity School* is as capitalized as the day is long.

And *theeeen* there's the wacky world of entertainment, in which all rules go out the window, because anyone who can provide us with enough fodder for six hours of binge-watching on a hungover Sunday afternoon doesn't need to follow any damn rules. Per the BuzzFeed Style Guide, "Standard practice in entertainment coverage is never to capitalize a job title except when it starts a sentence. The same goes for every position on a movie set: 'director Martin Scorsese,' 'screenwriter Tina Fey,' etc. Executives within the studios, however, follow the standard AP rules for title capitalization."

When introducing experts, it's helpful to spell out all titles and specializations that aren't commonly recognized medical degrees (e.g., spell out *registered dietitian* rather than using *RD*, but keep *PhD*, *MD*, and *MS* abbreeved). Know your audience. The idea is to give readers a sense of these experts' credentials to bolster their authority as sources—and show a little respect for the person who's sat through school for half their lives in order to help you live your best one—but what good is that if readers don't know what they stand for?

BuzzFeed style aligns with AP's in that the title *Dr.* should precede a person's name only if they hold a doctorate degree in medicine, dental surgery, optometry, osteopathic medicine, podiatric medicine, or veterinary medicine. If context makes the person's area of expertise clear enough, though, *Dr.* may be used before their name if their specialty is stated in first or second reference. The goal here isn't to downplay someone's PhD because it's not an MD but to help with clarity, as *Dr.* is often a distinction associated with physicians. And if it's clear we're talking about an expert in a particular field, tacking on a *PhD* to their name is fine; otherwise, specify what they hold a doctorate in. I'm typically in favor of using *MD* rather than *Dr.*, because it helps avoid ambiguity and also typically keeps the format throughout a piece with quoted sources consistent.

And how about the following "jobs": Ghostbusters (capped) or ghostbusters? Housewives (capped) or housewives (when referring to stars of the *Housewives* reality TV series, that is)? Fictional jobs or terms that derive from a title and serve to describe, for example, the cast of a TV show or film should be capitalized. So while a person who studies the paranormal and sets out on a mission to eradicate a haunted home from some troublesome spirits may playfully refer to themselves as a ghostbuster, the term we use to refer to the characters from the movie *Ghostbusters* should be capitalized (and in roman type). Same for a person who refers to herself as a housewife, whether ironically or unfortunately, vs. Bethenny Frankel, Housewife.

Similarly, fandoms derived from a proper name should also be cap-italized: Beliebers (for lovers of the Biebs), the Beyhive (loyal Beyoncé fans), Deadheads (Grateful Dead enthusiasts), Juggalos (lol, this term has roots in an Insane Clown Posse song called "The Juggla"), and Little Monsters (one of Lady Gaga's nicknames is Mother Monster, which led to the moniker for her devotees).

Starting sentences with conjunctions

Are we really still having this conversation? In the era of lists and Twitter and texting and interviews via Facebook Messenger, we'd be inflicting on ourselves unmanageable amounts of anxiety if we enter-tained worrying about whether or not starting a sentence with *and* or *but* or *because* was acceptable every time we came across one of those lil' fellas. You can start your sentences however you please, because your stylistic preferences make you you. Also? They're words, not weapons. They give your writing a voice, they signal to the reader a shift in tone, and they lend dramatic effect when intended. Go for the gold in the Conjunction Olympics.

Most often, the conjunctions traditionally thought of as being "incorrectly" used when placed at the beginning of a sentence (*and*, *because*, *but*, and *or*, specifically) are employed for emphasis. For instance: *This is where the story ends. Or is it?* Or (see what I did there), *I gave up dairy last year and it wasn't as hard as I thought it would be. But giv-ing up gluten? That was rough.* Of course you'd want to play up how hard it was to cut out gluten. Gluten-free pizza is the most unpalatable trash I have ever subjected my body to; my empathy for the gluten-intolerant runs deep. A comma connecting the first two sentences wouldn't pack the same punch, and starting the second sentence with *giving* would downplay the association between the two a bit. This doesn't mean we should turn every piece of writing into a collection of staccato sen-tences. And start every one with a conjunction. Because that's just abusing the system. And I think we don't want this power to be taken

away from us. Because that's what will happen if all our stories start looking like this. But I don't think you'll do that.

Similarly, ending sentences with prepositions is a topic I'll glide over briefly, because it is *so* obviously okay. That we live in an age where I still need to waste space reassuring you that ending a sentence with a preposition is not an abomination or unquestionably grammatically incorrect, as your dogmatic English teachers may have convinced you it was, fills me with not with unmitigated anger, but mere disappointment. Disappointment in our inability to stick it to the grammar man en masse. As Stamper tells us comfortingly in *Word by Word: The Secret Life of Dictionaries*, "The fact is that many of the things that are presented to us as rules are really just of-the-moment preferences of people who have had the opportunity to get their opinions published and whose opinions end up being reinforced and repeated down the ages as Truth." I'll just request you keep a mental note of how many times you find yourself asking the question "Where are you from?" instead of "From where are you?" or "Of what city are you an inhabitant?" and get back to me.

Nontraditional verbification

Sometimes a noun just didn't set out to be a verb from the onset in this cold, cruel world, and that's alright. At some point during their coming-of-age years, several of these brave souls decided to change paths, and I'm here to support them. Transforming words into forms of speech that they wouldn't normally be seen out and about in is fun and funny; so, much like the internet at large has done with letting *because* live its best life as a preposition when it sees fit, go on and give that noun the confidence it so desperately craves. Making up words to properly convey a certain thought or tone or action is sometimes the best route; don't ever let the dictionary tell you otherwise. And it's not a luxury reserved for lexicographers. Be stealthy and no one will question you. Some tips on verbifying with abandon:

- For a noun or other word that traditionally wouldn't take a verb form, use a hyphen plus *ing* to create the verb form if the word ends in a vowel (e.g., *bro-ing*—to describe the action of behaving like a typical bro—or *Vine-ing*); consider readability to determine if the past tense should be formed with an *-ed* or apostrophe + *d* (e.g., *bro'd down*, because *broed* is atrocious and could easily be misread). If the word ends in a consonant, add *ing* or *ed*, with no hyphen (e.g., *computering, computered*). Please keep this in mind next time you're trying to explain how you hahaed (or hahaëd, if you're at *The New Yorker*) your friend's Facebook status and they're curious if the language you're speaking is still a live one.

- What happens when slapping an *ing* onto a word that ends in a consonant just doesn't cut it? Use the ol' noggin and you'll get there eventually. Consider this inquiry for the ages:

here's a fun question: dick-picking ok as a verb? or piccing? or...i don't even know

One might argue that a verb form of said activity needn't exist at all—how about just "sending a dick pic"? Although that was my very response, there's something about the terseness of the form questioned that lends itself to the idea of it as a sport in its own right. Which, yeah. In that case, dick-picking sounds like an entirely different (and dangerous, possibly medieval) enterprise altogether. *Dick-picing* implies the pronunciation "dick-*pie*-sing," and *dick-piccing* looks bizarre. *Dick-pic-ing*, though not the most picturesque option, is probably our best bet. Whatever the case may be, talk yourself through it, trust your gut, and I'm sure you'll get to the most reasonable verb form safely.

- Use *ing* or an apostrophe + *d* to create the verb form of an all-capped abbreviation (e.g., *DIY'd*, *LOLing*). Both *DIYed* and *DIY-ed* could be mistaken for a newfangled version of home-ec class. *LOLing* (or *loling*, for that matter) doesn't really need an apostrophe—nor does it need a hyphen, if you were floating that idea—because a typical person living in this millennium will understand it either way. Plus it looks prettier without one. Does any of this really matter? Nah. Your reader will likely get the gist of what these verbs mean by the context in which they appear, apostrophes or hyphens or lack thereof notwithstanding. So do what you want, I guess.

Even our language's more traditional verb constructions have the capability to tear a competent copydesk apart at the seams. Take the present participle form of the verb *glue*:

emmyfavilla 5:24 PM
glueing or gluing

both look terrible but are acceptable per MW

drumoorhouse 5:26 PM
neither bother me

sarahwillson 5:26 PM
same

meganpaolone 5:26 PM
gluing!

dan.toy 5:27 PM
gluing fo sho

glueing for international?

emmyfavilla 5:27 PM
hahahahaha

sarahwillson 5:27 PM
m-w has blueing and shoeing which makes me think why not be consistent

but i honestly don't have an opinion

drumoorhouse 5:27 PM
i misunderstood; i'd go with gluing

emmyfavilla 5:32 PM
kinda #TeamGlueing too but in the least enthusiastic way possible

meganpaolone 5:32 PM
I will concede

if more people like the E

drumoorhouse 5:32 PM
gluing is webs preferred though; why vary?

meganpaolone 5:33 PM
m. webs

emmyfavilla 5:33 PM
it's just listed first

which doesn't necessarily mean preferred

drumoorhouse 5:33 PM
huh. that's what i've always been taught.

emmyfavilla 5:33 PM
(fun fact i learned at the ACES conference)

sarahwillson 5:33 PM
i thought we preferred it at least

emmyfavilla 5:33 PM
nope! it's just the entry that was first recorded

so one could argue

that glueing is more ~ evolved ~

In the end, who cares? Just pick one so you can focus on questioning the more important things, like why Chipotle's burrito bowl and salad are different menu items when they're essentially the same thing.

As written language that reflects spoken language inches its way to the standard, there's been less resistance to acknowledging unconventionally spelled words or phrasings that people actually use—even if not conventionally grammatically correct—like Kanye's infamous "I'mma let you finish." There was so much contention over how to spell *I'mma* that we added it to the BuzzFeed Style Guide.

A combo of *I'm* + *gonna/going to*, *I'mma* (which seems both to reflect its pronunciation better than *I'ma*, which I'd immediately read

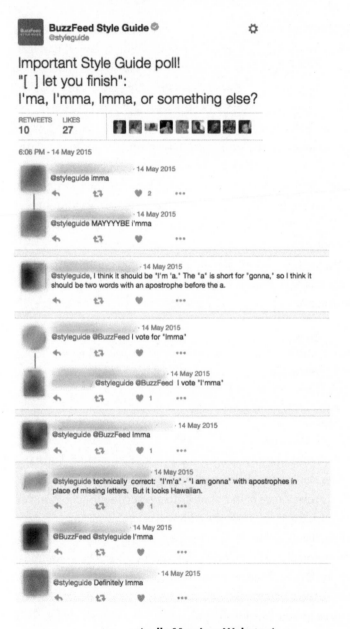

BuzzFeed Style Guide ✅
@styleguide ⚙

Important Style Guide poll!
"[] let you finish":
I'ma, I'mma, Imma, or something else?

RETWEETS	LIKES
10	27

6:06 PM - 14 May 2015

· 14 May 2015
@styleguide imma
↩ ↻ ♥ 2 ...

· 14 May 2015
@styleguide MAYYYYYBE i'mma
↩ ↻ ♥ ...

· 14 May 2015
@styleguide, I think it should be "I'm 'a." The "a" is short for "gonna," so I think it should be two words with an apostrophe before the a.
↩ ↻ ♥ ...

· 14 May 2015
@styleguide @BuzzFeed I vote for "Imma"
↩ ↻ ♥ ...

· 14 May 2015
@styleguide @BuzzFeed I vote "I'mma"
↩ ↻ ♥ 1 ...

· 14 May 2015
@styleguide @BuzzFeed Imma
↩ ↻ ♥ 1 ...

· 14 May 2015
@styleguide technically correct: "I'm'a" - "I am gonna" with apostrophes in place of missing letters. But it looks Hawalian.
↩ ↻ ♥ 1 ...

· 14 May 2015
@BuzzFeed @styleguide I'mma
↩ ↻ ♥ ...

· 14 May 2015
@styleguide Definitely Imma
↩ ↻ ♥ ...

calls Merriam-Webster

as "eema," and the fact that it comprises the contraction *I'm*, meaning *Imma* isn't quite right), in addition to simply being common parlance, carries enough pop-cultural significance to warrant a guideline on preferred spelling. Quoting Kanye as saying "I'm gonna let you finish" just wouldn't be accurate. Not to mention that *gonna* isn't in the dictionary either, though I'm sure it's only a matter of time. Squishing words together is a characteristic of contemporary speech, and our written language is still playing catch-up. I mean, *shan't* appears in most dictionaries, but no *gonna* or *I'mma* in sight; when was the last time you proclaimed something shan't be done? And some language resources still contend, as Cambridge Dictionary online does, that "contractions are usually not appropriate in formal writing." Haha, okay.

Also characteristic of modern linguistics is making up entirely new words altogether—or finding utterly ridiculous ways to spell them—and finding humor in using them in earnest:

Hi there!

So, if we are running recipes for three different hummus(es) how do we refer to them in a group? Is it hummuses? Miriam Webster does not address this great question for our times.

Thank you very very much.

 Emmy Favilla <emmy.favilla@buzzfeed.com>
to Sarah, Copy, Alison ⊡

hummi

Of course, the plural of *hummus* is not, in fact, *hummi*, but *hummuses*, though rejiggering the sentence—e.g., "three different types of hummus"—is probably a better choice than resorting to use of such a dreadful word. Or go ahead, use the adorably crisp *hummi* and give people something to talk about. Be the change you want to see in this world.

While you're at it, why don't you also go ahead and be as ungrammatical as you'd like when the situation calls for it? Here's a tweet from a post about Panera secrets, in which the non–grammatically correct structure—the purposeful placement of *not* after *at* rather than before—works for humor. It's unexpected, the subtle punchline of "not

Panera" acting as a stand-in for an unspecified but clear-enough-from-context noun (i.e., the supermarket). Sure, you could swap the *not* and *at*, but it wouldn't have the same effect. Simmer down, prescriptivists.

23. Or how to eat soup for every meal every day:

 shiza ✈
@LONQUTIE ✿ 2+ Follow

DID YOU KNOW YOU CAN BUY PANERA SOUP
AT NOT PANERA???

via Twitter: @bymameido

Getting things kinda-sorta right when it comes to numbers

Also tucked away under "Who cares?": formatting numbers. There's a reason why *APS* spells out one through nine and *CMOS* spells out one through ninety-nine. It's because it doesn't matter. Should you write *11th hour* or *eleventh hour*? It literally makes no difference!! Sure, try to be consistent about it, but don't beat yourself up about letting a *20s* sneak into a headline when your house style is *twenties*. You'll get 'em next time, slugger.

 emmyfavilla 4:49 PM
ps: house style is twenties
annoying copy editor alert

 katie 4:49 PM
damn

 emmyfavilla 4:49 PM
lol sorry
i suck

 katie 4:50 PM
do you think i can get away with it for the headline in the sake of brevity?

 emmyfavilla 4:50 PM
sure
i'm also drunk
so whatever

A World Without "Whom"

(The headline in question was "11 Things People Over 30 Feel When They Read BuzzFeed Posts About Being in Your 20s" by Katie Notopoulos, and IN MY DEFENSE, I'd had two shots of the Chinese liquor baijiu for a BuzzFeed video, so I wasn't just taking swigs at my desk to help myself forget that I'm the loser who has to take responsibility for calling these things out. I wait until at least 5:30 P.M. for that. Okay…sometimes 5.)

This is all to say that BuzzFeed doesn't neglect to have a style for how to treat numbers, of course. Like with most guidelines, we're fluid with our approach, not least because the rules differ depending on where they're being applied—especially at a place that produces such varied content. For instance, since the style guide's inception, the following ruling has been applicable across the site: "Format full dates as: Oct. 3, 1983." In 2016, however, one of our world news editors presented the argument we'd all been making, and ignoring, in our heads for the prior three years, knowing it would mean we'd have to be the ones to suggest revisiting one of the Big Rules:

Hi there, so I have a copy question pertaining to the features I put out.

I was wondering if, for features, we could make an exception to shortening the months? In the example below, it just reads odd to me not to spell out December. I understand the logic in news stories, for brevity, etc, but in a feature of 4,000 words, it seems unnecessary to cut five letters.

Hope all well with you!

Best wishes from London,

Paul

The U.S. special forces looked a little nonplussed, posing for an unplanned photo call in their fleece jackets, flannel shirts, and baseball caps. They had landed at Wattiya air base, southwest of Libya, on Dec. 14 last year, as part of an effort to train militias in their fight against ISIS.

The copydesk unanimously agreed, of course, because who is AP to tell us what we can and can't spell out, and just like that, the entry was changed to:

In most stories, format full dates as: Oct. 3, 1983. In features and essays, however, it is acceptable to spell out dates in full (October 3, 1983).

BuzzFeed takes a similar approach to the stylization of height: Generally, we advise using figures and spelling out *inches, feet, yards,* etc., to indicate depth, height, length, width, and weight. (Exception: noun phrases like *8×10s*.) However, in the context of a list, for instance, it is also acceptable to use foot and inch marks—technically known as the prime and double prime symbol, respectively—(5'6") to indicate a person's height if spelling out *5 feet 6 inches* in context seems out of place. Survey the surroundings.

Hey, guys!

I talked a little bit earlier in this book about the importance of using gender-neutral language for the sake of inclusivity. Where I personally draw the line, though, is with the word *guys*. I use it all the time, and I am of the persuasion that it is simply a stand-in for *people*, gender identity notwithstanding. It is also, as *MW* points out, a synonym for *creature*— as in *Look at this fuzzy little guy* in reference to a cute baby wombat, for instance. I refuse to use *y'all* (I do not hail from the South; there is nothing more cringeworthy than an unnatural *y'all*). I was born and raised in New York yet would never chime in to address a group with the abomination that is *yous*, because I am not Joe Pesci. It's cute when an old Italian grandma with a Brooklyn accent says it, and only when an old Italian grandma with a Brooklyn accent says it. I am not from Pittsburgh, and even if I were, I am unsure if I could bring myself to refer to a large group as *yins*.

Of course, I could open an email to the copydesk with a *Hey all*, or *Hey gang*, or *Hey comrades*, or *Hey wonderful human beings*, and I have. But I also open with *Hey guys*, because as a team we've all confirmed that we each find its use inoffensive. A product of patriarchal brainwashing over the past few centuries? Probably. But it's been a part of my vernacular in the genderless sense for decades now and it's not going away anytime soon. The ominous *Hey ladies* sounds too much like I'm about to describe in painstaking detail the list of activities for this weekend's upcoming luau-themed bachelorette party with a breakdown of how much each person owes and a confirmation of what sizes everyone has requested of the matching floral shirts I've ordered for us; *Hey men* and *Hey women* are both silly and ridiculous salutations...but so ridiculous that I just might actually start using them for homogenous gender-identifying groups of people on an email thread? (*Hey gentlemen* is half a step better.) *Hey gang* can come off as annoyingly enthusiastic if overused; and *Hey team* is something you'd expect to hear from the brusque and socially awkward but polite manager making strides to be seen as the "cool boss."

Not to mention *guys'* multifunctionality. *Hey, guys!* is a cute and warm greeting to use when walking into a room of your closest friends. It's well suited for use in casual business emails even to people you may not necessarily know well. Making a special announcement? It works on social media, to address the masses in a neutral manner. Reminder: This is my opinion, and I am aware that other people may feel otherwise. If my use of *guys* offends you, let me know, and I will cease to address you in a group setting using it.

I'd also like to make a similar case for *man* and *mankind*. "This is the best ice cream known to humans!" she said, losing the intended effect altogether. The *humankind* for *mankind* swap is simple enough, but I'm firmly in the camp that *man* is often synonymous with *the human race*—context to be considered, of course—with the added bonus that it does the job in just three characters.

The subjunctive: Would anyone care if it was to die?

As an intrinsically cynical person, I am a fan of the subjunctive mood. We categorize a verb as being in the subjunctive mood when it expresses something that is doubtful, wishful, or contrary to fact. What that means, in layman's terms, is using *were* instead of *was* (or adding the word *had* before a verb that isn't *was* or *were*):

> *I wish I were as cool as she is.*
> *If I were a millionaire, I'd adopt all the dogs at the animal shelter.*
> *If he had gone to bed earlier, he wouldn't be so tired.*

You're probably familiar enough with this construction, and have no issue with it. I'm with you. But I also have to admit that I don't jump out of my skin when I see or hear someone say something like *I wish I was there.* Would I ever utter this myself? No. Well, okay, maybe, in the company of people I trust. Would I correct this to *I wish I were there* in non-quoted, running copy? Of course I would. But I'm also a realist with low expectations for humankind; and I am wholly prepared to accept the death of the subjunctive as imminent. It's also something that English speakers have been fearing for nearly a century, as evidenced by a 1924 letter to the *New York Times* in which reader Ida M. Mason asked, "How many 100 per cent. Americans are alive to another sinister and subtle danger that is threatening a vital prop of the nation, viz., the frequent disregard of the subjunctive mood from the pens of those who should know better?"

So you were sick the day of this high school English lesson and never called your classmate to follow up on the homework. Good for you, doing only the things in life that make you happy. The subjunctive is a vessel by which we are given free rein to judge others on either (a) the quality of their education or (b) their level of regard for preserving "correct" English grammar. Basically, the subjunctive gives you an excuse to act like a jerk, so if you're one of those people mourning over its decline, I have good reason to believe you're a jerk too. Here's the

thing: The *if* in such constructions where the subjunctive is summoned is a pretty solid hint that what's being described is contrary to fact; the word *wish* is strong evidence you're dealing with a wishful situation. Do we really need a *were* in there to hammer the point home? Either way, we know what hand we're being dealt; I'm just trying to make life easier for all of us during our limited stay on this planet.

That being said, sometimes use of the subjunctive prevents ambiguity when it's used in phrasings that convey commands or suggestions. Consider the following:

> *She demanded that he leave immediately.*
> *We suggested that my mom move in with us.*

Nothing much to see here, except constructions that sound standard enough. Of course, *She demanded he leaves immediately* and *We suggested that my mom moves in with us* would get the meaning across just as well, albeit in a grammatically "incorrect" manner.

But then there's the odd sentence where a verb in the subjunctive mood actually *does* step up to the plate and make things clearer. Blog *Motivated Grammar* notes the following peculiar pair:

> *He's obsessed with the idea that everybody admire him.*
> *He's obsessed with the idea that everybody admires him.*

In the first sentence, which uses the subjunctive mood, the person in question is in need of some serious affirmation and wants nothing more in life than for the population at large to admire him. In the second, written in the indicative mood, this person appears to be suffering from delusions of grandeur and believes that everybody admires him, though in reality, this is likely not the case.

Sure, this situation is one you may not find yourself having to step in and clear up using accidental hero the subjunctive on a regular basis,

but basically: Use the subjunctive mood if you like the way it sounds and if it makes things clearer. You should never be forced into any situation you're uncomfortable with.

Who vs. that

"Use *who* with people, and *that* with inanimate objects" is a rule you might recall learning from your old, boring English teacher. And, yes, this is a safe general guideline, and one that most of the English-speaking world complies with—but calling a person a *that*, according to *American Heritage Dictionary*'s usage note for the word, goes back "to the Old English period, and has been used by the finest writers in English, as in '*The man that once did sell the lion's skin | While the beast liv'd, was kill'd with hunting him*' (Shakespeare), and '*Scatter thou the people that delight in war*' (King James Bible). In contemporary usage, *who* predominates in such contexts, but *that* is used with sufficient frequency to be considered standard, as in '*The atoms in a diamond…outnumber all the people that have ever lived or ever will*' (Richard Dawkins)." So there you have it. Do what comes naturally. Even the ol' chaps at a big-deal dictionary give you the green light.

And while you're at it, use *who* to refer to animals when it feels right too. "What about bugs?" once quipped an inquisitive editor. If you'd like to anthropomorphize that sweet little neon-green bug who happened to land on your shoulder this morning and accompany you on your daily commute, recognizing her for the unique sentient being she is, by all means, use *who*. If you're recounting the story of your apartment's bedbug infestation, use *that* to describe the creatures that ruined your life for a few months. Entirely your call.

How about this one: "Can a dog be a *he* or should we always use *it* for an animal?" asks the person who may not realize I live with a cat, a dog, and two rabbits and have a portrait of my cat wearing a crown tattooed on my forearm. If I had my druthers, animals (or, at the very least, pets) whose genders are known would *never*, under any circumstance,

be referred to as an *it*. Calling the furry lil' buddy who cuddles up with you at night and acts as though he's been given the keys to a warehouse full of peanut butter every time you walk through the door after a long day an *it*—much like identifying as neither a cat nor a dog person—is the clear marker of a sociopath. That cow named Dorothy who escaped from a slaughterhouse and was rescued by a sanctuary? A *she*. The mourning dove who just laid an egg on my windowsill? Also a *she*. What kind of barbarian, neglecting to acknowledge that these complex creatures have souls, would refer to either as an *it*?

My profound love and respect for animals may be clouding my judgment here, but could you imagine calling Bo, former first dog, or Socks, former first cat, an *IT*?? Yeah, I didn't think so, bud. At BuzzFeed we have a loose rule about this: In a list that assigns personality traits to animals, like "21 Dogs Who Are Excellent at Throwing Shade," it would be a disservice to the reader—and to the dogs throwing shade—to refer to them using anything but gendered pronouns (or, of course, the singular, epicene *they*). It makes the images more relatable, if not more adorable; not to mention the stiltedness of something like *This dog that scheduled a solo intervention to discuss your Crocs. It's really just worried about you tbh.* It's so unnatural-sounding, it's cringe-inducing—even, I'd imagine, for non–dog lovers/complete monsters.

In a hard-news story about, say, how a bird attacked a couple strolling through a park, however, you might be better off using the *it* pronoun—mostly, I'll argue, because the gender of the bird is unknown. (If the bird was someone's vicious pet parrot Larry, for instance, I'd make a strong case for using *he*—though, sure, Larry could be a female parrot's name too but it's not in this example, okay?) Anyhow, do what you want with pronoun use for animals, but just remember that your decision is a keen reflection of the inner workings of your soul.

#BanWhom

Face it: You hate *whom*. If you don't, you're likely a liar or someone with an English degree who actually still really hates *whom* but can't bear to come to terms with your traitorous hatred for fear of your over-priced degree being snatched from your cold, dead hands, never to be seen again. In casual conversation we end sentences with prepositions and we never use *whom*. It's a fact. And if you do use *whom* in conversational speech, you will never see yourself on an invite to a dinner party at my place. Mostly because I'm not the type of person who has dinner parties or uses *whom*. I see *whom* going the way of *shall*—phased out for the most part, and used only to evoke a sense of mocking fanciness. Have you ever heard anyone ask, "Shall we?" without air of playful poshness by means of a serious, deeper-toned voice or a faux British accent when posing said question? Maybe you have, but these people sound like no fun.

The worst offense? When *whom* is used incorrectly, like in the sentence *They were not sure whom would do a better job*. I understand the confusion here, and the assumption that because *they* is the subject of the sentence, there can be only one subject—and therefore only one noun in the subjective case—so of course *whom* is the object, spelled as such. Unfortunately, English is a little more complicated than that, and the clause *do a better job* is a hint that the doer of that action must be in the subjective case as well. (Still with me? You wouldn't have to be if *whom* were eradicated! Just saying.) *They were not sure who would do a better job* is in fact the grammatically correct sentence. Easy solution? Avoid *whom* altogether, for as long as you shall live! (See what I did there?) As Lisa McLendon, an editor and resident grammar expert at the University of Kansas, once preached to a roomful of copy editors, "When in doubt, use *who* so you're not wrong *and* pretentious." #bless

TL;DR? Chew on this: According to a study published in March 2016 by *PLOS One*, people who are obsessed with grammar aren't as nice as their don't-give-a-crap-about-grammar counterparts. The study

had participants read email responses to an ad for a roommate—some without errors, some with typos, and some with grammatical errors (or "grammos")—and then complete a personality assessment. The study found that "less agreeable people were more sensitive to grammos, while more conscientious and less open people were sensitive to typos." Ouch! Authors of the study speculated that "less agreeable people are less tolerant of deviations from convention" (…but deep down, we all knew this, right?). *sings "You Give Copyediting a Bad Name" while strumming on a guitar whose strings are made from spiralized pages of the world's largest usage manual*

Let's all put on our flexibility hats and agree to accept "deviations from convention" when necessary—because grammar is fun, but not more fun than being invited to cool parties. Especially cool parties with dogs.

How Social Media Has Changed the Game

The omnipresence of email, texts, and social media has corresponded with widespread use of off-the-cuff, informal language—writing, essentially, that mimics speech—which sometimes trickles outside the confines of the internet and back into speech. The cycle completes quickly, the trends happen organically. We are no longer slaves to the process of laboriously editing our handwritten letter, report, or memo before setting up shop in front of a rickety old typewriter, yanking out paper in frustration when a typo strikes amidst our carefully curated words. For better or worse, save for the content produced for

professional publications (though the argument could be made for that too), the relative ephemerality of modern written communication means that's there's simply less thought that goes into the words we toss onto a screen, and it's made for some really interesting plot twists in the story of our language.

Also, emojis.

Working for the internet adds another layer entirely: It means constantly making decisions about the packaging of stories, images, and videos based on where they will live in the digital space, to ensure they'll be optimally viewed and shared. *Will this photo look distorted on a mobile device? What's the best way to tweet this story? How can we make a compelling video based on this viral news post? Is this headline conducive to clicks?* Language guidelines and standards when writing or reporting about social media itself also have to be taken into account.

So let's dive right in.

Apps and stuff

One trend so common that most people don't give it a second thought is use of an app's name as a substitute for the service it provides or for the form of the content posted on the app. For instance, if I were to tell you how awesome my Airbnb in Spain was, you'd immediately understand that I was referring to the home I booked through Airbnb (and not, say, that Airbnb uses different interfaces around the world and I was commenting on the quality of the app or website in a different country). You could also call it an *Airbnb rental*, *Airbnb apartment*, or *the place I booked through Airbnb*—but why would you when it's just as easy to get the thought across using one word? The Venmo money-transfer app is another brand name synonymous with the service it provides: *Just Venmo me* is something you're probably more likely to hear than *Just send me the money on Venmo*.

Same goes for Instagram, which, in addition to being the name of the app, is also used to refer to the photos posted on it. If you were asked, "Did

you see her birthday-party Instagram?" it would be clear to most internet- and smartphone-using humans under age ninety-five that Instagram is a stand-in for *Instagram photo* and not, for instance, an Instagram account that was set up specifically to showcase the photos from some god-awful, self-involved human's birthday party. The exceptions to this type of phrasing include apps that already have words designated to describe the thing that you do on the app—for instance, a *tweet* for what you post to Twitter and a *snap* for what you transmit via Snapchat.

27 Times Chrissy Teigen's Instagram Was Actually Better Than Her Twitter

Seriously, the captions deserve a goddamn AWARD.

Did my mom just post another corny Aunty Acid not-quite meme on (or to?) *her Facebook* or *her Facebook page* or *her Facebook Timeline*? (Ack, which one do I choose? Who cares, *stressed* spelled backwards is *desserts*!) Any of those are understandable, of course. Although *posted on Facebook* would be one solution with brevity and elegance, per- haps in context it's important to understand that my mom posted it to *her* Facebook page rather than my dad's, or that she posted it to her Timeline rather than to her photo album. (My mom, who still prints out directions from the internet even though she has an iPhone with GPS, is generally unwieldy in her navigation of Facebook. Anything is possible.) I'm of the opinion that there doesn't need to be a blanket rule for this: Select the phrasing that gets the intended meaning across in the briefest way. You've got the power here, and I'm confident you'll use it wisely.

The BuzzFeed Style Guide offers the following guidance—with some extended notes here—for writing about apps and the social media world. (And, yes, we do really use the ~quirky tildes~ when explaining rules in our style guide. Because internet.)

Facebook

- Never use as a verb (*Facebooking, Facebooked*)—instead, use language such as *posted to Facebook*. Why? Because Facebooking sounds silly, that's why.

- For both *like* as the verb and the noun form, lowercase, keep in roman type, do not set in quotes. No need to throw in a bunch of distracting quotation marks like Facebook is a funky new fad and we haven't heard the word *like* used in the context of a Facebook reaction before. We all know what it means when you tell us you got seven hundred likes on that selfie you took in Bali. Let's move it along.

- Things got a little more complicated on February 24, 2016, when we were able to *Love, Haha, Wow, Sad*, and *Angry* posts too. Sure, the only actual verb in the mix is *Love*, and the result when we verbify the others sounds like a preschooler who hasn't quite perfected English-syntax comprehension yet (*Mama, I angry that*), but we don't really have a choice here; short of something like *give a "wow" reaction*, there's no easy way to avoid it. You'll have to make a decision on how to style this verbification, and any way you handle it, it isn't going to be pretty. Let's review the options for the past-tense forms of the most user-friendly reaction, solo verb on the scene *Love*:

 I loved that Facebook status. (Could be misread as simply having strong positive feelings for a Facebook status rather than using the "Love" reaction specifically.)

 I "Loved" that Facebook status. (Avoids being misread as the prior example, but something about the quotation marks is off-putting and almost implies disingenuousness.)

I "Love" reactioned that status. (No one would ever actually say this IRL; it's too cumbersome.) Same applies for other variations of this sentence using any combination of hyphens vs. no hyphen, quotation marks vs. none, lowercase vs. capitalized *love*: *I love-reactioned that status, I Love reactioned that status*, etc.

I "Love"d that Facebook status. (Holy eyesore alert.)

I "Love"'ed that Facebook status. (No.)

I Love'd that Facebook status. (Hmm. Not terrible, but we could probably do without the apostrophe, since *love* is a regular verb.)

I Loved that Facebook status. (Bingo! Clear and concise, this one seems like the winner.)

How does this translate to the other non-verb reactions? Er, not well, but we've got to do the best with what we've got. One thing we know based on the above discussion is that we should probably stick with no quotation marks across the board, and using an initial capital letter seems sensible. Our options, then, are as follows:

Hahaed, Haha'ed, Haha'd
Saded, Sad'ed, Sadded
Wowed, Wow'ed, Wowwed
Angryed, Angry'ed, Angried

Yup, this is the worst. *Wowed* is already a word that exists, so it might seem reasonable enough to go with this one, even though someone's status isn't being won over by you when you say that you "*wowed* it"—so I'm not entirely convinced it's the best choice.

As for the others: First off, let's knock out *Hahaed* and *Saded*, because these don't align phonetically with how you'd pronounce said faux verbs. The former looks like Latin and the latter reads as "sated." *Sadded* is inoffensive enough, but how about we make things easy and just go with a *'ed* across the board? In the *'ed* is the implicit idea that these are made-up verbs and we're kinda just making do with what we've got in a self-aware manner. But for the love of god, avoid these constructions when you can.

| Like | Love | Haha | Wow | Sad | Angry |

- Same deal with *friending* and *unfriending* someone—lowercase, not set in quotes. And yes, it's *unfriending* rather than *defriending* or *de-friending*; not only is *unfriending* easier on the ol' peepers, it's also what people actually say. (But, hey, if you say *defriending*, then use that instead: What do I care?)

- *Facebook Memories, News Feed, Timeline*—these are all branded Facebook features and should probably be capitalized to denote them as Facebook-specific things.

Instagram
- *Instagrammed, Instagramming*—simple enough.

- As a ~quirky~ verb form: to *'gram* for short.

- Capitalize filter names: *Amaro, Earlybird, Lo-Fi*, etc.

Pinterest

- *pin, pinned, pinning*—I can see the argument for the capitalized form here too, as a derivative of Pinterest, but I think we've gotten to the point where *pin* has evolved to signify in our brains the virtual form of the literal act of pinning something to a corkboard.

- *Pinterest board* (because there's no good reason to capitalize *board* too).

Snapchat

- *snap* (as both a noun and verb)—lowercase *s*, because, like *pin* before it, it's sort of taken on a literal-in-virtual-form–esque meaning outside of being simply a strict derivation from *Snapchat*. And also, BuzzFeed advises lowercasing *tweet*, so, consistency.

- *Snapchatted/Snapchatting, snapped/snapping*, or *sent a snap*—all terms are okay.

- *Snapchat Story/Snapchat Stories, Snapchat Discover*—these are branded Snapchat features. The abbreviated *snap story* is fine.

Tinder

- *Tindering/Tindered* are OK as verb forms, if you truly must. Otherwise *using Tinder* will do.

- *left-swipe/right-swipe* (hyphenate all forms).

Tumblr

- Individual Tumblr blog names are capitalized, in roman (e.g., Hot Dog Legs, Reasons My Son Is Crying). Sure, in the strictest sense, Tumblr pages could be classified as blogs, but—unlike

traditional blogs—entries that make up a Tumblr page can't always necessarily be named, so the "italics for bigger-picture title, quotation marks for components within it" formatting convention doesn't quite work the same way on Tumblr. Roman type makes everyone's life easier here.

Twitter
- *tweeted* (avoid *tweeted out*, because that's redundant when you think about it), *tweeting*, *tweet* (as verb and noun), *Twitter user* (preferred to *tweeter*, which is okay if you're a retiree who's just getting the hang of "this whole internet thing"), *Twitterstorm*, *tweetstorm*, *live-tweet*. Yes, I am aware that Twitter itself uses the capitalized *Tweet* for the noun (not the verb—so according to Twitter, you tweet a Tweet), but I find the inconsistency distracting, especially when you run into the retweeting-a-Retweet zone; why use different conventions for the noun and verb form of a word with a root in the same service? If you find yourself in disagreement, here's something to unify us: Let's all take a moment to acknowledge that the *New York Times* has referred to tweeting as "issuing a Tweet," as one might a subpoena, or a refund. Love you, *NYT*, but hope you'll make it to the other side soon.

- *hashtag* (one word for what was once known as the octothorp).

- For clarity, capitalize separate words in a hashtag name—e.g., *#ThrowbackThursday*—in running copy.

- Treat Twitter handles like proper names: Retain same capitalization as the handle (e.g., "In a tweet by @em_dash3…") and add just an apostrophe for the possessive of handle names ending in *s*.

- *Black Twitter* (cap "B")—for the network of active Twitter users who post about social issues relevant to black people and other people of color.

- *Weird Twitter* (cap "W")—for the network of Twitter users who tweet in a deliberately sloppy, absurd style for comedic effect.

- *retweet* preferred over *RT* in running copy.

- *subtweet, subtweeted, subtweeting* (but never *subtweeted about*, i.e., *He subtweeted me*, not *He subtweeted about me*—because that's just how the word works, that's why).

- *DM, DMs, DM'd, DM'ing* (for direct messages).

WhatsApp
- *Send a WhatsApp message* is preferred to *send a WhatsApp*, but, hey, do whatever feels right to you behind closed doors.

http://www.buzzfeed.com
You know that cute thing really old people do where they tell you about this great new website called www.amazon.com, saying all the "W's" (and maybe even spelling out the *http* part aloud too?). This is adorable when you are a grandparent who's just asked your grandchild if they've "called up" the Uber yet, but it's something regular internet users of a certain age generally do intentionally to seem silly. We all know that websites start with *www*. It's akin to someone asking for your address and you starting with your name. We all know you live there; that's why it's your address. And we all know websites live on the web and therefore start with a *www*. (And while there was once a time when *www1* and *www2* were used with a bit more frequency as subdomains as well, that's an awfully rare occurrence these days; if such is the case, it might

make sense to point it out, but typically if you type *www* for a www1 URL, you're automatically redirected to the correct one.)

We are also at a point in the internet's life cycle where the general population is aware that the majority of websites in existence use a *.com* domain extension. Some may use *.org* or *.net* or *.gov* or *.edu* (or *.uk* or *.ca* or what have you for international domains), but *.com* is by far the most common. At what point, then, can we comfortably drop the *.com* when referring to a site? We don't need it in Amazon, Etsy, or Facebook, that's for sure, and when was the last time someone mentioned that they found their apartment on Craigslist.org? Popularity of a site is certainly a determining factor. However, while you'd likely never sheepishly admit to confirming facts on Wikipedia.org, you might tell someone about the dog food sale on petco.com or that great deal you got on Diapers.com. In the latter examples there's a differentiation between the Petco website and its brick-and-mortar stores; perhaps you want to convey that the sale exists online only. For Diapers .com, the *.com* functions as part of the brand name—a common trend for sites with short, snappy names that may share a similar name with a generic product or word, which is also why I've capitalized it here. "My Diapers order should arrive tomorrow," when spoken (and even written), could sound like an order placed for diapers rather an order placed on Diapers.com—which may well be the same thing but is not the intended meaning of the sentence. When clarity is an issue, keep the *.com* without fear of judgment. (And this should go without saying, but there are also instances where a non-*.com* domain name should be specified to ensure the correct URL: There's no way around nyc.gov or harvard.edu.)

Monsters that the internet has spawned

Each generation forms strong ties with the slang of the time; adults labeling the things they hear coming out of the mouths of "kids these days" as bizarre is not a new phenomenon. And while, as always, some

trends fade and others persist, because the internet allows us to track language evolution in real time as we never have before, it may seem like slang has taken on even more absurd forms than its cohorts of eras prior. It's hard to tell if that's truly the case, but regardless, let's delve into more recent trends and phrases whose use has either been birthed or facilitated by the internet.

All the things

Assigning this term to something is just a superfluous way of saying "This is everything." (See *everything*, page 169.)

Because internet

Because is a VIW (very important word). In addition to functioning as a conjunction that can mean either "for the reason that" or "the fact that," it can also be seen running around town as part of the phrase *just because*, meaning "for no reason whatsoever." And, yes, I'll argue that "Just because" is perfectly acceptable as a stand-alone sentence, which, while nauseating to prescriptivist-leaning folk, is not the point here. The point is that, sometime around 2011, *because* decided to apply for a part-time job as a preposition—because twenty-first century. And good for *because*! Who are we to tell words what parts of speech they can and can't be? The [*because* + noun/noun phrase] construction has been spotted all across the internet over the last few years, and as language writer Stan Carey points out on his blog *Sentence First*, "the construction is more versatile than 'because+noun' suggests. This *because* can be yoked to verbs (*Can't talk now because cooking*), adjectives (*making up examples because lazy*), interjections (*Because yay!*), and maybe adverbs too, though in strings like *Because honestly.*, the adverb is functioning more as an exclamation."

Another example, from a BuzzFeed essay by April De Costa called "What 'The Baby-Sitters Club' Taught Me About My Disease":

Killjoy Kristy is their tomboy dictator, for she is bossy and the BSC was her brainchild; Claudia, the club's benign VP (because private landline), is creative, and at least once per novel something she is wearing is described as "funky"...

And one more from a helpful BuzzFeed list by Casey Gueren titled "23 Sex Habits All Twentysomethings Should Adopt":

You wouldn't rush through brunch, so why would you want to rush through sex? Both of those things are infinitely better when you slow down and add some variety. In fact, one study found that combining a variety of sex acts made it easier for both men and women to orgasm. So don't skip foreplay, because science.

In the first excerpt, *because private landline* is an abbreviated way of saying *because she has a private landline*, and in the second, *because science* substitutes for some iteration of *because science has proven that it's helpful.* Take, as yet another example, someone explaining how they wake up at 3 A.M. every night to the sounds of their feline companions galloping about the house, "because cats." In this instance, it's not simply an *of* that's been omitted, but an implied *because that's what cats do.*

Linguist and University of Pennsylvania professor Mark Liberman delved into the then-nascent linguistic phenomenon in a 2012 blog post, saying, "It seems usually to be associated with an implication that the referenced line of reasoning is weak..." and citing a *Jezebel* piece by Lindy West called "Are Men Going Extinct?" that includes the following passage:

Did you hear the big news? Men are going extinct. Really really slowly, and probably only in theory, but extinct nonetheless!...

Lame! RIP, dudes! Now, I'm sure kneejerk anti-feminist dickwads think that the eradication of men is *exactly* what we women mean by "plz can we have equal rights now thx." Because logic.

I seem to think, however, that the implication is often the opposite: that *because* + noun indicates that the referenced line of reasoning is blatantly obvious, and delivers its message with a tinge of irony—or, even more often, that there is no implication whatsoever. (To Liberman's credit, maybe its shift to broader use happened between 2012 and now. If you haven't noticed, things move kinda fast on the internet.)

Whether used sarcastically or in earnest, there's something about the timing of *because* + noun that works for comic effect as well—the only incentive, along with Twitter's limitations on characters, one might have for deliberately avoiding the use of several short words where they would otherwise rightfully belong—by going against the conventional structure of the sentence and the object of the eliminated *of* or other words appearing sooner than expected. It's sort of a surprise punchline—like the interrupting cow joke, but classier. (You know the one: "Knock, knock." "Who's there?" "The interrupting cow." "The interrupting c—" "MOOOO!")

It's nearly impossible to pinpoint the origin of the *because*-as-preposition trend (more likely, it can't be traced to a single definitive example), but it should be noted that the effect often isn't quite pulled off when there's a qualifier involved: *because no rules*, or *because too many people*, for instance, don't really work in the same way that *because anarchy* or *because crowds* do. The effect is closely tied to the brevity of the phrase, succinctness generally working in favor of all language trends that exist largely on the internet (because Twitter).

Break the internet
A profoundly annoying way to describe a viral situation.

Cash me ousside, howbow dah
Just dropping this one here so I can mention that it became such a huge meme, the BuzzFeed copydesk felt compelled to add our preferred spelling of one infamous *Dr. Phil* guest's viral catchphrase to our style

guide. It was simply popping up everywhere and we had to come to a consensus. (If you're not familiar with the clip, do yourself a favor and watch it immediately. Synopsis: An "out-of-control" thirteen-year-old girl tells the audience members laughing at her to "catch me outside, how 'bout that?"—but pronounces it the way it's spelled above. Yup. That's all. No, you can let our Founding Fathers know that we're all doing okay. Really, we are. Everything's fine.)

Doge-speak

Sometime in 2013, a photo of a Shiba Inu alongside multicolored, all-lowercase words typed in Comic Sans began making its rounds on the internet, and everyone totally lost their minds. The dog, real name Kabosu, would become known as Doge—the name in itself reflecting the idea that this anthropomorphized dog, trying to communicate on the internet with humans, was not even certain how to spell or pronounce the name of his own species, because, well, he's a dog, and of course he doesn't know how to do this, and how cute. (The pronunciation of *Doge* is also one that's much contested, with some, including me, insisting it should sound like *dohj* and others firmly in the *doag* camp.)

The idea being that this excitable dog can express his feelings only in the most rudimentary way, the two- or three-word phrases accompanying Doge typically use simple modifiers like *so*, *very*, *much*, and *such*, along with words like *excite*, *amaze*, and *wow* appearing somewhere on the image. Because, duh, dogs don't know how to form complete sentences or speak with words longer than two syllables. (And, of course, a dog—basically a furrier, happier toddler—would use the most childlike font in existence, Comic Sans, and totally ignore the existence of capital letters.) And, as Gretchen McCulloch, a linguist specializing in pop culture, wrote for *The Toast*, another reason for Doge's ungrammatical English is "the general principle of internet language these days that the more overwhelmed with emotions you are, the less sensical your sentence structure gets," mentioning every Frappuccino-toting girl

wearing Uggs' favorite expression, "I can't even," as well as its more evolved form, "I've lost the ability to can," as other examples.

Naturally, Doge was a hit because everyone who is cool and fun can agree it's hilarious to imagine one's pet communicating over-zealously the way a child just learning how to speak would, stringing together the most basic words to get their idea across—and, when realizing they had the opportunity to do so on the internet, choosing lime-green and hot-pink Comic Sans for extra pizzazz. The style of phrasing used on the original meme is immediately recognizable even without a corresponding picture of everyone's favorite Shiba; amidst peak Doge mania, plenty of party invites by my internet-savvy friends included some iteration of phrases like "such birthday" "so friends," "very alcohol," "much blacking out." #2014PartiesWereWeird

The following images, which feature appearances by Doge (but whose derivation from the meme would be clear even without him), are from BuzzFeed editor Samir Mezrahi's 2013 post, "14 Iconic Pieces of History Made More Wow With Doge."

Like lolcats before him—those memes of cats alongside gram-matically incorrect, misspelled phrases—Doge's heyday is a distant memory, and Doge-speak quickly reached its saturation point on the web, but there's something undeniably hilarious about intentionally misspelling words or using broken sentence structure to convey a sort

of pitiful, deer-in-the-headlights use of language by an otherwise fully functioning, cognizant living being.

Don't @ me
A very internetty way to say "I know this may be controversial, but this is how I feel and I don't want to hear a peep out of you about it." The @ (or *at*) in this case acts as both a literal and metaphorical expression of "Hey, don't troll me or complain about this to me on social media."

Everything
Once this word functioned merely as a noun meaning "all that exists." These days, labeling something as "everything" is basically another way of saying that it rules, or is cool, or you dig it. In 2016, Everything Culture™ truly blossomed. As Jody Rosen for the *New York Times* wrote in a god dang THINKPIECE on *everything* (yes, funeral arrangements for the word are being made), "It's a clever ploy, a word vague enough to appeal to all comers and too forceful for many to ignore." The article

NAMES FOR THE @ SYMBOL

The ubiquitous @—what most people who speak English commonly refer to as "the at symbol"—has an interesting past. In 1997 an online survey across thirty-seven countries found that it went by many different delightful names in different places. Among the most colorful include:

snabel-a: "(elephant's) trunk-a," Danish and Swedish
apestaart: "monkey's tail," Dutch
Klammeraffe: "spider monkey," German
kukac: "worm," Hungarian
grisehale: "pig's tail," Norwegian
gül: "rose," Turkish

(Source: *Shady Characters*, Keith Houston)

goes on to mention how, in 2015, LGBT magazine *"The Advocate* changed the title of its weekly cultural-recommendations roundup from 'Hot Sheet' to '7 Things That Are Everything This Week.'" Following in the footsteps of *radical* and *awesome* before it, this shift in meaning is, to be certain, nothing to get bent out of shape about. Casually describing a restaurant as "awesome" does not mean your dinner last night inspired feelings of intense awe and wonder, any more than calling your new Nintendo game "radical" in 1988 implied that it contained secret messages advocating extreme measures. Even *awful* didn't start out as the *awful* we know today—in common use for nearly a century now to mean either terrible or exceedingly great—but in fact its etymology has roots in the word *awe*, and it was first defined as meaning "inspiring" or "filled with awe." And so maybe two hundred years from now our descendants will be shocked to find that at one point *everything* was used primarily to mean "all the things that exist" and not "super cool."

Or, perhaps, as the kiss-of-death thinkpiece is wont to foreshadow, the new *everything* will fall by the wayside, buried in an unmarked grave snugly between *tubular* and *ace*, but I have faith that its staying power is one with a good shot at being in it for the long haul: It's not an entirely new or made-up word altogether—it's a simple one that most of us have used regularly since childhood—so it has comfort level going for it, for one. Second, its new usage is not so far removed from its original meaning that even the fogeyest of old fogeys couldn't likely get the gist of a sentence declaring the amazing burger you had yesterday as "everything." And its traditional usage has never been a loaded one in any capacity (as one could argue for a word like *insane* or *lame*), meaning the potential for offensiveness is nil. Finally, it's simply a beautiful metaphor for something that has moved you to such a state of all-encompassing emotion that everything else in existence ceases to exist for a brief moment and all you can experience is the subject at hand, making you a poet without even knowing it. Sign me up.

Feels

A stand-in for any noun associated with emotion, *feels* can refer either to experiencing a feeling or to an intrinsic component of a person. For instance, it can take the form of *all the feels* (*This gave you all the feels* = This made you overwhelmingly emotional), or *It will hit you in the feels* (aka it will hit you straight in the gut/make you feel overcome with emotion). It's also not uncommon for *all the feels* to stand alone as commentary on something particularly heartwarming, e.g., an Instagram comment on a video of a Labrador retriever serving as a seeing-eye dog for his blind canine companion reading "#AllTheFeels."

Hashtag

We all know what the hashtag is; it's even been proven worthy of its own dictionary entry, so if you don't know/are an alien invader, you can go there to read more about it. Slapping the word *hashtag* before a word or a phrase acting as silly or witty commentary in speech is a thing people started doing shortly after Twitter took off—for instance, running into your ex and their new partner while out to dinner with a friend and whispering, "Hashtag downgrade." It's a playful way of being all "I'm with the zeitgeist" and kind of assigning more weight to the word or phrase in question, but, honestly, overuse can be annoyingly cheesy, depending on the context (or the person using the word). #HatersGonnaHate

I can't even

If I need to explain this one to you, you may consider supplemental reading material in the form of literally everything on the internet. This phrase, lacking an ending—the implied "[deal with this]" or "[entertain this idea]"—serves as either a dismissal of or an acutely emotional response to the conversation topic at hand; the speaker cuts themselves off before they've even started to go into it, because it's just too taxing to think about delving into the subject or attempting to express themselves articulately. Of course, this dismissal or emotional response isn't

always genuine, and sometimes the person who can't even will proceed to go into the details of the can't-ing; they just wanted to preface whatever comes next by making the point that shit is bananas.

Can We Guess Why You Can't Even?

The world's whiniest quiz.

posted on May 21, 2016, at 8:01 p.m.

Maritsa Patrinos
BuzzFeed Staff

It me

Here we have the 2015ish-birthed trend of humans self-identifying with something like a hedgehog wearing pajamas and sitting in front of a pizza box, by tweeting or posting this picture with the tag *#ItMe* or *it me*. I'm sure there are myriad analyses of this ambiguous fad with ironic or self-deprecating connotations, but, like Doge-speak, the idea of using the language of the anthropomorphized animal in said picture often prevails. (*Ha ha ha, you're a dumb little hedgehog struggling to grasp the fundamentals of English too, and you love eating pizza and watching Netflix in your PJs all weekend! I get it! LOL.*) Either that or the point is to mimic an excitable young child who hasn't yet mastered how to create a basic sentence. I'm sure this won't be the last "Let's use broken English to sound silly" meme to thrive, so, copy editors, beware and be aware. Despite it being cringeworthy meme fodder, don't change those *its* to *it's* and give all of us a bad name, please.

Keyboard smash

Sometimes you are just so overcome with stomach-dropping bewilderment, rage, or excitement that words won't cut it in the expression department. That's when your fervor drips down into your phalanges and you go nuts on your keyboard, hastily pressing a bunch of keys at random and winding up with an unintelligible mix of letters like *ahduashdqjasyorq*.

Lit

This term may not have been born on the internet, but its use is so pervasive that I'd be remiss not to include it. Outside of its definition as the past participle of *light* and as an abbreviation for *literature, lit* can signify a few things: Most commonly it indicates a situation that is exciting, fun, or poppin' (sorry, I came of age in the '90s/early '00s, okay?), or being drunk or otherwise intoxicated—a meaning that dates back to 1914, per the *OED*. (Who knew!) You might be lit after five vodka-tonics, and the party you're headed to might be lit because it's packed and everyone's having a great time. And, thanks to the downward etymological spiral of all positive-connotation slang words that quickly reach oversaturation status, *lit* can also apply to something that is generally awesome, like a really good sandwich. Note that the fire emoji has also been spotted tag-teaming on this word, and *fire* in the adjectival sense often moonlights as a synonym for *lit*—e.g., "Damn, this song is fire!"

> oh god I just saw someone say "littest" on Twitter
> instead of "most lit"

emmyfavilla 1:20 PM
oh no

meganpaolone 1:20 PM
language is evolving before our eyes

Netflix & chill

This is a euphemism for *hook up*, in the ~sexytime~ way. You're welcome, anyone who has never used the internet. The population at large has been watching Netflix and chilling since 2007, when the service began streaming. (Netflix launched in 1997, but for argument's sake it's relatively hard to chill when you're waiting on your DVD to arrive via USPS and no one's home to sign for the package.) One day, however, an innocent night of watching *The Notebook* on loop on your couch with a Costco-sized bag of clearance-aisle Halloween candy at your side turned into a full-out raunchfest. Some credit this November 2014 tweet with catapulting the phrase into mainstream usage:

…which was followed several months later by this creepy-ass viral tweet, featuring a GIF of a woman frantically running away from an alien figure with an obscenely large member.

And then all hell broke loose. Celebs got in on it. B.o.B. released a song called "Netflix & Chill." The "20 minutes into Netflix and chill…" memes spun out of control.

63 years into reigning and chill and
she gives you this look.

But as all good slash terrible things must come to an end (or plateau), it seems the days of peak Netflix & chill are behind us:

Thank god.

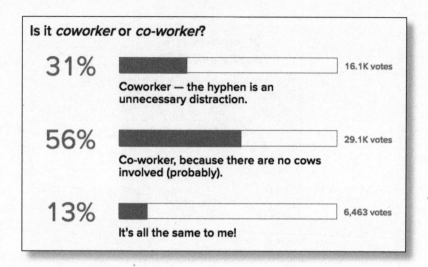

Is it *coworker* or *co-worker*?

31% | Coworker — the hyphen is an unnecessary distraction. | 16.1K votes

56% | Co-worker, because there are no cows involved (probably). | 29.1K votes

13% | It's all the same to me! | 6,463 votes

Neville Longbottoming

In 2013 it came to the public's attention that actor Matthew Lewis, who played Neville Longbottom in the *Harry Potter* films, had shed his awkward puberty-induced skin and emerged from underneath it the pinnacle of beauty. It took nanoseconds after this realization for the character's name to transform into a verb meaning to undergo said transformation, and two years later this was still happening:

TOP POST
3,163,709 VIEWS

20 Child Stars Who Have Neville Longbottomed Pretty Damn Hard

Blossoming like beautiful swans.

posted on Mar. 5, 2015, at 3:50 a.m.

The staying power of this one is dubious; it seems to have peaked in 2015, but, like Benjamin Buttoning, the potential for moderate future casual use is conceivable.

Noms

An either mildly cutesy or terribly annoying way to say "good food," depending on what side of the fence you're on. You may find yourself tagging that Instagram of your mouthwatering vegan brunch spread with hashtags #VeganNoms, #NomNomNom, and #BrunchNomz. (Note: If this is the case, we're probably not Instagram friends, and never will be.) As Dana Hatic for *Eater Boston* explains, *nom* likely derived from the happy, sloppy sounds everyone's favorite childhood monster made while eating: That's right, grown adults are using slang made popular by Cookie Monster with abandon these days. It seemed to trickle into mainstream internet culture by means of a 2007 meme on ICanHasCheezburger of a cat eating a birthday cake with the caption "nom nom nom," and, welp, here we are.

Savage

Like *fierce* before it, *savage* has taken on a lighter meaning, sliding gracefully into the "slang for something that's cool" category. Over the past few years, it's gained traction in memes and hashtags as a description of something that's unabashedly kick-ass in a teetering on (metaphorically) brutal way. There's something about the word that makes me uneasy about applying it in this sense—the fact that it literally means violently cruel or ferocious, maybe, and it's hard to separate its slangy usage from the image of a bloodthirsty Neanderthal—but the *New York Times* thinkpiece on *savage* is just around the corner.

Ship

An abbreviated form of *relationship*, to *ship* means to wish for the coupling up of a (usually fictional) pair. Typically it's used in reference to a romantic relationship, but occasionally it can refer to the hope for a platonic development as well. Example: *I totally ship Larry Stylinson* = I want to see Harry Styles and Louis Tomlinson get together and bang. Relatedly, *OTP* is an abbreviation for *one true pairing*, a term assigned to those who are shipped.

And as a derivative of *this*, *OT3* stands for "one true threesome." Other fun terms: *crack ship*, or *crack pairing*, to refer to a couple comprising two (usually wildly different) characters from different fandoms—like, say, Sebastian from *The Little Mermaid* and Harry Potter. A *canon ship* is a ship that has been confirmed by a series. And a *cargo ship* is when a sentient being and inanimate object are shipped.

The internet is *so* fucking weird, man.

Show me the receipts

Synonymous with "I want to see proof," this one has roots in a Whitney Houston interview. In 2002, Diane Sawyer asked Houston to comment on her alleged (very expensive) drug habit, to which she responded, "I wanna see the receipts." In a 2016 *Slate* article, Katy Waldman

writes, "Post-Houston, the concept appears to have germinated on LiveJournal—particularly a blog devoted to celebrity shenanigans called Oh No They Didn't—and moved to Tumblr, where 'receipts' referred to screen caps of abusive or offensive comments." And so more than merely proof, the idea of "receipts," as the piece explains, has also evolved into the concept of demanding accountability from those in positions of power.

Shruggie

You know, this lil' melancholy fella: ¯_(ツ)_/¯ Or lady, or nonbinary amalgamation of characters, or however you feel comfortable referring to this ubiquitous symbol of indifference, mental exhaustion, befuddlement, and/or a general loss for words. Basically the visual equivalent of saying, "It is what it is" or "I can't be bothered/don't care enough to provide a verbal response," shruggie, like most cool and cute things, was first used by the Japanese; it's what's known as a *kaomoji*, or "face mark." It really took off in mainstream Western culture in 2010 after Kanye West's infamous "I'mma let you finish" interruption of Taylor Swift's acceptance speech at the MTV Video Music Awards, in which he gave a shrug with arms outstretched, appearing like an IRL doppelgänger to our kaomoji friend above. As Kyle Chayka notes in *The Awl*, "The rap crew Travis Porter immediately tweeted, 'Kanye shrug—-> ¯_(ツ)_/¯' as a crude representation of the gesture." And so Shruggie Mania commenced.

Stan

Stan is another word for superfan, and it can be used as both a noun and a verb (i.e., a stan is someone who stans); its origins are in the Eminem song "Stan," about an obsessive, deranged fan. So this one wasn't birthed from the recesses of the internet per se, but the internet *has* provided the ultimate platform for fans to live their best stan life—essentially, to devote their entire online presence to the celeb they stan

for. In a BuzzFeed piece called "What Happens When a Stan Retires?" Katie Notopoulos explains, "On Twitter, you can easily identify a stan because they'll likely have a photo of their idol as their avatar, and often use a fake name that incorporates the singer's name—for example, if I were @KatieSpears, you'd know I was a Britney stan."

Remember when you were a little kid and you'd send your favorite celebrities letters (and maybe little presents, like friendship bracelets, if you were a real creeper) IN THE MAIL, expecting to get a response to all your burning personal questions to them? LOL. Loser. But now? You can tweet at pretty much any famous person in the world and not only is it a thousand times more likely (official scientific statistic) you'll get a response, you can actually have near-real-time conversations with them. Stanning, alas, has become an art form—with some stans becoming famous in their own right for the extremity of their superfan lifestyle.

Consider Myleeza Mingo, a Kim Kardashian West stan who took her superfandom to such an extent that she had to explicitly announce her "retirement" as a stan. (She had just graduated from college and was ready to launch a non-stan-centric career.) This was after she'd met Kim IRL several times *and* after the celeb sent her an Apple Watch as a graduation gift. Here's Kim responding to the news:

You can also stan for someone you know IRL, a non-celebrity, as a cute way of saying your friendship means so much or you think they are so incredibly cool that you could consider yourself a fan of them. I love that usage. I stan for stanning friends.

Tfw
An abbreviation for "that feel when," often used in memes, tweets, and Instagrams, accompanied by a photo or GIF of the sender's interpretation of said feeling, with the intent of resonating with others who have shared a similar experience.

 BuzzFeed ✔
@BuzzFeed
⚙ Following

tfw you fell for an April Fools' Day joke

RETWEETS	LIKES
547	1,633

1:02 AM - 1 Apr 2016

Scott Hoying ✔
@scotthoying
⚙ ➕ Follow

tfw you're so hungover u turn into daft punk

RETWEETS LIKES
370 2,764

11:06 PM - 17 Nov 2015

Like all things internet, *tfw* quickly devolved into use in the most outlandish, specific scenarios. Take, for example, my ungrateful cat, looking nonchalant AF while lounging on one of the most expensive items I own:

em_dash3

28 likes 3d

em_dash3 Tfw you buy yourself a $100 chair but your cat has decided you bought your cat a $100 chair so you agree

Or forgetting you made tea until eighty-six years later because you've fallen into a YouTube hole and can't get out:

>tfw you forget about your tea (by dilfosaur for BuzzFeed Comics)

Thirst trap
Being thirsty, aside from meaning the seeking of hydration to fulfill a biological need for water, is another way to describe being desperate—for attention, for likes, for sex, whatever. *Thirst trap* is essentially the *fishing for compliments* of the 2010s and beyond. Post a naked picture of yourself covered in pancakes for National Pancake Day? Thirst-trap central. Even if you own it, the most self-aware thirst-trappy social media posts are still a thirst trap. Or maybe not. Who am I to judge?

Throwing shade
Throwing shade and talking shit are two different animals. Shade is subtle; shit is not. Please preserve these distinctions. A term with roots

in the black and Latinx LGBT community (see iconic documentary *Paris Is Burning* for reference), *shade* can best be summed up in this tweet by RuPaul:

RuPaul ✓
@RuPaul

Throwing shade takes a bit of creativity, being a bitch takes none

← Reply ⟲ Retweet ★ Favorite ••• More

1,002
RETWEETS

421
FAVORITES

4:38 PM - 7 Dec 12

Tumblr
Not a monster in and of itself, but every time I see the word *tumbler* now it looks like a typo, and I hate myself and the internet for it.

Yaaass
Yes, official BuzzFeed style for the next-level *yes* takes three "A's" and two "S's." Don't @ me, don't ask me about the science. (But if you do, here's the breakdown: The *aaa* indicates an elongated *ahhh* sound, and the *ss* is for sibilance. Shout-out to my colleague Lyle Brennan for thinking way too much about this and offering that analysis.) While the internet didn't birth this word per se, it did catapult it into mainstream usage, mostly thanks to a 2013 viral video of Lady Gaga emerging for the paparazzi in which a young man yells, "Yaaass, yaaass, Gaga, you look so good!" (and shortly thereafter, by *Broad City*'s resident *yaaass* enthusiast, Ilana Wexler). The animated young man in question, John

Connolly, in an interview with *Mic*, didn't give himself credit for the phrase but said, rather, "It's something we just said naturally. I was just saying yaaass with everyone else."

The true etymology of *yaaass*? Within the greater LGBT community and probably, more specifically, black and Latinx drag queens. In yet another example of a word that has been appropriated from a marginalized community and thrust into common usage without proper credit being given or widely recognized, in the opening scene of 1990 New York–based documentary *Paris Is Burning*, in fact, a crowd gathered at a ball—where drag queens congregated, celebrated, and performed—can be heard yelling "Yaaass" at a performer clad in a flashy gold outfit.

Words being spelled in whatever new way you want to spell them
I'm talking your *doggo*s and your *smol*s. Why in the world did we feel it was necessary, collectively, to come up with yet another word for *dog* (and one that's two letters and one syllable longer)? See also: *pupper*. Does *canine* not cut it? The equally short but more adorable *pup* we've been using for ages suddenly too uncool? *Pooch*? *Mutt*? Did everyone simply forget these existed? Are we just bored? THERE WERE SO MANY SYNONYMS FOR *DOG* TO BEGIN WITH. Even *doggie* was just fine, for crying out loud. We did not need *doggo*, but here we are, folks.

How about *smol* instead of *small*, to describe something that's not only diminutive but also super freaking cute as a direct effect of its smallness, like a smol bebe bunny? Fine, there's a bit more of a case for that one, weighing in at one character less and carrying an added layer of meaning, but basically: There are no rules anymore.

Your fave could never
A laudatory expression that essentially means "Your favorite celebrity could never achieve this/be on this level/pull this off."

Madonna Slayed Everyone While Performing "Borderline" On "The Tonight Show"
Your fave needs to take a seat 'cause they could NEVER.

👤 Brian Galindo ⏱ a week ago 💬 14 responses

Willow And Jaden Smith Proved They're The Coolest Siblings Alive At The Met Gala
Your faves could never.

👤 Krystie Lee Yandoli ⏱ a month ago 💬 32 responses

Definitive Proof That No One Throws A Party Like Taylor Swift
Your faves could never.

👤 Kristin Harris ⏱ 11 months ago 💬 18 responses

We love our reader's [sic]: electronic interviews

We live in a world where feature-length stories can be written without a writer ever hearing the voice or seeing the face of a source quoted in their piece. Email has taken the place of the telephone when it comes to requesting statements from both individuals and organizations; it's the reason the number of BuzzFeed editorial staffers who have an office phone steadily hovers somewhere near the single digits. Entire interviews have been conducted via Gchat; collaborations on "round-table"-style posts are often cobbled together from Slack chat conversations. This is our life now, and it is beautiful and especially wonderful for those who consider themselves to be much more articulate in writing than in real life (::smiles and waves::)—though maybe not so much for the opposite group of folks. Either way, this, dear reader, is when the magic happens: when a copy editor transforms from lowly pruner of commas to person of the hour, swooping in to save quoted sources from looking like morons.

I'm of the opinion that "silently" making tweaks to quoted material for spelling, punctuation, and minor style issues is perfectly acceptable—and should, in fact, be encouraged. In face-to-face interviews or

OLD-TIMEY WORDS YOU NEED TO START USING AGAIN

Think you might jump off of the nearest bridge next time you hear about a party that was lit AF? You're in luck! There are tons of silly old-timey words collecting dust that are hankering for a comeback:

Flapdoodle: foolish words
First known use: 1878
How to use it: Henry thinks he's a genius, but everything he tweets is pure flapdoodle!

Claptrap: pretentious nonsense
First known use: 1799
How to use it: Oh, Ethel, we all know you're a trust fund baby—your constant complaining about how hard it is being an artist is just claptrap.

Tommyrot: utter foolishness or nonsense
First known use: 1884
How to use it: Every Tinder conversation I have is full of tommy-rot and goes nowhere—maybe I should just join Match instead.

Fiddle-faddle: nonsense (often used as an interjection)
First known use: 1577
How to use it: Oh, fiddle-faddle, William! ::throws hands in the air:: How many times did I tell you that I do NOT look good in the Mayfair filter??

Monkeyshine: mischievous or playful activity; a prank
First known use: circa 1832
How to use it: Quite frankly, Florence, I'm getting tired of all your monkeyshines, and you need to start acting like an adult.

OLD-TIMEY WORDS YOU NEED TO START USING AGAIN

Horsefeathers: foolish or untrue words; often used as an interjection
First known use: 1927
How to use it: I can't believe Edna canceled on me at the last minute and used the late-at-work-again excuse—she just Instagrammed a selfie with her cat. Horsefeathers, I tell ya!

Applesauce: nonsense
First known use: 1704
How to use it: Yeah, we broke up—I just couldn't take all his applesauce anymore, especially after I found out he still had an active OkCupid account.

Codswallop: nonsense (British)
First known use: 1963
How to use it: I was deathly hungover on Friday and said I had a stomach virus, but everyone knew it was 100 percent codswallop—I should've never tagged myself at the bar Thursday at midnight!

Blatherskite: a person who blathers a lot; nonsense
First known use: circa 1650
How to use it: Johnny's a real blatherskite on Facebook but I never hear two peeps outta him IRL.

Bafflegab: gibberish; gobbledygook
First known use: 1952
How to use it: Cut the bafflegab already, Beatrice, and talk to me in plain English instead of cryptic texts. I have no idea what *smh* means.

Stultiloquence: senseless or silly talk
First known use: circa 1913
How to use it: I went on a date with this smart and witty dude I follow on Tumblr, but our conversation was full of a bunch of stultiloquence. Maybe he was just nervous?

OLD-TIMEY WORDS YOU NEED TO START USING AGAIN

Taradiddle: a fib; pretentious nonsense
First known use: circa 1796
How to use it: Listen, Carl, I've had it up to here with all this taradiddle about how you're best friends with Harry Styles. He favorited your tweet like eight months ago and THAT'S IT.

Jiggery-pokery: dishonest or suspicious activity; trickery
First known use: circa 1892
How to use it: Hank and I were best of friends until all that jiggery-pokery he pulled when he hacked into my Facebook account and posted pictures of penises on everyone's page.

Piffle: trivial nonsense
First known use: 1890
How to use it: I am SO over Mildred's Snapchats! They're total piffle—I could not care less about what she has for dinner every night.

Humbuggery: false or deceptive behavior
First known use: 1750
How to use it: I fell for this hottie's humbuggery on Tinder—and ended up being catfished by my best friend. Sigh.

in discussions via video or phone, these elements are in the hands of the writer, so why should the process for an emailed interview be any different? It'd be foolish to treat punctuation or spelling variations transmitted via electronic medium as immutable.

A fun thing to do is to place bets on which sources will write you hate mail after their quotes have been published, only to find that their mention of a "recently-filed lawsuit" appeared as "recently filed lawsuit" or that their hyphen was sneakily printed as an em dash (with a space on either side!). If having more money today than you had yesterday is something you're into, I'd advise you always bet on "no one." I, for one, have better things to complain about than finding out my emailed response to a question was changed from *okay* to *OK* or that my serial comma was removed. Of course I'm also a copy editor who understands the calling from a higher power to strive for consistency and loyalty to house style, but let's be real: This is not the stuff that matters. Hell, I wouldn't even care if double spaces were added between my sentences—a truly deplorable style decision post-1985 (if I'm being generous), but one that makes me feel sad for you, not angry. Just don't fabricate things and pretend I said them or toss ellipses around so my words seem to express something else entirely and we're good.

And who wants to be quoted in a national publication with a misspelled word—or, worse, a [sic] next to their misspelled word—or a mistake like *customer's* instead of *customers* that makes them look like a bona fide bozo? No one, that's who. And we copy editors are here to acknowledge that and do our best to make sure you come across as mildly educated—unless, you know, the point of the story is how incompetent or terrible you are, in which case we'll be over here ignoring your *their* that should have been a *they're* and slinging [sic]s to our hearts' content. TL;DR: If you're cool, copy editors will look out for you and make your quotes shine. (Yeah, quotes, not quotations, despite what my favorite high school English teacher drilled into my brain about *quote* never, ever being a noun, because that word has evolved

too. Sorry, Mr. Carbone! You're still my idol and I'm glad we're Facebook friends these days.)

What happens, though, when social media posts are added into the mix? Consider the tweet that reads, for instance, "its my birtday! whose buying me tix 2 hamilton?" Holy copy editor panic attack. I'm of the mind that you have a few choices here: (1) You can either keep the tweet as is, misspellings and lack of punctuation front and center for all to see. (2) You can "silently" add an apostrophe to make that first word *it's* and fix the *birthday* and *who's* misspellings, noting that you've done so with either a [*sic*] or a line after the fact acknowledging that it's been edited for clarity. (3) You can go totally balls to the wall and capitalize *Hamilton*, *It's*, and *Who's*—in which case, report yourself to the police, because it's a tweet we're talking about here, guys. No one uses proper capitalization on Twitter, and you'll only make yourself look like a big ol' nerd by going that route. My thoughts? Let everything stand as it was tweeted or posted. We're not fooling anyone by pretending that people don't make typos, that they always know how to spell things correctly, or that they care about standard capitalization rules, and a reader will always be able to find the original tweet (if not least because it's been linked or embedded in the post in which it was quoted), and efforts to hypercorrect can appear silly or stodgy.

Recipes: 1 Tbsp of consistency, to taste
Recipes are one of the easiest genres of ~content~ to edit: They all adhere to a pretty identical format, there's no narrative or timeline to keep track of, no potentially offensive language to worry about, no heavy fact-checking to do. And so when a copy editor gets their excitable little mitts on a recipe, they know exactly what to look out for, ticking off all the boxes as they slay (original meaning) periods at the end of every *oz.* and replace each lowercase *t* in *tbsp.* with a capital one at lightning speed.

Along with the internet, however, came a whole new recipe ball game. Okay, a sort of new recipe ball game. A recipe is still a recipe. But

for a post that, say, aggregates content by linking to recipes from other sources, a few wrenches may be thrown into the works if your end goal is consistency. Does your site use the serial comma but the pasta with pesto, goat cheese, and tomatoes recipe that you're linking to doesn't? Your *one-pot pad Thai* someone else's *one pot pad thai*? Don't sweat it! Make an executive decision and stick with it. (I prefer using prevailing house style regardless of how the linked source styles its recipe name.) Do you initial-capitalize all of the words in a recipe when it doesn't appear in a headline, or do you not? Unless the dish name is trade-marked, you have the option to do either. Then there's also the issue of measurements being understandable to a wider, non-US audience. Perhaps that *tsp* is best spelled out, or the oven temperature noted in both Fahrenheit and Celsius. Figure out what makes the most sense, choose a style, and be done with it.

Citations via hyperlinks

A question that comes up often: "How many words should I use to hyperlink a URL?" An answer that I have often: "Who cares?" Two, three, four? Trust your gut on this one; as long as you're not linking an entire paragraph to one source, you're on the right track. A more important question is *when* you should link to a source. Doing so when citing any factual or quoted information that wasn't delivered to you firsthand is generally a good idea: results of a study, an interview from another publication or story, statistics, additional examples, etc. Think to yourself, *Would I have had to include this in my bibliography if this story were in the form of a college paper?* If the answer is yes, then link.

"Real" Words and Language Trends to Embrace

"In the broadest sense possible, writing well means to communicate clearly and interestingly and in a way that feels alive to the reader. Where there's some kind of relationship between the writer and the reader...there's an electricity about it." —David Foster Wallace, *Quack This Way*

How do you form an electrifying relationship with your reader? By speaking their language! Not by using the grammar rules our teachers taught us in 1989 (sorry, Mrs. Burger) or pretending that people aren't

really saying things like "I forgot how to person." Wallace makes the point that it's easier for teachers to make a sweeping statement rather than to explain that when you get to the point when you're going to write professionally as an adult, there will be exceptions: "Well, you're not going to do that with a third grader. Right? That's why this is not a skill that you learn once and you're done with it…You're never done."

Part of that learning process, of course, is accepting that contemporary language is continually shifting. At the most shallow level, people may be speaking and writing with brand-new words, derivatives of words, and even terms associated with the functionalities of new technology in ways they didn't ten years prior—like *adulting, shippers, right-swipe* (which undoubtedly/unfortunately has evolved to usage outside the context of dating apps, in IRL exchanges like "That guy standing over there—right-swipe or left-swipe?"), and various forms of *GIF*, like *GIF* and *GIF'd* as verb forms and *GIFable* as an adjective. They may be using less or no punctuation as a form of punctuation itself. And embracing and understanding these changes is key to communicating in ways that best resonate with various audiences. Consider, for instance, use of the word *fail* as a newfangled adjective:

 sharmila 3:05 PM
Or are they just sad, fail foods destined to make you feel guilty for still being hungry? "sad, fail foods"? Is that something that people say and should that comma be there?

 meganpaolone 3:06 PM
hmm

what's the context

 sarahwillson 3:06 PM
i think no comma

have not actually heard people say this, but i think i got it

 drumoorhouse 3:07 PM
i like it

 drumoorhouse 3:08 PM
the leftover pasta i just ate is unquestionably a fail food
😄 1

Or this crucial question, posed by one of BuzzFeed's UK copy editors:

 lylebrennan 10:34 AM
Good morning, America. Does one "put" their dick out for Harambe? Or does one "get" or "take" their dick out for Harambe? Or is Lyle failing to remember the exact wording of the meme's origin?

> The Cincinnati Zoo Has Had Enough Of People Putting Their Dicks Out For Harambe

> I would've thought you'd *get* your dick out for Harambe, but *put* your dick away in dismissal of his sacrifice

Harambe, if you recall, was a gorilla who was shot and killed at the Cincinnati Zoo in 2016 after a child fell into his enclosure. The explosion of ensuing memes showing respect and sympathy for the gorilla included a song called "Dicks Out for Harambe."

To that end, let's talk a little about a language trend I'd be negligent to ignore: everything eventually becoming one word. The *AP Stylebook* is a fantastic resource for very many things, and I realize BuzzFeed's job listings explicitly request "no haters," but, holy crud—it took until 2011 for *APS* to say sayonara to the hyphen in *email*. Wut? Way, way back in the '90s—when people were more likely to ask Jeeves than ask Google—*Wired*'s style guide boldly asserted, "We know from experience that new terms often start as two words, then become hyphenated, and end up as one word. Go there now." Descriptivists for the win! Go forth, young internetters, and close up those words (unless, you know, they look weird).

One example of a word that would perhaps be best left with a space is *pit bull*, to differentiate from Pitbull, aka Mr. Worldwide. In other situations, readability may be an issue, which is why I'd opt for *pre-op* rather than *preop*, *side-eye* rather than *sideeye*, and *gun-shy* rather than *gunshy*. We were all born with judgment for a reason.

sarah.schweppe 🎧 2:12 PM
backyard is one word and front yard is two... pretty f-ed up when you think about it 😜

meganpaolone ✨ 2:12 PM
rly makes u think

sarah.schweppe 🎧 2:13 PM
brb gonna do a jaden smith–esque tweet about it

Does this mean that *every day* might become *everyday* in fifty years? I wouldn't be shocked. Coming in strong as the number one typo I encounter—even in professional writing—*everyday* as the noun form would certainly make life easier for copy editors, at the very least. See also: *workout* being used instead of *work out* as a verb form. You've been warned, humans of 2065.

The one-word renaissance is simply a byproduct of the natural evolution of language. And it's not nearly as extreme as other trends that have been accepted without question. Consider this: It took a few centuries, but the word *nice* underwent a successful metamorphosis from meaning "silly" to "shy" to "pleasant." (And let's not ignore its pronunciation as *noice*, as my favorite ironically bro-y way of showing one's approval.) As Susie Dent's *What Made the Crocodile Cry? 101 Questions About the English Language* tells it:

> The word *nice*, derived from Latin *nescius* meaning 'ignorant', began life in the fourteenth century as a term for 'foolish' or 'silly'. From there it embraced many a negative quality, including wantonness, extravagance, and ostentation, as well as cowardice and sloth. In the Middle Ages it took on the more neutral attributes of shyness and reserve. It was society's admiration of such qualities in the eighteenth century that brought on the more positively charged meanings of 'nice' that had been vying for a place for much of the word's history, and the values of respectability and virtue began to take over. Such positive associations remain today, when the main meaning of 'nice' is 'pleasant' (if with a hint of damning with faint praise; it may yet turn full circle).

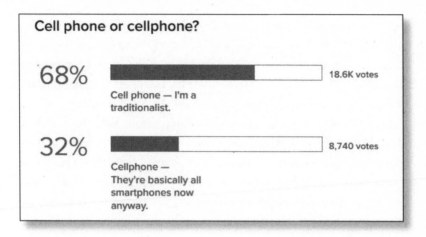

Cell phone or cellphone?

`68%` | 18.6K votes

Cell phone — I'm a traditionalist.

`32%` | 8,740 votes

Cellphone — They're basically all smartphones now anyway.

And there's of course the more recent evolution associated with the word *like*. In addition to the tragic overuse of *like* as a filler word in spoken conversation, there's also the use of *like* to mean *roughly* or *around* ("I was like nineteen when that happened"), as a synonym for *said* ("I was like, 'Can I help you?'"), and to describe a general state of feeling or being ("He was, like, this is not happening," or the meme-y "[fill in the blank] be like" phrasing accompanied by an illustrative image)—all of which have been met with varying levels of vehemence from even non-sticklers lamenting the dissipation of their language.

What I'd like to point out to all of these killjoys is that *like*'s evolution began not just several decades but several centuries ago. As *Slate*'s *Lexicon Valley* podcast hosts Mike Vuolo and Bob Garfield point out in an episode titled "What Do You Mean What Is It Like?": "There appears to be an invisible linguistic line right around the year 1800, before which 'What is X like' was taken to imply a comparison, and after which, a description." That is, *like* shifted from use in a strictly comparative sense (i.e., the answer to "What is it like?" would always elicit a response noting what the "it" in question was *similar* to, rather than *precisely* what it was) to its current iteration, which more often than not references a direct description of the thing or person in question (i.e., Q: "What is he like?" A: "Well, he's 6 feet tall, has brown eyes and curly hair, loves dogs…") somewhere before the turn of the nineteenth century. *Like* has had a more storied journey than most of our lineages have, so just let it live. It's already made it this far with no one getting hurt.

And let us not forget about the casualty that is *random*, a word whose use has been so diluted over the course of the new millennium that it now barely manages to deliver any meaning whatsoever, either as adjective or noun. "LOL, that's so random" is something you might recognize from the AOL Instant Messenger archives of anyone who was a teenager during the late '90s through the '00s. Like *nice* before it, *random*'s use is lazy, imprecise, and kind of annoying. It's so *what*, exactly? So strange? So funny? So unexpected? So illogical? Somewhere along the way, *random* mutated from meaning "without plan or pattern" to… literally anything you need it to be.

In its use as what I like to call nouveau *random*, it's often a filler word, lending no additional meaning other than perhaps a tone of trivialization, as in a sentence like *So I bought this random candy that I don't even like*, or *We went to some random bar that had a good happy hour*. In reality, no—you did not throw a bunch of candies in a bag and pick one out at random, nor did you list the names of several bars you might consider and select one from a hat at random. You made a calculated decision to

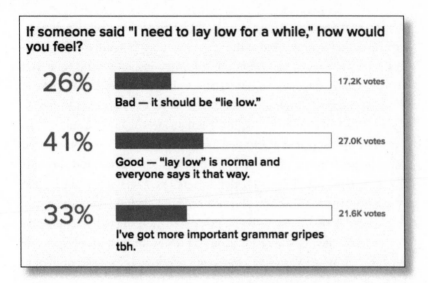

If someone said "I need to lay low for a while," how would you feel?

26% | Bad — it should be "lie low." | 17.2K votes

41% | Good — "lay low" is normal and everyone says it that way. | 27.0K votes

33% | I've got more important grammar gripes tbh. | 21.6K votes

pick up strawberry-flavored gummy candy because you like strawberry candies, and you passed by a bar with a sign for $4 drinks until 10 P.M. and made a conscious, financially savvy choice to step into said bar. Neither of these activities involved an element of randomness as much as an element of unfamiliarity. And it didn't take more than a nanosecond for *random person* to be reborn as a noun, *random*, and then just as swiftly turn into *rando* (as in *I hooked up with some rando last night*).

So is *random* really that bad? Naw. Like *awesome*, its off-center hyperbolic use has expanded beyond the word's traditional definition, but it's one that's easily understandable—if a bit hollow—by those millennials who've used it with abandon in this newer sense. And in the fourteenth century, *random* actually served as a noun meaning "impetuosity, great speed, force or violence in riding, running, striking, et cetera, chiefly in the phrase 'with great random,'" according to *OED* editor Jesse Sheidlower. Its "lacking a definite purpose" definition crept up in the seventeenth century, and its use in the mathematical sense in the nineteenth century.

Despite the meandrous course *random* has run from the fourteenth century to today, nouveau *random* has seen its heyday (I'm thinking the

deal on that one closed with the hit 2011 Disney Channel sketch comedy show *So Random!*), but at the very least, it's the signifier of a certain era. The same way that *cruisin' for a bruisin'* instantly transports you to a '57 Chevy filled with a bunch of unruly teens in letterman jackets, *That's so random!* travels alongside lucid imagery of Steve Madden platform shoes and chunky highlights. #LanguageIsATimeCapsule

The sped-up transformation rate of words that we've witnessed over the past decade-plus is due not only to niche slang trends becoming more quickly visible to a wider group of people, but also things like words rooted in TV shows and technology hastily making their way into everyday vernacular—like *catfish*, a verb meaning to trick someone online into thinking you're a person you really aren't, derived from the film and ensuing TV series *Catfish*, which follows the stories of people who are duped by romantic interests.

This trend is also reflective of the emergent realization that our once-revered dictionary should not always be considered the tyrannical ruler of what a word is and isn't and in what manner you have the freedom to use it. Also, sometimes the dictionary is on drugs and we're better off keeping our distance from it:

sarahwillson 5:38 PM
uploaded an image: **Screen Shot 2016-03-03 at 2.34.17 PM** ▾

> **Variants of NICKEL**
>
> also **nick·le** ◀ \ˈni-kəl\

emmyfavilla 5:38 PM
😳

meganpaolone 5:38 PM
omg

emmyfavilla 5:38 PM
as in -back

sarahwillson 5:38 PM
the most disturbing moment of my editing career
i still remember, it was 2004

sarahwillson 5:39 PM
and i was arguing with my boss about how to spell nickel
and he used this as proof
i was shocked

#DictionaryIntervention

I'm often asked by my colleagues, of certain funny or strange words, "Is this a *real* word?" Of course it is—you just used it. It was crafted using characters that create a sound we both recognize and a meaning we both understand. It is not a hologram; we can write it on a piece of paper and hold it close to us for as long as we'd like. It will not dissolve into thin air. We are simply never going to live in a world in which new words aren't regularly emerging and shifting in use. And if you prefer to live in such a stagnant, miserable world, I'm sure there are plenty of open positions for Latin and ancient Greek language teachers for which you can immerse yourself in years-long study to be qualified.

In *Internet Linguistics*, in fact, David Crystal introduces the possibility that English spelling will shift to rid itself of unnecessary letters: "It may well be that Internet users, voting (as it were) with their fingers, will introduce simplifications of the kind the reform movement has so long desired, such as the dropping of silent letters"—for instance, *mnemonic* eventually being spelled acceptably as *nemonic*. And I am 🌥️ here 🌥️ for 🌥️ it. I mean, doesn't *phlem* just look so much more pleasant?

As American lexicographer Erin McKean, in her TEDYouth TED Talk, said, "My job is not to decide what a word is; that is your job.

"Everybody who speaks English decides together what's a word and what's not a word. Every language is just a group of people who are trying to understand each other…

"Words in English are like Lego: If you use enough force, you can put any two of them together."

McKean tells a roomful of bright-eyed and bushy-tailed kids to "make words because every word is a chance to express your idea and

get your meaning across. And new words grab people's attention." What a beautiful world we live in—one in which our youth are being encouraged to celebrate the creation of as many new words as they see fit! Your middle-school English teachers could never. We've come a long way, but we've still got some work left to do.

It's part of the reason why Urban Dictionary (*gasp*) is quite often a helpful resource. The crowdsourced site keeps up with new slang almost instantaneously—in a way a "real" dictionary doesn't have the functionality to, by inviting the people driving language trends (aka teens) to submit entries for these words and phrases and users to upvote the ones they agree with. And so if you're not sure what that "savage AF" meme is all about, there's a seventeen-year-old from Nebraska who's got you covered.

"Vogue words tend to irritate people who aren't in the group that the vogue words are meant to signal inclusion with, possibly because part of the whole point is to exclude people who aren't in that group," says Wallace in *Quack This Way*. (See: swarms of teens and twenty-somethings leaving Facebook for Snapchat as soon as their parents and

grandparents found out about the former and started slinging—and misusing—things like "lol," "tbt," and maybe even "bae." ☹) Basically? Don't be a hater just because you're old and uncool. Every generation has their own set of trendy words or phrases. To write off new terms that you wouldn't ordinarily use or that you're wholly unfamiliar with as being ridiculous or as proof that our language is slowly but surely breaking down is to ignore the fundamental fact that language *always* evolves. And that teenagers will *always* find a way to distance themselves linguistically from their parents, and then slightly older people will catch on to all the cool new words, after which the teens will recoil in secondhand embarrassment upon hearing the olds use their words and immediately pick up new words the twenty- and thirtysomethings aren't yet hip to. And the cycle will continue, forever and ever. Or until we're communicating exclusively in emojis (but probably even then).

Life is short; let everyone speak the way they want to speak. I'm sure adults weren't too thrilled when *bee's knees* hit the scene either, but much like not having a cow, if these phrases don't stick around for the long run—or devolve into silly, ironic-only use over time—they at the very least are a marker of the spirit of the time. See also: a Prohibition-era newsman smoking a cigar, talking about a Jane who's simply the cat's pajamas. Words can be artifacts as well, and their study is fascinating.

thank–you–ma'am ◦

noun | \'thaŋk-yü- mam, -(y)é-\

Definition of THANK–YOU–MA'AM

Popularity: Bottom 10% of words

: a bump or depression in a road; *especially* : a ridge or hollow made across a road on a hillside to cause water to run off

Origin of THANK–YOU–MA'AM

probably from its causing a nodding of the head

First Known Use: 1849

Rhymes with THANK–YOU–MA'AM

aerogram, Amsterdam, anagram, Birmingham, Boulder Dam, cablegram, centigram, Christogram, chronogram, cofferdam, cryptogram, decagram

There was once a time when *party pooper* and *hauling ass* were new on the scene too, so let *yaaass queen* be to the 2010s what *totally tubular* was in the 1980s. Either the post-ironic use of squads getting turnt AF will become limited to an older, kinda losery niche group trying to hang on to relevancy as they find themselves wandering about, lost and scared, trying to stay afloat among the newest wave of slang words, or these terms will live on, tolerable in moderation, in our everyday lexicon. (Bet the parents of the 1920s never thought *scram* and *baloney* would have staying power, but here we are.) Or they'll fade quickly—"Eat my shorts," anyone?—and we'll all shudder at the thought of once using them in earnest. Wait it out for a minute, and in the meanwhile, let us live.

That said, one byproduct of communication in the digital era is that phrases once circulated primarily within a particular community or group often find themselves gliding rapidly into mainstream usage, shape-shifting in the process. In this age of the omnipresent hashtag, spotting an unfamiliar word traipsing around the internet and misappropriating it by assigning it the characteristics you think it reflects—or applying it in a manner that is most familiar to you—is one way this happens (as we've seen, for instance, with *basic* as a slang term, which has roots in hip-hop culture and originally signified something along the lines of "uncouth," but quickly became synonymous with a disparaging way to describe conformity). Sometimes, a major media event thrusts a word into the mainstream and that word shortly thereafter takes on a more nuanced meaning in other circles, as in *woke*.

Being "woke" is a sentiment that picked up momentum in the mid-2010s in mainstream culture. A derivative of "stay awake," it has strong associations with race and social injustice, and it's an adage central to the Black Lives Matter movement. It means, essentially, to have a heightened awareness—of situations that may not accurately reflect the truth, or situations you may not have firsthand experience living through, or things you may not wholly understand but want to make an active effort to—and to realize that one person's experience of reality is not

necessarily reality as it exists for the rest of the world. As old standby Urban Dictionary defines it, to "stay woke" is to "to keep informed of the shitstorm going on around you in times of turmoil and conflict, specifically on occasions when the media is being heavily filtered," referencing the August 2014 Ferguson, Missouri, events as an example:

The headlines say they looted McDonald's, but they won't tell you about the tear gas the police threw at the crowds, or the fact that they needed the milk from the McDonald's to treat the effects of it. Stay woke.

As with many modern slang terms with origins in black culture, being *woke* has been appropriated by the wider population and trickled into the mainstream dialogue. Consider the term *woke bae*, often used to describe those of the Matt McGorry ilk—an attractive man, in this instance, who makes a point on social media to articulate how much of a feminist he is and to recognize how both white and male privilege factor into social injustices that those who are neither white nor male may face. The story for which this headline appeared mentioned an essay the *Orange Is the New Black* actor wrote called "How Becoming a Feminist Felt Like Falling in Love" and pictured him wearing a #BlackLivesMatter bracelet, among other manifestations of just how "woke" he is:

Can We Talk About How Woke Matt McGorry Was In 2015?

He was so bae and so woke.

While *woke* is still prevailingly used to connote an awareness and an acknowledgment of how privilege (whether white, male, heterosexual, or otherwise) functions in our world, and signifies a state of being educated, compassionate, and supportive of basic human rights, it's also progressed to a stand-in for "Be aware of this truth" or "Here's what you should know":

 Chad Johnson ✅
@ochocinco

⚙ ➕ Follow

Your credit and your mistakes are the only things you can truly call your own #StayWoke

RETWEETS	LIKES
196	203

8:37 PM - 8 Jun 2016

 T'Chelly
@ChelsIsRight

⚙ ➕ Follow

This may be the rapture and we are getting left behind #StayWoke

> **BIG GHOST** @BigGhostLtd
> 2016 is takin ALL the legends from us yo

RETWEETS	LIKES
42	18

9:10 PM - 6 Jun 2016

Stilgherrian ✅
@stilgherrian

⚙ ➕ Follow

I think @TheNTNews has finally got woke about donkeys.

LIKE
1

3:30 PM - 30 May 2016

This was in reference to a tweet about actual donkeys, in response to an infographic detailing fatalities involving animal encounters in Australia; horses, ponies, or donkeys constituted seventy-seven of them between 2000 and 2010.

But please: Do a little homework before you criticize the newest slang words on the scene.

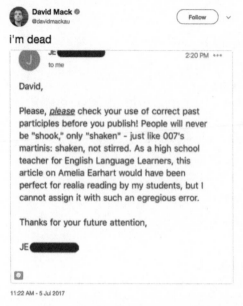

David Mack ✓
@davidmackau

i'm dead

> JE▬▬▬▬▬
> to me 2:20 PM •••
>
> David,
>
> Please, *please* check your use of correct past participles before you publish! People will never be "shook," only "shaken" - just like 007's martinis: shaken, not stirred. As a high school teacher for English Language Learners, this article on Amelia Earhart would have been perfect for realia reading by my students, but I cannot assign it with such an egregious error.
>
> Thanks for your future attention,
>
> JE▬▬▬▬▬

11:22 AM - 5 Jul 2017

One of the most frequently asked questions fielded by the BuzzFeed copydesk is how, exactly, to form the blithely abbreviated versions of words like *usual* and *casual*. Although all exhausted options appear to be yanked out of an Eastern European dictionary—*usz, usjz, ujsh, youj, cash, caszj, cajz,* and *casj* among them—we've collectively settled on *caj* and *usj* as the most reasonable, in the name of both accurate phonetic reflection and brevity. The abbreviated *us.* and *cas.* were viable contenders as well but ultimately didn't quite cut it, as periods lend themselves to the potential of ambiguity. And let me stop you right here before you even dare tell me to avoid the problem entirely and not abbreviate said words at all when I'm trying to be breezy or playfully aloof about the information I am about to relay to you and I have a tone I'm trying to adhere to. I'll be sitting over here, eating my yogz with bluebs, when you're ready to discuss something else.

emmyfavilla 12:12 PM
basically it's like... scientific term vs. colloquial term

what trumps what

i think sac is cute

meganpaolone 12:13 PM
"cute"

lylebrennan 12:08 PM
I'm furious that I missed the ballsac(k) discussion

dan.toy 12:09 PM
i'm relieved. i think i would've gotten testy

emmyfavilla 12:09 PM
are you #TeamSack?

nice subtle pun @dan.toy

dan.toy 12:09 PM

emmyfavilla 12:09 PM
more like...gotten teste

**Sac vs. sack: the dark tale of a copydesk divided.
We settled on "Follow your heart."**

Words are still words, however, and we all have our preferences—for slang and non-slang phrases alike. Whether it's a phonetic distaste or cringeworthy connotation (cc: *moist*) that pushes you to the edge, who am I to tell you what phrases you should and should not use? Personally, I'll never embrace the *it me* trend, but that doesn't mean I'll throw my hands up in the air in exasperation about it and tell you to stop talking like a stupid little toddler. I simply won't use the phrase myself.

And what of the idea that this newfound zeal for #Grammar-Anarchy is a product of millennials doing whatever the hell they want in their oyster of a world, without considering the consequences? Sure, that's probably a part of it. So what if we're not afraid to stand up to our grammatical forebears? If questioning authority means we're writing

in a manner that helps readers connect and allows us to communicate in a meaningful way, then embracing a lawless lexicon is nothing to feel ashamed of. Or, shall I say, is nothing of which to feel ashamed. Lol, jk.

One day, in fact, we may all be ripping up our usage manuals, tossing their decimated pages in the air in celebration of the deterioration of the distinction between *lay* and *lie* (don't say I didn't warn you). Sound scary? Maybe at first, but think, for a moment, of the pandemonium these two seemingly diminutive words have unleashed upon our society, without an ounce of remorse. Watching the biggest language burden ever known to exist among English speakers lifted from our collective shoulders would, in actuality, be a cause for a down-and-dirty dance party in the streets. Do you remember the last time you casually mentioned how you "lay down yesterday" or "had just lain down"? Of course you don't, because you are a normal human who says stuff like "I laid down last night and fell asleep right away." (Unless you are a robot programmed by the dictionary, which…cool. Let's hang out.) Can you recall a recent instance in which you slipped up and announced in speech that you were going to "lay down" rather than "lie down"? Don't lie! (Lol, accidental pun.) I know I have, only to instantaneously feel like merely a shell of the copy chief I have the potential to be. Wouldn't it be nice if we didn't have to feel this way? If we could use the words that both speaker and recipient understand to mean "I am about to rest for a bit," without having to feel conflicted about choosing the wrong three-letter word beginning with "l"? It's just all too much! *Lie* or *lay*, we're just trying to get some more goddamn sleep in our overworked lives here.

While I do have *some* boundaries and won't be using the incorrect form of *lie* or *lay* in written copy (…for now), and will continue to hate myself a bit more each time I accidentally use a *lay* instead of *lie* or vice versa in casual speech, I have faith that the time will come for these two little guys to shine bright and burst out of their ugly cocoons into the likable, uncontentious pair of words they were always meant to be. Even one hundred years will have been well worth the wait. Fly free, *lie* and *lay*. Fly free.

 sarahwillson 4:47 PM
oldhead? old head?

i have not heard this word before

even if Usher himself does seem like a bit of an oldhead when
juxtaposed with the young, rambunctious Thugger.

 drumoorhouse 4:48 PM
oh my that's new (and sad) to me

 emmyfavilla 4:49 PM
oldhead!

that's funny

i like one word?

also yes, sad

Making up words altogether and using terms as whatever parts of
speech we see fit, even when our language reference materials tell us
otherwise, is freeing and fun—and often wholly necessary. Creating
a new word when the one that would really nail the concept at hand
doesn't currently exist (according to the dictionary, anyway)—but not
feeling guilty enough about it to put said term in quotation marks—is a
habit we're seeing being embraced with more intrepidity.

Consider *science-ing* and *science-y* in the example here, since, well,
adding an element of science would be comically clunky and stilted (espe-
cially in a headline), and *scientific* just doesn't do the trick in the body copy:

**People Are Science-ing The Crap Out
Of Famous Movie Lines**

It is a true thing of nerd-beauty.

posted on Aug. 28, 2015, at 6:44 p.m.

Alex Kasprak
BuzzFeed Staff

There's something big a-brewing on Twitter. People
are taking famous movie lines and changing them
ever so slightly to be more science-y.

SO YOU'RE TELLING ME THERE'S A CHANCE!

Personing and *adulting* are other common examples of non-verb-as-verb usage. Internet regulars would likely understand what the sentence *I immediately forgot how to person* means: "I was immediately unable to act like a normal human being." And that phrasing works too, but does it get the intended effect across? Not quite. *I immediately forgot how to person*, an example of what linguist Gretchen McCulloch calls "stylized verbal incoherence mirroring emotional incoherence," more acutely conjures up the image of a grown adult stumbling around, rendered speechless, acting like a damn fool. It's sort of like onomatopoeia but more sophisticated.

You may also hate the word *adult* used in verb form, but *I'm adulting so hard right now* imparts an element of silly self-deprecation that *I'm acting like an adult so hard right now* does not. The breeziness of the former sentence, I'll argue, supports the idea that even the use of the "made-up" word *adulting* calculatedly undermines the speaker's attempt to convince themselves and those around them that they are actually an adult, for comical effect. It's kind of like saying, "I'm trying to prove to everyone that I'm not a fraud, so let me try using this new word, but, oops, that isn't quite correct and I guess I do have some work to do in the way of reaching full-fledged adultdom but I'm getting there." Or maybe people are just getting lazier, and I'm overanalyzing all of this.

These past few years have been big ones for goals—squad goals, dad goals, etc.—and their use as adjectival phrases. You may be of the persuasion that no one is as dad goals as Zayn Malik, for instance, and for those with a puzzled look on their face, no, that doesn't mean that Zayn has impeccable parenting skills but rather that he's hot AF. Creepy as it may be, we now live in a world where *mom* not only means mother but also "hot female-identifying person," and *dad* "hot male-identifying person" in a way that concurrently expresses not simply lust but also admiration. And so rather than describing someone as the dull aforementioned *hot*, being *mom AF* or even just *mom* can take

your appreciation of someone's attractiveness to the next level in a way that, somehow—often with a tinge of irony in tow—at once sounds a tad more respectful and, sometimes, acknowledges the superficiality of it all.

They are more dad than your typical Olympic sports.

Here's a subheading from a post about the US Olympic water polo team. I agree.

Similarly, you might see a picture of a group of powerful, beautiful celebrities all hanging out, having a blast on their yacht, and think, *This is so squad goals.* This simple two-word adjectival phrase ascribes to them the quality of being a bunch of people that you and your friend circle aspire to be similar to, and that's great news, because it's a hell of a lot easier than saying, "This is a group of people who I want my friends to be like." In the same vein as *mom/dad goals*, it's a laconic remark that serves to acknowledge the improbability that you and your friends will ever look like or act like or be as rich as Rihanna's or Taylor Swift's crew. (Sorry.)

AND THE WINNER OF THE BEST NEW WORD OF THE 2010S YOU NEVER KNEW YOU NEEDED IN YOUR LIFE SO BADLY GOES TO...

slé'ing, by BuzzFeed's very own Matt Stopera!

BUUUUUT, bad news: Just as B-girl is slé'ing all of our lives, her Vegas residency is about to end. As of right now, Dec. 31 is her LAST date in Vegas.

Via breatheheavy.com

Honorable mention for the word *tringle*, which was spotted in a sentence that began "Kourtney Kardashian is not only the eldest of the Kardashian tringle..." (also written by Matt Stopera) and stopped one BuzzFeed copy editor who thought perhaps her unfamiliarity with this hip new term spoke to her uncoolness—albeit the gist being clear enough in context. Turns out, as the writer said, "Jojo released an album of three songs and she called it a tringle so I appropriated it to mean group of three." It's like a simultaneously cuter and sassier *trio,* and I am here for it.

And here's one you didn't see coming:

 roryl 10:22 AM
http://www.buzzfeed.com/gracespelman/chris-christie-is-a-meme-now#.fu2gGAMGA

> BuzzFeed
> **28 Tweets From Super Tuesday That Will Make You LOLSob**
> Chris Christie is a meme now. (72KB) ▾

surely lolsob (Lolsob in headlines)

?

 meganpaolone 10:23 AM
oh god

 emmyfavilla 10:23 AM
oh wow

Lolsob looks like a nonsense word

and i would argue that either LOLSob or LOLsob is more immediately understandable

 roryl 10:24 AM
ok

although it is a nonsense word

 emmyfavilla 10:24 AM
i mean, yeah

but you know what i mean

 roryl 10:24 AM
will go for LOLsob then

 emmyfavilla 10:25 AM
yeah i'd lean toward that

THE DISGRUNTLED COPY EDITOR'S CALENDAR

AKA the same annoying shit we have to deal with each month of every year.

January:
New Year's Day, New Year's Eve, New Year's resolution, but ditch the caps when talking about the *new year*: "What will the new year bring?"

February:
On the loose this month: *Super Bowl* spelled as one word (it's two) and *halftime* spelled as two words or capitalized (it's one word, lowercase, and so is *halftime show*). Then, of course, there's Valentine's Day. Reminder: If someone is your valentine, (1) LUCKY THEM! (2) It takes a lowercase "v."

March:
St. Patrick's Day means people across the nation pregaming by slinging "Happy St. Patty's!" on Facebook walls like they invented the holiday and can mangle its name however they damn well please. If you go the abbreviated route, it should be St. Paddy's, which is derived from Pádraig, the Irish name for Patrick. (Patty, on the other hand, is most commonly a shortened form of the name Patricia.) If you must, St. Pat's is fine, but stay away from Patty's.

April:
Don't be an April fool: It's April Fools' Day, because fools abound. Also around this time of year, a select few decide to abbreviate the following months as *Mar, Apr, Jun,* and *Jul* like they are the newest recruits to the Calendar Police. Please stop. It is an irritating trend; these are already very short months and don't need to be abbreeved.

May:
Ah, Cinco de Mayo. Everyone's favorite holiday for muttering culturally insensitive phrases and taking racist photos! Aside from making sure your path is cleared of all "Cinco de Drinko"

references and inappropriately making words "Spanish" by adding an "el" to the beginning and an "o" to the end (no, I do not want to go to el baro with you to get el beero to celebrate, thanks), copy editors will find themselves lost in a sea of unnecessarily capitalized cocktail names. It's *margarita*, lowercase "m."

Also, let's not forget Mother's Day (and Father's Day next month), of course. Apostrophes should be placed as such, and use *Mom* only when addressing or referring to a specific person and using it in place of their name: "You look so much like your mom!" but "Hey, Mom, thanks for creating me!" (Fun fact: Mother's Day falls in March in the UK.)

June:
Happy Pride Month! Stop saying *gay marriage*, please. It's *marriage equality*, or *same-sex marriage*, if you must. The phrase *gay marriage* (1) implies that marriage equality affects only people who identify as gay, which is simply not true, and (2) lends itself to a sense of Othering those who identify as gay (whether or not its use in context is an accurate description of said partners' sexual orientation). Marriage is marriage, regardless of gender identity or orientation, and would you ever label a partnership as a "straight marriage"? Probably not.

July:
4th of July or *Fourth of July*? No one cares! Pick one, stick with it, and don't hurt anybody with all your fireworks smuggled in from another state. If you find yourself using it at the start of a sentence, spell it out, and be consistent. Easy breezy.

August:
This comes up only every other year, but the Olympics bring along with them not only an exciting lineup of athletic events but also a host of capitalization and style issues. The big ones: Treat the Olympics as plural, not singular, i.e., *The Olympics are...*(not *is*). Medals are lowercase (*gold, silver, bronze*). Capitalize the following as the *Summer Olympics*, the *Winter Olympics*, and the

THE DISGRUNTLED COPY EDITOR'S CALENDAR

Olympic Games, but lowercase *the games* on second reference when it stands alone.

September:
The Emmy Awards are this month, and if you work as an editor at an entertainment or news publication, chances are you find yourself fixing the same ol' stuff each year. The name of the awards show should be styled as it appears in the previous sentence: with a capitalized *Awards* and in roman type. On second reference, it's *the Emmys* (not *Emmy's*—unless you're referring to something that belongs to me) and *the awards*. Award names should also be capitalized (and in roman type) when referenced in full, but lowercase when an abbreviated form is used: *Outstanding Comedy Series* but *best comedy*.

October:
Halloween may be all fun and games for the general population, but for copy editors across the country, it's a hyphen-laden horror show. Take note:

- *Trick or treat!* = no hyphens in the exclamatory phrase

- *trick-or-treat* = hyphenated as a verb ("We trick-or-treated all night long, all night strong.")

- *trick-or-treater* = hyphenated to describe the human (or animal) doing said trick-or-treating

- *jack-o'-lantern* = just like that, with the apostrophe indicating the omitted "f" in *of* (since it's an evolved form of *Jack-of-the-lantern*)

November:
This came as a shock to me the first time I encountered it as a professional copy editor, but we turn our clocks forward for the

THE DISGRUNTLED COPY EDITOR'S CALENDAR

end of *daylight saving time*—not *savings*. How wild is *that*, right? (Also, AP style is to lowercase, and I trust them on this one.) Side note/editing hack: Save yourself the trouble of figuring out whether something occurred or is occurring during standard time or daylight time (e.g., EST vs. EDT) by eliminating the "S" or "D" altogether. Yes, you really can pretend daylight saving doesn't exist! Describing the time in effect as, for instance, ET (Eastern time) works just as well—and could save you from a potential inaccuracy.

And let us not forget *Thanksgiving Day* (official name of holiday) but *Thanksgiving eve* (not official name of day before holiday); *Black Friday* is also capitalized.

December:
Happy holiday-greetings nightmares to you and your loved ones! *Greetings* should typically be lowercase, with holiday names themselves capitalized, e.g.: *season's greetings, happy holidays, merry Christmas, happy Kwanzaa. Yule* and *Yuletide* take a capital "Y," and *Christmastime* is one word.

Gender inclusivity and the singular they

A more conscious shift toward gender-neutral language, including the singular, epicene *they* and more all-encompassing, neutral terms, is something that the internet has also been a vehicle for. Consider *Latinx* (pronounced la-*teen*-ex), a word that makes room for multiple genders and gender fluidity in a way that *Latino* and *Latina* do not. (*Latin@*, *Latinx*'s predecessor, is a construction that gained popularity via Twitter and Tumblr, though *Latinx* serves as an even bigger umbrella term, avoiding the gender binarism that could be implied by the @ as a stand-in for both *a* and *o*.)

As society has become more aware and celebratory of the fact that gender does not exist as a binary, some of our language choices

have had to play catch-up. One suuuuuuper-easy way to remedy the use of exclusively feminine and masculine pronouns? Befriending the singular *they* with arms wide open. I could write a dissertation on just how ludicrous it is to refute the value of the singular *they*, but I'll try to synopsize because I'm too lazy to actually write a dissertation: If you haven't noticed by now, I'm staunchly in favor of singular *they*, not least because it's too much of an elegant catchall to resist—*he or she, he/she, s/he*, or any similar iteration can all be filed under "assault on the eyeballs" (and, alternatively, having to arbitrarily choose either *he* or *she* when gender isn't relevant can be awkward, as well as neglects to recognize those who don't identify with either pronoun)—but also because it's obviously the more respectful choice, taking into consideration a spectrum of gender identities. Shakespeare used the singular *they*, as did a gaggle of other writers, including Jane Austen and Geoffrey Chaucer, as long ago as the 1300s. This is not a new trend, people!

Other gender-nonspecific pronouns have been floated, such as *xe* and *ze*, but they've yet to really take off in mainstream usage; I suspect this is in part because their pronunciation isn't immediately clear, and because they are brand-new words in our lexicon entirely. *They*, which doesn't face either of these challenges, for quite some time has been poised to be the neutral singular pronoun whose star will rise first. Of course everyone should be free to identify with the pronoun of their preference, but until English speakers are 100 percent on board with the singular *they*, *xe* and *ze* will likely be a bit of an uphill battle, but we're working on them.

Editors may find themselves walking a tightrope between clarity and the Othering of a person who is gender-fluid or does not identify as either male or female. Consider the following sentence in a news story that profiled three different protesters: *Williams describes themselves as part of a generation of Americans acutely affected by the Clinton era.* In the story, Williams self-identifies using the pronoun *they*, though without an explicit explanation someone reading this sentence may not immediately

realize who(m) *themselves* refers to, or read it as an error. So it could be helpful to include a note about the person's preferred pronoun near its first reference. For instance: *Williams (who uses the pronoun* they*), describes themselves as part of a generation of Americans acutely affected by the Clinton era.* Of course, context should be considered. In a story targeted to an audience who may be more familiar with terms that fall under the LGBT and genderqueer thematic umbrella, including the use of pronouns outside of the traditional binary arsenal, such an explainer might not be necessary. In, say, a politics story intended to reach a more general readership, however, you'll have to consider the best solution. And while we're on the topic: For those who don't prefer to be identified by gendered pronouns, *themself* would truly be a lifesaver. Let's start using it?

My team and I have had countless conversations about efforts to use gender-nonspecific job titles and descriptions. In references to general job titles—as in, for instance, *Here's what you'll need to be a successful [insert job title here]*—use of a neutral term is a no-brainer; gender has no place here. So we're talking *salesperson* or *sales rep* rather than *salesman*, *chair* rather than *chairman* or *chairwoman*, and *spokesperson* or *representative* rather than *spokesman* or *spokeswoman*. (Remember back in the day when *stewardess* and *male nurse* were actual things people said?) Sometimes, though, the answer is not so obvious:

sharmila 4:23 PM
gender neutral version of fishermen?

meganpaolone 4:23 PM
:raises monocle: :sticks out pinky:

fishers?

fishperson

meganpaolone 4:24 PM
fish harvester

fish industry worker

sharmila 4:24 PM
i'm seeing a half-fish/half-person

emmyfavilla 4:24 PM
everyone go home

emmyfavilla 4:26 PM
fisherx

meganpaolone 4:27 PM
fisherm@n

sarah.schweppe 4:27 PM
fishermxn

my electropop band, FSHRMXN

sarahwillson 4:29 PM
fishcatcher?

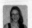
emmyfavilla 4:30 PM
fish collector

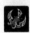
sarahwillson 4:31 PM
fishmaster

(We went with _fisher_.)

But there's also a case to be made for using gender-specific terms to effectively make a narrative come to life and create a vivid, accurate picture. Consider this:

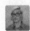
roryl 12:28 PM
MP Threw Charity Chairman Out Of Parliament Over Evictions Remark

I sort of feel you need Chairman so you know you're not talking about a chair

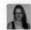
emmyfavilla 12:28 PM
absolutely

though that scenario would've been amazing

roryl 12:29 PM
a better story, arguably

emmyfavilla 12:34 PM
inarguably

If someone's first-person essay describes their interaction with a "petite, aggressive businessperson wearing pinstripes and a fedora," you might argue that replacing that _businessperson_ with either

221

businessman or *businesswoman* could lend itself to more lucid imagery. I understand the counterargument that perhaps this person in question, for all we know, may not adhere to either aforementioned gender identity, so, again, consider context, and when you feel it's necessary, rephrase something to avoid having to use a gendered word.

BuzzFeed style is to typically avoid words like *songstress, actress,* and *editrix* (as you might imagine, this one is easy enough), opting instead for *singer, actor,* and *editor* outside of quoted material. You may be thinking, *Well, she's a female actor, what in goddang hell is wrong with* actress? I see where you're coming from, and while "Best Actor" and "Best Actress" are indeed still separate awards-show categories (there is only one Best Director award, but we can save that conversation for another book), the question persists: Does gender even matter in this person's job description? After all, you wouldn't tack someone's race or religion onto their job title, unless race or religion was the focus of the story at hand.

Note that there may be instances where gender specificity *is* integral to the story, or where it otherwise provides meaning or validation—like a trans woman preferring to be identified as an actress rather than an actor. I will still contend, though, that the diminutive *-ess* suffix doesn't help women at all, suggesting the word it is tacked onto is somehow less powerful or important than the neutral or male-gendered form, despite how common a part of our modern lexicon it may be; words like *actress, seamstress,* and *songstress* might not have that "Oh, how cute, look at that quaint little lady!" connotation anymore, but the etymology behind these words remains a bit unsettling. The *-trix* suffix, on the other hand, seems to imply more power and strength than *-ess*—not least because one of the most-used words in our vernacular that includes these four letters is *dominatrix,* so this *might* just be a word-association thing— but, still, let's all agree that we really don't need any aviatrices or conductrices in our lives. (Side note: Has anyone ever hired a seamster to fit their new suit? No? Okay, then, let's stick with *tailor.*)

Sexism loves to be stealth, creeping its way onto paper and screens when you least expect it. A common maneuver you may be familiar with is the tossing of *female* (or, worse, *lady*—gross!) in front of a job description so the reader can be sure that it's not just any ol' regular doctor we're talking about here—it's a *female* doctor. Or a *female* coach. Or a *female* mayor. Because…that distinction is integral to understand how well that person can fulfill their professional duties, of course. Adding this one-word modifier is typically unnecessary, because the information it provides is irrelevant. Assuming the context is not a story comparing the number of female-identifying and male-identifying individuals within a particular industry, the addition of *female* implies that said person is not in their "normal" place or expected role. It's like mentioning someone is your favorite female athlete: How about saying she's simply your favorite athlete, and not reinforcing the binary?

And if gender *is* a relevant factor, should we *always* reserve *female* for the adjectival form and *woman* for the noun? There's a sub-discussion to be had about whether the word *female* is trans-exclusionary or if it's synonymous with *woman* in the adjectival sense—and how we're at a point where a phrase like *women directors* may almost sound more humanizing than *female directors* and just as natural to the ears of English speakers, despite *man* almost never being used as an adjective. (Have you ever heard someone refer to the leader of our country as a "man president"?) People may have varying preferences on using *female* or *female-identifying* vs. *woman* as a modifying phrase, so (say it all together now) use your judgment, follow your heart, and encourage open discussion with others when things aren't so black-and-white.

And outside of behavior analyses of the animal kingdom, I'd like to kindly ask that we give the use of *female* as a noun a rest. (Again, when was the last time you told your friends to check out that group of "males" over in the corner of the bar?) The noun forms of *male* and *female*, when used in casual conversation, sound awkwardly clinical; then there's an added layer of disparagement, considering that *female*

as a noun is used far more often than *male* is—almost implying that the former is of a different breed altogether. So let's not, thanks.

Same goes for usual suspects *male nurse, gay best friend*, or references to a person's race or ethnicity before their job title or another noun—basically using any other contextually irrelevant part of a person's identity as a descriptive word in order to emphasize that their demographic, in said context, isn't the norm (and, in turn, perpetuate stereotypes). The gay best friend trope is an especially tired one that reduces a person to an accessory of sorts—a caricature defined by their sexual orientation—rather than acknowledging them as a unique human being. Based on stereotypical portrayals in the media, the categorization serves to assume all gay best friends share the same personality quirks (namely an air of sass and an impeccable fashion sense). Let's put this one to bed too—a best friend is a best friend.

Making strides toward using more inclusive language in less obvious ways, like the phrase *pregnant people* rather than *pregnant women*—because trans men and gender-fluid people may have the ability to conceive—is something I hope will trickle into mainstream journalism and media at a swift pace. This particular example came about after a discussion with several editors about the appropriate phrasing to describe those who use period-tracking or fertility apps. There were seemingly three options available: (a) *women*, which could be construed as insensitive, leaving trans men and others out of the equation, (b) *women*, followed by a parenthetical caveat, like *(and others)*, and (c) *people*, the most inclusive word, but one that arguably could seem imprecise. While it's true that some readers may not immediately realize that there are people who do not identify as women who might fall into the category of those who would use such apps, we decided on *people* as the best choice here. In using the second-best alternative, *women (and others)*, aside from simply being clunky, there's still a sense of exclusion at play, of Othering in an explicit way.

drumoorhouse 1:51 PM
blood blockers

A creative solution floated during a copydesk chat to come up with a non-gendered term for pads, tampons, and menstrual cups. (We went with *sanitary products*.)

The gender-nonspecific honorific *Mx.* (pronounced "mix") is another inclusive term that's gained traction over the past few years, though it's dated back to at least the late 1970s. According to Dictionary.com lexicographer Jane Solomon, per a *Time* article published in November 2015, its etymological story goes like this: "The *M* was taken from the first letters of those gendered honorifics, and the *x* was attached to suggest an unknown quantity or thing, like it might in algebra class." Not only does this honorific work for the self-description of those who don't identify as either male or female—or those who identify as bigender or gender-fluid—it also saves us from misgendering a person whose preferred pronouns haven't been confirmed. *Mx.*, you are the angel we've been waiting for next to official document checkboxes for centuries.

Unfortunately, precisely because of their newness, neutral terms like *Latinx* and *Mx.* are not quite widely recognized in standard English vocabulary yet (outside of certain woke circles, if you will); and so, until the meanings of these terms become immediately discernible to the majority of English speakers, we may often have to alert those who are unfamiliar. Perhaps we do this by using a parenthetical after the first reference of such a term, which, yes, veers into the counteraction of inclusiveness by making a point of saying, "Hey, we recognize that there are nonbinary people as well!"—but so go the growing pains of introducing any new, necessary phrase into our vernacular.

Devaluing language:
We're all just trying to be heard here

The internet is a breeding ground for relentless hyperbole. Much like social Darwinism before it, digital content hinges on selling itself as the biggest and the best in order to survive. In a landscape so vast and overwhelming, whatever it is you choose to toss into the abyss—articles, Instagrams, tweets—has to scream over the crowd to get the views, the likes, the shares. From amplification to downright distortion, overstatements are one way to sell your content, and the pithier, the better.

Substance in a story lacking and need a little boost? Throw a headline on that baby like "This Picture of Justin and Selena Is EVERYTHING." Something so cute you're on the brink of combustion? Sling a !!!!!!! in a photo caption to really hammer the point home. Go ahead, shout something you're not entirely passionate about—only kinda-sorta are—in all caps and with no punctuation to let everyone know that you're so overcome with emotion, you can't be bothered to find the proper punctuation marks, but also you don't want to because it's funnier if your statement appears to have been bellowed into a black hole. We all want the recipe for the epic, amazing, life-changing, genius, batshit-crazy chocolate-chip brownie cake more than the recipe for that snoozefest "delicious brownie cake." At some point, though (barring use in ironic contexts), the evident desperation in regularly relying on such grandiose phrases can become annoying at best, and downright trickery at worst, when they fail to deliver at least a fraction of one's expectations.

By this point I'm confident we can all agree that as a nation we have been effectively desensitized to the word *epic*. It is the Adam Sandler movie of the adjectival world. Nothing epic can be taken seriously anymore. You'll often find it nestled comfortably between its buddies *nice* and *good* on a shelf in the Empty Shells of Words section. Used pretty much exclusively in casually ironic contexts these days (unless your demographic is the highest of the highest strata of bro, which, probably even

then), *epic* is everywhere from predictable Pinterest fails to clever-enough tweets to DIY dog toys. I mean, honestly, imagine telling someone twenty years ago that you were about to create an "epic dog toy" out of your old T-shirts (actual BuzzFeed post headline). They might anticipate a contraption that could keep your dog entertained for hours while scanning its brainwaves to report back to you precise information about your canine companion's mental health status every half hour. Not this:

Listen, in BuzzFeed's defense, the toy *is* pretty rad, given it's made from a torn-up tee, but it's also…a kinda standard dog toy. That's just where we are right now; it's what *epic* defines at this point in time: pretty cool. Nominally intriguing. Funny enough. Like *slayed*, *crushed it*, *killed it*, or even *murdered* to describe a situation in which someone exceeded expectations, the nonliteral, largely disingenuous exaggeration is implicit. Like those who witnessed the boy who cried wolf, we are wholly prepared to expect a less-than-figuratively epic, less-than-figuratively murderous thing, and that's neither sad nor cause for outrage—it's simply reflective of how the word has devolved.

As Nathan Heller poetically described it in *The New Yorker* in 2016, *epic* and words of its ilk belong "to what might be called élite brospeak, a collection of idioms that together reach for grandiose adventurism from a position of the comfortably banal." So why are we still using these tired words if they consistently fail to deliver and make us want to jump out of the window of the room in which the deliverer is stationed? Sometimes it's because we're lazy and we can't

be bothered to dig for a better word. Or maybe it's just your thing—your so-annoyingly-quirky-catchphrase-that-it's-become-hilarious-to-your-insufferable-group-of-friends thing—or maybe we just haven't played these words out quite yet to the point of exhaustion, but we'll get there, and soon enough they'll serve as relics of the first wave of the Overstatement Generation (so much cuter than *millennials*, right?). Or they'll continue to be used with abandon, forever and ever, because we know what we're in for with them, so why not? Guess we'll just have to wait it out.

Another important discovery we've made over the past decade or so is just how many heroes exist in this big ol' world of ours. I've never underestimated the depths of human selflessness or altruism, but did you realize there was literally a hero hanging out in every corner of the Earth's surface? A few of our population's most exemplary figures:

Ryan Gosling Acts Out A Scene With The World's Luckiest Audience Member

Karen, you're a hero.

The Man Nobody Noticed On The Red Carpet With Sonam Kapoor Is The Real Hero At Cannes

Not all heroes wear capes.

22 Reasons Why Gina Linetti Is The Hero We All Need

"Do you know how many basic bitches would kill to have the same personality as me?"

It's why a BuzzFeed post by Alan White titled "29 Goddamn Heroes" included a random guy passed out on a mattress hanging out of the bed of a moving pickup truck and why we can't deny that he truly is a hero.

This inflated use of the word has also led to endless memes derived from *Batman: The Dark Knight*'s infamous ending-scene quote: "He's the hero Gotham deserves, but not the one it needs right now." I present to you:

That Chemist From "Making A Murderer" Is A Science Badass

She isn't the hero we deserve, but she is the one we need.

👤 Alex Kasprak ⏲ 5 months ago 💬 6 responses

The Coolest Dad Ever Is Turning Videos Of His Toddler Into Mini-Action Movies

He's the hero we deserve, but not the one we need right now.

👤 Maycle Thornton ⏲ 2 years ago 💬 0 responses

17 Reasons Why Yuna Kim Will Forever Be The Ice Queen

Because she's not the hero we deserve, but the one we need...

👤 julie hong ⏲ 2 years ago 💬 12 responses

This Woman's Lonely Christmas Cards Are Hilarious

Bridget McCartney is the Christmas hero we deserve.

👤 Alan White ⏲ 5 months ago 💬 4 responses

Looking death square in the eye in the name of humanitarianism is no longer a requisite to be labeled a hero. All you have to do is something funny, or kind of cool. And sure, I get the backlash to it—affixing the hero designation to both a lifesaving firefighter and this cat, just sitting there:

The Hero Gotham Needs Is This Cat

This odd-eyed, "two-faced" kitten was posted to reddit as "the coolest cat ever." Finding it hard to disagree.

posted on Aug. 15, 2012, at 12:17 p.m.

Summer Anne Burton
BuzzFeed Staff

But, again, it's just where we are in the journey of the word, so chill out, OK? This little girl, though? Make no mistake—she's a hero:

A Little Girl Dressed Up As A Hot Dog During Princess Week And She's The Hero We Need

Be the #hotdogprincess you want to see in the world.

BUZZFEED.COM | BY ALICIA MELVILLE-SMITH

Also filed under "Please relax": Stop getting so caught up in *literally* used as an intensifier in a nonliteral context. In a nonscientific* study of the internet, it was discovered that *literally* always makes a

**imaginary*

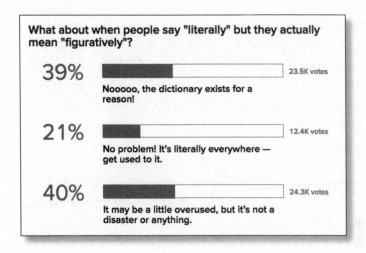

What about when people say "literally" but they actually mean "figuratively"?

39% | 23.5K votes
Nooooo, the dictionary exists for a reason!

21% | 12.4K votes
No problem! It's literally everywhere — get used to it.

40% | 24.3K votes
It may be a little overused, but it's not a disaster or anything.

sentence at least 25 percent funnier. We all know you are, in actuality, not going to transform into a triangular slab of crust, ruin your couch by dripping globs of cheese and sauce on it every time you sit down, and lose your job and any chance of ever being taken seriously again when you say you're "literally going to turn into a pizza" if you eat one more slice. Go on and eat another slice, and let's agree to get over it and move on to more pressing issues.

Same goes for *dying, I'm dead,* and *I'm a ghost*—often in all caps, with no end punctuation—and other altogether impossible phrases that express laughter, intense emotion of any sort, or a state of acute shock (e.g., that feeling when you get a notification that someone famous has followed you on Twitter) to the point that the intensity has killed you and you are typing from beyond the grave. *Wow, this is so cool and I'm so excited!* just doesn't convey the depth of emotion that *OMG I DIED TWICE, I'M STILL DYING* does. This may also be more succinctly expressed via a cluster of ghost and/or skull emojis. And sometimes there's no better way to express profound happiness than by painting a picture of an aortic collapse, as in the BuzzFeed headline "President Obama and Little Miss Flint Met and It Made My Heart Explode."

Noun slash conjunction

The word *slash* as a stand-in for the slash symbol has been spotted in recent years moonlighting as a conjunction for humorous or transitional effect: *He's my cat slash best friend.* Though you could just use the symbol (*He's my cat/best friend*), the deliberate spelling out indicates a slight change in function from the traditional use of the slash, which has typically served to mean *and* or *and/or.* Spelling it out implies "What I mean to say is," often in a self-deprecating or grudging reveal of a hidden meaning, as in *I worked on my book all day slash wrote a couple of paragraphs, napped, and ate everything in my refrigerator.* As Anne Curzan notes in a blog post dedicated to the analysis of what I'll call the New Slash (as opposed to Saul Hudson), this is one example of where "the slash is distinguishing between (a) the activity that the speaker or writer was intending to do or should have been doing, and (b) the activity that the speaker or writer actually did or anticipated they would do." She gives the additional example, from one underachiever: *I went to class slash caught up on* Game of Thrones.

Similarly, the word *slash* is often used to denote a follow-up statement or give more context to what precedes it, as in *Do you want to hang out tomorrow? Slash watch TV and drink wine?* (In these sorts of constructions, *aka* commonly functions the same way that *slash* would as well, e.g., *I had a wild Saturday night, aka I hung out with my dog and watched* SNL.) "But couldn't you just say, 'Do you want to watch TV and drink wine tomorrow' and forget the first sentence?" yells the curmudgeon from the corner of the room, sitting motionless in a puddle of his own tears and tossing copies of discolored usage books into the air in frustration. Yeah, sure. You could do that too. You'd lose the implied *We're aware that all we do when we say we'll "hang out" is watch TV and drink wine and that's fun and cool and part of our special bond as friends, and acknowledging that strengthens our friendship even more,* but maybe your friends are kind of boring, and that's okay too, because it doesn't make you bad people.

Curzan also mentions the use of *slash* "to introduce an afterthought that is also a topic shift," like in this text from a student: *12. JUST SAW ALEX! Slash I just chubbed on oatmeal raisin cookies at north quad and i miss you.* Admittedly, this is something I'm less familiar with in written communication—perhaps because I'm outside the demographic most likely to be using *slash* as a scene-changer—and something I'm a little less on board with, because there's no charming or funny implication behind its function in this context. Maybe I'm the old curmudgeon here, but I'll stick to my *and*s and *also*s. Young whippersnappers, you do you, and slash your way through life/texts to your heart's content. You are our future.

Nouns wearing adjectival clothing

Over the past few years, there's been an influx of nouns acting as modifiers where you'd normally use an adjective—*Minnesota accent* rather than *Minnesotan accent*, for instance, or *flower crown* rather than *floral crown*. Am I the only one who's noticed this trend? Regardless, it's fine any way you slice it.

It's a fucking jungle out there

We've seen a more casual approach to profanity across the web in recent years, and BuzzFeed's stance is no exception. Do you know what sort stuff is out there lurking in the darkest crevices of the internet, easily accessible via the fingertips of innocent children??? Porn, that's what. Coming across an uncensored headline like this should really be the least of protective parents' troubles:

27 Trees That Don't Give A Fuck About You Or Anything That You Do

JUST TRY THESE TREES. SEE WHAT HAPPENS.

As adults writing for (mostly) other adults, we also need to come to terms with the fact that subbing in an asterisk or two isn't tricking anyone—not even your seven-year-old son. In some cases, it's self-defeating. Asterisks lend themselves to the idea of a sanitized word, phrase, or quote that one has to protect their readers from—which means it could serve to detract from the gravity of a word's meaning in a context where the word's meaning is in fact central to an overarching theme or story. For example, in an essay by a person of color describing an instance where use of the n-word was directed toward them, the writer's choice to spell the word out should be honored; censoring it could be seen as almost diminishing the author's agency in using it.

stephaniemcneal 1:37 PM
hiya, can we say cock in a dek

emmyfavilla 1:39 PM
lol

This is my life now.

That being said, in most instances, BuzzFeed's policy for the most offensive words in the (American) English language is to style as *the c-word* and *the n-word*, for example. Feel free to otherwise bathe in a sea of expletives and invite everyone in town to join. It's the hot new thing. As Sam Kriss writes in *Vice*'s "How Twitter Ruined Swearing," "Since the sexual revolutions of the 20th century, the really offensive words now no longer pertain to vulgarity but bigotry. It's far worse in polite society to use *gay* as a pejorative or throw around ethnic slurs than it is to go effing and blinding…This is, of course, a good thing; after centuries being horrified by blasphemy or indecency, we've finally decided that what's really unacceptable is language that actually causes harm to other people." Hooray for progress and caring about things that actually matter!

However—there's also hilarity in the "bleeping" of a casual-use profane word in a situation like this:

5. This picture where he just looks f*cking adorable.

Anne-christine Poujoulat / AFP / Getty Images

It has the effect of an "Oh no, shield your eyes from this bad word because it's not something I usually say or want to use but the situation is so extreme here that I just have to"—which is funny not only for that sentiment alone but because of how obvious using an asterisk in place of only one letter does nothing to mask the word. There's humor in the calculation of it all, and of course a good copy editor will preserve this voice at the risk of being inconsistent about approaches to profanity.

Grace's 31 Tweets For Girls That Don't Give A Fuck was one of the top posts on the site and on FB last week. It ties a huge part of our audience with a cool personality aspect. Try this with:

- Single People Who Don't Give A Fuck
- Parent's Who Have Fucking Had It
- Married People Who Give Zero Fucks
- Or even "Tweets From People Who Just Don't Give A Flying Fuck"

Also "Fuck" has been working really well in headline — as as evidenced by these two posts.

A typical BuzzFeed email.

Millennials: Like it or not, they're here to stay

BuzzFeed has had a real bone to pick with the word *millennial* in years past. We were hesitant to adopt the term—coined in 1991 by historians Neil Howe and William Strauss in their book *Generations: The History of America's Future, 1584 to 2069*—because of the open arms with which marketers and advertisers wholeheartedly embraced it in their attempts to snatch the millennial wallet. BuzzFeed stood by the internal policy that, were we to use this word, "it should have real or implied quotation marks, or appear as a term of art, and with kind of a wink," as Editor-in-Chief Ben Smith wrote in an email to our editorial staff in December 2013. And about two months later, when we published our style guide, we made public our subtle attempt to ban it, with this entry:

> *millennials* (avoid using this term when possible; otherwise, generally use *twentysomethings, twenty- and thirtysomethings,* or *teens and young adults,* depending on context)

In November 2015, we revised the entry to add that we should avoid the term "except when referring specifically to demographics," because the workarounds were…pretty clumsy. Finally, in April 2017, after years of clinging to this largely unenforceable "rule," we succumbed and lifted the quasi-ban altogether.

And whether you still find this term a cringeworthy buzzword of sorts or a dismissive way to refer to the heavily technology-reliant generation, you cannot refute that it describes what would otherwise require a laughable amount of unspecific, ever-changing words. At the time of publication, millennials (yes, lowercase; if you have a problem, you can see me about it) will encompass those roughly between the ages of seventeen and thirty-six (i.e., those born between 1981 and 2000ish), figures that fluctuate based on the source consulted.

My feelings on the word itself are staunchly neutral, though I will say that, as someone on the older end of the spectrum, whose birth year technically makes me both a Generation Xer and a millennial, I find it offensive to be placed in the same category as a whiny seventeen-year-old. (Do you remember what *you* were doing at seventeen? I was wearing a shirt with a play on the Reese's Peanut Butter Cups logo that instead read "Feces Peanut Butter Cups" and mooning passersby while I polished off a 40 on a dead-end block in my neighborhood. Every Saturday night.) Maybe in fifty years this distinction will make more sense, but in 2017 it is nothing less than enraging. While I don't find it logical for a thirtysomething to be placed in the same category as a fifty-year-old either, so goes trying to fit humans of different ages into neat little compartments for the sake of statistics and marketing ploys.

Millennial is a term that often conjures up the image of a crop-topped twentysomething attached to their smartphone for 95 percent of their waking hours, placing filters on expertly curated selfies and brunch photos, and walking around texting friends rather than taking in all the IRL beauty this planet has to offer. I won't lie: I *love* crop tops, my phone, and brunch, but of course many find the word pejorative—one that paints a picture of entitlement, narcissism, and little to no attention span. Perhaps every label used to describe the current generation who are coming of age has always leaned toward the pejorative, though, in a "Get off of my lawn" kind of way, and we just need

to stick it out until millennials are the ones shaking their fists at a horde of rambunctious teens wearing VR headsets. In fact, a 2015 study by the Pew Research Center found that while 60 percent of eighteen- to thirty-four-year-olds don't consider themselves millennials, this rejection of a generational label isn't unique—only 58 percent of Gen Xers identify as such, and 82 percent of the so-called silent generation don't love their name either. So let's reclaim the word, fellow millennials!

To describe this generation in any other way would call for something like "teenagers, twentysomethings, and early thirtysomethings," or "twentysomethings and thirtysomethings" or whatever demographic the label may include depending on time of reference. Just say *millennials*, for the love of god. TL;DR: I am #TeamMillennial, if only for succinctness.

How the Internet Has Changed Punctuation Forever

Our present-day approach to using punctuation thanks to the idio-syncrasies of the web is nothing short of beautiful. From the humble tilde to an arsenal of emojis at our fingertips, we've come a long way from the punctus, kids.

Tilde end of time: The punctuation mark you never knew you needed but can't live without

The tilde is wondrous because it does something we didn't realize we needed punctuation for. It has the capacity to express things we were

previously unaware a punctuation mark or boldface or italic font *could* express, functioning in myriad ways an adorable asterisk pair could never: for ~whimsical~, self-deprecating, sarcastic, or ironic emphasis. (BuzzFeed style calls for additional punctuation outside the ending tilde, FWIW.)

The tilde pair acknowledges tired clichés or emphasizes the ridiculousness of words with an awareness that says, "Yeah, this is silly, but I'm going to use it anyway." It gives us a way to distance ourselves from the words we've just typed, almost as if to protect ourselves from being accountable for them. And sometimes tildes simply function as a more droll pair of asterisks, for emphasis when, say, italics aren't available (e.g., on Twitter, in texts) or when shout-y all caps are too severe. As BuzzFeed's own Joseph Bernstein elegantly wrote in "The Hidden Language of the ~Tilde~," "One special power of the tilde is to let the enclosed words perform both sincerity (*I sincerely want to share this with you*) and irony (*Man are we both sick of people who share or what?*) without a cynical effect." He goes on to say that "tildes here strip words and phrases of their baggage, and render their meaning and implications inoffensive, fun."

Emmy Jo Favilla @em_dash3 470d
Do u think shakira yodels in the ~bonezone~

Follow

A tweet I'm very proud of.

The most surprising thing for me in the reveal was the shape of my body in the outfit. I don't typically wear things that necessarily show off my ~hourglass~ shape—especially in winter. This outfit was literally showing it ALL off. Even the fact I was wearing a halter...

What's interesting is that other punctuation marks in the past have tried and failed to catch on as indicators of sarcasm or irony the

way the tilde has managed to do successfully, and organically, in a main-
stream way (albeit not necessarily as an explicit marker of sarcasm, as
we see with the use of tildes in that last example, which make the word
hourglass seem a bit lighter and serve to sort of poke fun at the idea of
its use as a legitimate descriptor). In *Shady Characters: The Secret Life
of Punctuation, Symbols & Other Typographical Marks*, Keith Houston
explains that there have been attempts to punctuate irony with every-
thing from inverted exclamation marks in the 1600s to what resembled
a reversed question mark two hundred years later, to the "SarcMark,"
whose tragic demise seemed to occur within mere moments of its public
announcement as an "invention" in January 2010. The SarcMark looks
kind of like an @ symbol on drugs—flipped upside down, slightly elon-
gated, and with a dot in the middle rather than a lowercase *a*—or like a
reversed 6 with a dot in it. To put it mildly, people just weren't that into
it. As Houston says, "Almost every aspect of the SarcMark succeeded in
riling one commentator or another," noting its flawed visual design and a
Gizmodo Australia article titled "SarcMark: For When You're Not Smart
Enough to Express Sarcasm Online" (ouch). There was also use of a sin-
gle tilde, floated by a blogger named Tara Liloia as a "professional" alter-
native to the winky-face emoticon, which—spoiler—failed to take off.

The SarcMark.

It's unsurprising that none of the aforementioned marks had
much staying power: Everyone was just trying too damn hard. And,
after all, as Houston observed via critics of the SarcMark, if you need
the crutch of specialized punctuation mark to clarify your sarcastic or
ironic intent, maybe you need to re-examine your writing skills. It's a
competitive world out there, kiddos. Also, beating your readers over the
head with punctuation meant to point out sarcasm is kind of like telling

a joke and then following it by saying, "Hey, I just told a joke!" It is the very definition of having no chill.

So what is it, exactly, about the tilde pair that stuck? They look festive? They're one of the last things on our keyboard without a designated function in the English language (aside from sometimes being used to indicate the word *approximately* before a figure)? You don't have to pay $1.99 to access a font that includes it? (Yes, using the SarcMark cost $1.99.) Perhaps it's because the tilde is multipurpose; it's less in-your-face as a definitive symbol representing sarcasm, a more general sentiment of flippant detachment, open to interpretation. It seemed to appear virtually out of nowhere, no blatant solicitation or marketing attempts in sight to convince us it was the new must-have.

I think it's fair to say that we reached peak tilde between late 2014 and early 2015, and in the years since, the oversaturation of its use has inevitably led to its abuse—similar to *LOL*'s evolution (see page 289) but on a much smaller scale. We must respect the unique utility of the tilde pair and actively make an effort not to reduce its function to near nil, a trite marker of emphasis that leads the irritated reader to ask, "Did you *really* need tildes in that sentence about your cool new ~shirt~?" It's insulting to a punctuation mark that contains multitudes beyond simply being decorative. So, please, stop telling us about how you're sitting down to have your ~morning coffee~ or that you're on your way ~to the gym~. You're ruining it for the rest of us who proudly use our tildes (sort of) carefully, and systematically.

> Just remember that despite what the Mainstream Media would have you believe, dogs and mailmen are not natural enemies. In fact, they can be the bestest of friends.
>
> what do you think about Mainstream Media there?
>
> funny or weird
>
> **meganpaolone** 3:02 PM
> I would prefer tildes

Asterisks and colons: Where the action is

Whether it's giving side-eye or throwing confetti in the air while you swirl around, sometimes words alone can't completely convey the nuances of a particular action. In the absence of the perfect GIF, it's common practice to enclose said nonverbal expression in either asterisks or colons (or double colons, if nostalgia for the days of beta internet moves you). Web-savvy folks will understand the use of any of 'em as a device for indicating behavior that momentarily jumps outside the prose it accompanies:

> *cackles maniacally*
> :gives raging side-eye:
> ::bows down to Kesha::

Some questions that often come up regarding said usage: Capitalize or lowercase the first letter of this phrase? Is it okay to use a line like this in a dek by itself? If so, should it take end punctuation? My answers to these, respectively: Do whatever you want, yes, and no. I prefer to use a lowercase letter in the same way one would when traditionally indicating a nonverbal cue in an interview, like [*laughs*] or [*shakes head*]. If you're a capital-letter aficionado, though, do you. No one is going to care, I assure you. Secondly, it's perfectly fine to use as a stand-alone dek or subheading, sure. And, no, there's no need to clutter it up with end punctuation.

The period: U mad, bro?

Virginia Hughes ✓
@virginiahughes ⚙ 👤 Follow

dont know if you guys have noticed but we've
dropped all punctuation of any kind from stories
written or edited by millennials

Periods perform an essential function in prose. We can all get on board with that statement, yes? We need periods in stories—from novels to news briefs and everything in between—to indicate where one sentence ends and another begins, or else the whole reading thing can get real messy and real stressful real fast. But in text messages, chats, and quick emails, we are forced to confront the new reality that they aren't *truly* necessary. And, hey, guess what? It isn't a reality that we need to resist, or be fearful of, or angry about. It simply is. And often it's not just because the *lack* of a period has no impact on the clarity of a sentence but rather that the *addition* of one *does* have an impact on tone. That's right: We are living in a world where the period, our most fundamental punctuation mark, is a loaded one. A world where proper punctuation is terrifying. Strunk and White could never.

A period, these days, has the ability to turn an otherwise innocent phrase into an expression of annoyance, passive aggression, or even aggressive aggression (contingent on the temperament of the sender). Such expression may be intentional or it may not—and often it may not even be crystal clear to the receiver, especially when the sender is someone whose communication style they aren't totally familiar with. Much in the way ellipses have functioned for ages, the use of the period is, these days, open to interpretation in brief exchanges, and context should be considered. The period at the end of a text from a friend who never uses periods in their messages is a highly distressing one; the one at the end of a text from the friend who always properly punctuates and capitalizes their messages is no cause for alarm. The email from your boss that punctuates all sentences—fine. The one-liner with a period in your inbox from that person you went on a date with last night, maybe not so much, but ultimately unclear.

There's a simple reason behind the period's newfound social status as the bully in town: its super-chill archnemesis, the line break. Communication via text, Gchat, or any form of social media allows us to indicate the end of a sentence by pressing "send." Unlike analog

generations of yore, we often send thoughts piecemeal, rather than as a complete package. The death of the period, to be clear, is not imminent: I am confident of this. Writing a full-length letter, or a story, or anything more than a sentence long, really, will always absolutely require periods—lest we all appear to be in a train-of-thought trance induced by heavy psychedelics. (Which indeed may be the case; I'm not here to tell you how to spend your free time.) Now that we have more opportunities to send sentences one by one, putting in the effort to add a rather unnecessary period can lend to it a sense of gravity—the emphasis that, make no mistake, this is a Serious Sentence™—which could be read as either ironic or genuine, depending on context (and personality of the sender).

Imagine, if you will, the person who has signed off a casual, lukewarm chat exchange with a "Talk to you later." Scary, no? Use of the period ends the dialogue with an uneasy abruptness, the only reasonable alternative being to avoid the period altogether. The exclamation mark is a viable option, but maybe you're just not that excited about the other person and don't want an overly enthusiastic "Talk to you later!" to come across as insincere—or maybe you're just not the exclamation-mark type and don't want to freak out your friend on the other end with out-of-character mania.

Even the *New York Times* acknowledged this trend in 2016 (albeit by mockingly, and head-spinningly, forgoing the use of periods at the ends of sentences altogether in a piece by Dan Bilefsky): "If the love of your life just canceled the candlelit, six-course, home-cooked dinner you have prepared, you are best advised to include a period when you respond 'Fine.' to show annoyance," wrote Bilefsky in "Period. Full Stop. Point. Whatever It's Called, It's Going Out of Style." "'Fine' or 'Fine!,' in contrast, could denote acquiescence or blithe acceptance." As we've seen in "Tumblr English" (more on that on page 263), there's often a performative nonchalance suggested by nixing periods where they should otherwise be used, most often in the "staccato sentences favored by millennials."

The period, alas, has become a marker of stodginess. Who needs a period, after all, when the message is so brief? More than once, I've written a one-line email that I'd initially ended with a period—only to delete the period, add it back, then delete it again before sending, all because I was concerned it would be received as more sober than the good-humored message I'd intended. The *NYT* piece quoted David Crystal as saying, "The period now has an emotional charge and has become an emoticon of sorts. In the 1990s the internet created an ethos of linguistic free love where breaking the rules was encouraged and punctuation was one of the ways this could be done." Linguistic free love! How liberating. BRB, coordinating Linguistic Woodstock.

The modern line break can be compared to the medieval punctus, "an all-purpose piece of punctuation that inserts pauses wherever we're feeling it," as Jeff Guo posits in the *Washington Post*'s "Stop. Using. Periods. Period." The punctus, for reference, was a fundamental punctuation mark in old-ass texts. It was basically a dot that functioned in all the ways the period, comma, and semicolon do today, helping the reader to parse a sentence and figure out where to pause. Guo notes that it sometimes even did the job of what we would now use a hyphen to clarify: "'The medium green car' is an ambiguous phrase. Is the color medium-green, or is the car a medium-size car? Putting in a hyphen— 'The medium-green car'—eliminates that confusion. In natural speech, we would distinguish between the two meaning[s] by adding subtle pauses in different places. To convey the same information in medieval writing, a scribe could have grouped the words using punctus marks: 'The · medium green · car.'"

Holy reverse FOMO! Anyone else feeling seething jealousy over missing out on an era with such a simple, carefree approach to punctuation right about now? Because we all know how that story ended. A whole crew of weird snobs agreed that we needed textbooks full of rules and standardization, and all of a sudden the entire world was introduced to a slew of strange marks and the concept of "correct" and

"incorrect" grammar—ushering in a new means by which people felt they had the right to judge others at a time when most of the world's population were unconvinced of the Earth's round shape. If we've learned anything from history, though, it's that all cool trends wax and wane, then come back when we least expect it. And maybe the punctus won't have that glorious second wind we'd all love to see, but a more relaxed attitude toward punctuation is back in business, and you'd better get used to it. I'm talking to you, period-at-end-of-text users who are slowly watching their IRL friend count dwindle as the months go by and can't figure out where they went wrong.

Listen. The period will never be exterminated, and the idea of reading anything in print (or on a screen) more than a few lines long without a single one in sight is outlandish and no more likely than our resorting to communicating exclusively in emojis.

sarah.schweppe 1:06 PM
^reading an article w/o periods is making me feel carsick

Just as there is for using emojis, there is a time and a place for withholding a period for intended effect and without consequence (see the Slack message above, in fact). In the same vein, overpunctuation more often than not indicates a performance of sorts as well—one of giddy mania (*!!!!!*), or of utmost dumbfoundedness (*????*), for instance. Punctuation marks are just as alive as the words they accessorize, folks. Note the effect that several exclamation points have when used at the end of a question, in lieu of any question marks:

23 Dumb Animals That I Can't Believe Are Really Real

Who's responsible for these!!!!!

posted on Jun. 23, 2016, at 10:01 a.m.

Erin Chack
BuzzFeed Staff

The upward inflection that would normally accompany a properly ended question (i.e., one that uses a question mark) is lost. The exclamations lend a sense of being so shout-y—because something is so utterly ridiculous or shocking—that the speaker has lost the will to phrase it as a question and would rather just yell it. Because can you even believe that this Pokémon stunt double is actually a living creature that exists in our world!!!!

RIP, curly quotes

Traditionally, curly (or so-called "smart") quotes have had a use distinct from straight (also called "regular" or the not-so-nice "dumb") quotes. Pairs of the former are used to enclose quoted material—and they're "smart" enough to know when to open a quote and when to close it, hence the moniker—while the latter should be reserved for, say, the symbolic expression of inches.

Enter the internet and many a CMS, who all didn't have time for you and your concern for these trivial differences. "We all know the function of a quotation mark in context, so why do we need two different types?" your too-cool-for-school CMS said. Not to mention that the use of curly quotes rather than straight ones has led to issues with encoding and broken links, and sometimes it takes some effort for the curl to go the right way (e.g., if you type '90s in a Word doc, the curly quote thinks it's being smart by acting as an opening single

quote mark and will appear thusly, though it should correctly read as *'90s,* which you'll have to manually make happen by typing the symbol again between the ' and the 9 so it thinks it's functioning as a closing quote mark). Is your head spinning yet? Good, because maybe you'll be convinced that straight quotes are simply the more pragmatic choice for CMSes to default to, sensitive typographers and traditionalists be damned. Curly quotes are cool and all, but not cool enough to keep you up late worrying when there are things like, I don't know, CLIMATE CHANGE to think about instead.

Stand-alone punctuation marks

Punctuation marks are in the prime of their lives. Yes, language is alive and it evolves, yada yada—but do you think our ancestors would have ever imagined we'd reach a point (or, depending on how some may see it, revert back to a time) where we'd be able to give a (sort of) comprehensible response in the form of punctuation marks *alone*???? Like the emoji, stand-alone punctuation marks, when applied thoughtfully, have the capacity to speak volumes. Let's take a look at the possibilities:

- ! = Wow! Can convey either positive or negative shock or moderate excitement.

- !!!! = Muted shrieks. Imagine: You've just gotten some really fucking awesome news but you're sitting on your couch by yourself, so you just close your eyes tightly and make two fists and send your arms soaring straight in the air, above your head, and you keep them there, in silence, for ten seconds. May also signify a dropped-jaw, open-mouth, no-words situation.

- ???? = Utter confusion. You're staring at a person while moving your head once from left to right, brows furrowed,

simultaneously opening your hands, palms up, fingers pointed toward them. A next-level "What happened?" *or* "Annnnd... what's the problem?"–type deal.

- **?! or ?!?!** (or a similar sequence) = A more positive spin on *????*, *?!* signifies the anticipation for an answer, often with an expectation of good news. (Side note: BuzzFeed style is *?!*, not *!?*, which I've curiously been quizzed on more often than I had ever anticipated for such a seemingly innocuous entry in the word list. I have no distinct recollection of the moment at which this style decision was made, but it seems like a solid one to me, the logic being that the sentence it punctuates is a question more so than it is an exclamatory phrase; the *!* is just an added bonus.)

- **...** = No words, disbelief. Usually negative connotation.

Commas: Splice up your life

Remember the run-on sentence? Right up there with cigarettes and strange men in vans, you were warned to avoid it at all costs from the moment you emerged from the womb all the way through adolescence. Go ahead, dive deep into the recesses of your childhood memories, and I guarantee you'll summon up at least several images of adults in positions of authority foaming at the mouth, spewing more contempt for the run-on sentence than for underage drinking and unprotected sex combined.

Emmy Jo Favilla ✅
@em_dash3

lol remember how much teachers hated run-on sentences, like get a life they're so cool now

How I really feel.

A run-on sentence is a product of what's called a comma splice: using a comma to connect two independent clauses—i.e., two groups of words that should, by conventional grammar standards, instead be either two separate sentences, connected with a comma and the word *and*, or connected with a semicolon (or, in worst-offender cases, a colon).

But it's a new millennium and the comma splice is back—and it's done taking shit from anyone. Because sometimes a pause between the two clauses in question (the one that a period or semicolon or *and* would signal) just isn't what you're going for; forgoing punctuation to indicate a breath in between may effect, for instance, an air of exasperation or urgency. And sometimes it's not a matter of tone but of the sentences being so closely intertwined that the commas splice mimics the cadence of what our speech would be in such situations. Consider the following:

> *"He's already moving in with his new girlfriend, I can't even deal."*
> *"There's nothing worse than tweeting spoilers, can you guys stop?"*
> *"There's a new girl at work, she's awesome."*
> *"I put hot sauce on everything, I can't eat a meal without it."*
> *"What I said was the truth, I'm not going to take it back."*
> *"It's not about us being protected, it's about our children being safe."*

According to one of the premier grammarians of the modern era, Bryan A. Garner, "More and more people are communicating with comma splices—perhaps in text messages and in email messages—and it could be that comma splices will soon be somehow considered standard." As he continued in an interview with *Business Insider*, "I don't think so—I would say over my dead body," he said. "But one is seeing more and more of these all the time."

I feel for Garner, I really do. Like a parent coming to terms with the fact that, no, their eighteen-year-old daughter is not coming back

before midnight, and, no, they can't make her, because she's a legal adult now, and she's also dating an ex-con and, no, you'll never break them up because they're soulmates, it can be devastating to feel like you're losing a grip on the one thing you thought you knew so well, had complete control over, and love so purely. But just like people, grammar rules shift and grow and conform to the conventions of the times—and trying to stop them is only going to frustrate you and make you look like a big ol' dullard who's not very fun to hang with. When clarity isn't at stake, what's the problem? Splice it up. (You'll find plenty of examples in this very book.) And don't even *think* about adding a semicolon to a spoken quote that would otherwise contain a comma splice. That's just rude—no one thinks or speaks in semicolons. Use a dash if you must.

Like with any radical grammatical move, take the temperature of a room before you plunge right into the splice. You're best avoiding a comma splice in a cover letter for a copy editor job (unless that cover letter is addressed to me, or it's explicit that you made the choice in the name of advancing grammar-evolution advocates' agenda), for instance, or in a *Financial Times* article covering something boring about stocks. But in a personal essay or a funny list with an informal tone, you'd be doing readers a disservice by adhering blindly to a "rule" that's evolved into what I like to think of as more of a soft suggestion. Having such a simplistic approach to the use of the comma splice—one that basically dictates abstinence—is insulting to the writers who rely on it for literary effect, who use it knowingly and successfully to achieve certain nuances in tone. Literary luminaries and notable human beings—Samuel Beckett, E.M. Forster, W. Somerset Maugham, and William Faulkner among them—have been using them for centuries. Strunk & White's, Garner's, and Fowler's usage manuals dip their toes in the water on this one, all noting some iteration of acceptance of its use when clauses are short and closely related—"I hardly knew him, he was so changed" and "Here today, gone tomorrow" are two examples from *The Elements of*

Style—but that another stylistic choice is preferred.

Of course, even I can concede that this doesn't mean a sentence like "I love cats, I love dogs too" should ever be deemed acceptable. Lynne Truss puts it best: "Done knowingly by an established writer, the comma splice is effective, poetic, dashing. Done equally knowingly by people who are not published writers, it can look weak or presumptuous. Done ignorantly by ignorant people, it is awful." Still, the hearts of many a copy editor are still waiting to be won over on this, including BuzzFeed's own deputy copy chief:

"It's not about us projecting our personal opinions on people, it's about us kind of being good shepherds."

i'm totally fine w/that comma splice

and constructions like that, in general. i hope that doesn't make you too sad @meganpaolone

meganpaolone 11:21 AM
ah sorry I just responded

emmyfavilla 11:21 AM
oh!

ok no worries

meganpaolone 11:21 AM
sometimes I'm fine with them, but I think in that particular sense a dash has the same effect

emmyfavilla 11:21 AM
i knew you would hate that one

Megan Paolone 11:20 AM (1 minute ago) ☆ ↩ ▾
to Steve, Copy, Dennis, Reggie ▾

I would just add a dash to the last one to avoid the splice:

"It's not about us projecting our personal opinions on people — it's about us kind of being good shepherds."

otherwise these look good! can't wait to read this

Come over to the dark side, Megan.

Emojis: Emotional powerhouses

Let's get this out of the way first: Yes, plural form *emojis*, per BuzzFeed style (and, excitingly, AP style as well!). Don't write me any letters about it until I hear about you eating the last raviolo on your plate or enjoying your panino outside the borders of Italy. As Patricia T. O'Connor writes in *Woe Is I: The Grammarphobe's Guide to Better English in Plain English*, "Only ignorami would say they live in condominia." And at the ACES 2016 conference in Portland, Oregon, Lisa McLendon, hero among heroes, presented a session on grammar myths dispelled, in which she unapologetically asserted that once a word has entered the English lexicon, it's ours and we're allowed to do whatever the hell we want with it. That was all the convincing I needed. So if that means we have the option to indicate the plural form by adding an "s" to a word rather than adhering to the conventions of the language in which it originated and which does not use an "s," why not make it easier for English speakers to discern whether we're talking about one emoji or two hundred emojis? Let's be reasonable here. (I admittedly realize that there is some dissonance between the desire to Anglicize foreign words for ease of reading and being culturally aware and respectful of the linguistic differences among different languages. Borrowing another language's word and fitting it to our syntactical conventions may seem a bit jingoistic—but the singular *ravioli* doesn't appear to be leaving our vernacular anytime soon, so, hey, dance what you feel.)

Emojis are searchable on Instagram by hashtag, and over the past few years many have evolved to connote some very specific (if initially unintended—) concepts. I recently left a five-star review of a new bar in my neighborhood that was simply the "100" emoji, in addition to this sparkling review on Facebook:

Emmy Favilla
6 hrs · New York, NY · 🏠 ▾

Little late here but holy shit this Carly Rae Jepsen album 🔥🔥🔥🔥

(It's true.)

What's hard to wrap my head around is anyone's harbored belief that emojis are ruining or "dumbing down," if you will, the English language. I do hope we've transcended that and entered into an era where this is no longer a thought entertained by anyone with the ability to communicate. In the unfortunate case that a few of you are still lingering out there, I will now proceed to dismiss that argument in one fell swoop: Perhaps you regularly find yourself using emojis (or writing stuff like *::hands raised emoji::* to be quirky) because they express more succinctly, emphatically, or comically what words cannot. They lend mood to otherwise mood-less phrasing, as a punctuation mark 2.0. Consider various forms of the enigmatic "OK" text and probable translations:

- *OK = Wait so are you mad at me or no?*

- *OK. = Oh shit. Fuck.*

- *OK! = You seem a little too enthusiastic about this. Chill out. Or…are you being disingenuous? Is our entire friendship a lie??*

- *OKKK = You're not OK. You're agreeing to what I want you to do against your will and you're annoyed by it.*

- *OK* 💃💃💃 *= Phew, you really do mean it's OK!*

Emojis are by no means taking away from our written language but rather accentuating it by providing a tone that words on their own

often cannot. They are, in a sense, the most evolved form of punctuation we have at our disposal. Ruminate, if you will, on the differences among the following sentences:

- *Can't believe I did that.* 😓 😪 🙁

- *Can't believe I did that.* 🙈 😉

- *Can't believe I did that.* 😎 🎉 🏆

- *Can't believe I did that.* 😡

Without any context as to what *that* is referring to in this statement, the tone communicated by the sender is at once revealed only thanks to the respective emojis in each example:

- In the first sentence, this speaker seems sad, regretful, guilty.

- In the second, they're embarrassed, but not in an entirely sincere way; they've let whatever they just did roll off their back, and they can see the humor in their misstep.

- In the third, this person is feeling proud and celebratory about the event that has just unfolded.

- And in the last, the sender is clearly angry and upset at themselves.

So, yeah, you could switch up even these few emojis above to create combinations that convey a myriad range of emotions. Amazing what power these tiny little guys hold, right?

In addition to their ability to add another layer to our communication, emojis simply provide joy. Just text a friend about something cool

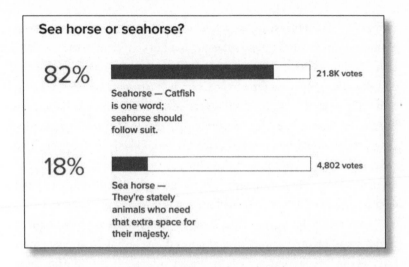

you did? You'd be lying if you said a response that read "Awesome!" followed by a few clapping emojis and maybe a confetti emoji or sparkling heart wouldn't put an extra spring in your step the way a lone "Awesome!" would not. It's common knowledge that searching for the perfect emoji or emojis requires a certain amount of effort (aka a few seconds' worth, but, hey—it's the thought that counts). Plus we all know that pictures make everything more fun. It's why Instagram's user base is bigger than Twitter's. It's why even as adults, when discovering an image-filled insert in the new book we're reading, we feel a lil' baby thrill shoot up our spines. Images provide context, dancing together with words to offer the reader a fuller scope of the situation at hand. Jesus Christ, it's why memes work! To anyone who resents the use, or even overuse, of emojis, each a tiny beacon of light and merriment with the capacity to pull us outside of the grimness of human existence for one brief moment, I say: Shame on you.

Need more convincing? According to a 2013 scientific study, looking at a smiley face activates the same parts of our brain that looking at an IRL human face does. Our moods may change, as might our actual *facial expression*, to mimic the lil' teeny face we're looking at. Even more

impressive is that this study was done with *emoticons*—essentially cave-man renderings—and I'm no scientist, but I'm confident in the assumption that emojis have the capacity to trigger an even more heightened emotional response. As Dr. Owen Churches, a researcher on this study, said, "There is no innate neural response to emoticons that babies are born with. Before 1982 [the first recorded instance of the digital emoticon] there would be no reason that ':-)' would activate face sensitive areas of the cortex but now it does because we've learnt that this represents a face." He continued, "This is an entirely culturally created neural response." Essentially, technology is rewiring our brains.

And we're opting for emojis rather than words more and more across social media…if you haven't noticed. According to an Instagram Engineering Medium post, "The vocabulary of Instagram is shifting similarly across many different cohorts with a decline in internet slang corresponding to rise in the usage of emoji." The post noted that some emojis correspond to some particularly distinctive hashtags, a few examples being:

- 🙌 : #waitonit, #nuffsaid, #yeslawd, #youtherealmvp, #stayblessed, #thatisall, #enoughsaid, #onlythebeginning

- 👯 : #sistersforlife, #sistersister, #bestiesforlife, #sisterfrom-anothermister, #bffl, #bestiesfortheresties, #bestfriendsforever

- 💃 : #birthdaybehavior, #ladiesnight, #turnuptime, #dontmissit, #bdaycelebration, #bethere, #grownandsexy

And, using their algorithm, Instagram observed some of the most popular emojis have meanings in line with early internet slang:

- 😄 (ranked 1st in emoji usage): lol (and many iterations thereof), lmao, lfmao, lolz, ahahha

- 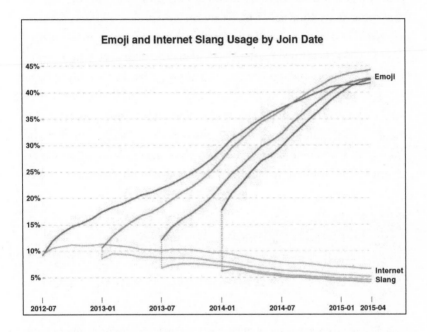 😍 (ranked 2nd in emoji usage): beautifull, gawgeous, gorgeous, perfff, hottt, gorgeous, cuteeee, baeeeee, babeee, sexyyyy, hawttt

- 💜 (ranked 3rd in emoji usage): xoxoxo (and many iterations thereof), babycakes, muahhhh, babe, boobear, loveyou, bunches

Emoji and Internet Slang Usage by Join Date

Apart from bolstering transnational communication with one another—one need not know how to say *beautiful* in a foreign language when the heart-eyes emoji is there to do it for you—emojis can also do wonders for strengthening human relations. One cool thing about them is that they can mean different things to different people—as well as in the context of different cultures (Did you know that in Japan, the words for *poop* and *luck* sound similar, so the pile-of-poop emoji is sometimes sent as a funny way to wish good luck?) Emojis can serve as inside jokes, or a secret code of sorts. A former partner and I, for

instance, would use the snowflake emoji to mean *Chill*, as in *Nah, chill* or *Chill out*. There was something cozier about getting a text response in the form of single snowflake emoji than the word *Chill*, because it's one emoji that we used only with each other to denote a specific meaning outside of its generally accepted one. Corny? Sure. But when you're in your thirties, you accept that the ship for sending nudes to your significant other sailed long ago. Emojis are the new nudes. Tell your friends.

In "The Emoji Is the Birth of a New Type of Language (No Joke)," *Wired*'s Clive Thompson writes: "We also use emoji to convey a sort of ambient presence, when words aren't appropriate. Ryan Kelly, a computer scientist at the University of Bath, has found that when texters finish a conversation, they often trade a few emoji as nonverbal denouement. 'You might not have anything else left to say,' Kelly says, 'but you want to let the person know that you're thinking of them.'" How sweet! Emojis: Is there anything they *can't* do to make our lives better?

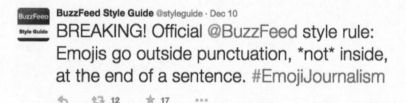

I mean, what a time to be alive, seriously. In a world where *wine o'clock* and *butthurt* are real entries in Oxford Dictionaries online, an emoji dictionary seems not entirely out of the question, if not a necessity altogether. Which brings us to Oxford Dictionaries' 2015 Word of the Year—the "Face with Tears of Joy" emoji. 😂 When it was announced that 2015's "word" was this lil' fella, people lost. their. shit. (And, yes, I am assigning him a male gender because this is a free country, and in my mind he's a cute little bald grandpa with a cheery disposition.) All right, so, fair enough, an emoji is not a word. I get that. But since an emoji can often convey an idea or mood more concisely than any one single word

can, I appreciate the boldness in this acknowledgment—especially as a decision made by an organization and a dictionary traditionally regarded as maintaining a certain air of stodginess and immutability (see the following year's Word of the Year, *post-truth*, for reference). As Casper Grathwohl, president of Oxford Dictionaries, said, "As a twenty-first-century culture, we've become so visually driven, emotionally expressive, but also obsessively immediate. And traditional alphabet language has a hard time keeping up and adapting to our needs here. And the idea of a pictogram communication form like emoji, coupling that with traditional alphabet languages, allows for a deeper subtlety and richness." Amen, Casper. Amen.

On to the next argument that has been posed in the circles of language-obsessed weirdos regarding the unconventional choice: Are there better emojis out there? Certainly. There is an exceedingly large pool of more nuanced, multipurpose, and more adorable emojis to choose from. Let's face it: Face with Tears of Joy is the Ugg boot of the emoji scene. But its ubiquity is precisely what landed it the top spot. This distinction wasn't based on the emoji with the most character, because the Word of the Year isn't chosen arbitrarily; it won the honor because it was 2015's most-used emoji *in the world*, making up 20 percent of all emojis used in the UK that year, and 17 percent of those in the US (up from 4 percent and 9 percent, respectively, in 2014). It transcends all demographics and has no hidden meanings to date, and as a more visually pleasing alternative to *lol*, of course it's the most-used emoji in the world.

So 2016's Word of the Year wasn't an emoji, which was disappointing. Most likely 2017's won't be either. And I'll come right out and say what everyone's thinking: We should really just have an Emoji of the Year as determined by a board of distinguished experts as well. Please email me if you would like to help coordinate this, thanks.

The birth of the modern emoticon, grandparent of the emoji, is widely accepted to be attributed to Scott E. Fahlman, a Carnegie Mellon

DID ABRAHAM LINCOLN INVENT THE EMOTICON?

It's possible. According to a transcript of a speech by Lincoln, printed in the *New York Times* in 1862, what now reads to us as a winky face appeared after the word *laughter*:

> **It is also true that there is no precedent for your being here yourselves,**
> **(applause and laughter ;) and I offer, in justification of myself and you, that I have found nothing in the Constitution against.**

Whether this was indeed a forebear of the emoticon, we'll never know. While some argue that because the transcript was typeset by hand, and because later audience reactions in the speech are enclosed within brackets rather than parentheses, its use was deliberate, other experts attribute the semicolon to grammar conventions at the time. It's the only use of the alleged winky face in the transcript, and other typographic errors within it don't help its case.

A discovery by literary critic and University of Chicago Press editor Levi Stahl, however, placed the potential origin of the emoticon more than two hundred years earlier than Lincoln's speech—in a poem called "In Fortune" by English poet Robert Herrick. The first two lines of the poem read:

> **Tumble me down, and I will sit**
> **Upon my ruines (smiling yet :)**

Again, perhaps this was a typographical error or simply a colon placed inside a closing parentheses for an ambiguous literary effect—but if the latter, was the placement of the maybe-smiley face close to the word *smiling* merely coincidental? The world will never know.

University professor who sent an email to his students on September 19, 1982, that read:

> **I propose the following character sequence for joke markers:**
>
> :-)
>
> **Read it sideways. Actually, it is probably more economical to mark things that are NOT jokes, given current trends. For this, use**
>
> :-(_

Seventeen years later, father of the emoji Shigetaka Kurita would create the first one—a heart—for Japanese telemarketing company NTT Docomo, before finishing off the first 176 emojis for cell phones. They hit the iPhone in 2011 and it's been the most beautiful love story of our time ever since. ♥

See you later[.] punctuation

The loss of punctuation as a form of punctuation itself, for humorous emphasis or in abstract or rhetorical use, is a trend that has roots in what's often referred to as "Tumblr English." This style has moved beyond Tumblr's platform and now functions to signify abstract or rhetorical speech across the web and in personal communication:

prismatic-bell:

atomicairspace:

copperbooms:

when did tumblr collectively decide not to use punctuation like when did this happen why is this a thing

it just looks so smooth I mean look at this sentence flow like a jungle river

ACTUALLY

This is really exciting, linguistically speaking.

Because it's not true that Tumblr *never* uses punctuation. But it *is* true that lack of punctuation has become, itself, a form of punctuation. On Tumblr the lack of punctuation in multisentence-long posts creates the function of *rhetorical speech*, or speech that is not intended to have an

answer, usually in the form of a question. Consider the following two potential posts. Each individual line should be taken as a post:

ugh is there any particular reason people at work have to take these massive handfuls of sauce packets they know they're not going to use like god put that back we have to pay for that stuff

Ugh. Is there any particular reason people at work have to take these massive handfuls of sauce packets they know they're not going to use? Like god, put that back. We have to pay for that stuff.

In your head, *those two potential posts sound totally different.* In the first one I'm ranting about work, and this requires no answer. The second may actually engage you to give an answer about hoarding sauce packets. And if you answer the first post, *you will likely do so in the same style.*

And as the author of this Tumblr post said in a follow-up message to me, "Very simply, the #1 criticism of the post was 'Wow, Tumblr sure is special, in 2,000 years nobody has EVER thought of this,' and, of course, that isn't what I meant at all. After all, if punctuation had never changed, we'd still be using ':' to terminate sentences! But the changes occurring in punctuation right now, as a result of the internet being free and open, are similar in magnitude to those brought about by Gutenberg's printing press in the 1500s."

Harley Grant, a linguistics graduate from the University of Glasgow and creator of the fascinating and endlessly entertaining Tumblinguistics Tumblr blog, focused on Tumblr speech and internet linguistics in her 2015 dissertation, *Tumblinguistics: Innovation and Variation in New Forms of Written CMC* (computer-mediated communication)—a dissertation I highly recommend for anyone who regularly reads things on the internet. (Side note: I have never in my life recommended a dissertation or read one for pleasure. This is truly a gem.) She writes of the Tumblr exchange above:

"If we punctuate the first post, and employ Standard English grammar, the tone of the utterance changes completely:

When did Tumblr collectively decide not to use punctuation? Like, when did this happen? Why is this a thing?"

The post sounds much more emphatic with the use of punctuation—far less casual and spontaneous-looking than the original, unpunctuated post.

secretlyjohnwatson ⇄ flamiekitten ▣ ♥

crowleyaziraphale:

> edgebug:
>
> > turnabout-taisa:
> >
> > > my-singing-soul:
> > >
> > > > why is it that all the most popular posts on tumblr
> > > >
> > > > are written like this
> > > >
> > > > with no capitals
> > > >
> > > > and no punctuation
> > > >
> > > > i just really want there to be a popular and grammatically correct post on tumblr
> > >
> > > I think the majority of Tumblr's dialect (is there a word for a written dialect? Hardly anyone speaks Tumblr.) comes from influence within the tag system.
> > >
> > > My theory is that the lack of capitalization is stylized, ironic laziness (same reason as the increasingly popular use of abbreviations such as idek and ikr, and particles like desu), whereas the punctuation stems from the tag system, where commas split up tags. So, "this is like, so totally cool" would be tagged "this is like" "so totally cool."
> > >
> > > With commas struck from the tumblr blogger's arsenal, they rely on run-on sentences and other means to show emphasis. One such means, spacing, is another quirk influenced by the tags. If you repeat a tag, it will only show once, which is why you get "really r e a l l y weird things like this."
> > >
> > > Also common on Tumblr are people who show their enthusiasm through their text by pretending their haNDS ARE FRKEAKIGN OUT AN D THEY CANT TPYE OMFGGGG. This adaptation is actually pretty cool, I think, as it serves to communicate tone across a very toneless medium.

Did you hear that noise? That was the sound of my desk breaking. My linguistics boner just snapped it in half.

#we've created our own language with its own set of rules and guidelines #based on the environment #that is cool #if you don't think that's cool you're wrong

Similar to McCulloch's "stylized verbal incoherence mirroring emotional incoherence," it's a manifestation of what's described here as "stylized, ironic laziness," which, as Grant notes, supports linguist Jack Chambers' views on adolescent language—that is, that students often want to appear casual about their schoolwork, even though they may be working hard at it. Grant goes on: "Though this is a fairly general statement regarding adolescent social attitudes, Chambers' notion of 'appearing casual' reflects the argument that Tumblr users can employ 'stylized, ironic laziness' in their language to appear 'cool', or less emotionally invested in what they are discussing. And, though Tumblr is an asynchronous medium, this style is very speech-like."

She continues: "There seems to be a tendency towards the dichotomy of 'stylized, ironic laziness' and extreme enthusiasm on Tumblr.

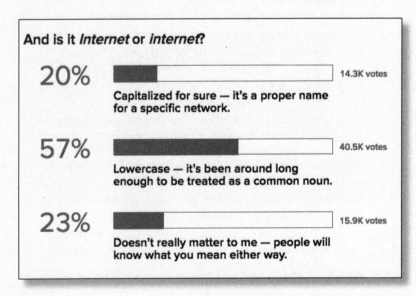

And is it _Internet_ or _internet_?

20% 14.3K votes
Capitalized for sure — it's a proper name for a specific network.

57% 40.5K votes
Lowercase — it's been around long enough to be treated as a common noun.

23% 15.9K votes
Doesn't really matter to me — people will know what you mean either way.

This 'excited' style of typing is interesting as, whilst we know that the user's ability to type has not been compromised, it is effective in portraying a frenzied emotional state. Examples of this particular style can also be seen in tags, alongside variants of *SCREAMING* and *I'M CRYING* (very frequently produced in all capitals) which indicate laughter."

Essentially, by ignoring all standard rules for capitalization and punctuation, we're able to effectively communicate an offhand tone that may not have otherwise been possible. How cool is that? For instance, deliberately forgoing end punctuation in an attempt to express a sort of breezy afterthought can be especially comical when juxtaposed with a weighty statement. I'm not advocating for the abandonment of all punctuation marks completely and operating exclusively from a state of either too-cool-for-everything-in-existence flippancy or complete mania, but there's a time and place for such stylistic choices to be made for effect. An investigative feature detailing how immigrant workers are not being paid fairly is not one of them; commentary in which one analyzes the logic behind Ariana Grande licking a doughnut on display is. Pompous copy editors out there, please don't ruin this for us.

2. Early in the relationship you find yourself trying things you wouldn't normally touch with a bargepole.

Glohv

And lying about your reaction to it because you fancy them. "YUM YES TOFU FOR BREAKFAST IS DEFINITELY AS GOOD AS BACON THANKS u r so cute."

"Smiling face with halo"

Apple: "Hehe, I'm so innocent."
Samsung: "Hello father I was a good boy today can I please have some chocolatey pudding?"

See how lack of punctuation effects an "I just spit this all out in one breath because I'm so excited about it" air of silliness in these examples?

Consider how something as simple as a *Noooooo* sans punctuation makes you envision a trailing-off into the abyss—as though someone were screaming this as they fell into an infinitely deep hole, and you were listening from above ground, the sound growing more distant with each passing second. *Noooooo.* isn't quite the same. It's more abupt—harsher and devoid of the goofiness implied in the former version.

15. The #LipChallenge.

Via youtube.com

Noooooo

Periods are also being used in more stylized ways in addition to the calculated elimination of them. Using periods not to indicate the end of a sentence but to signal that words should be read more slowly and dramatically is one example, as in "My mind. was. blown." To cap or not to cap each word following the periods? The choice is all yours. Any fuddy-duddy who cares is more likely to be outraged by periods breaking up a single sentence than by a capitalization call in this kind of construction.

Our old friend the period has also been seen milling around where a question mark would typically be used, and not just in rhetorical questions. Similar to the way so-called Tumblr English ditches punctuation to convey a sense of performative apathy, losing the inflection effected by a question mark in a sentence that would normally be phrased as a question delivers a deliberate, aloof directness—a flatness that can express myriad sentiments, like "I want you to know I feel strongly about this, so I'm not phrasing it as a question because there is no response that will satisfy me," "I'm so over it," or "I'm in such disbelief I cannot possibly be asked to change the intonation in my voice, so I'm using a period." Some examples:

Why is my uterus trying to kill me.
This dog knows how to ride a bicycle. OMG are you kidding me.
What. I had a baby! Three years ago.
I drank eight shots of Fireball last night. How am I even alive right now.

Å̊çč̈ëñt mârkš

Naïve or naive? Café or cafe? Get a hobby! Either way, it's clear what the word means. Accent marks aren't as critical in English as they might be in other languages, where they can clarify pronunciation and sometimes meaning (or, in extreme cases, differentiate a surname from a vulgar word). While I'm partial to using accent marks any chance I can get, because they are cute (and because every time I see an umlaut,

I sing "Umlaut!" to the tune of Hanson's hit song "Mmmbop" in my head), going without them typically isn't going to cost you points in the clarity department—except in the rare instances in English where they're indeed essential to distinguish the accented term from a similar non-accented word: like *divorce* and *divorcé.*

about a week ago

Why in the hell are the phrases "magical" and "magic juice" surrounded in tildes?

🖓 RESPOND 💙 0 💔 1 � SHARE ▾

about a week ago

Because it's not really magical.

🖓 RESPOND 💙 1 💔 0 � SHARE ▾

about a week ago

Then you are to use QUOTES to denote sarcasm. Not tildes!

🖓 RESPOND 💙 0 💔 2 � SHARE ▾

A comment thread with the world's biggest party pooper.

From Sea to Shining Sea

Regional Stylistic Differences

From taking more liberties with forgoing punctuation to the birth of new phrases and slang words altogether, there've been some very obvious (and very contested) changes to language and usage over the past decade alone, a significant amount largely due to the omnipresent influence of the internet. All things considered, though, the shift has not, in actuality, been that of seismic proportions. Despite abbreviations and other cool new words on the scene, according to a talk that David Crystal gave in 2013, "the vast majority of English is exactly the same today as it was twenty years ago," and, based on his collected data,

even e-communication isn't wildly different: "Ninety percent or so of the language you use in a text is standard English, or at least your local dialect." It's why we can still read an eighteenth-century transcript of a speech George Washington gave to his troops and understand it in its entirety (flowery stylistic choices aside), and why grandparents don't need a translator when sending an email to their grandchildren (for the most part). As Crystal observes, "Language is not moving at a rate so absurdly fast we cannot keep up with it."

What has, perhaps, moved along with greater velocity than in eras past is the accessibility of regional expressions to a broader audience—it's something the web has allowed for on a much wider scale than any form of media before it. Sure, we've been entertained by television shows and movies and the radio for the greater portion of the last century, and being exposed to characters of all demographics and of various regional backgrounds is nothing new; I'm not giving the internet any credit for pulling society at large out of a bubble and finally revealing the speech tics specific to a Southern Californian to the rest of the US. But the internet *has* increased exposure to various dialects and the language trends specific to certain demographics, and invited dialogue about it, via informal conversation on social media—and even viral quizzes like the *New York Times*' 2013 "How Y'all, Youse and You Guys Talk." And then there's the fact that every local news source, dialectal quirks and regional references included, is now available to everyone else online who can understand that language.

As a born-and-bred New Yorker, I was utterly shocked to find that most other people in the country don't stand *on* line, they stand *in* line. Or that confirming I was indeed dead-ass about something would be met with blank stares outside the confines of my cozy five boroughs. And how about *calling out sick*? I'd never thought twice about it (the phrasing, not the act itself, because it's hard not to be consumed with all-encompassing, soul-devouring guilt when you work on the internet but are presumably so ill that you can't even bear to bring your laptop into bed with you) until

BuzzFeed's Los Angeles–based copy editors mentioned that it sounded utterly bizarre to them not to say *calling* in *sick*.

 sarahwillson 4:52 PM
is "call out sick" ok to leave? i hadn't heard of it, but then i found this:
http://behindthegrammar.com/2009/08/call-in-sick-versus-call-out-sick-versus-call-off-sick/

> 〞 behindthegrammar.com
> "Call In Sick" Versus "Call Out Sick" (Versus "Call Off Sick") — Behind the Grammar
> To Infinitives and Beyond!

 meganpaolone 4:52 PM
oh yeah totally

 sarahwillson 4:52 PM
i pretty much wanna change it to "call in sick"

whoa

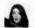 **meganpaolone** 4:52 PM
"called out" is definitely a thing

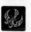 **sarahwillson** 4:52 PM
seems like it's a ny/nj thing

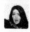 **meganpaolone** 4:52 PM
and I have totally heard "called out sick" also

These are just a few examples of the nonlocal language choices one may not necessarily be exposed to via traditional print or broadcast media, often standardized, to an extent, in the name of user-friendliness for the broadest possible audience—but with tweets and snaps and comments and blog entries and identity posts at every turn, we're being exposed to more localized regional slang just by doing our normal, everyday things on the internet. And that doesn't stop at the US border, of course.

The UK gets a lot of stuff right. For one, the metric system. Measurements based on multiples of ten rather than random-ass numbers have been giving the majority of the world a solid excuse to ask the United States, "Who hurt you?" since 1776 (or whenever our

total flop of a measurement system was founded). Also: dates. How much easier is it to read *10 April 2016* than *April 10, 2016*? A word sandwich, no commas necessary. Get with the program, USA. Here are other important (and a few cheek-pinchingly cute) regional English distinctions to note:

- You're always safe with *different from*. *Different than* (primarily US) and *different to* (primarily UK) have wider regional differences.

- The word *tabled* has opposite meanings in American and British English (and has, as a result, caused political troubles in the past); it can be used to mean both to postpone the discussion of something (chiefly American) and to place on the agenda (chiefly British).

- Election Day is the official name of the day designated for voting in the US; not so in the UK or Australia, where it's the generic *election day*.

- To have a *lie-in* in the UK refers to what the US calls *sleeping in*, after which you might have *fry-up* to ease your hangover after getting *pissed* (essentially, a full, greasy breakfast to help nurse you back to sobriety).

- Smarties in the UK are starkly different—and better!—candies than they are in the US, because chocolate.

- *Hundreds and thousands*, which sounds like a snack for elves, is what our British counterparts adorably use to describe what Americans call sprinkles.

- The UK's *cookery books* are the more magical-sounding form of what we know in the US as cookbooks.

- CUTE ALERT: A *bobsled* is called a *bobsleigh* across the pond.

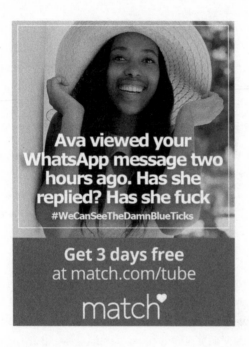

- *Has she fuck* and *have they bollocks* are common idiomatic expressions in the UK, roughly equivalent to *the fuck she has/they have.*

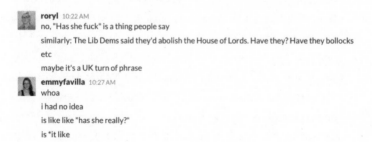

roryl 10:22 AM
no, "Has she fuck" is a thing people say
similarly: The Lib Dems said they'd abolish the House of Lords. Have they? Have they bollocks
etc
maybe it's a UK turn of phrase

emmyfavilla 10:27 AM
whoa
i had no idea
is like like "has she really?"
is *it like

 roryl 10:28 AM
no, because it's definitely negative
"Has she replied? Has she fuck." (edited)
It basically means "no" here (edited)

 meganpaolone 10:30 AM
I love this
but I am afraid I would use it the wrong way

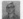 **roryl** 10:32 AM
it's not really "no", actually. It's more "Of course she fucking hasn't"

- *Quite* carries considerably more weight in the US than in the UK. A phrase like *quite nice* in America would be synonymous with *very nice*, whereas it translates roughly to *kinda nice* across the pond. As the usage note in *Macmillan Dictionary* puts it:

 In British English *quite* usually means "fairly": *The film was quite enjoyable, although some of the acting was weak.* When American speakers say *quite*, they usually mean "very": *We've examined the figures quite thoroughly.* Speakers of British English sometimes use *quite* to mean "very," but only before words with an extreme meaning: *The whole experience was quite amazing.*

 This is especially helpful to know when you're an American professional managing a Brit who's up for a long-awaited promotion and you tell them they're doing a "quite nice job" and then wonder why they've suddenly broke out in hives and are maybe crying.

- Perhaps most disturbingly—are you ready for it?—the UK DOES NOT ACKNOWLEDGE THE EM DASH. Well, generally. Oxford University Press style is one exception to this. (Unless my UK sub-editors are trolling me, in which case...you've been doing a quite nice job. You're fired.) Instead, the en dash typically functions as an em dash (ridiculous, tbh), and what we in the US know as the en dash...does not exist in its capacity as a hyphen 2.0. I know. It makes me cringe that the founders of American ideas of democracy and freedom hailed from a country so cruel too.

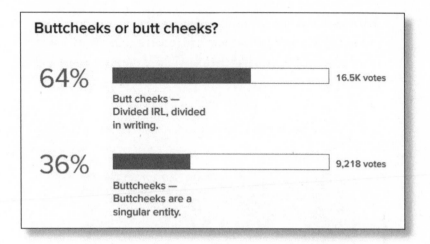

Buttcheeks or butt cheeks?

64% — 16.5K votes

Butt cheeks —
Divided IRL, divided
in writing.

36% — 9,218 votes

Buttcheeks —
Buttcheeks are a
singular entity.

- Thanks to those gorgeous British accents, which can make even people with negative IQs sound like they have the capacity to successfully lead the country, the abbreviated form of *because* sounds more like *cos*—and so we'll easily agree to disagree on the "correct" shortened form of the word, with *'cos* appearing in the BuzzFeed UK Style Guide as the cuz to the Americans' *'cause*. Thanks, folks, here all night.

- The word *shit* is used much more often in the adjectival sense in English abroad than it is in these here United States. You may, for instance, overhear someone in London chatting about how they had a real "shit day," while their buddy in New York would be more likely to reference it as "a shitty day." A *shit show*, alas, is something starkly different than a *shitshow*—a terrible TV program and a completely out-of-control scenario, respectively. For that reason, the modifying phrase *shit ton*, while clear enough in America, may cause unintended confusion for our British counterparts, and so it's hyphenated in BuzzFeed UK stories. (*Shitton* is out of the question, of course, which I feel confident I

don't need to explain to anyone with a modicum of good editing instincts, but which I do want to add makes me envision a new breed of animal shaped like the love child of the poop emoji and an adorable fluffy kitten.)

I Drank A Shit Ton Of Water For A Month And I Still Don't Look Like...
WTF. (96KB) ▾

Does it only look weird to British eyes to write "shit ton"? it reads to me like "shit" is modifying "ton of water" (edited)

(Of course, as Lyle points out, even we would never write "shitton", because then it would look too much like the name of this charming hamlet in Dorset, which apparently means "farmstead on the stream used as an open sewer": https://en.wikipedia.org/wiki/Shitterton) (edited)

- Collective nouns are typically treated as plural in the UK: We're talking *band*, *group*, *team*, and even *government*. This makes a whole lotta sense, because presumably more than one human constitutes the thing each of the aforementioned words describes. But to the ears of US dwellers, "The team are fighting" could sound like a little tyke in the throes of learning subject-verb agreement. We're also more likely to use a singular verb with the word *band* and a plural one with the actual name of the band, even if singular in construction (e.g., "The band is playing Saturday";

"Modest Mouse are playing Saturday"), so, really, who are we to give any advice on the matter? Do what feels and sounds right to you, regardless of where you live or who your editor is.

- Next time you ask some British schoolchildren if they'd like you to pack them a peanut butter and jelly sandwich and are met with looks of utter repulsion and maybe even a little bit of actual vomit, you'll know why: The gelatin-based dessert Jell-O is called *jelly*, while the stuff added to peanut butter sandwiches is called *jam*.

- *Noodles* refer specifically to the long strands of pasta you'd have in East Asian cuisine.

- Sports as a general topic is called *sport*. (*Sports* is used only to refer to a plurality of individual sports.) In contrast, the US's *math* is called *maths*. Whatever, dudes.

- It's *pyjamas*, not *pajamas*, which is cute.

- *Zzzs* (as in to catch some, or get some sleep) is pronounced (and often written) as *zeds* because the letter *z* is pronounced "zed" in the UK, not "zee." Aw.

zeds

Word Frequency
● ● ● ● ●

or zzzs ('zɛdz)

▶ Definitions

Collins English Dictionary
plural noun informal

1. sleep

2. *See* catch a few zeds

- No word is probably more fraught with tension within the sphere of regional differences than *cunt*—arguably one of the top two or three most offensive words in American English. Anyone with a British, Irish, or Australian friend may be aware that this word is far less offensive, and that it's non-gender-specific, in most English-speaking countries outside the US; it basically acts as a synonym for *jerk* or *idiot*. In America, where the word typically functions as an extremely derogatory way to refer to a woman and/or a woman's genitals, most writers and editors are careful about stylistic and censoring choices.

BRITISH SWEARWORDS: A GUIDE FOR THE BEWILDERED

Here's a look at some British swearwords—some a bit more lively than others—presented by BuzzFeed UK's deputy copy chief Rory Lewarne in his list of "49 British Swearwords, Defined."

1. **Arse, arsehole** – n., variants of *ass* and *asshole*. Can also be used to mean bothered ("I can't be arsed") or acting the fool ("Stop arsing about!"). Mild.
2. **Bastard** – n., illegitimate child or mongrel; objectionable fellow, probably one who has won one over on you; unpleasant situation ("I'm having a bastard of a morning!"). Medium strength. See also: *git, rotter, swine.*
3. **Bell, bellend** – n., head of a penis; fool. (Only write as *bell end* if referring to the end of an actual bell.) Medium strength. See also: *dickhead, knobend.*
4. **Berk** – n., idiot. Very mild, yet apparently originated as rhyming slang for "Berkeley hunt."
5. **Bint** – n., derogatory synonym for *woman* appropriated from the Arabic word for *daughter* or *girl*. Avoid, on the whole.
6. **Blighter** – n., person or thing to be regarded with contempt/envy. See also *cad, rotter, swine.* Mild.

BRITISH SWEARWORDS: A GUIDE FOR THE BEWILDERED

7 **Blimey, blimey O'Reilly, cor blimey, gorblimey** – n., expression of astonishment. Thought to derive from the phrase "God blind me!" Terribly mild. See also: *crikey*.

8 **Bloody** – adv., intensifier, popularly used in the phrase "Bloody hell!" Very common, medium strength.

9 **Blooming** – adj., basically a very mild, somewhat archaic form of *bloody*. Use with abandon.

10 **Bollocks** – n., testicles. Used to mean rubbish or nonsense, as in the exclamation of disbelief "Bollocks!" and the album title *Never Mind the Bollocks, Here's the Sex Pistols*; in phrases such as "the dog's bollocks" to mean something definitive and perfect; and, in the related word *bollocking*, a dressing-down ("I gave the useless fool a bollocking"). Medium strength, and very common.

11 **Bugger** – n., sodomite (i.e., someone who practises buggery); jerk; silly fool. As a verb, can mean to sodomise; to ruin ("You've buggered that up!"); or to tire. Also used as an exclamation of annoyance ("Bugger!"); as a milder variant of *fuck* in the phrases "bugger off" and "bugger all"; and, in the phrase "playing silly buggers," to act the fool. Medium strength. Also very popular in Australia.

12 **Cack** – n., shit. Also: Cack-handed – adj., clumsy, inept. A cack-handed execution will often lead to a cock-up. Mild. Use merrily.

13 **Cad** – n., untrustworthy person to be regarded with contempt/envy. See also *blighter*, *rotter*, *swine*. Mild.

14 **Chav** – n., working-class person with an urban sporty style. Very patronising. Avoid.

15 **Cobblers** – n., nonsense. Very mild.

16 **Cock-up** – n., snafu. As a verb, means to screw up drastically. Mild.

17 **Codger** – n., an old man, often grumpy. Mild.

18 **Crikey** – n., expression of astonishment. Synonym for *Christ*. Very mild.

19 **Cunt** – n., vagina; an unpleasant or stupid person. Strong, but much less offensive than in the US. Can be used as

BRITISH SWEARWORDS: A GUIDE FOR THE BEWILDERED

an adjective in the related word *cuntish*. Use with care, unless writing a piece based on East End gangsterisms.

20 **Dickhead** – n., a stupid, irritating person, usually a man. Moderate strength. See also: *knob, knobhead, knobber*.

21 **Duffer** – n., elderly idiot. Mild.

22 **Feck** – milder Irish variant of *fuck* that caught on in the UK thanks to the '90s sitcom *Father Ted*.

23 **Git** – n., someone who has just beaten you at pool, stolen your spouse, bought the last pasty in the shop, got the job you wanted, or in some other way won one over on you. Mild.

24 **Gordon Bennett** – n., variant on *Gorblimey!* and the profane outburst *Jesus Christ!* Derives from the Victorian publisher and playboy James Gordon Bennett Jr. Mild.

25 **Gormless** – adj., dim. Mild.

26 **Knob, knobend, knobhead, knobber** – n., a stupid, irritating person, usually a man. *Knob* is a synonym for penis. Mild.

27 **Manky** – adj., worthless, disgusting. Mild.

28 **Minger** – n., a very unattractive person or thing. Mild.

29 **Minging** – adj., foul, disgusting, worthless. Mild.

30 **Munter** – n., unattractive woman. Avoid.

31 **Naff** – adj., tasteless, crap. Mild.

32 **Numpty** – n., Scottish idiot. Mild.

33 **Nutter** – n., crazy person. A synonym for the US *nut*. Avoid.

34 **Pillock** – n., idiot. Mild.

35 **Pish** – n., Scottish piss.

36 **Pissed off** – adj., angry, synonym for the US *pissed*. Medium strength.

37 **Plonker** – n., annoying idiot. Immortalised in the '80s BBC sitcom *Only Fools and Horses*. Mild.

38 **Poxy** – adj., riddled with pox; crappy, third-rate. Mild.

39 **Prat** – n., idiot. Mild.

40 **Rotter** – n., person to be regarded with contempt/envy. See also *blighter, rotter, swine*. Mild, unless of course

BRITISH SWEARWORDS: A GUIDE FOR THE BEWILDERED

preceded by a strong intensifier, as in Steve Jones' line: "What a fucking rotter."

41 **Scrubber** – n., promiscuous woman. Avoid.

42 **Shite** – n., variant of *shit*. Moderate. Used in a bewildering variety of constructions, including *gobshite*, *shite-hawk*, and Steve Coogan's Paul Calf catchphrase, "bag o' shite."

43 **Swine** – n., person to be regarded with contempt/envy. See also *blighter*, *cad*, *rotter*, *swine*. Mild.

44 **Taking the piss/Mick/Michael** – v., taking liberties, making fun of. Mild.

45 **Tosser** – n., masturbator; despicable person. A milder synonym for *wanker*.

46 **Tuss** – n., Cornish idiot. Synonym for either *penis* or *someone from St Just*, depending who you ask. Mildish.

47 **Twat** – n., vagina; rotter. Milder synonym for *cunt*. Can also be used as a verb to mean hit ("Watch me while I twat him") or inebriated ("I was twatted"). Use with care.

48 **Wally** – n., fool. Possibly short for Walter. Terribly mild.

49 **Wanker** – n., masturbator; despicable person. As a verb, can also mean very inebriated ("I was absolutely wankered"). Strong. See also: *tosser*.

Homework: Next time you're faced with an unpleasant situation and feel yourself on the verge of muttering a "Jesus Christ..." under your breath, stop. Throw your hands up in exasperation and exclaim, "Oh, Gordon Bennett!" You'll feel a lot better, I promise. Or you won't, and people will just look at you funny. But I guess it's worth a shot?

• Words I think should be eradicated from the British lexicon immediately include *plughole* (this makes me SO uncomfortable; just say *drain* like the rest of us), *per cent* (the 1800s called—they

want their spelling of this word back), *yoghurt* (a spelling that inexplicably makes me feel physically ill), and, of course, *diarrhoea* (did we need this word to look even worse than what it describes?). Thank you, UK lexicographers; those are my only requests for now.

- Writers across the pond tend to use colons before quotations of any length, whereas standard practice in the US is to reserve them for use before quotes more than one sentence long. And the UK's rules for punctuation with quotation marks are both confusing and distasteful, if I'm being honest. Typically—and as opposed to punctuation rules in the US—punctuation marks always go outside quotation marks in British English, unless a full sentence is enclosed within the quotation marks. So that means:

Then he said, "This was the greatest day of my life."
but
Then he called it "the greatest day of my life".

What?

- What we call parentheses in the US are known as *brackets* in the UK; and what we know as brackets are called *square brackets*.

- The Brits see things *anticlockwise*, while the US opts for *counterclockwise*.

- While Americans *take* exams, Britons *sit* them and Canadians *write* them.

- Canadians park their car *on* the driveway, while those in the US typically park *in* the driveway.

AND THE AWARD FOR BEST SYNONYMS GOES TO...

Macquarie Dictionary's entry for *speedos*.

speedos
/ˈspidooz/ (say 'speedohz)

plural noun a close-fitting swimming costume made of some synthetic fabric and used especially in competitive swimming, for men comprising a pair of briefs, and for women a one-piece costume, usually in a single colour; racers. Compare ballhuggers, budgie-smugglers, cock jocks, cod jocks, dick pointers, dikdaks, dipstick (def. 4), knobbies, lollybags, nylon disgusters, sluggos, toolies; *Chiefly NSW Colloquial* dick stickers; *Chiefly Qld Colloquial* dick togs; *Chiefly Qld Colloquial* meat-hangers.

Also, **Speedos**. [trademark]

Excuse me while I refer to swimming briefs exclusively as meat-hangers from this point forward.

And let's not forget the wacky slang that's been birthed by the land down under:

- Australia refers to McDonald's as Macca's, which is just one of many zany, delightful slang words and abbreviations used regularly: *cozzie* (short for "swimming costume," aka a bathing suit), *doona* (a bedspread), *goon* (a stupid person OR cheap wine), *goon bag* (the bladder from said cheap cask of wine), *mozzie* (a ridiculously twee way to abbreviate *mosquito*), *rekt* (wait for it... wrecked), *rellies* (relatives! adorbs), and *yakka* (typically associated with the phrase *hard yakka*, meaning physical labor) are among my favorites.

- Ah, football. Not only does this word for what we call soccer in the US lead to endless taunts from our British counterparts about how *football* makes no sense to describe a sport in which the feet are not the primary means of transporting a ball (which, yeah, you are correct), to make matters even more complicated,

in Australia it refers to either Australian rules football or rugby league but not soccer, as it does in the UK. Note: Australians also use the impossibly adorable *footy* to refer to either aforementioned sport.

Currency

A cool thing about countries using different currency is that you always have an easy souvenir for your loved ones if you completely blank and forget to pick up something from the museum gift shop during your international travels. Bills in Costa Rica have sloths on them. THERE ARE PICTURES OF SLOTHS ON THEIR MONEY. Frame one of those bad boys when you get home, hand it over to Mom with an "I thought you'd get a kick outta this!" and thank me later.

An uncool thing is that the symbols for international currency may not always be widely discernible to the unseasoned traveler. We should assume a shred of worldly awareness on behalf of our reader, but we also don't want them checking out of a story just to google what ₹ is (it's the symbol for the Indian rupee; you're welcome). BuzzFeed's rule is to spell out foreign currency (*euros, yen*, etc.), rather than using symbols, the exception being the British pound (£). Why does the pound get the royal (hardy-har) treatment? Arguably it's the most widely recognizable non-dollar symbol to US eyeballs, and also, BuzzFeed publishes a lot of shopping posts that link to UK retailers—so we decided to forgo inelegantly spelling out what's a pretty ubiquitous symbol. You could contend that the euro (€) ties for that spot too, but we try to make our copy accessible to the broadest audience possible. Typing the euro symbol also requires one more keystroke on a Mac (*alt + shift + 2* vs. £'s *alt + 3* on non-UK Mac keyboards), so just saving you some energy over here. Our BuzzFeed UK editors, however, use € rather than the spelled-out *euro* in their posts; after all, it's just two hours on the Eurostar from London to Paris.

Additionally, since the dollar ($) is not exclusive to the United States, be sure to indicate when you're referencing a foreign dollar.

BuzzFeed style is to use said currency's abbreviation following the number: e.g., *$50 AUD*, *$50 CAD* (and for writers outside the US, *$50 USD*).

And while we're at it, bitcoin, a shady AF digital currency I've never used and am confident I will never understand, is lowercased in all forms per BuzzFeed (and AP) style, given the gray area between currency and concept.

Native peoples

The appropriate ways to refer to native and other populations in English-speaking regions vary across the globe. A few points as noted in BuzzFeed's Australia and Canada style guides follow:

Australia
Indigenous is an umbrella term for the Aboriginal and Torres Strait Islanders communities and should be capitalized to show respect and differentiate Indigenous people from other indigenous people around the world.

- *Auntie* and *Uncle* are community honorifics, not family roles, and should be capitalized.

- To be *on country* is to be on the land or homeland of your (Indigenous) people/community.

- Many—but not all—Indigenous transgender people to refer to themselves as Sistergirls or Brotherboys, terms that incorporate gender identity and cultural identity succinctly.

Canada
Indigenous is also capitalized as a sign of respect and to signify sovereignty. Some groups in the country include Aboriginal Canadians,

First Nations peoples, First Peoples, Métis, and the Inuit. Always try to identify people by their specific First Nation if possible and if preferred. When possible, always ask how a person prefers to be identified.

- Unlike the more common *reservation* used in the US, *reserve* is preferred to refer to the land where Indigenous people live.

- According to guidelines in *Editing Canadian English*, "unlike in the United States, the black population in Canada is more culturally diverse, making 'African Canadian' less desirable and accurate." Opt for more specific terms such as Nigerian Canadian or Jamaican Canadian.

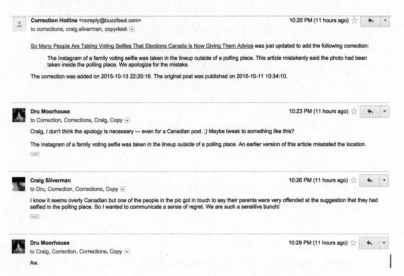

Correction Hotline <noreply@buzzfeed.com>
to corrections, craig.silverman, copydesk
10:20 PM (11 hours ago)

So Many People Are Taking Voting Selfies That Elections Canada Is Now Giving Them Advice was just updated to add the following correction:

The Instagram of a family voting selfie was taken in the lineup outside of a polling place. This article mistakenly said the photo had been taken inside the polling place. We apologize for the mistake.

The correction was added on 2015-10-13 22:20:16. The original post was published on 2015-10-11 10:34:10.

Dru Moorhouse
to Correction, Corrections, Craig, Copy
10:23 PM (11 hours ago)

Craig, I don't think the apology is necessary — even for a Canadian post. ;) Maybe tweak to something like this?

The Instagram of a family voting selfie was taken in the lineup outside of a polling place. An earlier version of this article misstated the location.

Craig Silverman
to Dru, Correction, Corrections, Copy
10:26 PM (11 hours ago)

I know it seems overly Canadian but one of the people in the pic got in touch to say their parents were very offended at the suggestion that they had selfied in the polling place. So I wanted to communicate a sense of regret. We are such a sensitive bunch!

Dru Moorhouse
to Craig, Correction, Corrections, Copy
10:29 PM (11 hours ago)

Aw.

Yes, Canadians really are that polite.

At the Intersection of E-Laughing and E-Crying

I have a complicated relationship with *lol*. *Lol* and I pretty much came of age together, laughed together, spent time on AOL Instant Messenger together, me in my wide-leg cords freshly arrived from the Delia's fall catalog, enjoying *lol*'s comforting presence into the wee hours of the night as I overanalyzed the sporadic one-line responses from my high school crush. (Spoiler: He wasn't that into me.) Yet, at some juncture, *lol* lost focus and, well…its life spun completely out of control. It did not receive the intervention it so desperately required; we all failed *lol*. I do not enjoy revisiting the sordid tale of *lol*'s decay, but, alas, it goes something like this:

It was the year 2000. Angsty lyrics in purple Comic Sans adorned your AIM away messages as you waited twenty minutes for a song to download—that same one that would probably become your MySpace page song three years down the line. You felt fun, you felt kewl. Go ahead, savor the memories of this sweet, sweet, formative moment in time. The most tragic part of this bygone era? This was a time when *LOL* literally meant *laughing out loud*, and you probably spelled it in all caps just like that, so the person on the receiving end knew just *how* hard you were genuinely laughing. Ahh…Breathe in. Relive it for as long as you need to. Hold hands with the person sitting next to you if it helps, as we take a brief journey together and reflect on the way things were:

> **LOL:** Something funny made you chuckle, IRL, out loud.
> **LMAO:** Something funny elicited from within you a hearty laugh; a real guffaw, if you will.
> **LMFAO:** Add on another ten seconds of laugh time.
> **ROTFL:** Your laughter is uncontrollable at this point.
> **ROTFLMAO (or some other combining-form iteration):** Your laughter is so uncontrollable—maybe even painful—you *actually* almost fell off your chair. Your friend is effing hilarious!

It is worth noting that the first known use of *LOL* may be attributed to a man named Wayne Pearson, who says he invented it on a Canadian bulletin board system (BBS—add that to the list of acronyms no one will understand on first reference today) in the early or mid-1980s:

> A friend of mine who went by Sprout (and I believe he still does) had said something so funny in the teleconference room that I found myself truly laughing out loud, echoing off the walls of my kitchen. That's when "LOL" was first used.
> We of course had ways of portraying amusement in chat rooms before that (>grin< >laugh< *smile*) and the gamut of

smiley faces, but I felt that none of them really got across the fact that the other person just made you feel foolish by laughing out loud in a room all by yourself (or worse, with other family members in another room, thinking you quite odd!)

If you missed it: The first person to use *LOL* did so to illustrate the fact that he was feeling foolish *for laughing out loud in a room by himself.* A laugh that *echoed off the walls.* ECHOED. OFF. THE. WALLS.

Fast-forward to the mid-'00s, which ushered in the Age of LOL Abuse. And let's not even pretend anyone is respectful enough to use all caps anymore.

unlucky if ur bdai is on the 29th of Feb cos u wnt be celebratin 2moz lol sorri but its 1st of March lol dnt cry lol pls lol im sorri HB 2 u

05:20 PM - 28 Feb 13

Lol party tomorrow n still don't know what to wear lol lol lol #alwayslastminute

02:18 PM - 07 Mar 13

i just dont gain any followers lol even when people give me a shoutout

11:48 AM - 06 Mar 13

None of these *lol*-toting statements are capable of eliciting even a half smile, let alone an echoing guffaw! Multiple *lols*, especially paired with *smh*, raise some questions. Are you feeling nervous?

Lol why don't I know my own ring size tho? Lol just a shame smh I am not a true woman lol.

01:37 AM - 07 Mar 13

Ashamed?

smh! its funni lost like 7 or 8 followers gained 20 more smh lol.. so ask me if i care.com lmaoo .. um not! lol

05:14 AM - 24 Jun 10

Trying to hide something?

Smh...lol I despise when girls tell me I have like 5 other girlfriends...smh...don't txt me with that bull lol

11:41 PM - 27 Feb 13

Defensive?

Don't assume that you're someone's priority lol, assuming will get your feelings hurt. Take note...

11:39 AM - 06 Mar 13

Feeling snarky? Throw in a *lol* to soften the blow, why don't you.

Lol we asked for one thing and you have to get an attitude about it

11:57 AM - 06 Mar 13

Open up Instagram on any given day and you'll find yourself asking: *Why are you laughing at a fortune cookie? A view of a sparkling cityscape? At an EYEBALL??? Is everyone on drugs?*

And as for the atrocity that is *lolol*—what does that even *mean*? Well, it means "laughing out loud out loud," which, no. The quantitative-to-qualitative association in adding extra *ha*'s onto your *haha* doesn't work the same way for *lol*. Lose the *ol*, add an exclamation mark (or even an *al*, for "a lot") if you absolutely must, or simply take the plunge into *lmao* territory.

literally every guy starts liking my bestfriend after they meet them #Lol #Annoying

↩ Reply ⭢ Retweet ★ Favorite ••• More

Lol is but an empty shell of an abbreviation, a sad silhouette of what once indicated sincere enjoyment of an uproarious joke. A sparkling diamond reduced to cubic zirconia status, *lol* (and yes, even I've resigned to using the lowercase form, because, frankly, *LOL* seems too grandiose for what it really connotes these days) now finds itself with the daunting responsibility of serving as a marker of acknowledgment for anything from a mildly amusing idea to a genuinely comical statement to a pleasant observation to a downright shitty situation.

And before our very eyes, in just two decades, *lol* devolved from an expression of one of the most joyous, pure experiences of human existence—the all-consuming urge to laugh out loud after reading profoundly hilarious words on a screen—to a measly filler word, or a pragmatic particle, as linguist John McWhorter explained in his TED Talk "Txtng is killing language. JK!!!" saying, "It's a marker of empathy. It's a marker of accommodation."

"*LOL* does not mean laughing out loud anymore; it's evolved into something that's much subtler," McWhartor said. He notes the use of "more guffawing" than we're used to when referring to inconveniences like in the following exchange:

> **SUSAN:** I love the font you're using, btw.
> **JULIE:** lol thanks gmail is being slow right now
> **SUSAN:** lol, I know.
> **JULIE:** I just sent you an email.
> **SUSAN:** lol, I see it.
> **JULIE:** So what's up?
> **SUSAN:** lol, I have to write a 10-page paper.

While I'd like to conclude this diatribe with a sweet *RIP, lol*, I cannot, in good conscience, do so—because I too am now guilty of using *lol* to denote something between sincere *lol*ing and use as a pragmatic particle. Like most O.G. *lol*ers, for me, the devaluation of the

abbreviation has led to the necessity of exclamations like *I literally just laughed out loud!* when my response to something funny calls for a *lol* in its truest sense. But it takes the perfect combination of witty words on a screen, just enough caffeine, and a particularly good day for me to *literally* laugh out loud, so most of the time my *lol* (and the majority of *lol*s, let's be real) is really equivalent to a *Ha! That was a good one* or a self-deprecating-tinged acknowledgment of a comically annoying or embarrassing situation, as in *I can't go to happy hour because I have to vacuum and clean my apartment tonight lol.*

My transition from *lol* to *haha* happened swiftly, but seamlessly. It was probably around 2004, and *lol*, alongside hit Evanescence jam "Bring Me to Life," had reached its saturation point. In addition to abandoning *lol* simply because it was played out, I enjoyed the ability to stack *ha*'s like bricks to really express the extent of my amusement with precision. It seemed more sophisticated, more accurate, and more genuine to *hahaha* than to *LOL*, and at twenty-one, I was ready for more of all three of those qualities in my written communication. And so I phased out *LOL*, *lol*, and *LoL* (the best variation, imho), proceeding to judge the use of *lol* as a marker of bad taste and immaturity, and the user still hanging on to it as not quite ready to observe this faded relic from a distance and trade in a piece of their youth for a more highbrow expression of laughter.

And then the ubiquity of *lol* became too much too ignore. The ironic *lol* started to creep its way into texts, Gchats, and emails, the *lol* punctuation itself eliciting a silent chuckle. That was fine—lovely, in fact, as it invoked a sense of both nostalgia and a "We're not one of the *real lol*-user losers"–type camaraderie among those who were self-aware of their ironic use.

Enter PILE: the Post-Ironic LOL Era. Here we are, folks. It's hopeless to aspire to things ever returning to the way they used to be—for *lol* to truly and exclusively indicate laughing out loud, or even laughing at all—but I suppose its reduction to filler status isn't all so bad.

While of course a *lol* doesn't conjure up the image of booming laughter so intense it's caused someone to nearly fall out of their desk chair, the way it may have back in the '90s, it's just another piece of evidence to support how the internet is speeding up the evolution of our lexicon; I can get behind its use to indicate mild amusement or not taking oneself so seriously. *Lol*s mean different things to different people, and there's a sort of poetic beauty in that. And remember: No one can ever take our *haha*s away from us. (I hope.) Plus we have emojis now.

In a 2015 study by Facebook, in fact, it was found that *haha* is the reigning champ of e-laughter indication by a landslide. Of the people in the study's data set, 51.4 percent used *haha*, 33.7 percent preferred emojis, 13.1 percent (weirdos/pervs) used *hehe*, and a minuscule 1.9 percent went with *lol* because, of course, *lol* is off doing more important things these days, like filling awkward e-silence. Also, there were some interesting demographically based discoveries: "Young people and women prefer emoji, whereas men prefer longer *hehe*s. People in Chicago and New York prefer emoji, while Seattle and San Francisco prefer *haha*s." Make of that what you will, but I'm happy that I'm not a man e-laughing in Seattle.

Here's a list by my colleague Katie Heaney of forty-two ways to type laughter, defined:

1 **haha** = I'm acknowledging that you've said something you perceive to be funny, though I don't find it particularly funny myself.
2 **haha.** = I am weary and loath to laugh, but here, you have forced it upon me. OR: I hate you.
3 **haha!** = I am pleasantly surprised to learn you are capable of modest humor.
4 **ha ha ha** = Very funny, you fucking asshole. You piece of shit.
5 **ha** = I am actually the most furious I have ever been in my entire life.

6 **ha.** = I knew it. I *knew* it. It is very tiring to be right about everything, but I live with it.

7 **ha!** = Clever little joke, sonny!

8 **HA** = Vengeance and/or justice has been served appropriately.

9 **hah** = Three-quarters of the way toward typing the most tepid indication of appreciation there is, I became too bored to continue.

10 **haaaaaa** = I am disgusted with (but not surprised by) humankind.

11 **hehe** = I am a middle-aged, self-proclaimed pickup artist who is pleased to have recently discovered Reddit.

12 **hehehe** = I just said something intended to be mildly sexual, but now I'm realizing it was maybe not clear that it was mildly sexual, so maybe I'll quickly also type the laughter of a cartoon villain wearing an eye patch???

13 **heh** = I have never experienced mirth, nor do I expect to.

14 **eh heh** = I am cautiously optimistic about my own evil plans.

15 **muahaha** = I am very optimistic about my own evil plans, and possibly an actually bad person.

16 **mwahaha** = I am very optimistic about my own evil plans, and possibly an actually bad person, and not a great speller.

17 **heehee** = I have done something mildly transgressive.

18 **teehee** = I have done something mildly transgressive and I think it's adorable.

19 **hahaha** = That was funny! I legitimately laughed, or at least smiled, and I am slightly happier now than I was before you just said that.

20 **ahahaha** = Like *hahaha* but less concerned with appearances.

21 **bahaha** = Like *ahahaha* but less concerned with appearances.

22 **gahaha** = Like *bahaha* but less concerned with appearances.

23 **hahahaha (etc.)** = What you just said was really funny. OR: What you said was only kind of funny, but I want to have sex with you.

24 **haha......** = Goooooooooooo fuck yourself.

25 HAHA = I made an audible laughter-type sound at this!!

26 HAHAHA = I am IRL laughing so much!!!!!

27 HAHAHAHAHAHAHA (etc.) = I am starting to panic that I may never stop laughing!!!!!!!!!!!!!

28 lol = I feel nothing. I want this sentence/conversation to be over but lack the wherewithal to end it directly, with purpose; I want to admit to a feeling but lack the conviction; I want to tell you how you've hurt me but want more to pretend I am invincible; I want to laugh, *really* laugh, but do not remember how. OR, maybe: that was funny, whatever.

29 Lol (sent from iPhone) = The above, but with an added element of Autocorrect shame. I did not mean to be so formal; I wanted it clear how little I cared.

30 lol. = Like *ha.* but sadder. Angrier.

31 lolol (etc.) = I am so self-conscious right now!!! What am I sayinggggg, ever!

32 lolllllll = I feel beneath my skin surface a brimming hysteria, an existential query both exhausting and frantic: What am I doing here? The things that amuse me now are so different from anything I could have imagined as a young child. Partway through typing I realized the absurdity, the smallness of that which made me lol, and so I held my finger firm upon the "l" key for a while, and I wondered what would happen if I held it there forever.

33 LOL = I briefly, but not disingenuously, chuckled.

34 L-O-L/L.O.L. = I want nothing more than to cry. OR: I made a joke and I'm your dad.

35 lolz = I am Gchatting/texting with two to four other people at this time; each of them is significantly more interesting than you.

36 lulz = I am Gchatting/texting with five to seven other people at this time; each of them is significantly more interesting than you.

37 lmao = That is the dumbest thing I've ever heard.

38 lmfao = That is the dumbest fucking thing I've ever heard.

39 **lmbo** = I'm neither laughing nor happy, but I am arguing a point I'm pleased with in my role as a person who works on the internet.

40 **rofl** = I am an extraterrestrial who learned to approximate human language by scanning millions of pages of AOL chat logs collected in the early 2000s.

41 **roflcopter** = I am a police officer working the undercover teen drug-use chatroom circuit.

42 **lollerskates/lollercoaster** = Sometime between 2000 and 2004 I was a starred internet forum poster, and someone I chatted with regularly—someone a little older, whom I looked up to, someone with lots of "x's" in their username—used this word, and I was overcome by impossible coolness. I am now grown, and quite serious, and typically hyperarticulate. But sometimes, when I find something a little funny, I indicate pleasure with an improbable portmanteau like this one, and I feel again that I am young, and excited, and waiting to get online.

chapter
11

Email,
More Like
Evilmail, Amirite?

Email is terrible, and it has the power to morph words into the very worst versions of themselves. Friendly requests can come across as threats; casual banter, with one too many period-punctuated sentences, has the capacity to be read as hate mail. It's anyone's guess how the recipient is going to interpret the innocent, thoughtful words you've strung together, and every day we're expected to silently accept this as reality—a reality that transcends languages, cultures, and demographics. Good luck staving off your next anxiety attack, entire world!

Email is, essentially, ruining everything: our productivity (there are *too many emails*), our chill vibes (when someone hasn't heard back from you in a few hours and replies, to *their* email to you, with "??"), our interpersonal skills (we've all emailed with the person who literally sits across from us at least once), and our ability to fucking relax (it's on our phones, attached to us 24/7). It's taking over our goddamn lives, one Groupon deal for staplers or goodbye email from that intern you just discovered existed at a time. Short of turning off email on your phone during designated hours or switching over to a chat app, like Slack, for your non-urgent communications, email has you in the palm of its merciless little hand. You are a hostage of email, and you're never leaving its grip. Ever.

So you might as well try to make the most of it, because this is your life now.

Writing emails is hard. There's frankly too much thought that goes into the whole process, because now that we don't have to spend an hour typing a letter up, printing it out, and making sure everything is perfect before we lick the envelope and toss it into a big blue box, we think it's an excuse to get creative every step of the way. It is not. My advice: Just start your message off with "Hi [name of recipient]" (more on whether or not to use a comma after *Hi* on page 107), say what you came to say, and end it with your name—unless you already have an email signature, in which case, you can probably screw it. Applying for a job? Go the "Dear hiring manager" or "Dear [Mr./Ms./Mx. + surname of hiring manager]" route in your cover letter and use a professional signoff that seems appropriate. We'll get into all the motley options shortly.

But first, here's a list of the forty-eight most annoying ways to start off an email by BuzzFeed UK editor Luke Bailey. (The delightful British slang in a few of these makes them only marginally less annoying.)

1 **Hi** = I'm trying to be as normal as possible.
2 **Hi!** = I'm trying to be as normal as possible while making this email seem more exciting than it actually is.

3 **Hiiii!** = I'm a bit annoying.

4 **Hey** = I'm trying to be a bit more relaxed and have met you in person once.

5 **Hey!** = Having met you in person once, this is the first of many emails I will send you today.

6 **Hey, mate** = Having met you in person once, I need a massive favor.

7 **Heeeeeeey!!!** = I'm still not allowed to use scissors.

8 **Hello** = I'm trying to be a bit different.

9 **HELLO** = I think this email is more exciting than it actually is.

10 **To...** = I wish people still wrote letters.

11 **Dear...** = I think people still write letters.

12 **Greetings** = I'm having a fancy day.

13 **Howdy** = I watched *True Detective* last night.

14 **Good morning** = This is the first email I sent today.

15 **Good morning!** = This is the first email you're getting today, but I've been up for hours.

16 **What's up?** = This is my first day.

17 **Yo!** = This is my first and last day.

18 **Ahoy** = I'm a sailor.

19 **Ahoy there** = I'm a sailor and would like you to join me on my boat.

20 **Afternoon** = I wrote an email this morning and then forgot to send, so I just changed the greeting.

21 **Afternoon!** = I had the morning off.

22 **Good evening** = You need to know that I work harder than you.

23 **How are you?** = I need something from you.

24 **How's it going?** = I need something from you, but slightly less urgently.

25 **Hope you're well** = I need something from you, but really don't want to engage.

26 **Hope your well.** = I need something from you, but can't spell.

27 **How was your weekend?** = I need something from you, and it's Monday.

28 **How is your week going?** = I need something from you, and it's Tuesday, Wednesday, or Thursday.

29 **Any plans for the weekend?** = I need something from you, and it's Friday.

30 **Enjoying the weather?** = I need something from you, and it's sunny.

31 **Happy [Insert day here].** = I need something from you, and I'm running out of ideas.

32 **Just a quick one** = Cancel everything you had planned for today.

33 **Just letting you know** = This is very serious, but we're hoping you'll skim-read this.

34 **Just filling you in** = Something important happened, but we decided not to involve you until it was too late.

35 **We're having a slight issue** = This will have a considerable impact on your life.

36 **We're having an issue** = This will have a major impact on your life.

37 **We're having a significant issue** = You're fucked.

38 **It's come to our attention** = You've fucked up.

39 **We've recently learned** = We've fucked up.

40 **It's unclear at this stage** = We've no idea who fucked up.

41 **Something's come up** = I never wanted the meeting in the first place.

42 **Hoping you can help me out** = You're the eleventh person I've sent this to.

43 **Hoping someone can help me out** = I've BCC'd everyone I've ever talked to.

44 **Not sure if you're the right person to talk to** = You're the twenty-sixth person I've sent this to.

45 **Not sure if you got my last email** = You ignored my last email.

46 **I'm having trouble getting hold of anyone** = Everyone is ignoring me.

47 **Haven't been able to get you on the phone** = You're screening my calls.

48 **Been having some trouble with my emails** = Why won't anyone talk to me?

Next up: the message itself. If you have a shit ton of information to relay, like post-meeting notes or instructions for a big upcoming project, use bullets unless you want everyone to set their computer on fire before paragraph three. Do not use emoticons. Barring that quirky habit you've established as a signature thing with the friend you've shared email exchanges with since the dawn of emailing, when the novel thrill of discovering a colon and a closing parentheses resembled a face that had fallen on its side and couldn't get back up, just don't. Go for the emoji, if you must. Emojis are decidedly less creepy than emoticons, but consider your audience.

A few other sage words for the body of your message: Cut the fluff. A true professional stays far away from *Hope you've been well* and *Have a great week.* Can you recall the last time your boss sent you a message that opened with a *Wow, aren't you glad summer's finally here? Hope you're enjoying the weather!* before diving into their request? Just tell the person what you need from them or pitch your gluten-free, vegan, organic, locally sourced subscription box already.

And if there's one thing you should avoid just as aggressively as emoticons, it's ellipses. As discussed earlier, their intention will always be ambiguous. Is the sender being a giant creep? A sarcastic A-hole? Do they despise you? Hard to tell, and because they're so open to interpretation, use these lil' buggers carefully outside of signifying elided text. Avoid in professional emails—and all matter of professional writing— as to not appear either shady or confused (or both). Consider *Let's meet later*...What is this supposed to mean? Are you trying to be sexy?

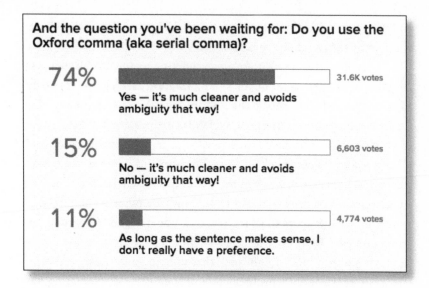

And the question you've been waiting for: Do you use the Oxford comma (aka serial comma)?

74% — 31.6K votes
Yes — it's much cleaner and avoids ambiguity that way!

15% — 6,603 votes
No — it's much cleaner and avoids ambiguity that way!

11% — 4,774 votes
As long as the sentence makes sense, I don't really have a preference.

Foreshadow a homicide? Express dire uncertainty at the idea of even meeting in the first place?

And after you've selected the perfect greeting and gotten everything down in a concise but not unfriendly but not overly friendly message because you don't want to come off as either unprofessional or that annoyingly gung ho friend of the group—just when you think you're in the clear—you realize it: Email signoffs are super fucking stressful too. Email does not want us to win.

In interoffice emails with the people I communicate with on a weekly if not daily basis, I generally forgo the signoff altogether, because who has time for that, and usually the email I'm sending is just a GIF reaction anyway. (Lol, BuzzFeed, amirite?) Outside of those situations, I've been Stockholm syndromed into using *best* at all times… but I have no idea why. Presumably an abbreviated form of *all the best*, or *best regards*, or *best wishes*, *best* is phony AF when it comes down to it, because I don't even know half of the people I'm emailing IRL. And

if I did, who's to say I wouldn't want to wish them all the averageness at best, or all the terror and misery in the world at worst?

I recoil at the very sight of my own visage after I've used a *best*, but the other options for business email signoffs aren't any less grisly. *Thanks* is odd if you're not actually thanking the recipient for anything aside from reading your email, which is sort of pathetic. *Sincerely* is too "Here's how I learned how to write a letter in elementary school." *Warm regards* I guess is okay? But a little too intimate for me. I don't feel anything close to a warm sensation when I envision any human who is not a treasured friend or close family member, let alone someone with a face I couldn't pick out of a lineup. Once I heard about someone who signs off with *warmth*, which is kinda cute and not as annoyingly try-hard. I might pick that one up soon. *Regards* is a little less intense and it's probably one of the more reasonable signoff choices, save for no signoff whatsoever. *Take care* sounds like you're embarking on a dangerous mission and this could quite possibly be the last correspondence of your life. *Xo* is for children, I shouldn't even have to tell you that.

Here's a list of forty-one ways to sign off an email, defined, by BuzzFeed UK editor Robin Edds. (FYI, the Brits use *x* or *xx* instead of *xo* because there's nothing the UK abhors more than the em dash than an awkward hug.)

1 **Thanks** = Well done on reading this whole email.
2 **Thanks!** = Genuinely amazed you made it all the way through this.
3 **Many thanks** = Zero thanks.
4 **Thank you** = I am furious with you.
5 **Thx** = I think Zayn is my favourite member of 1D.
6 **Regards** = I really couldn't care less.
7 **Kind regards** = I really couldn't care less, but this is my way of appearing like I could.

8 **KR** = I couldn't even be bothered to write the full words, that's how kind my regards are.

9 **Warm regards** = If we ever meet, I'll probably try to smell your hair…

10 **Warmest regards** = …and I don't mean the hair on your head.

11 **Sincerely** = Insincerely.

12 **Faithfully** = The internet is a hub of pornography and violence and I think the world's problems would be solved if everyone just wrote handwritten letters.

13 **Yours** = There's a picture of you on my pillow.

14 **Cheers** = Look how normal I am.

15 **Cheers, mate** = Look how normal I am, now let's get to the pub.

16 **Ta** = I am too busy to write whole words, so this noise shall suffice.

17 **Bye** = Fuck you.

18 **Good-bye** = Fuck everyone.

19 **Best wishes** = I have to write something here, and this will do.

20 **Best** = I'm thinking about what I'm going to have for lunch.

21 **Very best** = I know what I'm going to have for lunch now and I'm super psyched.

22 **All the best** = BURRITO MINUS 30 MINUTES!

23 **[Your name]** = I can spell my own name!

24 **[Your initial]** = I can't quite spell my own name.

25 **:)** = This emoticon is happier than I could ever hope to be. Why does no one love me???

26 **;)** = I totally would.

27 **Laters** = I have so much disdain for you that I just made up a word.

28 **Looking forward to hearing from you** = REPLY IMMEDIATELY.

29 **x** = I'm flirty.

30 **xxx** = I'm currently under investigation for an HR violation.

31 xxxxxxxxxxxxxxxxxxxxxxxx = I'm not allowed to use scissors.

32 Take it easy = You'll never see me again.

33 See you soon = Oh god I hope not.

34 Talk soon = See above.

35 Sent from my iPhone = I HAVE AN iPHONE.

36 Sent from my iPhone so please excuse typos = I HAVE AN iPHONE and I'm zany.

37 Love = So lonely.

38 Lots of love = So very, very lonely.

39 Write back = Write back, or the cat gets it.

40 TTYL = YSPNTTMABIACAS (You Should Probably Never Talk To Me Again Because I Am Clearly A Sociopath)

41 Take care = Die in a fire.

chapter
12

We're All
Going to Be Okay

Hey, remember Latin and its roughly 18,239,721 conjugations for every word? (If you don't, your high school days were much brighter and probably filled with many more cool parties than mine.) We survived the evolution away from declensions, and we will survive this free-for-all era unscathed as well. Simpler doesn't necessarily equate to a loss of impact or clarity. It just means fewer strict guidelines to follow. And that's okay. Have you read the news lately? We have enough utterly horrifying, faith-in-humanity–destroying stuff going on in our day-to-day to worry about.

The fear that our language is deteriorating because we're making calculated decisions to nix periods or because more people are pretending that *whom* doesn't exist or they're swapping emojis for words is as irritating as the performance that die-hard carnivores often put on of a paralyzing fear of trying vegan food. Pull yourself together. It's not going to kill you, and it might actually make you a more well-rounded person with a new perspective. (And, no, I'm not vegan, but I'm trying, alright?)

There are things that we, as a society, would be remiss not to be sticklers about: inclusive language that shows respect for and validation of the people who inhabit this world, and information that's presented accurately and clearly (I'm talking *Shit, another hole in my pants!* vs. *Shit another hole in my pants* careful comma usage here) in our professional writing. That's pretty much a non-negotiable. Everything else, grammar-, punctuation-, and syntax-wise? Have fun! Life is short.

It's a tale as old as time: Language trends come onto the scene strong and often fade into the background just as quickly. Those with staying power persist, and it doesn't mean we forget the ways we used to write or the guidelines that were considered standard before exposure to the latest trends, any more than we forget our first language after we've learned a new one.

Teenagers might be weird and annoying, but they're not stupid. Okay, some of them are, but the fact that younger internet users—I hesitate to use the cringey term *internet generation* but I guess I just did—including those golden children millennials, can switch back and forth between slangy webspeak and "formal" or "regular" language puts them at a clear advantage. Being able to change language patterns and tone based on audience, or what's commonly referred to as code-switching—e.g., realizing there's a stark difference between the phrasing you'd use in a Snapchat Story or a text and the way you'd write a cover letter or speak during a job interview—is a new form of multilingualism that can't be discounted, especially so in the editorial, advertising, and marketing industries. As the *New York Times* noted in 2015,

"On Twitter, Cap'n Crunch cereal 'just can't even with this right now.' Taco Bell 'literally can't.' When a public relations firm listed Charmin among its favorite Twitter brands last year, the toilet paper company tweeted: 'We. Can't. Even.' Applebee's favorited it. In turn, the young have found a way to monetize this process of linguistic appropriation. Corporations hire recent undergraduates to tune their Twitter feeds to appeal to their younger siblings."

Maybe it's not a fear of linguistic and grammatical shifts as much as it is fear of irrelevancy that propels a stubbornness to accept new language trends. Aging is inevitable, but disconnecting from the zeitgeist isn't—unless you make a concerted effort to approach the change happening in the world and in the way people are actually communicating with scorn. And at some point (especially if you're not a writer or a linguist) you might not want to make the effort to learn more, or to care, about how people decades younger than you are conversing, or about the imminent linguistic trends lurking in the corners of the internet, and that's fine—who's to blame you? Teens and twentysomethings are exhausting.

Younger generations, as recent history has proven, are the driving force behind all manner of trends—that much is a reality we all must come to grips with, depressing and ever clearer as it may get with each year closer to our impending death. Every era has had their slang and their quirks and their weird sartorial preferences. You don't need to accept them as yours, but you shouldn't discount them by default; just because you don't want to wear that choker or crop top in the store window doesn't mean no one should. Or do scoff at them, what do I care? Go forth and live your life a crotchety old stickler for the grammar, punctuation, spelling, and syntax of yore and stand your ground. Petition to bring back Latin. Spell *till* however you'd like to. Do what feels right to you.

#yolo

Acknowledgments

Immeasurable thank-yous to:

My agent, the incomparable Charlotte Sheedy, for taking a chance on this deer-in-the-headlights first-time author and making my idea come to life. There are no words to express my gratitude for your patience, thoughtfulness, humor, guidance, and effervescence.

My editor, Nancy Miller, for having the utmost confidence in my work from day one and for your keen edits and formatting guidance; thank you for allowing me the ability to execute this project just as I had envisioned it, and scrubbing it all up in the seemingly seamless process! Laura Phillips, who dealt with my relentless edits and queries effortlessly; Patti Ratchford, for the vibrant and playful cover; this book's dedicated New York and international marketing and publicity teams, including Laura Keefe, Tara Kennedy, Chloe Foster, Zoe Grams, and Jamie Broadhurst; and of course, to my copy editor, David Chesanow. Dear god, you are a lifesaver.

The creative and editorial copydesk staff at BuzzFeed—Lyle Brennan, Rory Lewarne, Drusilla Moorhouse, Megan Paolone, Sarah Schweppe, Dan Toy, Sharmila Venkatasubban, Sarah Willson—for providing inspirational daily fodder for this book and being the very best copy teams in the biz. Thank you for not reporting me to HR for being an unfit manager every time I told you to "follow your heart."

Ben Smith, Isaac Fitzgerald, Dennis Huynh, Nabiha Syed, Steve Kandell, and Tommy Wesely, for their unique wisdoms and unwavering support of this project from start to finish. And to Doree Shafrir, for hiring me—I am forever indebted!

The very many writers, editors, producers, illustrators, and content creators at BuzzFeed whose work I've been lucky enough to edit, learn from, and advise on—and who inadvertently helped me realize how the internet has paved the way for more nuanced modes of expression, and how exciting that is, and how, hey, maybe someone should write a book about it.

Jonah Peretti, the genius without whom any of this would exist.

Anna Wahrman, who helped me realize I was pretty OK at copyediting and that maybe I should do it professionally.

Acknowledgments

Marisa J. Carroll and Alison Jurado, who trusted a fresh-faced NYU grad enough to hire her as associate copy editor at *Seventeen.* Thank you for my first full-time copyediting job and for everything you taught me during those two very formative years of my career.

My friends who didn't sever all ties when I disappeared every weekend for eight months straight to write this thing.

Samantha Sleeper, whose Napa vacation coincided wonderfully with my needing a week of solitude to bang out the last stretch of the book, and whose cozy Vermont home and two adorable cats helped me see it through to the finish line.

The legion of copy editors, grammarians, lexicographers, and linguists I've met, listened to, and learned from—including but not limited to Lynne Truss, Patricia T. O'Conner, Kory Stamper, the late Bill Walsh, and the multitude of word nerds who have produced endlessly entertaining books about grammar, language, punctuation, and style—who've emboldened me to challenge my previously held notions about "the rules."

I'd also like to thank the following for their permission to use the images and passages noted:

- Syllabus on page 11 provided by Jennifer Follis, University of Illinois.

- Chart on page 81 courtesy of the American Press Institute. Full description of the study, by Fred Vultee at Wayne State University, can be found here: www.americanpressinstitute.org/publications/research-review/the -value-of-copy-editing/

- Oxford University Press for permission to reproduce the passage on page 196.

- Merrill Moses for the photo on page 212.

- Brandon Turner and photographer Sarah Nativi for the bottom photo on page 230.

- Nina M. (Tumblr user prismatic-bell) for the Tumblr post on page 263.

- Twitter users @GreyEditing (Sarah Grey), @bymameido, @BASDNAF-RICAN, @MyleezaKardash (Myleeza Mingo), @ChelsIsRight, and @stil-gherrian (Stilgherrian), for permission to reproduce their respective tweets on pages 55, 143, 174, 180, and 206.

- Meghan Lunghi at Merriam-Webster for permission to reproduce all Merriam-Webster-attributed passages, definitions, and tweets throughout the book.

The BuzzFeed Style Guide
Word List

#

?! (never *!?*)

@replies, @mentions (on Twitter)

11th hour (but hyphenate as an adjective, e.g., *11th-hour negotiations*)

1D (as an abbreviation for One Direction)

24/7

3D

4chan (use a lowercase C, and avoid using it to start a sentence when possible)

4th of July

7-Eleven

A

ABCs

AC (for *air-conditioning*)

administration (lowercase "a" in political terms, e.g., *It has been something the administration has avoided.*)

adviser

AF (for *as fuck*)

afterparty

agender (adj., describes someone who does not identify with a specific gender)

AIDS

Airbnb

airlift

airstrike

aka (unless it starts a sentence, in which case *AKA* is acceptable—*Aka* just looks weird)

alcoholic drink names are usually lowercase unless derived from a proper noun (exceptions: *Bloody Mary, Old-Fashioned*)

A-list, B-list (etc., when referring to an *A-list celeb*)

Al Jazeera (not italicized)

al-Qaeda

all-nighter

a.m., p.m. (OK to cap in headlines)

Amex (for American Express)

amendments: First Amendment, 19th Amendment (cap "A" when referencing specific amendments)

amfAR (American Foundation for AIDS Research)

amirite

anti-Muslim (preferred to *anti-Islam* or *Islamophobic*)

anti-vaxxer

apeshit

the Apple Store

Argentine (preferred to *Argentinian* as adj. meaning of or relating to Argentina)

A side (n.); **A-side** (adj.)

AstroTurf

autocorrect

autofill

Auto-Tune

awards season, awards show (preferable to *award*)

B

baby daddy, baby mama (two words)

backstory

badmouth (v.)

bandana

bandmates

band names: Usually take a plural construction (*The band is on tour*; but *Arcade Fire are playing tonight*.)

batshit

BCE, CE (for *before common era* and *common era*; not *BC, AD*)

beatboxer, beatboxing

beatdown (n.)

Beautyblender

Bernie Bros

best-seller, best-selling (e.g., *the* New York Times *best-seller list*)

BFF

bi-curious

Big Oil, Big Pharma, etc.

binge-watch

bitchface

bitcoin (always lowercase)

BlackBerry, BlackBerrys

blonde (adj. and n., all uses)

Bloody Mary, Bloody Marys

blow job

bocce ball

bodyweight exercises

body slam (n.); **body-slam** (v.)

bougie (adj.); **bougiest** (from *bourgeoisie*)

boy band, boy-bander

bread crumbs (for the food); **breadcrumbs** (for the computer-y term)

breakdance (all forms), **breakdancer**

breastfeed, breastfeeding (one word, all forms)

Britpop

bro-down

bro-ing

brony

brunette (as adj. and n., all uses)

Brussels sprouts

BS, BS'd, BS'ing

B side (n.); **B-side** (adj.)

BTdubs

bull dyke (n.); **bull-dyke** (adj.)—avoid, unless used in a direct quote

bused, busing, buses (for forms of *bus*)

butt-dial (all forms)

buzzer beater

byproduct

bytes (measure of digital storage capacity)—abbreviate and cap
 kilobytes, megabytes, gigabytes, terabytes, etc., when used with
 a figure, with no space between the abbreviation and the figure
 (e.g., *my iPhone is 64GB, a 128GB storage capacity*)

C

Cabinet (cap when referring to the governmental advisers)

caj (for the abbreviation of *casual*)

camel toe

Cap'n Crunch

cash me ousside, howbow dah

catfight

catfished (v., lowercase)

CBGB (not *CBGB's*)

ceasefire (n.)

celebricat (for a celebrity feline)

celebridog (for a celebrity canine)

cell phone (but *smartphone*)

cesarean (i.e., *C-section*)

champagne

ChapStick

chatroom (one word)

cheese: Consult *MW*, but here's a list of some commonly referenced
 cheeses: *Asiago, Brie, cheddar, Comté, feta, fontina, Gruyère,*
 Monterey Jack, mozzarella, Parmesan, Parmigiano-Reggiano,
 Romano

checkbox

checkmark (one word in all forms)

child care (all forms)

chile vs. chili: Use *chile powder* to refer to ground dried chile peppers
 (like ground ancho chiles or ground cayenne chile); use *chili pow-*
 der for the spice mix of cumin, paprika, and cayenne (and other
 stuff) that is often added to chili (the stew). (Note: British English
 generally uses *chilli*.)

chocolaty (not *chocolatey*)

chode (slang for a penis wider than it is long)

chokehold

cinderblock

circle jerk

cis, cisgender (both adj.)

civil rights movement

clapback (n.)**; clap back** (v.)

class-action lawsuit

click through (v.), **click-through** (n., adj.)

cliffhanger

co. (as in *TK and company*)

Coca-Cola

cockblock

colorblock (one word, all uses; preferred to *colorblocked*)

color-correcting (one word, all uses)

come (v.)**; cum** (n.)—(omg yes, this is really here)

comic con (for a generic comic con); adhere to self-stylization for specific cities (e.g., *New York Comic Con, San Diego Comic-Con*)

coming-out (n., adj.); **come out** (v.)

company names: Refer to a company as *it*, not *they*. In lighthearted, non-News posts, it's OK to personify brands by using *they*, especially if the alternative sounds awkward and/or stilted. Omit *Co., Corp., Inc., Ltd.,* etc.

Con Edison, Con Ed (OK on second reference)

congressional district (lowercase "c" and "d")

copydesk

copyedit (v.)

councilor (for a member of legal council)

court cases: Italicize and use *v.* instead of *vs.* (e.g., *Roe v. Wade*)

Craigslist

cray-cray (as slang for *crazy*)

creepshot

cringey

crop top

crossfire

CrossFit

crow's-feet (n.)

crowdfund (all forms)

crowdsource (all forms)

crowdsurf

cueing (not *cuing*)

D

d-bag

dab, dabbing (dance move)

dadbod (and similar constructions, one word for all forms)

dancehall (music genre)

Dark Web, Deep Web

dashcam

day care (two words)

Day-Glo (trademark, used for fluorescent materials or colors);
 dayglow (airglow seen during the day)

deadlift (one word, n. and v.)

deal breaker (two words)

decade-long

Deep South

Democratic Party (cap P)

die-hard (adj.); **diehard** (n.)

Disney Princess (for the brand/line of characters); **Disney princess**
 (when referring to a specific character from a Disney film)

diss (meaning to disrespect)

Division One, Two, etc. (for sports references)

DIY

DJ (n., v.), **DJ'd, DJ'ing**

"don't ask, don't tell" (lowercase, in quotes, with a comma for the US
 military policy; in subsequent references, no quotes or abbreviate
 as *DADT*)

dos and don'ts

douchebag

doughnut (but *Dunkin' Donuts*)

down-low (also, *on the DL*)

Down syndrome

downtime

doxx (not *dox*)

Dr.: Do not use the term *Dr.* to refer to nonmedical doctors who hold a
 doctorate

DREAMer (when referring to advocates of the DREAM Act)

drive-thru (n.)

drunk driving (n.), **drunk-driving** (adj.); preferred to *drunken driving*

drunk-text (hyphenate as a compound verb)

Duck, Duck, Goose
duckface
dude-bro
dumbass (n.)
dumpster
du-rag

E
Earth (capped only when referring explicitly to the planet; e.g., *the biggest on Earth* but *a down-to-earth guy*)
eBay
e-book, e-cigarette, e-commerce
[editor's note:] (for editor's notes in running text; cap *[Editor's note:]* if it starts a sentence or is its own sentence)
Ecstasy (cap "E" for the drug)
editor-in-chief
Election Day (but lowercase *election night*)
Electoral College
email
emoji (singular, and as a collective language unit), **emojis** (plural)
ever closer (no hyphen)
Exxon Mobil
eyeing
eyeroll
eyeshadow

F
Facebook-stalk (v.)
facedown (adj.)
facelift
facepalm (one word, all forms)
face-swap (all forms)

face-to-face (adj., adv.)

FaceTime (the Apple app), but **face time** (n.) (in all other uses)

faceup (adj.); **face up** (v.)

fanbase

fanboy, fangirl

fansite

fanfiction, fanfic

farmers market

fast food (n.); **fast-food** (adj.)

fauxhawk

fave, faved, faving (e.g., *I faved his tweet*)

FBI (OK on first reference)

fiancé (all instances, regardless of gender)

fieldworker

final girl

first lady, first family

first-timer

first-world problem

fist-bump (v.); **fist bump** (n.)

flashpoint

flat iron (hair tool, n.); **flat-iron** (v.); **Flatiron District**

flatscreen (one word, both as n. and adj.)

Fleshlight

flier for one who flies; **flyer** for the circular/paper

Fox News (not *FOX*)

Frappuccino; Frap

freshman 15

friend zone (n.); **friend-zone** (v.)

Frisco (acceptable on second reference for *San Francisco*)

frontman, frontwoman

frontrunner (one word, contrary to *APS* and *MW*)

fundraiser, fundraising (contrary to *APS* and *MW*)

Froot Loops (not *Fruit Loops*)
froyo
fsociety, (*Fsociety* in headlines, but avoid if possible)
fuckup (n.), **fuck up** (v.), **fucked-up** (adj.)
F-you (n.)

G
Gambia (not *the Gambia* or *The Gambia*)
Gchat
GED
gel (v.)
genderqueer
Generation X, Gen X'er
GIF/GIF'd (v.); **GIFs, GIFable** (pronounced *gif* with a hard *G*, NOT like the peanut butter Jif)
GIF set
Girl Scout Cookie
girly (as a synonym for *girlish*); **girlie** (featuring scantily clad women)
glowstick
god: Cap only if explicitly referring or alluding to a deity; lowercase otherwise, especially in common phrases (e.g., "Thank god she was OK," "*Oh god,* he thought," "And god knows we needed all the help we could get")
god-awful
goddamn (per *MW*), **goddamnit, goddamned**
gonna (not *gunna*)
goodbye
good Samaritan
Google (n.); **google** (v.); **Google+** (preferred over *Google Plus*); **google-able**
goosebumps
Gov. (OK on first reference preceding governor's name)

gravesite

gray (not *grey*)

grown-up (as n. and adj.)

G-spot

guest star (n.); **guest-star** (v.)

gun control, gun rights (never hyphenate)

gut-wrenching, heartrending, nerve-racking: Via *MW*, *heartrending* denotes sadness; *gut-wrenching* is meant to describe something that causes *great mental or emotional pain*; and *nerve-racking* describes something causing someone to feel nervous.

H

hacktivist

haha (interjection); **ha-ha** (n.)

hair care (n.); **hair-care** (adj.)

hair dryer (but *blow-dryer*)

hairspray

hairstylist

half hour (not *half-hour*) (n.)

hand job

handover (n.)

Hanukkah

happy-cry (all uses)

hardcore (all uses)

hardline (adj.)

hashtag

hate-watching (n.), **hate-watch** (v.)

HBIC

HBO Go

"he said, she said"

head count

headscarf

headshot

health care (all forms)

higher-up (n.)

hip-hop

hippie (as in Woodstock, peace and love, and all that)

hippy (as in big-hipped)

hitmaker

hi-top fade

HIV-positive and -negative (hyphenate in all uses, e.g., *Are you HIV-positive?*, *the HIV-positive patients*)

ho (plural: *hos* for the derogatory term)

homeowner, homeownership

homepage (also, *homescreen*, etc.)

homestretch

hoodie

hookup (n.), **hook up** (v.)

hotspot (Wi-Fi connection place); **hot spot** (for other uses, e.g., *vacation hot spots*)

hourlong

hoverboard

H/T (for hat tips, never *H/t*)

humankind (preferred over *mankind*)

humblebrag

Huthi rebels

I

ice cream (n., adj.; never hyphenate)

iced coffee (not *ice coffee*)

ID (for identification)

Ikea (not *IKEA*)

IMAX

IMDb

I'mma (i.e., *I'm going to*, as in: *I'mma let you finish…*)

indie pop, indie rock (but hyphenate as modifiers, i.e., *indie-rock band*)

Instagram, Instagramming (capped in all forms)

internet

Internet of Things

iPad Mini

iPhone 5s, iPhone 6 Plus (use lowercase "s," "c," etc., with model numbers)

Iraq War

IRL

ISIS (not *ISIL* or *Islamic State* for militant group)

IT (OK on first reference for *information technology*)

It girl, It couple

J

JCPenney

J.Crew

Jell-O (for the trademarked product); **jello** (as the generic term)

jetpack

JPG, JPEG

JPMorgan

judgy (not an actual word, but preferred to *judgey* in casual prose)

Juggalo, Juggalette

K

K-9

keychain

kimchi

koozie (for beer/alcoholic drinks)

L
LA
ladies' night
LARPer, LARPing (for *Live-Action Role-Playing*)
laundromat (lowercase)
lawnmower
leaker (preferred term for someone who leaks information, regardless of intent)
left-swipe (hyphenate all forms)
Lego, Legos (plural)
less vs. fewer: Use *less* when referring to mass nouns, distance, or money; use *fewer* when referring to things that are quantifiable, e.g., *There was a less of a risk with that option. There were fewer people at Jane's party than at Julie's.*
life hack
lifespan
likable
like: Use commas on either side for an interjection: *If you have, like, a really bad day…* No quotation marks when used as a self-referential pseudo-quote: *I was like, we could never do that. And then we did.* Don't set off with commas when used as a substitute for *about: There were like five dudes standing there.* As a suffix: See Combining Forms section.
likes (as in Facebook)—lowercase, not set in quotes
lil' (for shorter form of "little")
lip gloss, lip liner, lipstick
lip sync (n.); **lip-synch** (v.)
listicle: avoid, use *list* instead
Listserv: Avoid unless referring to the trademarked software; use *email list* instead
livestream (all forms)
live-tweet

locs (for abbreviated form of *dreadlocks*)
log in (v.); **log-in** (n.)
logline (brief summary of a TV program or film); **log line** (used on
 ships)
lolcat
LOL'd, LOLing
longform
longread
lookalike (one word, all forms)
loveseat
lower/upper Manhattan (lowercase "L" and "U")
lunchbox

M
MAC (the cosmetics brand)
mac 'n' cheese
maiden name: Avoid, use *birth name* to refer to someone's last name
 before marriage
make do (not *make due*)
makeout (n., the act of making out)
makeup (when referring to cosmetics)
mama
man-child
manila envelope
mani-pedi
mansplain, mansplaining
manspreading
mashup
mason jar
match-fixing (hyphenated in all uses)
matzoh
MD, MDs (plural)

mecca (lowercase)

meet-cute (n.)

meetup (n.)

megabank

meme (avoid phrasings like *giant meme* or *viral meme*, which are redundant and often hyperbolic; OK as a verb, e.g., *Hurry, meme this cat picture!*)

memeufacturing

men's rights activists (no caps)

MIA

mic'd (as the adj. or v. meaning to attach a microphone)

middle-aged (not *-age*)

midseason

Midtown Manhattan/Midtown (capped)

mile-high club

milkshake

millennials

mindset

misgender (v., for the use of a pronoun or form of address that does not correctly reflect the gender with which a person identifies)

mixtape

M.O.

ModCloth

mohawk (lowercase as the hairstyle)

Molly (when referring to the drug)

MoMA (for *Museum of Modern Art*)

mommy blogger: avoid, use *parent blogger* or *lifestyle blogger* instead

more than vs. over: OK to use interchangeably, but typically use *more than* with quantities and *over* with spatial relationships. (e.g., *There were more than twenty people packed into the apartment, The plane flew over the Atlantic Ocean.*)

mother-effing

mpreg
Muay Thai
mugshot
mustache

N
'n' (when using in place of *and*, e.g., *mac 'n' cheese*)
Nae Nae (dance move)
naptime
NARS (the cosmetics brand)
NASCAR
Nasdaq
National Airport or Washington National Airport: preferred over
 Reagan National Airport
Native American (not *American Indian*, unless a person self-identifies
 as such); *Native* is also used as an adj. to describe things specific
 to the population
Necco (not *NECCO*)
nerdom
Netflix and chill (n. and v.)
never mind
News Feed (when referring to Facebook's News Feed); **newsfeed**,
 one word, in other references
news gathering
New York magazine
New Wave (for film genre); **new wave** (for music genre)
nip slip
nonprofit (as n. and adj.)
No. 1 for official rankings, like on music charts (except in quotes);
 spell out *number one* in all other uses (*Tuberculosis is the number
 one cause of death in people living with HIV*); **#1** also acceptable
 informally

now: When referring to time, do not use a comma (*I used to be completely terrified of heights. Now I'm generally OK with heights*). When used colloquially, use a comma (*Now, I'd never say that all cats are awesome, but I've never met one who wasn't*).

the n-word (style thusly)

NYC

O

"O Canada" (for both the national anthem and expressions)

Obamacare

OB-GYN

O-face

offscreen (adv. and adj.)

offseason

OG (no periods)

oh man, oh my god, oh no (all OK without comma after *oh*)

OkCupid

ombré

omega-3

omelet

on-again, off-again

onboard: one word as a modifier (*onboard entertainment*), but *There was a baby on board.*

on demand (lowercase, unless part of a service's official title)

onesie

onscreen (adv. and adj.)

Other, Otherness: Capitalize to indicate use of the term as a category, especially when discussing race e.g., *I think people make a clear distinction that [Lupita Nyong'o] is this exotic, fetishized Other— and therefore not "black" like the rest of us.*

P

PA (for personal amplifier)

page 1, page 2, etc. (for references to book pages)

pageview

Paleo diet

partier

pawprint

peekaboo

peeping Tom

pet sitter, pet-sit, pet-sitting

PhD, PhDs (plural)

phone calling (as a v., no hyphen)

photobomb, videobomb

photo op

photo shoot

Photoshop (n., the program), **photoshop** (n., generically, an image that has been altered), **photoshopped** (adj.), **photoshop** (v.)

the Pill: Capitalize when referring to birth control, but only when used as a n. and after *the*, e.g., *She was on the Pill to regulate her period. There's a new pill on the market with a lower dose of estrogen.*

pinecone

pins, pinners (on Pinterest) are always lowercase

PJs

placemat

playoff

pleaded (not *pled*, for past tense of *plead*, per *APS*)

Plexiglas for the trademarked product; **plexiglass** as the generic term

plus-one (preferred to *+1* in running copy)

plus-size

Pokémon

pop star, rock star

Pornhub
porta-potty
Post-it Note
pour-over (as in the coffee)
PrEP (for the HIV prevention regimen)
primetime (one word, all forms)
protester
pro tip
***pseudo* words:** Don't hyphenate, e.g., *He rose from Obama stand-in to pseudo strategist.*
publicly (not *publically*)
Pumpkin Spice Latte (capped when referring to the trademarked Starbucks beverage)
punchline

Q
Q&A
quote-unquote (in speech)
Qur'an

R
rainforest
rearview (adj.)
Recode (the tech site)
Reddit (capped in running text), **redditor** (lowercase for someone who uses Reddit)
red-light district
reform: Avoid in descriptions of political policy, and instead opt for specificity, e.g., *tax-cut plan* rather than *tax reform*
refriend, retweet, repin
Republican National Convention but *Republican convention* if not spelling out entire name

Republican Party (cap "P")

ribcage

rickroll

ride-hail, ride-hailing (preferred over *ride-sharing* to describe services like Uber and Lyft)

ride-share, ride-sharing (use only when referring to a shared-ride service, like UberPool)

riesling

right-click (hyphenate all forms)

right-swipe (hyphenate all forms)

RIP (no points)

road trip (n.), **road-trip** (v.)

rock 'n' roll

Rock, Paper, Scissors

Rock and Roll Hall of Fame

roid rage

rom-com

room 1, room 202, etc. (lowercase "r" in reference to room numbers)

round trip (n.)

royal baby (lowercase)

royal family (lowercase)

RT'd, RTs, RT (on Twitter)

runtime

S

Satan, satanic, satanism

SBD (silent but deadly)

sci-fi (but *science fiction* in all forms)

screencap

screengrab

screensaver

screenshort (a screenshot of text shared on social media)

screenshot (OK as n. and v.; *screenshot* as past tense and past participle)

seahorse

seatbelt

semi-automatic

service member

setlist

al-Shabaab

Sharia: *Sharia* is defined as *Islamic law*, and therefore *Sharia law* is unnecessary/redundant when discussing the general framework of Islamic religious law; the term *Sharia law* should be used to refer to a code of government-implemented criminal and civil laws that are claimed to be derived from Islamic teachings or a provision of such a code.

Shiite, Shiites (not *Shia*, for the branch of Islam, but *Shia* is acceptable in quotes)

ship names: capped and italicized (USS *Awesome*; *Millennium Falcon*)

shippers (when referring to fans who yearn for a fictional couple's romance); **ship, shipping** (v.)

shitfaced

shithole

shit list

shitload

shitshow

shitstorm

shit talk (n.); **shit-talk** (v.)

shit ton

shoebox

shoegazer

ShondaLand

shoo-in

shortform

showrunner

showtunes

shyest

sideboob

sidebutt

side-eye

sideview (adj.)

slideshow

slushie (n.)

smartglasses

smartphone (but *cell phone*)

smartwatch

snowblowed (for past tense of *snowblow*)

S.O. (for *significant other*)

softcore

Solo cup

soulmate

soundcheck

soy milk

spacewalk

spandex

spell-check (n. and v.)

spinoff (n.)

spoke out: Avoid; *said* generally works just as well.

SpongeBob SquarePants

spray paint (n.), **spray-paint** (v.)

Sriracha

stand-up (comedy)

Stanky Legg (for dance move)

Starbucks drink sizes: tall, grande, venti, trenta (lowercase)

startup

Statehouse (always capped)

the States (when referring to the United States)

STD/STI: STI (sexually transmitted infection) is preferred to *STD* (sexually transmitted disease) in body copy, spelled out on first reference, but *STD* is acceptable in headlines and when lots of quoted material in a story uses *STD* and using both terms interchangeably could be potentially confusing to the reader.

Steadicam

stepgrandfather, stepgrandmother (Close up all *step* relationships unless next word starts with a vowel.)

stop-and-frisk (Hyphenate in all uses.)

storyline

straight-up (Hyphenate as an adj. before a n., v., etc.)

streetwear

struggle bus (a metaphor to describe a tough situation)

student-athlete (also, *student-performer* and the like)

subreddit

sucker punch (n.); **sucker-punch** (v.)

sugarcane

supercut

superfan

super PAC

superpredator (when referring to the 1990s crime myth)

supervillain

surfbort

Sweet 16

synthpop

T

tae kwon do

takeout (n.); **take out** (v.); **takeaway** (n.)

TARDIS

Taser, tase, tased, tasing (OK to use as a v., contrary to *APS*)

taste test (n.); **taste-test** (v.)

tear gas (n.); **teargas** (v.)

TED Talk

teepee

teleprompter

TfL (as an abbreviation for *Transport for London*)

The One (as in destined romantic interest)

thinkpiece

third world: Avoid; use *developing world/country* instead.

tick-tock

Time **magazine** (not *TIME*)

time-lapse (adj.); **time lapse** (n.)

timeline (one word, all forms)

timeshare (one word, all forms)

timestamp (one word, all forms)

tl;dr (all lowercase, unless it starts a sentence, in which case, *TL;DR* should be followed by a colon if introducing a sentence)

the *Today* show (not *The Today Show*)

touchscreen

Tourette syndrome

Toys 'R' Us

TP'd (for *toilet-papered*)

tracklist

tractor-trailer

transatlantic

treehouse

trendspotting

T. rex

tristate (one word, lowercase)

try to (not *try and*, e.g., *I'm going to try to call her later.*)

Twitter, tweeting, tweets

Twitterstorm

two-buck Chuck

type A, type B (as in personality)

U
ugly-cry (all uses)
UK
UN
underboob
underway (all uses)
unfriend (not *de-friend*)
unsee
updog (*Nothing, what's up with you?*)
up front (adv.)**; up-front** (adj.)**; upfronts** (n., refers to the meeting held by television executives)
upvote/downvote (n. and v.)
US, USA (generally interchangeable)
username

V
V-Day (as an abbreviation for *Valentine's Day*)
Vine-ing (*post a Vine* or *use Vine* is preferred; cap in all uses)
Viner (i.e., someone who uses Vine [RIP 💀])
vinyasa yoga
Vitaminwater
V-neck
Vogue **Paris,** *Vogue* **Italia** (not "French *Vogue*," "Italian *Vogue*"), but British *Vogue*
voicemail
voiceover
vs. (with a period, lowercase in list-y posts), *versus* (spelled out in news articles, longform stories); but *v.* for court cases
V-shaped

W

wack (adj.), not cool, effed up; **whack** (n., v.), a hard or resounding blow, to hit with a hard or resounding blow; also gangster (as in *Godfather*) slang, to kill

Wall Street (spell out, rather than *Wall St.*, in running text, unless talking about a specific address)

Walmart (for the retail store and the corporation)

"war on terror" on first reference, no quotation marks on subsequent references (same applies to similar phrases, e.g., *war on drugs*)

Washington, DC; the DC area—but in datelines just *WASHINGTON*

watch list

web, website, webpage

web comic

web forum

weightlifting (but **weight lifter**)

Western (cap for film or book genre, but lowercase for music genre)

wetsuit

whitewater (adj., as in rafting)

whiz (n.)

whoa

who's who

wide-awake (hyphenate as an adj. before a n.)

widescreen (one word, both as n. and adj.)

Wi-Fi

WikiLeaks

windbreaker

wineglass

wine varietals: See *APS*

workflow

workwear

World Wide Web

writers room

www: Never use in a URL unless it you can't access the site without it (or if the URL requires the odd *www1.* or *www2.*)—all very rare instances!

X
Xacto

Y
YA (for young adult lit)
yaaass
Yahoo (no *!*)
yeah
young'un
YouTube, YouTuber

Z
zeitgeist (lowercase, even though *MW* ~often~ caps)
zip code (not *ZIP code*)
Ziploc for the trademarked product; **ziplock** as the generic term
z's (aka sleep)

The BuzzFeed UK Style Guide Word List

Always use the British spelling of words such as *colour, travelling, centre*, and *analogue*. This is a good guide to the ways British and American spellings differ. Note that BuzzFeed UK (like most UK publications) spells words like *apologise* and *realise* with *-ise*, not *-ize*.

A
aeroplane (not *airplane*)
ageing
airstrike
A-level
alright (perfectly alright as an informal variant of *all right*)
among (not the old-fashioned *amongst*)
analogue (also *catalogue, travelogue* etc)
any more (not *anymore*)
apologise (also *itemise, realise, recognise, sympathise* etc)

B
Battle of Britain
bedroom tax (no need to put quotes around term)
bellend
black-cab driver (for drivers of black cabs)
breakup
Brit Awards

bubblegum

C
Central line (also District line, Hammersmith & City line, Northern line, etc)
centre (also *fibre, litre, metre, theatre* etc)
Channel tunnel
Chas & Dave
colour (also *flavour, honour, neighbour* etc)
Corbynmania
'cos (for the abbreviation of *because*)
cossie (colloquial term for *swimming costume*)
courts: magistrates' court, crown court, youth court etc
crown jewels

D
disability living allowance (DLA)
the Doctor (when referring to the protagonist in *Doctor Who*)
Dr

E
East End (but see next entry)
east London, south Glasgow etc
ecstasy (for the drug)
Edinburgh festival, Edinburgh Fringe, the Fringe, the festival
employment and support allowance (ESA)
etc
euro, eurozone, Eurosceptic

F
filmmaker
food bank

football (not *soccer*)
freshers' week
fulfil

G
grey (not *gray*)

H
healthcare
home in (not *hone in*)
hospitals: Royal Free hospital, Hereford county hospital, St Thomas'
 hospital etc
houseshare
hummus

I
inquiry
Irn-Bru

J
jewellery
jobcentre
jobseeker's allowance
judgment (not judgement)

K
King's Cross

L
licence (as a n.)
London Overground, the Overground

M
makeup
marvellous
maths (not *math*)
Metropolitan police, Yorkshire police, British Transport police etc
Mr, Mrs, Miss, Ms

N
national living wage (NLW)
no one (not *no-one*)
normality (not *normalcy*)
the North/South divide, but **northerner, southerner**

O
offie (slang for *off-licence*, i.e. alcohol shop)
oilfield
on to (never *onto*)
orangutan

P
per cent (although use % unless a number starts a sentence and needs spelling out)
personal independence payment (PIP)
PigGate
practise (as a v.)
programme (but *program* for software)

Q
the Queen

R
Ramadan, but **Ramzan** in India

royal baby, royal family, royal wedding etc

S
shitload, shit-ton
skilful
storey (when referring to levels of a building)

T
the TARDIS
TfL (not TFL), aka **Transport for London**
think tank
travelcard
travelling (also *fuelling, modelling* etc)
the tube, the underground, but **London Underground** for the company
 name

U
UKIP-er (for the term meaning supporter of UKIP)
union jack, union flag (the terms are interchangeable)
universal credit

W
wars: Iraq war, second world war, cold war etc, but World War II, the
 Great War
the West Country
Wetherspoon's, Spoon's (*J.D. Wetherspoon* for the company name)
while (not the old-fashioned *whilst*)
wilful

Y
year 7, year 11 etc (for UK school years)
yoghurt

Terms You Should Know

BRB: be right back

CMS: content management system (aka the thing you use to make stories come to life on the internet)

dek: another word for a subheading—the typically one or two lines that supplement a story's headline

FOMO: fear of missing out

FWIW: for what it's worth

hed: an abbreviation for *headline*

IDK: I don't know

IMO (and the more intense *IMHO*)**:** in my opinion/in my honest opinion

IRL: in real life

JK: just kidding

LOL: laughing out loud (which, as you may notice throughout these pages, I've capitalized—or not—with a strict adherence to the "Follow your heart" rule; sometimes context calls for a weightier, more sincere *LOL*, and sometimes an understated *lol* does the job, in which case an ensuing *jk* typically follows suit; *Lol* may be used to start a sentence)

noob/n00b: a cute and funny way to say *newbie*

SMH: shaking my head

stet: a traditional proofreader's mark meaning "let it stand" (aka keep text as is)

TBH (and variations thereof, e.g., *TBQH*)**:** to be honest/to be quite honest

TBT: throwback Thursday (often used in hashtag form to caption an old photo)

TL;DR: too long; didn't read (often left as a comment by an impatient reader)

WTF: What the fuck?

Appendix III

Headlines on the Internet

A cool thing about working on the web is all the unlimited space you get to play with in order to get your thoughts across. It's like an all-you-can-eat buffet but with words. And like an all-you-can-eat buffet, endless amounts of stuff can be fun and exciting, but at some point you start feeling terrible and you say to yourself, *Man, this is just too much. I've gone too far.* So, to conclude this incredibly lazy analogy, use a healthy serving of words, and try to stay within reason. The same way eating fifteen tacos when five would have satisfied you, no one needs—or wants—to read 10,000 words when half of that gets the job done without all the unnecessary shit to deal with. (I take that back; that was a brilliant analogy.)

This is important to keep in mind when crafting headlines. First off, hooray, you don't have to torture yourself by writing one of those uncomfortably stilted newsy headlines! ("It Only Tuesday" is an *Onion* headline I love for taking a jab at the wooden phrasing traditionally abound in newspapers.) However, having a virtually infinite number of characters at your disposal for your story's headline doesn't mean you should go full-out anarchy. A few things to consider: One, it's probably in your best interest to use a headline that can be read in full when it's tweeted. At the very least, try to have the crucial stuff up at the beginning before it might get cut off on the channels on which you're sharing it. One example of this, done well by the *Daily Mail*, was a shocking story in January 2015 about children being abused and held in

deplorable conditions with the headline "Children Caged to Keep the Streets Clean for the Pope: Police Round Up Orphans and Chain Them in Filth During Pontiff's Visit to Philippines." The optimized headline for Twitter and Facebook: "Five-Year-Olds Caged to Clean Up Streets for Pope Francis."

Also, because stories on the internet are floating around piecemeal, and not as part of one big printed package in which the unlucky reader has no choice but to be exposed to all the stories published within its covers, unsavory headlines and all, getting a headline right on the web is arguably more crucial than in its print counterparts. Many online publications optimize headlines to see what performs best, and small tweaks can often make a big difference in terms of selling a story. A helpful guideline is to ask yourself, *How would I describe this story to a friend?* Shocker: Using normal language works really well! Imagine your office deskmate's curiosity upon hearing you shriek in shock, then peeking over to find you staring dumbfoundedly at your computer screen. "What happened?" he asks. In slow motion, you turn your head to face him, and you utter in pure disgust, "Girl opened tuna can, found surprise."

Just kidding. Of course you don't. You say, "Whoa, a girl opened a tuna can and found a gross little creature staring back at her," because you are not a cyborg. There's no trickery involved, no awkward newspaper-y phrasing. A headline that speaks to you in those same straightforward layman's terms—in the way you'd synopsize the story in casual conversation—is simply more inviting. It's like a big hug from a loved one who's also just vomited after seeing the same disgusting tiny tuna-can monster you did.

Holy Crap, This Poop-Themed Café Is Fucking Gross But Sign Me Up

In another example, my deputy copy chief created a post rounding up all of the most brilliant tweets under the #ModernCollectiveNouns

hashtag (side note: Do yourself a favor and read through all of these as soon as you can, "a bulge of mansplainers" and "a seried of typos" being among them) called "27 Hilarious Modern Collective Nouns That Should Exist." The performance of the post using that headline paled in comparison to the one tested with "27 Hilarious Words for Groups of Things That Should Exist"—a description with plain language rather than a term with a mission to bore the reader to death. *Collective noun* may not be a household phrase, but everyone knows what "groups of things" are.

Similarly, a BuzzFeed post originally published under the headline "I Dressed Up and Down As a Black Man and This Is What Happened" had significantly more traffic when it ran with "A Black Man Wore Different Kinds of Clothing to See If People Treated Him Differently." This may have also been because the former was a bit ambiguously worded; it almost sounded like the author may not, in fact, have been a black man, but had dressed as one—whatever that means—to see what would happen (not cool, FYI). The more clickable headline gives the reader a clearer idea of what they're in store for.

Given the general success of the test-and-observe method, if there's one question that makes me want to see the internet take one final bow before the curtains are drawn on it forever, it's some iteration of "So, what's BuzzFeed's secret sauce?" I hate the "secret sauce" metaphor, if not least because it brings back painful memories of the last Big Mac I ate, which was also the last Big Mac I threw up, as a seven-year-old traumatized by the steep price I never envisioned I'd have to pay for a rinky-dink Hamburglar Christmas ornament. A website, to be clear, is not a burger. And there's nothing secret about BuzzFeed's strategy; much of the time our editors don't even know what it is about our strategy that's making half the people on Facebook click and share our posts. Cat's outta the bag!

On an episode of one of my favorite podcasts, *The Allusionist*, hosted by Helen Zaltzman, titled "Going Viral," BuzzFeed UK's very

own editorial director Tom Phillips noted that it's hard to tell if the phrasing of a particular headline has an effect on its views and shares, or if "the random fluctuations of the internet" are to blame—because, after all, "the internet is a capricious and willful beast." Despite my unwavering disdain for the "secret sauce" concept, I will acknowledge that there are a few factors—ones that Phillips mentions on this episode—that have been observed to be associated with internet virality. First off, while use of "curiosity-gap" headlines (those of the "This happened and you'll never guess what happened next!" variety) have been met with great success by other sites in the past, it's not a tactic BuzzFeed has ever embraced—we favor the "Tell it like it is" approach. "The headline should actually inform you rather than tease you or trick you," as Phillips said. It's not exactly rocket science: People don't like being duped. Directness is more sustainable.

Being inundated with trash at every corner while cruisin' the 'net (sorry) can undeniably put a little wear and tear on one's mental well-being—but if there's one glimmer of positivity to be found from deep within that pile of rubble, it's that our bullshit detectors are getting stronger. We've seen "and you won't believe what happens next!" fail to deliver often enough that we are indeed prepared to believe what happens next. (Something normal AF, that's what.)

Clickbait, to be certain, may mean different things to different people. There are clickbait-y headlines of the hyperbolic variety, with their *blow your mind*s and *literally*s and other wildly oversized statements demanding your attention, which I'll argue are infinitely more tolerable than curiosity-gap headlines when there's an element of self-awareness, irony, or just plain silliness interwoven: "These Pictures of Ryan Gosling at Cannes Will Destroy You," "Kendall Jenner Just Killed Everyone When She Showed Up at the Met Gala," and "Can You Make It Through This Post Without Getting Pregnant?" are prime examples. As Phillips notes, hyperbole "has to be inventive, it has to be creative, it has to not be bullshit. It has to be something that everybody gets instinctively."

There are also the sarcastic headlines, which, though impolite, rouse even the most impervious to typical clickbait—the Francophile who's taken the headline at face value and is ready to launch a Change.org campaign calling for the resignation of the writer who had the gall to publish a post titled "42 Reasons You Should Never Visit France," or the animal rescue advocate ready to hunt down the person who wrote "24 Reasons Why No One Should Ever Have a Pit Bull As a Pet." While this format was successful for a brief moment, eventually readers became desensitized to—and annoyed by—the sarcasm, and we retired these sorts of headlines for the most part (but not before we were moved to add a disclaimer of sorts, like "lol jk" in a dek, for those who just ~didn't get it~).

And what of those teaser headlines that offer just enough intrigue to convince you that you absolutely need to know what the hell an *Upworthy* article titled "Watch the First 54 Seconds. That's All I Ask. You'll Be Hooked After That, I Swear" is all about? Spoiler: kids making instruments out of garbage. Make no mistake: These headlines are bullies who are not here to make you laugh but instead make you feel like a big ol' dummy who believed you'd be shocked about what this man opened up his refrigerator to find, but really it was just moldy bread. Sucks to be moldy-bread man but joke's on you, idiot!

The thing is, to sites like *Upworthy*'s credit, headlines of this ilk *did* work really well—but the expiration date on that tactic is long behind us; after their third or fourth begrudging click, readers acknowledged the lack of sufficient shock to warrant such a sensational headline, and Pavlovian instincts took over. Modern-day patrons of the internet are more skilled at sniffing out the truly interesting "viral news" from the snoozy and the misleading. Headlines, by their nature, must be reductive to an extent, but that doesn't give them license to be downright deceptive. Humans don't like being tricked. We can watch *Catfish* marathons for our schadenfreudian fill of that.

Another notable influence on virality: "The word *actually*—just adding that to otherwise innocuous headlines seemed for a while…to

definitely make them better," said Phillips. "Like simple quizzes, rather than 'Which Kind of Beyoncé Are You?' 'Which Kind of Beyoncé Are You *Actually*?'" There's something sweetly naïve here: the idea of the loyal, trusting reader, confident that the addition of *actually* is truly going to separate this quiz from all those other fake-ass "Which Beyoncé are you?" quizzes out there—the quizzes that this very quiz is, in fact, acknowledging are out there but are in no way close to the real deal. The idea that the editors of said quiz have been working tirelessly, day in and day out, consulting with Queen Bey herself to analyze how her inner-most thoughts, her motivations, her sartorial preferences, have shifted along the way, from Destiny's Child to *Lemonade*, in order to ensure that this, dear internet, will be the quiz to end all Beyoncé quizzes. That this quiz will deliver, once and for all, a definitive answer to whether you're "Crazy in Love" Beyoncé or "***Flawless" Beyoncé, because sweet Jesus, how else are you ever going to figure this out in your lifetime? And also, you know, it's just funnier to share the results of something so bathetic.

Also effective is the use of what is called litotes—or as Zaltzman explains it, "the use of understatement for rhetorical effect," like saying, "The view from Empire State Building isn't bad" or describing a very attractive person as "just all right."

But the takeaway here is that humans get bored, and there will likely always be backlash to too much of anything; one too many litotes-leaning headlines may push your audience away eventually too, the same way teaser headlines did after reaching their saturation point. Like all irritating trends that inevitably return, maybe one day we'll see a resurgence of tricksters like the curiosity-gap headline and the sarcastic headline in new iterations—and then their appeal will wane, and it will happen over and over again until we die, or the internet dies. Whichever comes first.

The internet is exhausting.

Most heart-achingly—even more heart-aching than permitting two-line headlines that use periods to fly under my watch after years

of resistance, which, *fine*, I guess they work for dramatic effect some-times—I've had to come to terms with the fact that headlines with a misplaced *only* often tend to fare better than their technically correct counterparts. Take, for instance, "Things You'll Only Understand If You Grew Up in the '90s" (incorrect placement of *only*) vs. "Things You'll Understand Only If You Grew Up in the '90s" (correct place-ment of *only*). As any sober copy editor who's had a decent night's sleep will confirm, technically *only* should directly precede the phrase it is intended to modify and be placed no farther away than that. Maybe it's just my pet peeve, but hear me out. In the example mentioned, the "things" in question will be understood by someone who grew up in the '90s, and so *only* should directly precede the phrase *if you grew up in the '90s*. By placing *only* before *understand*, the implication is that if you grew up in the '90s, you'll only understand these—and maybe you won't understand *anything else at all* or be able to perform any other action besides understanding these things. Do you really want to be confined to such dismal existence? Where the only things you're able to understand if you grew up in the '90s are twenty-six pictures in a BuzzFeed post??? RIP, your brain.

Of course you don't, and of course that isn't how anyone is reading that headline. You'd more than likely read the former headline as mean-ing the latter, because *this is how we speak*. Admittedly, in my career as a copy editor, I've been a bit of a stickler about the proper placement of *only*, and as a result, have been hyperaware of incorrect usage in my conversation, so I do make a point of using it accurately in spoken dialogue, but no matter. Most people do not do this. Will this be yet another grammar rule laid/n to rest sooner than we can say "I'm going to lay down" without having to worry about a pack of rabid copy edi-tors charging full speed ahead at us, clutching usage manuals shaped as knives in their clammy hands? Maybe so.

Appendix IV

Editing for an International Audience

When you publish stuff on the web, you're writing for a global audience, whether it's your intention or not. Awareness of this is specific to the plight of the digital copy editor; print publications generally tend to have more defined demographics that individual pieces traipsing through the internet do not. If you're writing something in English and hitting "publish," chances are your readers aren't all going to be residents of the same country.

Wading through the murky waters of regional dialects, you'll learn many fascinating things—frequently via really mean commenters (or short-fused editors). If you work for a global media company, when possible, aim to hire copy editors in the UK and Australia (or those with familiarity editing stories in British and Australian English)—if not only so you can hear stories about how your sub-editors troll the expats working out of your UK office by exaggeratedly pronouncing the *u* in words like *colour* and *favour*. Even then, though, fingers will still be pointed across the pond, wondering why in hell you would ever think changing *in hospital* to *in the hospital*, *on the cards* to *in the cards*, or *have a shower* to *take a shower* was necessary. (The former in each pair is perfectly acceptable phrasing in the UK.)

 drumoorhouse 5:10 PM
til: cba = "can't be arsed"

 meganpaolone 5:10 PM
I just learned that
good acronym

emmyfavilla 5:11 PM
oh wow
good to know

Learning things every day at BuzzFeed.

It's this awareness of a wider English-speaking audience's language conventions and turns of phrase that has led the BuzzFeed copydesk to make a few stylistic choices in the interest of user-friendliness across the globe. One such decision was the revision of a previous style guideline to use state abbreviations such as *Conn.* and *Fla.* when preceded by a city name. It takes long enough for a person within domestic borders to remember that *Mo.* stands for Missouri, not Montana (I'm confident it can't just be me?); how are residents of Iceland or New Zealand expected to immediately recognize this abbreviation? In addition to such abbreviations often being an eyesore (cc: the genius who settled on *Calif.* instead of *Cali.*), spelling states out is also a no-brainer in terms of search benefits. When Michael Brown was killed in Ferguson, Missouri, BuzzFeed noticed the majority of searches were being done for terms "Ferguson Missouri" rather than "Ferguson Mo"—not surprising given an international readership. (*APS* has also since revised its guideline, noting to abbreviate state names—barring Alaska, Hawaii, Idaho, Iowa, Maine, Ohio, Texas, and Utah—in datelines only, not in running copy.)

The BuzzFeed Style Guide has extended this logic to its recipes section, in which the guideline for measurements in ingredient lists formerly suggested using the standard abbreviations (like *lb, oz, tsp, Tbsp*) found in most printed recipes. There are a few issues that jump out here. One: There is neither an "l" nor a "b" to be found in the word *pound*. This is something you'd think would have been addressed by now, more than a millennium and a half after the fall of Ancient Rome. Long after we ceased seeking amusement by watching gladiators fight lions, we still use the abbreviation for the Ancient Roman *libra ponda* ("pound of weight") to denote 16 ounces. As for *oz*? That one comes from the Medieval Italians'

word for *ounce*: *onza*. Yeah. That sound you hear in the distance? Don't worry, it's just the rest of the world laughing *with* us, not at us. And who had such pitiful faith in literate human beings that they decided we needed an extra reminder that a tablespoon is bigger than a teaspoon, so how about we use a capital "T" in *Tbsp* just so no one forgets? Stop the madness and start spelling everything out if space constraints aren't an issue. Let us not consider our own time more valuable than that of someone else who just wants to make the damn salmon already but lives in another country and doesn't have all day to look up what antiquated abbreviations mean and how they convert to metric (aka logical) measurements.

Other concerns you'll have to face include more technical stuff, like punctuation. If you leave this appendix with just one takeaway, it's that there are two things the UK doesn't understand about the States: (1) our obsession with guns (same, tbh), and (2) our obsession with periods. Or, as they're elegantly called over across the ocean, full stops. (Though, I guess if we called them something as harsh as full stops we might not be as wont to sprinkle our pages with them like confetti.) The UK HATES periods. (The punctuation kind, not the reproductive-organs kind. Yes, okay, fine, I can see the argument for calling them full stops.) And you know what, I can't totally disagree with them. Periods take up precious space, and I'm positive we wouldn't miss them if they were gone. Whether you have a Ph.D. or PhD, we all know you're important. And it does kind of make more sense, consistency-wise. Why do most national news publications use periods in *U.S.*, *U.K.*, and *U.N.*, but not *CDC* or *FBI* or *STI*? That's a great question, and one I'm not fully prepared to give a good answer to, because as a nation we are collectively in the wrong. It's AP style, yes, and perhaps it's a style American eyeballs are more used to seeing in print, and maybe *U.S.* functions to distinguish the United States from someone yelling "us" really loudly—so it stood in the BuzzFeed Style Guide since day one... until one fateful summer day.

See, things get kinda #awk when you consider that the official name of our bureau in London is BuzzFeed UK, not BuzzFeed U.K.,

punctuated sans periods, even in a US post. And after enough years of realizing that the divide between offices due to geographical distance was only being intensified by punctuation preferences—not to mention wildly different emotional responses to tea—the BuzzFeed copydesk took a stand in the name of copy editor/sub-editor unity, and a *major* style revision was announced in July 2016:

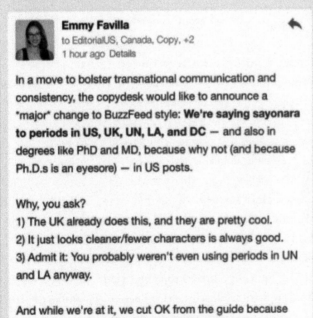

 Ben Smith ☑
@BuzzFeedBen

 ⚙ Following

Rushing back from Cleveland to put down the coup on our copy desk

Emmy Favilla ↰
to EditorialUS, Canada, Copy, +2
1 hour ago Details

In a move to bolster transnational communication and consistency, the copydesk would like to announce a *major* change to BuzzFeed style: **We're saying sayonara to periods in US, UK, UN, LA, and DC** — and also in degrees like PhD and MD, because why not (and because Ph.D.s is an eyesore) — in US posts.

Why, you ask?
1) The UK already does this, and they are pretty cool.
2) It just looks cleaner/fewer characters is always good.
3) Admit it: You probably weren't even using periods in UN and LA anyway.

And while we're at it, we cut OK from the guide because sometimes you need an *OK* and sometimes you need a

RETWEETS LIKES
109 317

This was a little traumatic for my team, to say the least.

Megan Paolone ✔
@meganpaolone

Following

I am LOSING MY MIND

BuzzFeed Style Guide @styleguide
We're saying sayonara to periods in US, UK, UN, LA, and DC! (And also in degrees
like PhD and MD, because why not — and Ph.D.s = 🍸)

LIKES
5

3:56 PM - 18 Jul 2016

That's our deputy copy chief.

But we knew in our heart of hearts that it was simply the right thing to do, crippling fear of change be damned. (To be clear, I'll draw the line at *Dr.*, *Mrs.*, *etc.*, *vs.*, *e.g.*, *i.e.*, and the like—I don't think eyeballs in the USA are ready for the period-less forms of them just yet.)

Listen, I'm not telling you what you should or shouldn't do, or advising you to re-evaluate house style if you're still using periods in *US* and *UK*. What I *am* saying is that you can only worry about such things for so long before acknowledging that no one's losing their life over this, and could you even *imagine* dealing with the stress of being a surgeon who has others' lives in their very hands? See. You already forgot all about those dumb little periods. Perspective, people.

At BuzzFeed, figuring out a consistent style to adhere to for our world-news section, with stories by writers across the globe, has been nothing short of head-spinning. The agreed-upon solution? Just don't worry about being consistent, and stick to the standard grammar, spelling, and punctuation guidelines used in the region where the writer is located. Reasonable enough, right? But what happens when said pieces make reference to a global organization that *doesn't* use local spelling?

BuzzFeed style is to follow the way the organization self-styles (e.g., World Health Organization, World Food Programme), regardless of the location of writer (meaning someone reporting from the UK wouldn't be expected to change the aforementioned to World Health Organisation). Easier and less awkward for everyone.

It's also helpful to be aware of acronyms and initialisms that are recognizable enough to stand alone without being spelled out, which can vary not only based on the age and culture of your readership, but also, of course, on geographic location. Some universally recognized ones across English-speaking countries include *AIDS, CEO, MTV,* and *PMS*. In the UK, *UKIP* on first reference is acceptable for United Kingdom Independence Party, whereas an American audience may not readily recognize the acronym; in Australia, *HSC* (Higher School Certificate) is fine on first reference as well, much the way *GED* in the US is referenced more often as such than the fully spelled-out *general equivalency diploma*—which, admittedly, I just googled to verify, so arguably, it's *more* recognizable as an initialism.

In addition to abbreviations, it's important to be mindful of general terms that may not be immediately familiar to someone outside of a domestic readership. Consider, for instance, a 2015 story that BuzzFeed ran about the "1099 economy." To an average adult in the United States—at least one intelligent enough to be interested in a story about the 1099 economy—it should be clear that *1099* refers to the tax forms often associated with independent contractors. The story in question even explained that "the '1099 workers' are so named because of the IRS tax form they fill out for contract work at places like Uber and Lyft, as opposed to the traditional W-2 form for full-time employment." In 2016, BuzzFeed published a story about why tax day is difficult for Uber drivers, in which a line read: "But the independent contractors who deliver groceries for Instacart and drive for Lyft—not to mention those who teach yoga, cut hair, or consult independently—file 1099 forms, entering them into a whole different, and usually more complicated, tax process."

Someone tweeted at me asking if we could standardize *1099* for our international readers (a tweet I admittedly never got around to responding to, for reasons that may or may not have been because of its slightly patronizing tone—but here's your response now, concerned reader!), as the latter sentence could be misread as someone filing a whopping 1,099 forms. Perhaps we could put *1099 form* in quotation marks, they suggested. Well, no. Reason #1: Stylizing "1099 form" as such would simply look silly to American readers, arguably the primary audience of both of these stories, which were written by American writers working out of an American bureau. This is not to say we do not welcome readers from around the globe, of course, but quotations could make it seem like said form is a new, unfamiliar, or made-up term. Reason #2: Commas! As much as the lil' bugger can get on all of our last nerves sometimes, when it comes down to it, the comma is our friend—and can mean the difference between 1,099 forms (a big, scary pile) and 1099 forms (not a big, scary pile, but still kinda scary). Reason #3: Google! Google is also our friend, and if you're not sure what something means but can sort of guess based on context that we're not actually referring to a giant stack of over a thousand forms, search "1099 form" and you'll learn something new.

I will confess, however, that I did see a glimmer of validity in that request, and thought to myself, *Why don't we try to find a better way of phrasing that*—short of using quotation marks—*so that our British and Australian and Canadian counterparts (and, hey, maybe any fellow Americans who have evaded taxes for all their lives and might not be certain what a 1099 is either) might better understand the situation?* After an edit, I changed the line to "But the independent contractors who deliver groceries for Instacart and drive for Lyft—not to mention those who teach yoga, cut hair, or consult independently—file what are known as 1099 forms, entering them into a whole different, and usually more complicated, tax process," which I hope improved clarity a bit for all.

And finally, for those of you looking for employment overseas, before perusing job listings, remember that the people (lifesavers, miracle workers, VIPs—we go by many monikers) known as copy editors in the US are referred to as sub-editors across the pond. As if finding a job weren't (wasn't? whatever) stressful enough.

Additional Quizzes

Do You Know What These Weird English Words Actually Mean?

These are all words that can be found in a current dictionary. Without looking them up, try to guess the correct meaning of the following:

Trumpery

(a) Luggage designed for carrying an instrument

(b) Worthless nonsense

(c) The act of being more important than someone else

(d) A place where trumpets are serviced

Koumpounophobia

(a) Fear of buttons

(b) Fear of crocodiles

(c) Fear of raccoons

(d) Fear of sharp objects

Bumfuzzle

(a) A cluster of honeybees

(b) The act of tripping and falling

(c) To confuse or fluster

(d) To flourish or grow

Borborygmus

(a) A mythical horned sea creature

(b) A rumbling sound in the intestines

(c) A lump on the skin due to excessive growth of fibrous tissue

(d) A scarring of the bronchial tubes

Callipygian

(a) Having a shapely booty

(b) A person who has beautiful handwriting

(c) A person who has big eyes

(d) One with extensive knowledge of firearms

Pilgarlic

(a) A cruciferous vegetable

(b) A jokester

(c) A tool used for carving rocks

(d) A bald-headed man

Mumpsimus

(a) One who steals things that are not very valuable

(b) A notion that is held even though it's unreasonable

(c) Talk that is not important or meaningful

(d) The dead body of someone who has voluntarily donated an organ

Gardyloo

(a) A collection of tulips

(b) A guest outhouse

(c) An herb that grows in tropical climates

(d) A warning cry

Abecedarian

(a) A person learning the rudiments of something
(b) A former magician
(c) One who studies clay or clay minerals
(d) A person who is especially prone to illness

Slubber

(a) To fumble with one's words
(b) To lose confidence
(c) To lose focus
(d) To perform carelessly

Answers
Trumpery: B; **Koumpounophobia:** A; **Bumfuzzle:** C; **Borborygmus:** B;
Callipygian: A; **Pilgarlic:** D; **Mumpsimus:** B; **Gardyloo:** D; **Abecedarian:** A;
Slubber: D

Can You Identify the '90s Movie From Just Three Emojis?

(a) *Titanic*
(b) *The Truman Show*
(c) *Billy Madison*

(a) *Richie Rich*
(b) *Forrest Gump*
(c) *Toy Story*

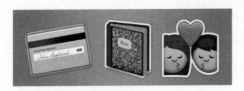

(a) *She's All That*
(b) *Empire Records*
(c) *Clueless*

(a) *Pulp Fiction*
(b) *Kids*
(c) *Heat*

(a) *Cruel Intentions*
(b) *Pretty Woman*
(c) *Mrs. Doubtfire*

(a) *Edward Scissorhands*
(b) *Dumb and Dumber*
(c) *Home Alone*

(a) *The Big Lebowski*
(b) *Reservoir Dogs*
(c) *Total Recall*

(a) *Kingpin*
(b) *The Prince of Egypt*
(c) *The Lion King*

(a) *Scream*
(b) *Home Alone*
(c) *American Beauty*

(a) *The Usual Suspects*
(b) *Fargo*
(c) *A Few Good Men*

Answers
367 top: A; **367 middle:** B; **267 bottom:** C; **368 top:** A; **368 middle:** B;
368 bottom: A; **369 top:** B; **369 middle:** C; **369 bottom:** C; **370:** B

Notes

Chapter 2: Language Is Alive

14　"The moment English stops changing": Katherine Connor Martin, "Ask a
　　Lexicographer" (session presented at the American Copy Editors Society
　　annual conference, Pittsburgh, Pennsylvania, March 27, 2015).

15　On a visit to China: Paul Chevannes, "Writings on the Wall," *Tracking
　　Changes: The Journal of the American Copy Editors Society*, Spring 2016 (Vol.
　　19, Issue 1), 21.

15　"the internet is allowing more people to influence": David Crystal, "The
　　Story of English Spelling," *The Guardian*, August 23, 2012.

17　"It is virtually impossible now": David Crystal, *Internet Linguistics: A Student
　　Guide* (Abingdon: Routledge, 2011), 68.

17　the word *minuscule*: "Minuscule." *Merriam-Webster.com*. Merriam-Webster,
　　n.d., web, accessed May 20, 2017.

17　the technically incorrect *miniscule*: "Minuscule or Miniscule?"
　　OxfordDictionaries.com, Oxford University Press, n.d., web, accessed May
　　20, 2017, en.oxforddictionaries.com/spelling/minuscule-or-miniscule.

19　*type* is not a synonym for *kind of*: William Strunk Jr. and E.B. White, *The
　　Elements of Style*, 4th ed. (Needham Heights: Macmillan, 2000), 62.

19　"overworked as a term": William Strunk Jr. and E.B. White, *The Elements of
　　Style*, 4th ed. (Needham Heights: Macmillan, 2000), 64.

19　George Orwell's six rules: George Orwell, "Politics and the English
　　Language," first published in *Horizon*, April 1946.

20　"It's really a question of attitude": Anne Curzan, "What Makes a Word
　　'Real'?" TED Talk presented at TEDxUofM, Ann Arbor, Michigan, March
　　2014, www.ted.com/talks/anne_curzan_what_makes_a_word_real.

20　"'Descriptivist' is not a slur": Kory Stamper, "A Compromise: How
　　to Be a Reasonable Prescriptivist," *Harmless Drudgery: Defining the
　　Words That Define Us* (blog), August 23, 2013, korystamper.wordpress
　　.com/2013/08/23/a-compromise-how-to-be-a-reasonable-prescriptivist.

24 85 percent of the *American Heritage Dictionary*'s Usage Panel: "Impact."
American Heritage Dictionary online, Houghton Mifflin Harcourt, n.d., web,
accessed May 20, 2017.

26 "the second sense of *hopefully*": "Hopefully." *Merriam-Webster.com*.
Merriam-Webster, n.d., web, accessed May 20, 2017.

27 "Four points about this word": Bryan A. Garner, *Garner's Modern English
Usage*, 4th ed. (New York: Oxford University Press, 2016), 470.

28 "Some people insist on maintaining": "Healthy." *American Heritage
Dictionary* online, Houghton Mifflin Harcourt, n.d., web, accessed May 20,
2017.

29 BuzzFeed copydesk has made a point: "More than vs. over." *BuzzFeed Style
Guide, BuzzFeed*, web, first published February 4, 2014, accessed May 20,
2017.

30 According to Allan Metcalf: Allan Metcalf, *OK: The Improbable Story of
America's Greatest Word* (New York: Oxford University Press, 2011), 1.

33 "There is no logical reason": "Alright." *OxfordDictionaries.com*, Oxford
University Press, n.d., web, accessed July 3, 2017, en.oxforddictionaries
.com/definition/all_right.

33 MW's entry for both variants: "Alright" and "all right." *Merriam-Webster
.com*. Merriam-Webster, n.d., web, accessed July 3, 2017.

33 Alright's first known use: "Alright or all right? Which is correct,
and when?" *Merriam-Webster.com*. Merriam-Webster, n.d., web,
accessed July 3, 2017, www.merriam-webster.com/words-at-play/
all-right-or-alright-which-is-correct.

34 "Our goal as editors": Samantha Enslen, "Why the *Washington Post* Stopped
Sending 'E-mail,'" *Tracking Changes: The Journal of the American Copy
Editors Society*, Spring 2016 (Vol. 19, Issue 1), 12.

Chapter 3: Getting Things Right: The Stuff That Matters

42 *were* with singular noun *menagerie*: Emmy Favilla, "My Dad Doesn't Say 'I
Love You,' but He Makes Great Coffee," *BuzzFeed*, June 16, 2016.

46 of a certain body part: Casey Gueren, "Here's the Truth About Pineapple
and Oral Sex," *BuzzFeed*, May 31, 2016.

46 sometimes a mix of both: Katie Herzog, "I Used to Be an Alcoholic. Now I'm
a Stoner Who Has a Drink Sometimes," *BuzzFeed*, September 9, 2015.

50 some examples from the stylebook: "Possessives" entry. *The Associated Press
Stylebook* online, The Associated Press, n.d., accessed May 20, 2017.

53 "Hyphen use is just a big bloody mess": Lynne Truss, *Eats, Shoots & Leaves:
The Zero Tolerance Approach to Punctuation* (New York: Gotham Books,
2006), 176.

Chapter 4: How to Not Be a Jerk: Writing About Sensitive Topics

62 "a person who is forced to leave his home or country": "Refugee, migrant, asylum seeker" entry. *The Associated Press Stylebook* online, The Associated Press, n.d., accessed May 20, 2017.

62 referring to male partners: Dan Vergano, "CDC Reports First Sexual Transmission of Zika in Same-Sex Male Partners," *BuzzFeed*, April 14, 2016.

64 "Many people have gender expressions that": "Gender-Nonconforming" entry. *GLAAD Media Reference Guide*, 10th ed., GLAAD (October 2016), 11.

67 "biographical and announcement stories": "Race" entry. *The Associated Press Stylebook* online, The Associated Press, n.d., accessed May 20, 2017.

70 the example of Deng Xiaoping: "Chinese names" entry. *The Associated Press Stylebook* online, The Associated Press, n.d., accessed May 20, 2017.

72 APS's guidelines on disability: "Disable, handicapped" entry. *The Associated Press Stylebook* online, The Associated Press, n.d., accessed May 20, 2017.

73 less tolerant toward individuals: Darcy Haag Granello and Todd A. Gibbs, "The Power of Language and Labels: 'The Mentally Ill' Versus 'People with Mental Illnesses,'" *Journal of Counseling & Development*, January 2016 (Vol. 94, Issue 1), 31–40.

73 "Person-first language is a way": Honor Whiteman, "How We Label People with Mental Illness Influences Tolerance Toward Them," *Medical News Today*, January 30, 2016.

73 in line with the social model of disability: "The Social Model of Disability," Inclusion London, InclusionLondon.org.uk, n.d., web, accessed May 20, 2017.

75 *short stature* instead of *little person*: "Dwarf/little person/midget/short stature" entry. *Disability Language Style Guide*, National Center on Disability and Journalism, n.d., web, accessed May 20, 2017.

79 There's a reason, as *Time* noted: Katy Steinmetz, "6 Things BuzzFeed's Style Guide Tells Us About What's Happening to Language," *Time* online, February 5, 2014.

Chapter 5: Getting Things As Right As You Can: The Stuff That Kinda-Sorta Matters

81 a recent study showed that copyedited stories: Fred Vultee, "Audience Perceptions of Editing Quality," *Digital Journalism*, January 6, 2015 (Vol. 3, Issue 6), 832–49.

81 "greater willingness to pay for edited journalism": Natalie Jomini Stroud, "Study Shows the Value of Copy Editing," American Press Institute, March 3, 2015.

82 "Dictionaries are not guardians of language": Kory Stamper, "Ask a Lexicographer" (session presented at the American Copy Editors Society annual conference, Pittsburgh, Pennsylvania, March 27, 2015).

82 "Hour-long." *Merriam-Webster.com.* Merriam-Webster, n.d., web, accessed July 3, 2017.

82 "Daylong." *Merriam-Webster.com.* Merriam-Webster, n.d., web, accessed July 3, 2017.

82 "Weeklong." *Merriam-Webster.com.* Merriam-Webster, n.d., web, accessed July 3, 2017.

82 "Monthlong." *Merriam-Webster.com.* Merriam-Webster, n.d., web, accessed July 3, 2017.

82 "Yearlong." *Merriam-Webster.com.* Merriam-Webster, n.d., web, accessed July 3, 2017.

82 "I think most people": Anne Curzan, "What Makes a Word 'Real'?" TED Talk presented at TEDxUofM, Ann Arbor, Michigan, March 15, 2014, www.ted.com/talks/anne_curzan_what_makes_a_word_real.

84 the entry for *Mumbai*: "Bombay" and "Mumbai." *Merriam-Webster.com.* Merriam-Webster, n.d., web, accessed March 26, 2016.

89 allows for FBI on first reference: "FBI" entry. *The Associated Press Stylebook* online, The Associated Press, n.d., accessed May 20, 2017.

89 spelling out the Department of Motor Vehicles: "Ask the Editor" entry, *The Associated Press Stylebook* online, The Associated Press, May 23, 2011, www.apstylebook.com/ask_the_editors/10713.

90 the use of *reasons why*: "Reason." *OxfordDictionaries.com*, Oxford University Press, n.d., web, accessed May 20, 2017.

91 italic type vs. quotation marks: "Italics" and "accent marks" entries. *The Associated Press Stylebook* online, The Associated Press, n.d., accessed May 20, 2017.

93 titles of book series: "Capitalization, Titles" "Chicago Style Q&A" entry, *Chicago Manual of Style Online*, n.d., web, accessed May 20, 2017, www.chicagomanualofstyle.org/qanda/data/faq/topics/CapitalizationTitles/faq0014.html.

115 "a colon means 'that is to say'": "Colons," GrammarBook.com, Jane Straus/GrammarBook.com, n.d., web, accessed May 20, 2017, www.grammarbook.com/punctuation/colons.asp.

115 "spineless and ineffectual prevaricators": University of Chicago Press editorial staff, *But Can I Start a Sentence with "But"?* (Chicago: University of Chicago Press, 2016), 41.

120 as a sort of pseudo-title: Anne Helen Petersen, "Jennifer Lawrence and the History of Cool Girls," *BuzzFeed*, February 28, 2014.

122 what kind of foods constitute a normal breakfast: Alanna Okun, "Hey, You

Notes

Should Totally Eat Non-Breakfast Food for Breakfast," *BuzzFeed*, March 22, 2016.

123 "According to Bob Wyman": Susan C. Herring, "Should You Be Capitalizing the Word 'Internet'?" *Wired* online, October 19, 2015.

125 "in a historical sense": "Eastern Europe" entry. *The Associated Press Stylebook* online, The Associated Press, n.d., accessed May 20, 2017. "Ask the Editor" entry, *The Associated Press Stylebook* online, The Associated Press, April 16, 2014, www.apstylebook.com/ask_the_editors/21330. "Ask the Editor" entry, *The Associated Press Stylebook* online, The Associated Press, March 15, 2016, www.apstylebook.com/ask_the_editors/27955.

129 "all caps for names that aren't initialisms": Bill Walsh, *The Elephants of Style: A Trunkload of Tips on the Big Issues and Gray Areas of Contemporary American English* (New York: McGraw-Hill, 2004), 32.

131 "You have to draw the line somewhere": Ibid., 38.

133 "A formal title generally is one": "Titles" entry. *The Associated Press Stylebook* online, The Associated Press, n.d., accessed May 20, 2017.

134 "A final determination on whether a title": Ibid.

137 Stamper tells us comfortingly: Kory Stamper, *Word by Word: The Secret Life of Dictionaries* (New York: Pantheon, 2017), 48.

142 "contractions are usually not appropriate": "Contractions." *Cambridge Dictionary* online, Cambridge University Press, n.d., web, accessed May 20, 2017, dictionary.cambridge.org/us/grammar/british-grammar/writing/contractions.

147 a 1924 letter to the *New York Times*: Philip B. Corbett, "Save the Subjunctive!" *After Deadline: Newsroom Notes on Usage and Style* (blog), *New York Times*, September 11, 2012, afterdeadline.blogs.nytimes.com/2012/09/11/save-the-subjunctive-2/.

148 then there's the odd sentence: Gabe Doyle, "Sometimes the Subjunctive Matters. That Won't Stop It from Dying." *Motivated Grammar* (blog), February 15, 2012, motivatedgrammar.wordpress.com/2012/02/15/sometimes-the-subjunctive-matters-that-wont-stop-it-dying.

149 calling a person a *that*: "That." *American Heritage Dictionary* online, Houghton Mifflin Harcourt, n.d., web, accessed May 20, 2017.

151 "When in doubt, use *who*": Lisa McLendon, "Sweat This, Not That: Real Rules vs. Grammar Myths" (session presented at the American Copy Editors Society annual conference, Portland, Oregon, April 2, 2016).

151 a study published in March 2016: Julie E. Boland and Robin Queen, "If You're House Is Still Available, Send Me an Email: Personality Influences Reactions to Written Errors in Email Messages," *PLOS One*, March 9, 2016, journals.plos.org/plosone/article?id=10.1371%2Fjournal.pone.0149885.

Notes

Chapter 6: How Social Media Has Changed the Game

163 [*because* + noun/noun phrase] construction: Stan Carey, "'Because' Has Become a Preposition, Because Grammar," *Sentence First* (blog), November 13, 2013, stancarey.wordpress.com/2013/11/13 /because-has-become-a-preposition-because-grammar.

163 from a BuzzFeed essay: April De Costa, "What 'The Baby-Sitters Club' Taught Me About My Disease," *BuzzFeed*, July 24, 2015.

164 from a helpful BuzzFeed list: Casey Gueren, "23 Sex Habits All Twentysomethings Should Adopt," *BuzzFeed*, August 24, 2015.

164 "associated with an implication": Mark Liberman, "Because NOUN," *Language Log* (blog), July 12, 2012, languagelog.ldc.upenn.edu/nll/?p=4068. Lindy West, "Are Men Going Extinct?" *Jezebel*, July 11, 2012.

166 "general principle of internet language": Gretchen McCulloch, "A Linguist Explains the Grammar of Doge. Wow." *The Toast*, February 6, 2014.

167 feature appearances by Doge: Samir Mezrahi, "14 Iconic Pieces of History Made More Wow with Doge," *BuzzFeed*, November 14, 2013.

169 "It's a clever ploy": Jody Rosen, "How 'Everything' Became the Highest Form of Praise," *New York Times* online, May 24, 2016.

169 The ubiquitous @: Keith Houston, *Shady Characters: The Secret Life of Punctuation, Symbols, and Other Typographical Marks* (New York: Norton, 2014), 87–88.

173 Some credit this November 2014 tweet: Kevin Roose, "'Netflix and Chill': The Complete History of a Viral Sex Catchphrase," *Fusion*, August 27, 2015. See also knowyourmeme.com/photos/1008330-netflix-and-chill.

177 *nom* likely derived from: Dana Hatic, "The Origins of the Annoyingly Trendy Word 'Nom,' Explained," *Eater Boston*, November 2, 2016.

178 "I wanna see the receipts": Katy Waldman, "How 'Show Me the Receipts' Became a Catchphrase for Holding the Powerful Accountable," *Lexicon Valley* (blog), *Slate*, July 21, 2016, www.slate.com/blogs/lexicon_ valley/2016/07/21/how_show_me_the_receipts_became_a_catchphrase_ for_holding_the_powerful_accountable.html.

179 "The rap crew Travis Porter immediately tweeted": Kyle Chayka, "The Life and Times of ¯_(ツ)_/¯," *The Awl*, May 20, 2014.

180 "On Twitter, you can easily identify a stan": Katie Notopoulos, "What Happens When a Stan Retires?" *BuzzFeed*, June 24, 2016.

185 "It's something we just said naturally": Jon Levine, "Yaaass, You Have Black Drag Queens to Thank for the Internet's Favorite Expression," *Mic*, October 7, 2015.

185 a crowd gathered at a ball: *Paris Is Burning*. Directed by Jennie Livingston, New York: Off White Productions, 1990.

Notes

Chapter 7: "Real" Words and Language Trends to Embrace

193 "In the broadest sense possible": David Foster Wallace, *Quack This Way: David Foster Wallace & Bryan A. Garner Talk Language and Writing* (Dallas: RosePen Books, 2013), 25–26.

195 "We know from experience that new terms": Constance Hale and Jessie Scanlon, *Wired Style: Principles of English Usage in the Digital Age* (New York: Broadway Books, 1999), 14.

196 "The word nice, derived from Latin *nescius*": Susie Dent, *What Made the Crocodile Cry? 101 Questions About the English Language* (New York: Oxford University Press, 2009), 92.

197 "There appears to be an invisible": "What Do You Mean What Is It Like?" *Lexicon Valley* podcast, presented by *Slate*, Panoply Network, produced by Mike Vuolo, hosted by Bob Garfield and Mike Vuolo, August 10, 2015.

199 "*random* actually served as a noun": "That's So Random: The Evolution of an Odd Word," *All Things Considered* radio program, NPR, segment reported by Neda Ulaby, November 30, 2012.

201 "It may well be that Internet users": David Crystal, *Internet Linguistics: A Student Guide* (Abingdon, UK: Routledge, 2011), 66.

201 "My job is not to decide": Erin McKean, "Go Ahead, Make Up New Words!" TED Talk presented at TEDYouth 2014, Brooklyn, New York, November 15, 2014, www.ted.com/talks/erin_mckean_go_ahead_make_up_new_words.

202 "Vogue words tend to irritate": David Foster Wallace, *Quack This Way: David Foster Wallace & Bryan A. Garner Talk Language and Writing* (Dallas: RosePen Books, 2013), 51.

203 *thank-you-ma'am*: "Thank-you-ma'am." *Merriam-Webster.com*. Merriam-Webster, n.d., web, accessed May 20, 2017.

205 "to keep informed": "Stay woke." *UrbanDictionary.com*. Entered by user pazwell on August 19, 2014.

205 how "woke" he is: Michael Blackmon, "Can We Talk About How Woke Matt McGorry Was in 2015?" *BuzzFeed*, December 16, 2015.

211 "stylized verbal incoherence": "Are Emojis a Language?" *Lexicon Valley* podcast, presented by *Slate*, Panoply Network, produced by Mike Vuolo, hosted by John McWhorter, July 26, 2016.

219 Shakespeare used the singular *they*: Gretchen McCulloch, "This Year Marks a New Language Shift in How English Speakers Use Pronouns," *Quartz*, December 21, 2015.

219 Williams self-identifies: Ruby Cramer, "'Superpredators' Heightens Divide Between Clintons and New Generation of Black Activists," *BuzzFeed*, April 13, 2016.

225 its etymological story: Katy Steinmetz, "This Gender-Neutral Word Could
 Replace 'Mr.' and 'Ms.,'" *Time* online, November 10, 2015.

227 "epic dog toy": Ashley McGetrick and Candace Lowry, "Make an Epic Dog
 Toy Out of Your Old T-Shirts," *BuzzFeed*, video presented by Nifty, May 17,
 2016.

227 *epic* and words: Nathan Heller, "An Epic Takedown of Élite Brospeak," *The
 New Yorker* online, March 3, 2016.

228 It's why a BuzzFeed post: Alan White, "29 Goddamn Heroes," *BuzzFeed*,
 March 4, 2014.

231 the New Slash: Anne Curzan, "Slash: Not Just a Punctuation Mark
 Anymore," *Lingua Franca* (blog), *The Chronicle*, April 24, 2013,
 www.chronicle.com/blogs/linguafranca/2013/04/24/slash-not-just-a
 -punctuation -mark-anymore.

234 "Since the sexual revolutions": Sam Kriss, "How Twitter Ruined Swearing,"
 Vice online, March 3, 2017.

236 We were hesitant: Neil Howe and William Strauss, *Generations: The History
 of America's Future, 1584 to 2069* (New York: Quill, 1991), 14.

236 when we published: "Millennials." *BuzzFeed Style Guide*, *BuzzFeed*, web, first
 published February 4, 2014, accessed May 20, 2017.

238 don't consider themselves millennials: "Most Millennials Resist the
 'Millennial' Label," report by the Pew Research Center, September 3, 2015.

Chapter 8: How the Internet Has Changed Punctuation Forever

240 "One special power": Joseph Bernstein, "The Hidden Language of the
 ~Tilde~," *BuzzFeed*, January 5, 2015.

241 attempts to punctuate irony…failed to take off: Keith Houston, *Shady
 Characters: The Secret Life of Punctuation, Symbols, and Other Typographical
 Marks* (New York: Norton, 2014), Chapter 11: "Irony and Sarcasm."

241 its flawed visual design: Nick Broughall, "SarcMark: For When You're Not
 Smart Enough to Express Sarcasm Online," *Gizmodo Australia*, January 13,
 2010.

245 "If the love of your life": Dan Bilefsky, "Period. Full Stop. Point. Whatever
 It's Called, It's Going Out of Style." *New York Times*, June 9, 2016.

246 "an all-purpose piece": Jeff Guo, "Stop. Using. Periods. Period." *Wonkblog*
 (blog), *Washington Post*, June 13, 2016, www.washingtonpost.com/news
 /wonk/wp/2016/06/13/stop-using-periods-period-2/?utm_term=
 .4ebcb49468a1.

251 "More and more people": Daniel McMahon, "The World's Top Grammarian
 Fears That This Punctuation Error Is Becoming Standard English," *Business
 Insider*, May 2, 2016.

Notes

253 "Done knowingly by an established writer": Lynne Truss, *Eats, Shoots & Leaves: The Zero Tolerance Approach to Punctuation* (New York: Gotham Books, 2006), 88.

254 "Only ignorami": Patricia T. O'Connor, *Woe Is I: The Grammarphobe's Guide to Better English in Plain English,* 3rd ed. (New York: Riverhead Books, 2009), 32.

254 grammar myths dispelled: Lisa McLendon, "Sweat This, Not That: Real Rules vs. Grammar Myths" (session presented at the American Copy Editors Society annual conference, Portland, Oregon, April 2, 2016).

254 many have evolved: Cara Rose DeFabio, "Instagram Hashtags Could Be the Best Guide to Emoji Meaning We've Ever Had," *Fusion,* May 1, 2015.

257 looking at a smiley face: Owen Churches, Mike Nicholls, Myra Thiessen, Mark Kohler, and Hannah Keage, "Emoticons in Mind: An Event-Related Potential Study," *Social Neuroscience,* January 6, 2014 (Vol. 9, Issue 2), 196–202.

258 "There is no innate neural": Anna Salleh, "Emoticon Language Is Shaping the Brain," *ABC Science* online, February 6, 2014.

258 "The vocabulary of Instagram"…with early internet slang: Instagram Engineering, "Emojineering Part 1: Machine Learning for Emoji Trends," May 1, 2015, www.engineering.instagram.com/emojineering-part-1 -machine-learning-for-emoji-trendsmachine-learning-for-emoji-trends -7f5f9cb979ad.

259 words for *poop* and *luck*: Naline Eggert, "Emoji Translator Wanted — London Firm Seeks Specialist," *BBC News* online, December 12, 2016.

260 "We also use emoji to convey": Clive Thompson, "The Emoji Is the Birth of a New Type of Language (No Joke)," *Wired* online, April 19, 2016.

261 "As a twenty-first century culture": "Oxford Dictionaries Word of the Year – Casper Grathwohl," YouTube video, posted by Oxford Dictionaries, November 16, 2015, www.youtube.com/watch?v=ivV8x2K_DSU.

261 most-used emoji *in the world*: "Oxford Dictionaries Word of the Year is… 😂 " *Oxford Dictionaries* blog, *OxfordDictionaries.com,* Oxford University Press, November 2015, blog.oxforddictionaries.com/2015/11 /word-of-the-year-2015-emoji.

261 The birth of the modern emoticon: Paul Bignell, "Happy 30th Birthday Emoticon! :-)" *The Independent* online, September 8, 2012.

262 Abraham Lincoln: Jennifer 8 Lee, "Is That an Emoticon in 1862?" *City Room* (blog), *New York Times* online, January 19, 2009.

262 its use was deliberate: Keith Houston, *Shady Characters: The Secret Life of Punctuation, Symbols, and Other Typographical Marks* (New York: Norton, 2014), 235.

262 A discovery by literary critic: Thomas Gorton, "Is This the World's First Emoticon?" *Dazed* online, April 14, 2014.

263 Seventeen years later: Mayumi Negishi, "Meet Shigetaka Kurita," *Japan Real Time* (blog), *Wall Street Journal* online, March 26, 2014, blogs.wsj.com /japanrealtime/2014/03/26/meet-shigetaka-kurita-the-father-of-emoji.

263 The loss of punctuation: Tumblr post by user prismatic-bell, June 15, 2015, via prismatic-bell.tumblr.com/post/121650071961/atomicairspace -copperbooms-when-did-tumblr.

264 Tumblr speech and internet linguistics...indicate laughter: Harley Grant, *Tumblinguistics: Innovation and Variation in New Forms of Written CMC* dissertation, n.d., web, www.academia.edu/18612487/Tumblinguistics _innovation_and_variation_in_new_forms_of_written_CMC.

Chapter 9: From Sea to Shining Sea: Regional Stylistic Differences

271 "the vast majority of English": "David Crystal — The Effect of New Technologies on English," YouTube video, posted by BritishCouncilSerbia, November 29, 2013, www.youtube.com/watch?v=qVqcoB798Is.

272 even viral quizzes: Josh Katz (most questions based on those in the Harvard Dialect Survey, by Bert Vaux and Scott Golder), "How Y'all, Youse and You Guys Talk," *Sunday Review, New York Times* online, December 21, 2013.

276 "*quite* usually means 'fairly'": "Quite." *Macmillan Dictionary* online, Macmillan, n.d., web, accessed May 22, 2017.

280 some British swearwords: Rory Lewarne, "49 British Swearwords, Defined," *BuzzFeed*, January 30, 2015.

285 "speedos." *Macquarie Dictionary* online, Macquarie Library, n.d., web, accessed March 4, 2016.

288 "unlike in the United States": Karen Virag (editor-in-chief) and Editors' Association of Canada, *Editing Canadian English: A Guide for Editors, Writers, and Everyone Who Works with Words*, 3rd ed. (Toronto: Editors' Association of Canada, 2015), 20.

Chapter 10: At the Intersection of E-Laughing and E-Crying

290 Canadian bulletin board system: Wayne Pearson, "The Origin of LOL," University of Calgary – Department of Computer Science, n.d., web, accessed May 22, 2017, pages.cpsc.ucalgary.ca/~crwth/LOL.html.

294 "It's a marker of empathy": John McWhorter, "Txtng Is Killing Language. JK!!!" TED Talk, February 2013, www.ted.com/talks/john_mcwhorter _txtng_is_killing_language_jk.

296 *haha* is the reigning champ: Lada Adamic, Mike Develin, and Udi Weinsberg, "The Not-So-Universal Language of Laughter," Facebook Research, August 6, 2015, research.fb.com/the-not-so-universal-language-of-laughter.

296 to type laughter: Katie Heaney, "The 42 Ways to Type Laughter, Defined," *BuzzFeed*, February 5, 2014.

Chapter 11: Email, More Like Evilmail, Amirite?

301 to start off an email: Luke Bailey, "The 48 Most Annoying Ways to Start an Email, Defined," *BuzzFeed*, April 9, 2014.
306 to sign off an email: Robin Edds, "The 41 Ways to Sign Off an Email, Defined," *BuzzFeed*, March 31, 2014.

Chapter 12: We're All Going to Be Okay

311 "On Twitter, Cap'n Crunch": Amanda Hess, "When You 'Literally Can't Even' Understand Your Teenager," *New York Times Magazine* online, June 9, 2015, www.nytimes.com/2015/06/14/magazine/when-you-literally-cant-even-understand-your-teenager.html.

Appendix III: Headlines on the Internet

349 held in deplorable conditions: Simon Parry, "Children Caged to Keep the Streets Clean for the Pope: Police Round Up Orphans and Chain Them in Filth During Pontiff's Visit to Philippines," *Daily Mail* online, published January 14, 2015, updated January 17, 2015.
351 On an episode of one…"just all right": "Going Viral," *The Allusionst* podcast, Radiotopia/PRX, hosted and produced by Helen Zaltzman, January 28, 2015.

Appendix IV: Editing for an International Audience

361 "the '1099 workers'": Mat Honan, "Elizabeth Warren on Rise of the 1099 Economy: 'A Real Problem,'" *BuzzFeed*, May 26, 2015.
361 "But the independent contractors": Caroline O'Donovan, "Tax Day Is Hell for Uber Drivers," *BuzzFeed*, April 11, 2016.

Quizzes/Sidebars

Emmy Favilla, "Punctuation Ranked from Worst to Best," *BuzzFeed*, August 19, 2014.
Emmy Favilla, "15 Silly Old-Timey Words You Need to Start Using Again," *BuzzFeed*, December 2, 2014.
Emmy Favilla, "Do You Know What These Weird English Words Actually Mean?" *BuzzFeed*, January 27, 2015.
Crystal Ro, "Can You Identify the '90s Movie from Just Three Emojis?" *BuzzFeed*, July 10, 2015.
Sarah Willson, "How Normal Are Your Grammar Gripes?" *BuzzFeed*, June 18, 2016.

Notes

"Old-Timey Words You Need to Start Using Again"

"Flapdoodle." *Merriam-Webster.com.* Merriam-Webster, n.d., web, accessed December 2, 2014.

"Claptrap." *Merriam-Webster.com.* Merriam-Webster, n.d., web, accessed December 2, 2014.

"Tommyrot." *Merriam-Webster.com.* Merriam-Webster, n.d., web, accessed December 2, 2014.

"Fiddle-faddle." *Merriam-Webster.com.* Merriam-Webster, n.d., web, accessed December 2, 2014.

"Monkeyshine." *Merriam-Webster.com.* Merriam-Webster, n.d., web, accessed December 2, 2014.

"Horsefeathers." *Merriam-Webster.com.* Merriam-Webster, n.d., web, accessed December 2, 2014.

"Applesauce." *Merriam-Webster.com.* Merriam-Webster, n.d., web, accessed December 2, 2014.

"Codswallop." *Merriam-Webster.com.* Merriam-Webster, n.d., web, accessed December 2, 2014.

"Blatherskite." *Merriam-Webster.com.* Merriam-Webster, n.d., web, accessed December 2, 2014.

"Bafflegab." *Merriam-Webster.com.* Merriam-Webster, n.d., web, accessed December 2, 2014.

"Stultiloquence." *Merriam-Webster.com.* Merriam-Webster, n.d., web, accessed December 2, 2014.

"Taradiddle." *Merriam-Webster.com.* Merriam-Webster, n.d., web, accessed December 2, 2014.

"Jiggery-pokery." *Merriam-Webster.com.* Merriam-Webster, n.d., web, accessed December 2, 2014.

"Piffle." *Merriam-Webster.com.* Merriam-Webster, n.d., web, accessed December 2, 2014.

"Humbuggery." *Merriam-Webster.com.* Merriam-Webster, n.d., web, accessed December 2, 2014.

Index

Note: Page numbers in *italic* refer to illustrations and images.

abbreviations, 88–90
abortion, 61
 abortion rights advocate, 61
 anti-abortion, 61
 pro–abortion rights, 61
 pro-choice/pro-life, 61
academic titles, 135
accent marks, 91–92, 269–70
acronyms, 88–89
addressing people, 106–7, 145–46, 301
adjectives, 54
adoption, 61
adulting, 211
adverbs, 54
affect/effect, 38
African-American/black, 68
afterward/afterwards, 31
agreement, 40–44, *43*
aid/aide, 38
Airbnb, 154
Alaska Natives, 69
alleged victim, 76–77
all the feels, 171
all the things, 163
alright/all right, 33
animals, *who* vs. *that*, 149–50
any and verb agreement, 44

apostrophes, 40, 109, 138, 139
April Fools' Day, 215
Arabic names, 69
"Are Men Going Extinct?" (West), 164
Argentine/Argentinian, 68
artworks, 125–26
Associated Press Stylebook (*APS*), 9, 27, 91, *91*, 195
asterisks indicating behavior, 243
@ (at symbol), 169
Australia, 285–86, 287
award names, 217
awesome, 170
awful, 170

Bailey, Luke, 301
Baker, Katie J.M., 76
band names, 278–79
Bantu names, 69–70
bare/bear, 38
because, 163–65, 277
beg the question, 129
Bernstein, Joseph, 240
bigotry, 234
Bilefsky, Dan, 245
Black Friday, 218
black individuals/culture, 68, 204–5
blogs, stylization of, 92

Index

Blue Book of Grammar and Punctuation (Straus), 102, 115
bobsled/bobsleigh, 275
bodies and body image, 77–79
Bombay/Mumbai, 84, 84
brackets, 116, 284
brands
 capitalization of, 125–26, 128–29, 131–32
 pronouns for, 132–33, 133
 pseudo-brands, 120–21
break the internet, 165
Brennan, Lyle, 184
broken English, 172
brospeak, élite, 227
But Can I Start a Sentence with "But"? (University of Chicago Press Editorial Staff), 115
buttcheeks/butt cheeks, 277
butthole/butt hole, 23–24
BuzzFeed Style Guide, 4, 5–12, 35

caj/casual, 207
calling in/out sick, 272–73, 273
Canada, 287–88, 288
canon ship, 178
capital/capitol, 37
capitalization, 117–36
 of brands/trademarks, 34, 34, 125–26, 128–29, 131–32
 of deities, 124–25, 125
 of directionals, 124
 for emphasis, 121–22, 122
 of food and drinks, 119–20
 of *internet*, 9, 123, 266
 of job descriptions/titles, 133–36
 making style decisions on, 9
 of proper nouns, 40, 118
 of pseudo-brands, 120–21
 randomly applied, 121
 and Tumblr English, 267, 267

vanity capitalization, 125–28, 127–28
Carey, Stan, 163
cargo ship, 178
Caribbean, ethnicities from, 68
cash me ousside, howbow dah, 165–66
catfish, 200
'cause/'cos/because, 277
cell phone/cellphone, 197
censorship, 234–35
Chambers, Jack, 266
ChapStick, 82
Chayka, Kyle, 179
Chevannes, Paul, 15
Chicago Manual of Style (CMOS), 9, 91, 94, 115
Chinese names, 70
chords/cords, 38
Churches, Owen, 258
Cinco de Mayo, 215–16
citations via hyperlinks, 192
clarity, 33, 40
code-switching, 310
collective nouns, 41–44, 278–79
colons
 indicating behavior, 243, 243
 ranked in value, 110
 in United Kingdom, 284
 usage, 115
come/cum, 10
commas, 102–8, 111
 comma splices, 250–53, 253
 guidelines for, 53–54
 with interjections, 107–8
 in salutations, 107, 301
 serial/Oxford commas, 104–6, 111, 305
company names, 128–29, 132–33
compounds and en dashes, 95
conjunctions, starting sentences with, 136–37
consistency, 35, 80, 191–92
cookery books/cookbooks, 275

copyediting and copy editors, 41, 81, *81*, 126, 190–91
'cos/'cause/because, 277
coworker/co-worker, *176*
crack ship/crack pairing, 178
credibility, 37, 80–81
criticism of new terms, *207*, 207
Crystal, David, 15, 17, 201, 246, 271–72
cunt, 280
currency, 286–87
curvy individuals, 78
Curzan, Anne, 20, 82, 232, 233

dates, 53, 144–45, 215, 274
datum/data, 42
daylight saving time, 218
dead/dying/died, 231
deadnaming, 67
deaf/deaf-mute, 74
De Costa, April, 163–64
degrees/titles, commas in, 53
deities, 124–25, *125*
Dent, Susie, 196
descriptivism/prescriptivism, 18, 20–21
DeVos, Betsy, 16
dictionaries, 81–85, *84*, *85*, 202
different than/to, 274
direct address, commas for, 106–7
directionals, 124
disabilities, 72–75
discreet/discrete, 39
diseases, 75–76
disjuncts, 26–27
DM/DMs/DM'd/DM'ing, 161
doctorates (PhD), 135
do/due, making, 37
Doge-speak, 166–69, *167*, *168*
domain names and extensions, 162
don't @ me, 169
double spaces between sentences, 40

doughnut/donut, 15, *15*
DREAMers/DREAM Act, 61
Drink Drank Drunk podcast, 23
dwarfism/little people, 75

Eats, Shoots & Leaves (Truss), 54, 102
Edds, Robin, 306
effects/affects, 38
Election Day, 274
The Elephants of Style (Walsh), 34, 128–29
elicit/illicit, 39
ellipses, 112, 116–17, 304–5
email
 email/e-mail terms, 33–34, 83, 195
 writing, 300–308
em dashes, 99–102, *101*, 114, 276
Emmy Awards, 217
"The Emoji Is the Birth of a New Type of Language (No Joke)" (Thompson), 260
emojis, 254–63
 in emails, 304
 and hashtags, 258–59
 and internet slang, 258–59, *259*
 and mood, *255*, 255–56, *256*
 and punctuation, 255–56, *260*
 user demographics for, 296
emoticons, 258, 261, 262, 263, 304, 307
en dashes, 95–99, *96*, *97*, *98*, 109–10, 276
entertainment coverage, 134
entitled/titled, 30
epic, 226–27
ethnic slurs, 234
euphemisms, 75
every day/everyday, 196
everything, 169–70
exaggerated language, 226–31
exclamation marks, 114, 245, *247*, 247–48, 249–50

experts, titles and specializations of, 135

Facebook, 155, 156–58, 296
faceful/face full, 87–88, 87–89
"Face with Tears of Joy" emoji, 260–61
Fahlman, Scott E., 261, 263
fail, 194, *194*
fandoms, 136
Father's Day, 216
fat individuals, 78
feels/all the feels, 171
female/male, 223–24
Fernández de Kirchner, Cristina, 71
films, 94
fire and fire emoji, 173
flair/flare, 39
food and drinks, 119–20
football, 285–86
forego/forgo, 38–39
fractions, hyphenation of, 54
franchises, 94
friending/unfriending, 158
fry-up, 274

Garfield, Bob, 198
Garner, Bryan A., 27, 251
Garner's Modern English Usage (Garner), 27–28
gay best friend trope, 224
gay identity, 62–63. *See also* LGBT issues and topics
gender-neutral language, 22, 145–46, 218–25, *225*
geographical names and commas, 53
Gerstein, Julie, 77
Gibbs, Todd, 73
GIF, 10
glueing/gluing, 139–40, *139–40*
goals, 211–12, *212*
grammar, concern for, 151–52
GrammarBook.com, 115

Grant, Harley, 264–65, 266
Grathwohl, Casper, 261
Great Britain. *See* United Kingdom
Gueren, Casey, 164
gun-shy/gunshy, 195
Guo, Jeff, 246
guys, 145–46

haha, 295, 296–99
halftime, 215
Halloween, 217
Harmless Drudgery blog, 20–21
hashtags, 160, 171, 258–59
has she fuck/have they bollocks, 275–76, *275–76*
Hatic, Dana, 177
Hawaiians/Hawaii residents, 68–69
healthy/healthful, 28–29
Heaney, Katie, 296
height, stylization of, 145
Heller, Nathan, 227
here's/here are, 44
heroes, 228, 228–30, 229, 230
Herrick, Robert, 262
Herring, Susan C., 123
Hispanic/Latino, 68
hoard/horde, 39
holidays, treatment of, 215–18
homophones, 37–40
honorifics, 225
hopefully, 26–28
Houston, Keith, 241
"How Twitter Ruined Swearing" (Kriss), 234
Humans of New York (HONY), 93–94
hundreds and thousands, 274
hyperbole, 226–31
hyperlinks to sources, 192
hyphens/hyphenation
 and en dashes, 95, 98, *98*
 guidelines for, 45, 54–58, *55–56, 57*
 plus *ing*, 138–39

ranked in value, 113

ICanHasCheezburger, *177*, 177
I can't even, 167, 171–72
Icelandic names, 70
illicit/elicit, 39
I'mma let you finish, 140–42, *141–42*, 179
immigration, 61
imminent/eminent/immanent, 37
impact, 24–26, *25*
importantly, 29
inclusive language, 22, 59–60, 310
independent clauses, 54
indicative mood, 148
indigenous groups, 68–69, 287–88
Indonesian names, 70
ing, creating verbs with, 138–39
initialisms, 88–89, 129
insidery language, 14
Instagram, 154–55, 158, 257, 258–59, 293
integrity, 36–37
interjections, commas with, 107–8
internet
 and rate of change in language, 14–18
 term, 9, 123, 266
Internet Linguistics (Crystal), 17, 201
interviews, 46–47, 186, 190–91
iPad devices, 131–32
italics vs. quotation marks, 91–94
it me, 172, 208

job descriptions/titles, 133–36, 220–21, 220–23
Juggalo/Juggalette, 10, 16
July 4th holiday, 216

Kandell, Steve, 6
Kelly, Ryan, 260
keyboard smash, 172
Kriss, Sam, 234

Kurita, Shigetaka, 263

Latinos/Latinx, 68, 71, 218
lay/lie, 209
left-swipe/right-swipe, 159
Legos/Lego bricks, 131
Lewarne, Rory, 280
Lexicon Valley podcast, 198
LGBT issues and topics, 62–67
 in Australia, 287
 and BuzzFeed Style Guide, 79
 discrimination, 63
 gender-inclusive pronouns, 22, 65–66, 218–20
 identification, 63–64
 marriage, 65, 79, 216
 out vs. *openly*, 65
 and *throwing shade*, 183–84, *184*
 transitioning, 66–67
Liberman, Mark, 164, 165
lie low/lay low, 199
lightening/lightning, 38
like, 197, 197–98
likes, 156
Liloia, Tara, 241
lit, 173
literally, 230–31, *231*
little people/dwarfism, 75
lol and variations, 289–99
lolcats, 168
LOLSob, 214

mac 'n' cheese, 7–8
Macquarie Dictionary, 285
man/mankind, 146
marriage
 and naming conventions, 71, 72
 of same-sex couples, 65, 79, 216
Martin, Katherine Connor, 14
math/maths, 279
McCulloch, Gretchen, 166–67, 211, 266

McKean, Erin, 201–2
McLendon, Lisa, 151, 254
McWhorter, John, 294
measurements, 191–92, 273–74
medal/meddle/metal/mettle, 39–40
media companies/publications, 92–93
medical degrees (MD), 135
menagerie, 42
mental disabilities, 74
mental illness, 72–73, 74–75
Merriam-Webster, 9, 82–84, *84, 85*
Metcalf, Allan, 30
Mezrahi, Samir, 167
mic/mike, 33–34
midget, 75
migrants, 61–62
millennials, 236–38, 310
minuscule/miniscule, 17
misspelling words, 168–69
mistakes, standardization of, 16–17
mom/dad goals, 211–12, *212*
months, abbreviating, 215
Moore, Jina, 69
Mother's Day, 216
multilingualism, 310
Mumbai/Bombay, 84, 84
Muphry's Law, 8
Mx., 17–18, 66, 225

naming conventions, 69–72, 108
native peoples, 287–88
Netflix & chill, 173–75, *174, 175*
Neville Longbottoming, *176*, 176–77
New Slash, 232–33
news websites, 92–93
New Year's terms, 215
New York Times, 160, 169, 178, 245, 272, 310–11
nice, 196
noms, 177, *177*
nonessential clauses, 54
noodles, 279

Noooooo, 268, 268
North Korean names, 71
Notopoulos, Katie, 10, 144, 180
nouns as modifiers, 233
numbers, standards for, *143*, 143–45

O'Connor, Patricia T., 254
OK/O.K./okay, 30–32, *31–32*
Okun, Alanna, 121
old head/oldhead, 210
old-timey words, 187–89
Olympics, 216–17
one-word trend, 18, 195–96
organizations, 132–33
Orwell, George, 19–20
OT3 (*one true threesome*), 178
OTP (*one true pairing*), 178
over/more than, 29–30
Oxford commas, 104–6, 111, *305*
Oxford English Dictionary, 17–18, 260–61

pajamas/pyjamas, 279
parentheses, 40, 100–101, *101*, 111, 284
Paris Is Burning (1990), 184, 185
peanut butter and jam/jelly, 279
Pearson, Wayne, 290
performers, styling of names, 126–28, *127–28*
periods, 113, 243–48, *247*, 269
Perlman, Merrill, 34
personal names, conventions for, 69–72
person-first language, *73*, 73
personing, 211
Petersen, Anne Helen, 120
Pinterest, 159
pissed, 274
pit bull, 195
plurality, 40, 131–32, 142–43, 278–79
"Politics and the English Language" (Orwell), 19–20

Index

pored/poured, 40

possessives, 47–52, *50*

pregnant people, 224

pre-op/preop, 195

prepositions, ending sentences with, 20, 137

prescriptivism/descriptivism, 18, 20–21

Pride Month, 216

product names, 125–26, 128

profanity, 233, 233–36, *234*, *235*, 236

professorships, named, 134

pronouns

 for companies, brands, or organizations, 132–33, *133*

 and gender inclusivity, 22, 65–66, 218–20

 possessive forms of, 49

proper nouns

 capitalization of, 40, 118–20

 possessive forms of, 48–49, 51–52, *52*

publications, 92–93

punctuation

 absence of, 194, 226, 243–48, 263–67, *268*

 effect of internet on, 239–70

 and emojis, 255–56, *260*

 indicating behavior, 243, *243*

 overpunctuation, 247

 ranked worst to best, 109–14

 stand-alone, 249–50

 and Tumblr English, 263–68, *268*

 See also specific marks

Quack This Way (Wallace), 202

queer people, 63. *See also* LGBT issues and topics

question marks, 112, 247–48, 249–50, 269

quite, 276

quotation marks, 45, 91–94, 109, 248–49, 284

quoted material, 46–47, 186, 190–91

race and ethnicity, *67*, 67–72

radical, 170

random, 198–200

rape and sexual assault, 76–77

"real" words, 20, 82, 201

reasons/reasons why, 90–91

receipts, 178–79

recipes, 191–92

redundancy, 90–91

refugees, 61–62

regional stylistic differences, 271–88

reigns/reins, 40

relevance, importance of, 34, 311

repeated words, 103

restauranteur/restaurateur, 18

roller coaster/rollercoaster, 22–23, 35

Rosen, Jody, 169

run-on sentences, 250–53

Russian names, 71–72

sac/sack, 208

same-sex partners, 62–63, 216. *See also* LGBT issues and topics

sarcasm, 241–42, *270*

SarcMark, *241*, 241, 242

savage, 178

science-ing/science-y, 210, *210*

sea horse/seahorse, 257

seasonal terms, 215–18

semicolons, 110, 252

sensitive topics, 59–79

 abortion, 61

 adoption, 61

 bodies and body image, 77–79

 disabilities, diseases, and disorders, 72–76

 immigration, 61

 LGBT issues and topics, 62–67

 migrants and refugees, 61–62

 race and ethnicity, *67*, 67–72

rape and sexual assault, 76–77
slavery, 62
suicide, 62
Sentence First blog, 163
sentence modifiers, 29
serial commas (Oxford commas), 104–6, 111, *305*
series, 94
Shady Characters (Houston), 241
shall, 151
shear/sheer, 39
Sheidlower, Jesse, 199
ship, 178
shit, 86–87, 277–78, *278*
show me the receipts, 178–79
shruggie, 179
side-eye/sideeye, 195
sign language, 74
-size/-sized, 91
slash (spelled out), 232–33
slashes, 58
slavery, 62
sleeping in/lie-in, 274
slé'ing, *213*
Smarties candies, 274
smiley face, 262
Smith, Ben, 6, 8, 102, 236
Snapchat, 155, 159
social media, 153–92
 Pinterest, 159
 Snapchat, 155, 159
 Tinder, 159
 WhatsApp, 161
 See also Facebook; Instagram; Tumblr; Twitter
Solomon, Jane, 225
speech, influence on written language, 140–42
speedos, 285
spelling standards
 and deviations in slang, 185
 and homophones, 37–40

internet's influence on, 15
and misspelling words, 168–69
one-word trend, 18, 195–96
shifts in, 17
simplifications in, 201
tracking variations in, 15, *15*
sport/sports, 279
square brackets, 284
Stahl, Levi, 262
Stamper, Kory, 20–21, 81–83, 137
stan, 179–81, *180*
stationery/stationary, 37
STD/STI, 75–76
Stopera, Matt, 213, *213*
"Stop. Using. Periods. Period" (Guo), 246
St. Patrick's Day, 215
subjunctive mood, 66, 147–49
suicide, 62
Super Bowl, 215

tabled, 274
tense, 45–47
tfw, *181*, 181–83, *182*, *183*
Thanksgiving Day, 218
thank–you–ma'am, 203
they (singular), 218–20
thirst trap, 183
Thompson, Clive, 260
throwing shade, 183–84, *184*
tildes, 239–42, *240*, *242*, *270*
Time, 79
Tinder, 159
titled/entitled, 30
titles of creative works, 92–94
titles of people
 job titles, 133–36, *220–21*, 220–23
 pseudo-titles, 120–21
toward/towards, 31
trademarks
 capitalization of, *34*, 34, 129, 131–32

of food and drinks, 119–20
and generic terms, 47
pluralizing, 131–32
triangle, 213
Trump, Donald, 16
Truss, Lynne, 54, 253
trust, importance of, 34
Tumblinguistics (Grant), 264
Tumblr, 93, 159–60, 184, 263–68, 265–68
Twain, Mark, 33
Twitter, 160–61
 and *because*, 165
 and emojis, 257
 and hashtags, 160, 171
 quoting users on, 191
 and tweets, 155, 159, 160
 and user handles, 160
type, 19

United Kingdom
 regional stylistic differences, 273–80, 283–86
 swearwords of, 280–83
updog, 10
Urban Dictionary, 202, 202
usj/usual, 207

Valentine's Day, 215
Venmo, 154
verbification
 nontraditional, 137–43, 211
 in social media apps, 156–57
vocative case, 106–7
Vuolo, Mike, 198

Waldman, Katy, 178–79
Wallace, David Foster, 193–94, 202
Walsh, Bill, 34, 128–29, 131
Washington Post, 33–34

web, 9
websites, 92, 161–62
West, Kanye, 140–42, 179
West, Lindy, 164
What Made the Crocodile Cry? (Dent), 196
"What Makes a Word 'Real'?" (Curzan), 20, 82
WhatsApp, 161
Whelan, Nora, 77
whet/wet your appetite, 37
which, commas following, 104
White, Alan, 228
whom, 151
whose/who's, 38
who/that, 149–50
Wilson, Woodrow, 55
winky face, 262
Woe Is I (O'Connor), 254
woke, 204–6, *205*, *206*
Word by Word (Stamper), 137
words
 creating new, 137, 201–2, 210, *213*
 criticism of new, *207*, 207
 and dictionaries, 81–85, *84*, *85*, 200, *200–201*, 202
 inclusion signaled by, 202–3
 misspelling, 168–69
 old-timey, 187–89
 rate of transformation, 200
 "real," 20, 82, 201
 signaling inclusion, 202–3
workout/work out, 196
worth while, 19

yaaass, 184–85
your fave could never, 185–86, *186*

Zs/zeds, 279, *279*

A Note on the Author

Emmy J. Favilla joined the BuzzFeed team in 2012 and is now global copy chief. She is also the creator of the BuzzFeed Style Guide, which garnered a great deal of media attention as the unofficial "style guide for the internet" when it went public in 2014. A New York University graduate, Favilla has worked as a copy editor at *Seventeen*, *Teen Vogue*, and *Natural Health* magazines. She lives in New York City with a cat, a dog, and two rabbits.